FRANCIS HAYMAN

FRANCIS HAYMAN

BRIAN ALLEN

Published in association with English Heritage (the Iveagh
Bequest, Kenwood) and the Yale Center for British Art by

YALE UNIVERSITY PRESS
NEW HAVEN AND LONDON 1987

Published to coincide with the exhibition
held at the Yale Center for British Art, 1 April–31 May 1987
and at the Iveagh Bequest, Kenwood, 24 June–30 September 1987

Set in Monophoto Baskerville and printed in Great
Britain by BAS Printers Limited, Over Wallop,
Hampshire.

Library of Congress catalog card number:
LC 86–51284
ISBN: 0–300–03915–8 (hardback)
ISBN: 0–300–03953–0 (paperback)

CONTENTS

ACKNOWLEDGEMENTS

In the course of researching and writing this catalogue I have received assistance from institutions and individuals too numerous to record individually. However, a number of individuals warrant particular mention.

Professor Michael Kitson, now Director of Studies at the Paul Mellon Centre for Studies in British Art but formerly Deputy Director of the Courtauld Institute of Art, supervised by PhD thesis on Hayman, submitted to the University of London in 1984, and made numerous suggestions for improvement. I am fortunate in now having the benefit of Professor Kitson's profound wisdom and experience as a colleague.

My former colleague Dr Christopher White, now Director of the Ashmolean Museum also offered much encouragement and support and the staff of the Paul Mellon Centre have all contributed in one way or another. In particular I must thank Mrs Evelyn Newby for much practical help over the years and without Douglas Smith, many of whose excellent photographs of Hayman's work can be seen in this catalogue, my task would have been a great deal more difficult.

I also owe an enormous debt to the late Sir Ellis Waterhouse. With characteristic generosity he made his files on Hayman and his contemporaries available to me from the start of my research and shared his unparalleled knowledge of British painting of the eighteenth-century with me over many memorable lunch meetings.

Among the numerous scholars who have helped I must single out Dr David Solkin with whom I have had many stimulating discussions over the last decade. In addition I would also like to thank David Alexander, Dr Geoffrey Ashton, Professor David Bindman, Malcolm Baker, Walter Brettingham, Constance Clement, Malcolm Cormack, Dr T. J. Edelstein, Dr John Edgcumbe, Miss Elizabeth Einberg, Dr Hilarie Faberman, Joan Friedman, Richard Godfrey, Dr Catherine Gordon, John Ingamells, Amanda Kavanagh, Alastair Laing, Clare Lloyd-Jacob, Dr Tessa Murdoch, Patrick Noon, Dr Nicholas Penny, the late Dr Robert Raines, Dr Aileen Ribeiro, Dr Kimerley Rorschach, Frank Simpson, Dudley Snelgrove, Michael Snodin and Scott Wilcox.

Many members of the London art trade have been of assistance. James Miller and David Moore-Gwyn of Sotheby's have been exceptionally helpful so too has Richard Kingzett of Agnew's and David Posnett and Lowell Libson of the Leger Galleries.

A Hayman exhibition would never have taken place without the encouragement of the museums involved and the generosity of the lenders. I must thank Duncan Robinson, Director of the Yale Center for British Art and John Jacob, Curator of

the Iveagh Bequest, Kenwood for responding so enthusiastically to my proposal and giving me the freedom to undertake the task. The Registrar of the Yale Center, Timothy Goodhue has responded to all my demands with good-humoured efficiency and at Kenwood Anne French and Julius Bryant could not have been more helpful. I must also thank John Nicoll and Faith Glasgow of Yale University Press for their expertise in seeing this catalogue through the press with such speed and efficiency.

Finally, I would like to thank my parents for their support over the years. My wife Katina has been exceptionally patient in living with Francis Hayman and his biographer for the past eight years. I dedicate this catalogue to them.

Brian Allen
November 1986

PREFACE

This exhibition is the result of partnership between the Iveagh Bequest, Kenwood, which is administered by English Heritage, and the Yale Center for British Art. At Kenwood, it continues a long tradition of focussing attention, by means of exhibitions, upon the work of eighteenth-century British artists. For the past ten years, on the opposite side of the Atlantic, the Yale Center has fostered similar aims. Both institutions welcome this opportunity to join forces and, with the indispensable assistance of Brian Allen, to present in London and New Haven the work of Francis Hayman, R.A.

Appropriately, Hayman's last exhibition was at Kenwood in 1960 with a pioneering catalogue by Mary Crake. Modest in scale (twenty-six oil paintings, fourteen drawings, twenty engravings and a selection of books illustrated by the artist), it nonetheless marked a turning point in his twentieth-century fortunes. Thirty years ago, the best that could be said of Hayman was that he was 'an intermediate step between Hogarth and Gainsborough'. Today, he can be seen as a prominent figure in his own right and times, a painter who was active in all of the more innovative artistic schemes of the period, including the Foundling Hospital, Vauxhall Gardens, the Society of Artists and the foundation of the Royal Academy.

Upon this process of rehabilitation the research of Brian Allen, Assistant Director and Librarian of the Paul Mellon Centre for Studies in British Art in London, places the seal. With his help we have been able to assemble by far the largest selection of Hayman's works to date, and we have done so in the knowledge that Dr Allen's catalogue will remain after the exhibitions in London and New Haven the standard work on the artist. On behalf of our respective institutions, we thank him for his efforts, and we congratulate him upon his lasting, scholarly achievement.

With him, we wish to thank all of the lenders to our exhibitions. Dr Allen has been indefatigable in tracing Haymans throughout the world, but without the generous cooperation of their present owners, both private and institutional, his knowledge of their whereabouts would have remained academic. To John Nicoll and Faith Glasgow of the Yale University Press in London, we are indebted for the printing and co-publication of the catalogue.

Duncan Robinson
Director, Yale Center for British Art

John Jacob
Curator, the Iveagh Bequest,
Kenwood

ABBREVIATIONS

Dimensions are given in inches followed by centimetres, height before width. The following abbreviations are used:

Prov: Provenance

Exh: Exhibited

CL Checklist (following catalogue)

Engr: Engraved

Exeter, 1951 Exeter, Royal Albert Memorial Museum, *Three Exeter Painters of the eighteenth century: Francis Hayman R.A., Francis Towne, John White Abbott* 1951

Gowing, 1953 Lawrence Gowing, 'Hogarth, Hayman and the Vauxhall Decorations', *Burlington Magazine*, XCV (January 1953) pp. 4–19

Kenwood, 1960 The Iveagh Bequest, Kenwood and Nottingham University Art Gallery, *Paintings, Drawings and Prints by Francis Hayman R.A. (1708–1776)* 1960

Allen, 1981 Brian Allen, 'Jonathan Tyers's Other Garden', *Journal of Garden History*, I, no. 3 (July–September 1981) pp. 215–238

Yale, 1983 Yale Center for British Art, *Vauxhall Gardens* 1983

Rococo, 1984 Victoria & Albert Museum, *Rococo Art & Design in Hogarth's England* 1984

Chaloner Smith John Chaloner Smith, *British Mezzotinto Portraits . . . being a descriptive catalogue of these engravings . . . &tc.* 4 vols. (London, 1883)

Paulson, I & II Ronald Paulson, *Hogarth, His Life, Art and Times*, 2 vols. (New Haven & London, 1971)

INTRODUCTION

The period before the establishment of the Royal Academy in 1768 has been dominated by the overwhelming presence of William Hogarth, yet an examination of how some of the lesser men of that generation built up their professional careers and reputations explains the transition from the age of Kneller to the great era of Reynolds and Gainsborough in the second half of the century. The years 1720–1770, which encompass Hayman's career, far from being moribund are revealed as a period of exciting diversity and change.

During those years – a crucial period in the history of painting in England – not only did the range of genres professed by native artists expand and consolidate, but the skill with which they worked improved noticeably. At the beginning painting was largely devoted to decorative work, often historical in character, at which the most noteworthy practitioner was Sir James Thornhill; portraiture, dominated by foreigners adept at turning out dull masks and getting paid considerable sums for them; and landscape, largely in the form of prospects of country houses. By 1768, painters like Reynolds and Gainsborough were in their prime and Hogarth had been dead for four years. By then the kinds of painting practised ranged through various kinds of portraiture, history painting, fancy pictures and a wide variety of landscape types.

When Francis Hayman arrived in London exactly half a century earlier as a boy of ten, the London art world was in a relatively primitive state. There were few opportunities for a young artist to obtain a sound training. Kneller's Academy, established at his Gt. Queen Street house in 1711 was, by the early 1720s, already divided into splinter groups and was never comparable to the type of organised art-school that existed all over Europe.[1] Even the opportunities to see great art were severely limited since there was nothing comparable in England to the paintings and sculpture accessible in churches and palaces on the Continent, and few collections of any note existed in London, or the country at large, since the disposal of Charles I's collection during the Commonwealth. As a result, the knowledge gained by all but a handful of artists who had travelled abroad was based on written description, prints or copies of works of art. In the years immediately before 1720, Jonathan Richardson's treatises were just beginning to be published and they were to have a profound effect both in helping to elevate the status of the artist as well as educating the aesthetic sensibilities of the gentleman.[2]

When Hayman came on the scene, artists were still restricted by a hopelessly inadequate system of patronage that frequently left them dependent on the support of one or a small group of individuals who made the artist part of the household.

But the days of the great cultural Maecenas like Lord Burlington or the Duke of Chandos were already numbered by the 1720s and the problem for Hayman's generation was to gain access to the new type of patron that emerged in significant numbers in the second quarter of the eighteenth century: the professional men – bankers, lawyers, physicians and clergymen for example – whose occupations had flourished since the late seventeenth century,[3] and the Grand Tourists, who as well as stuffing their country houses full of booty from Italy also demanded the traditional portrait. Artists had to be increasingly aware of the forces of supply and demand as patrons discovered a wide variety of sources for art overseas provided by the dealers and auctioneers.

An awareness of these changing conditions of patronage is vital to our understanding of this complex period. Those patrons from that sector of society that Daniel Defoe had dubbed 'the middle sort, who live well'[4] derived much of their cultural information from the fast-expanding book and periodical trade which helped to create a mass of new work for illustrators and engravers. Although architects and sculptors were still largely dependent on the upper classes, painters like Hogarth and Hayman were forced to experiment and derived much of their income from prints aimed at the same middle-class audience for whom Richardson and Fielding wrote their novels. The boom in book illustration from the 1740s provided a regular source of income for artists like Hayman and Gravelot whose work for middle-class impresarios like Robert Dodsley and the Knaptons gave them increasing independence and a consciousness of their own status.

By the middle of the eighteenth century, the distinction between the aristocratic and middle classes had greatly lessened, both socially and culturally. Unlike on the Continent, the English aristocracy often entered and sprang from commercial and industrial life, while the middle class could rise socially by purchasing estates, acquiring seats in the House of Commons and titles.

As yet, we cannot write the history of this intensely interesting period, but through an examination of the careers of artists like Francis Hayman, we can attempt to fill in some of the detail without which such a history will not be written. In the 1740s, by far his most active years, Hayman was central amongst modern painters. Friend of Hogarth and Garrick, teacher of Gainsborough, his work encompassed several of the newer genres, from the portrait conversation piece to theatrical painting, while he was intimately involved in supplying illustrations to those editions of Shakespeare and other contemporary authors like Richardson which were bought by those very people who might progress to buying works of art.

CHAPTER 1

BIOGRAPHY

On Saturday 3 February 1776 the following notice appeared in *The Public Advertiser*:

Yesterday Morning died at his House on Dean St., Soho, of the Gout, and in the sixty eighth Year of his Age, Francis Hayman, Esq., Librarian to the Royal Academy. He was one of the oldest Artists of Great Britain, and one of the best Painters of his Time. In the early part of his Life he was Scene Painter to the Drury Lane Theatre, and excelled in small Conversation Pictures. But he left that Trait for the higher Walks of History. His pictures and Sketches in Vauxhall Gardens, at the Foundling Hospital, and many private houses, have been the just admiration of the Public. His taste and Excellence in his Drawings and Designs have been no less esteemed. Witness his Compositions for Milton, Shakespeare, Pope, the Spectator, Don Quixote and numberless other Pieces. His Talent for Humour, and his Worth as a Man, will make his Friends and Acquaintances much concerned for his Death.

That obituary was a balanced and accurate summary of Hayman's activities and reputation over the previous half-century.

To my knowledge there is no significant amount of documentary or manuscript material in existence to shed light on Hayman's career, as distinct from his character.[1] This is a pity because the few letters written by him that do survive are refreshingly candid and revealing about him as a man and they reinforce the impression of his character based largely on a variety of amusing anecdotes which might otherwise be treated with suspicion. Anecdotes abound testifying to Hayman's capacity as a bon viveur and to his jocular personality.[2] However, in the absence of more reliable information, these tend to confirm the traditional image of him as an amiable, hard-living buffoon. However, from these stories we gain virtually no impression of his intellect, which creates an uncomfortable imbalance for an artist who saw himself, and indeed was seen by others, primarily as a history painter. No doubt Hayman was frequently gluttonous and dissolute, but this aspect of his character is invariably over-emphasised. In the early 1740s, the Fourth Earl of Radnor, for instance, considered him eminently fit to reside with George II's chaplain, the Suffolk antiquary and collector Dr Cox Macro (see pp. 50—52). Similarly, the artists of the St. Martin's Lane Academy thought highly enough of his political astuteness to elect him as the first Chairman of the artists' committee which negotiated the establishment of the Society of Artists in 1759. It is hoped that an examination of his work in the ensuing pages will, to some extent, redress that imbalance.

In his lifetime and until well into the nineteenth century Hayman's artistic

reputation was considerable. André Rouquet, for instance, devoted almost as much attention to him as to Hogarth and Reynolds[3] and in 1748 Mrs Delany described him as 'the best master I know of'.[4] Although Hayman's work was invariably dismissed by Horace Walpole, Edward Edwards, who had aspirations towards history painting himself, commented at the beginning of the nineteenth century:

> In the pursuit of his profession, he was not extremely assiduous, being more convivial than studious, yet he acquired a very considerable degree of power in his art, and was unquestionably the best historical painter in the kingdom, before the arrival of Cipriani.[5]

Hayman's origins are extremely obscure. Most of the skimpy biographical notes about him published in the later eighteenth and early nineteenth centuries give his place of birth as Exeter,[6] although Horace Walpole, for instance, states only that he was a Devonian.[7] Nothing has been found in the Exeter archives to confirm the place or date of his birth.[8] However, he must have been born in 1708 for both Walpole and his obituarist give his age at his death in 1776 as sixty-eight. Although Francis Hayman's baptism is not recorded, Deborah Lambert has noted that the name Hayman appears in the Exeter Cathedral records and those of the various city parish churches.[9] It is also significant that a large settlement of Haymans appear in the registers of the Church of Ottery St. Mary, within the diocese of Exeter.[10] It is there recorded that in July 1700, one John Hayman married Jane Browne, who, according to an earlier entry, had a younger brother named Robert. In 1713 another entry records the baptism of Thomas Hayman, son of John and Jane and later the same year a John Hayman was buried in the church. This John Hayman was presumably the father of the artist, for the first firmly documented evidence about the young Francis comes in the form of the Somerset House Apprentice Records which reveal that in 1718 Francis Hayman, 'son of the widow Jane', was apprenticed to Robert Browne, 'citizen and history painter', for the sum of £84.[11] As Deborah Lambert has noted, it is tempting to surmise that Robert Browne was the boy's maternal uncle and this might explain such an early apprenticeship.[12] What little we know about Browne is summarised later, but we can only speculate about any lasting influence exerted by him on the young Hayman.

Very little is known about Hayman's early career as a decorative artist and painter of stage scenery at Goodman's Fields and Drury Lane Theatres; what evidence we have, beginning as early as 1732, is discussed in Chapter 2. Hayman may well have been more active, successful and prosperous by the 1730s than can be documented for how else can we explain the enormous sum of £500 mysteriously received by him in 1737 from the Rev Dr Claude Fonnereau, the owner of Christchurch Mansion, Ipswich?[13]

The decade of the 1740s was undoubtedly Hayman's most active period. A high proportion of his surviving work is datable to these years yet he seems at this time to have played as hard as he worked. By the early 1740s, if not much earlier, he had become a close companion of Hogarth. In 1735 Hogarth helped found The Sublime Society of Beefsteaks. The Beefsteak Club, as it was generally known, probably saw itself as another version of the Liberty or Rumpsteak Club (founded in 1734) by a group of Whig Peers who had been snubbed by George II at his levées.[14] Hayman was elected a member of the Beefsteak Club on 5 February 1742, exactly

a week after Hogarth's re-election. The membership of Hogarth, Hayman and the landscape painter George Lambert is a fascinating manifestation by some of the leading artists from the St. Martin's Lane Academy of their fondness for aping aristocratic trends. Hogarth appears alongside Hayman in several anecdotes[15] and the tradition that Hayman sat as the model for the dissolute young nobleman in the second scene of *Marriage-à-la-Mode* is perfectly credible.[16] Another early source suggests that the bedraggled sign-painter perched on a ladder in Hogarth's *Beer Street* was a portrait of Hayman.[17]

Hayman was also one of the party that accompanied Hogarth on that celebrated excursion to France in August 1748, after the Peace of Aix-la-Chappelle. As Vertue noted:

upon the treaty of peace & preliminarys agreed. the passage from Dover to Calaiss being free and open several Artists resolved and agreed to go to Paris Mrss Hudson. Van Acken. 7 his brother Mr Hogarth. Mr Hayman, painters. & Mr Sheers sculptor but Hogarth & Hayman soon returnd. the others went from Paris to Flanders Holland c. – however it happend Hogarth & Hayman. attempting to draw some Views of Fortifications &c. were surprized & clapt into the Bastile. from whence they were soon glad to return to England.[18]

As far as we know this trip to France was Hayman's only Continental excursion and there is not a scrap of evidence to support Mrs Esdaile's statement that Hayman accompanied Roubiliac, Hudson and Arthur Pond on a trip to Rome in 1752.[19] Vertue limits that party to Hudson and Roubiliac.[20]

If significant events in Hayman's career are hard to document, his personal life is even more elusive. Apparently he married twice[21] but nothing whatever is known of his first marriage. He married his second wife on 25 April 1752 at Petersham.[22] She was Susanna 'daughter of Thomas and Grace Williams of the Parish of St. James Westminster' and the widow of Hayman's old friend, Charles Fleetwood, the patentee of Drury Lane Theatre who had died in 1747.[23] This marriage was evidently not a happy one if we are to believe one witty anecdotalist who recorded that:

Hayman's wife was ordered by the physicians to France for the benefit of hr health. She afterwards wrote to him to come and fetch her, which he refused to do. Some time after her death, on looking over the charges for her funeral, he said to Paine, the architect, who was his particular friend, and who knew on what indifferent terms they lived, at the same time shrugging up his shoulders: "Well, I ought not to grumble, for she would have paid such a bill for me with pleasure".[24]

Whatever their relationship while alive, the second Mrs Hayman's death evidently left her husband in possession of a 'pretty addition to his property'.[25] by Susanna Williams Hayman had an only daughter, also Susanna, to whom administration of his estate was granted on 16 February 1776.[26] There is some confusion about what became of Hayman's daughter. Edward Edwards noted that Hayman left her 'some property, but she did not survive her father by many years.'[27] W. H. Pyne stated that Hayman 'bequeathed her £300 a year. She became the wife of Captain Broughton, and died within a year after marriage.'[28] Joseph Farington, meanwhile, had noted in his Diary on 6 June 1801 that

Baker mentioned to me Miss Hayman daughtr. of Hayman the Painter, who a few years ago resided in the neighboroud [sic.] of Drury Lane in apparently limited circumstances. – I observed that she had a fair claim upon the Academy for assistance and He wd. enquire if she be still living . . .[29]

From the mid-1750s Hayman's artistic output seems to have decreased, probably because of his involvement with the various artists' committees established to lobby for the founding of a state-sponsored academy. But he may also have been conscious that he was being outclassed by a younger generation of men like Reynolds who had benefitted from a trip to Italy. However, these later years of his life are somewhat better documented.[30]

Hayman's involvement with the academic branch of his profession probably began in the later 1730s. Certainly by the end of 1744 he was prominently involved with the St. Martin's Lane Academy for Vertue tells us that he was then playing a leading rôle there as an instructor alongside Ellis, Gravelot and Wills.[31]

The St. Martin's Lane Academy was an off-shoot of the first official Academy of Art in London which had opened in 1711 in Sir Godfrey Kneller's house in Gt. Queen Street. After an unsettled start it had been revived, so Vertue tells us, in 1735 by Hogarth who had inherited its management and equipment from his recently deceased father-in-law, Sir James Thornhill.[32] From all accounts it would appear that the St. Martin's Lane Academy was no more than a life-class,[33] but this is not to underestimate its importance not only as an arena for lively aesthetic debate but as a place to consolidate the efforts of those *avant garde* artists who frequented Old Slaughter's Coffee House nearby.[34]

Old Slaughter's, on the west side of St. Martin's Lane, a few doors from Great Newport Street, had opened in 1692.[35] From the outset its convivial atmosphere made it a favourite resort of many of the artists who attended the nearby Academy. As Mark Girouard has so aptly put it, Old Slaughter's 'was to the mid-eighteenth century what the Café Royal was to the 1890s'.[36] Hogarth, Gravelot, Roubiliac, Cheere, Moser, Hudson, Ware, Paine, the young Thomas Gainsborough and of course Hayman were all habitués, whilst from outside the immediate world of the visual arts could be found Henry Fielding and David Garrick alongside academics like Dr Martin Folkes, President of the Royal Society.

With the notable exception of Hogarth, many of the St. Martin's Lane artists were keen to establish a more formal academy, administered on continental lines and it may have been because of Hogarth's increasingly isolated position in the 1750s,[37] reinforced by the publication of his *The Analysis of Beauty* in November 1753, that the artists looked to the experienced Hayman to carry their cause.

In October 1753 Hayman was a prominent signatory on a printed circular distributed from St. Martin's Lane designed to stir support 'for a public academy for improvement of painting, sculpture and architecture'[38] and a week later he chaired the resultant meeting of interested parties.[39]

A satirical print published a few months later drew attention to the increasing schism between Hogarth and his brother artists. In *A Club of Artists* (cat. no. 97) only Hogarth, on the extreme right has hitherto been identified,[40] but it is highly probable that the seated figure immediately to the left is Hayman, who offers Hogarth an Academy study of a naked woman, and says 'hear a Director's Academy take

4

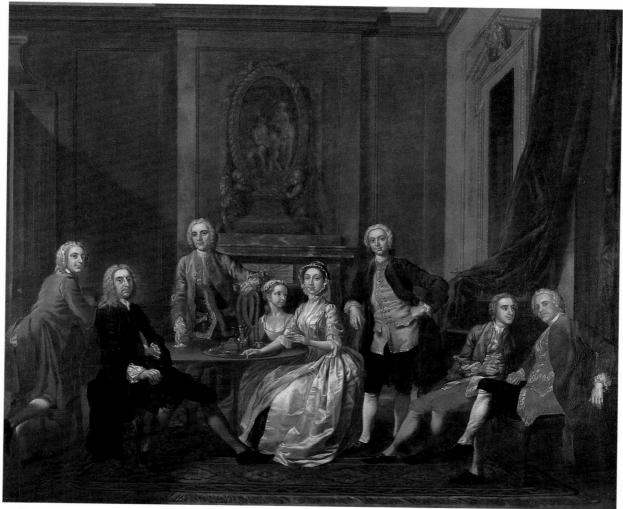

Plate I *Grosvenor Bedford with his Family and Friends* (cat. no. 4)

this'. This figure bears a strong resemblance to other portraits of Hayman, particularly Isaac Cruickshank's which served as the headpiece to John Taylor's anecdotal poem *Frank Hayman – A Tale* (cat. no. 99). Throughout the mid and later 1750s Hayman led the Artists' Committees in negotiations with the Society of Dilettanti and the newly established Society of Arts, Manufacturers & Commerce,[41] in the hope of collaborating towards a common goal of establishing a Royal Academy; but after much talk nothing was achieved except a realisation that the aims of patron-dominated bodies were incompatible with those of the artists.[42]

Finally, the artists decided to proceed alone and at the Annual Artists' Dinner at the Foundling Hospital on 5 November 1759. Hayman proposed a scheme 'for a publick receptacle; to contain Works of Artists, for the general advantage and glory of this nation, and satisfaction of foreigners'.[43] A week later Hayman chaired a meeting which resulted in a plan to hold an annual exhibition in April.

This exhibition, the first of its kind to be held in London, opened in The Great Room of the Society of Arts premises in the Strand on 21 April 1760 and did indeed become a regular feature of the London calendar and a forerunner of the Royal

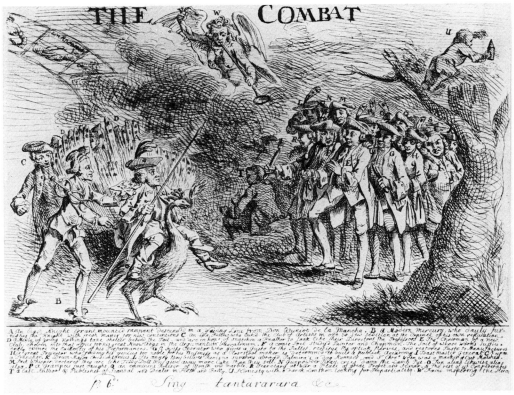

Fig. 1 *The Combat*. Anon. etching. London, The British Museum (cat. no. 98)

Academy's annual exhibitions.

On 22 December 1761 George Lambert succeeded Hayman as Chairman of the Society of Artists' Committee. Hayman may well have wanted to relinquish his Chairmanship for at that time he was faced with his largest commission for many years – the four large history paintings for Jonathan Tyers's Rotunda at Vauxhall Gardens (see Chapter 4). However, it is possible that Hayman was not entirely in agreement with the re-election of his old friend, the anti-academic Hogarth, to the Artists' Committee on 15 December 1761. A satirical print, published soon after this event and mainly related to the absurd Sign-Painters exhibition held in the Spring of 1762[44] suggests that there was some friction between Hayman and Hogarth. In *The Combat* (cat. no. 97, fig. 1), presumably published about the time of the exhibition, Hogarth is shown as a Quixotic figure tilting at windmills, urged on by Bonnell Thornton, the other guiding light behind the Sign-Painters exhibition, and opposing a mob of artists (the Society of Artists) of whom Hayman is the leader. The letter-press on the print facetiously identifies Hayman as 'The Chairman of a New Club, chosen into office for his great knowledge in the Argumentum baccalinum'.[45]

Early in 1765 Hayman was thrust back into a position of prominence. Within days of the Society of Artists receiving its Royal Charter of Incorporation its President, George Lambert, died. Hayman was once again elected President on 7 February 1765.[46]

These turbulent early years in the Society's history were fraught with problems for Hayman and his Committee. By 1767 an increasing amount of Hayman's time

was given over to attempting to placate the bickering factions within the Society. Throughout the 1760s the management of the Society was in the hands of a Committee which had moved towards a position of total power. Certain younger members, or Fellows as they were known, felt that the Committee too frequently abused its powers in favour of self-interest. A particular point of contention was that the hanging of the exhibition, where reputations could be made, was entirely in the hands of members of the Committee.[47]

The landscape painter Thomas Jones, who began to exhibit with the Society in 1765, and was much involved with the Society's politics in later years, recalled the events of 1767–8 from the point of view of one of the younger artists who resented the self-seeking behaviour of the more established artists who had often been their masters.

The meetings of the Society at the Turk's head had been for some time very much agitated with these Jarring Sentiments, nor could all the good humour of our jolly and facetious President, *Fran. Hayman* persuade the disputants to lay aside their mutal Bickerings, and drown their Heartburnings in bumpers of wine.[48]

Despite Hayman's efforts to ease the unrest the two camps were bitterly divided, and at a meeting on 18 October 1768 sixteen of the directors, including Hayman, were voted out of office – 'their places supplied by a like number of ingenious artists from among the fellows.'[49] The eight directors not removed resigned within weeks and were followed a few days later by other notables like Reynolds.[50]

The inexperienced new President, Joshua Kirby, was now left with the problem of filling vacant directorships with suitably experienced candidates and it appears that his new Committee was desperate enough to ask Hayman, whom they had just ousted, to resume his Directorship, although not the Presidency. Hayman's reply to Kirby's invitation, dated 25 November 1768, contains a justifiable measure of damaged pride:

<div style="text-align: right">To Joshua Kirby</div>

Sr,

You inform me that I am elected a Director of the Society of Artists &c. this is an honour I am very sorry I must decline, not from any dislike to the Society, many of whom I love and esteem, but having been thrown out so lately & only call'd in now to help fill up a Gap, you must pardon me if I cannot jump at the honour. besides having been so long harrast with most disagreeable altercation, I am most desirous to enjoy a little repose in a private station –

<div style="text-align: right">I am Sr
Yr most Humble Servant
F. Hayman</div>

I should have sent this sooner but was in hopes to have been able to wait on you before now

<div style="text-align: right">Fryday 25th[51]</div>

Judging from the tone of his letter, Hayman was thoroughly disillusioned with the whole affair and seems to have withdrawn from the furtive negotiations undertaken over the following weeks by the ousted directors which led to the establishment

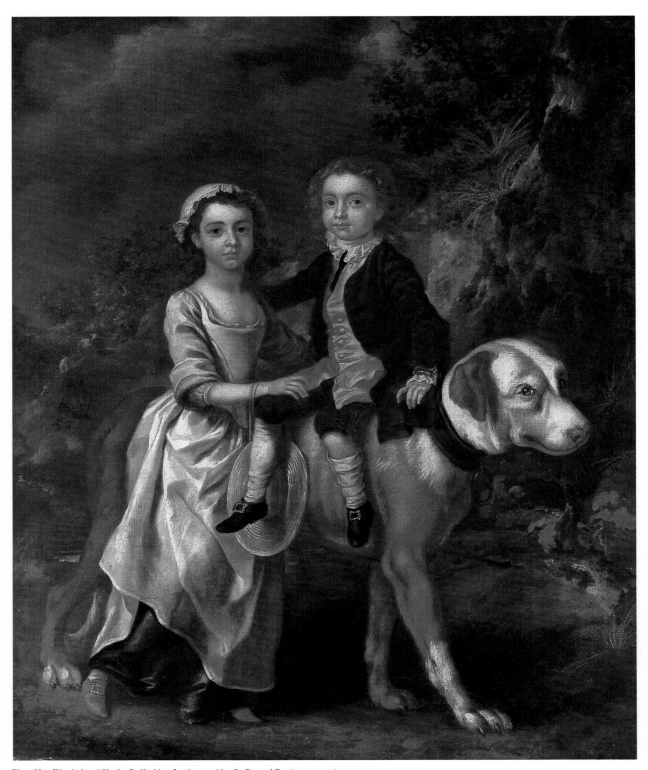

Plate II *Elizabeth and Charles Bedford in a Landscape with a St. Bernard Dog* (cat. no. 12)

of the Royal Academy on 10 December 1768.[52]

Within months of the establishment of the Academy there is evidence of Hayman's failing health. The Academy's Instrument of Foundation had decreed that from among their number 'there shall be elected annually . . . nine persons, who shall be called Visitors; they shall be Painters of History, able Sculptors, or other persons properly qualified; their business shall be, to attend the Schools by rotation, each a month, to set the figures, to examine the performances of the Students, to advise and instruct them, to endeavour to form their taste, and turn their attention towards that branch of the Arts for which they shall seem to have the aptest disposition.[53]

Hayman as a founder member of the Academy was among the first Visitors appointed, no doubt because of his seniority and experience as a history painter and teacher at the St. Martin's Lane Academy. However, prolonged attacks of gout were making his attendance impossible. With the prospect of a fine of ten shillings and six-pence for non-attendance,[54] Hayman wrote to one of his colleagues on 21 June 1769:

Dear Sir,
The occasion of this trouble is in one word to ask you if you will change times with me in your attendance on the Royal Academy. I begin, according to lot, the 29th inst.; the next month is yours. I am hobbling along at present from a late touch of the gout, though but a slight one if it goes off so. However, for fear of the worst I should be glad to defer my attendance another month; if this will suit your convenience I will infinitely oblige.

Your most humble servant
F. Hayman[55]

Very little is known about Hayman's movements beyond this date. One suspects that his few subsequent Academy exhibits – four Biblical history paintings – were all painted some years before. Except for the frontispieces to the incomplete Jennens *Shakespeare*, also designed years before, no further works can be documented after this date. In the Autumn of 1770 the office of Librarian to the Royal Academy was established; in its early years a virtual sinecure. At the express command of the King, Hayman became the first incumbent:

His Majesty having thought fit to establish a Place of Librarian to the Royal Academy, with a sallary of fifty Pounds per Annum and it being his Gracious Intention that the said Place should alwayes be held by some Academician whose Abilities and Assiduity in promoting the Arts had long rendered him Conspicuous, he has now appointed Francis Hayman, Esq., R.A., ordering that his sallary should commence from Midsummer last.[56]

It was only proper that, ageing and increasingly infirm, Hayman should have received just recognition from the organisation that he had fought to establish over the previous two decades.

Hayman's final appearance for posterity is in Zoffany's group portrait, *The Academicians of the Royal Academy* (fig. 2), exhibited at the Academy in 1772, as the corpulent, Falstaffian figure in the left middle ground.

After his death on 3 February 1776 Hayman was buried in St. Anne's Church, Soho, having lived the last decade of his life in Dean Street.[57] On 15 June 1776 his collection of pictures was sold at Langford's but, sadly, no catalogue has survived

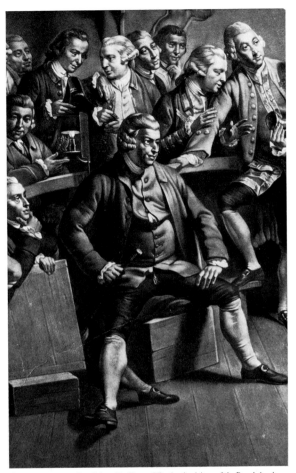

Fig. 2 Earlom after Johan Zoffany, *The Academicians of the Royal Academy*.
Mezzotint (detail showing Francis Hayman)

to provide a vital clue to his collecting habits and taste. Almost two years later, on 7 March 1778 an advertisement appeared in *The Daily Advertiser* announcing the forthcoming sale at Langford's, 'by order of the executrix' of 'the large and valuable collections of prints, drawings and books of prints of Francis Hayman Esq., deceased'[58] but alas, no catalogue has been traced.

Despite the shortage of biographical material, what does emerge from a study of Hayman's work is his remarkable versatility. Hayman was of a generation required to earn a living by a variety of artistic means. Trained as a scene painter, he adapted with ease to the type of fashionable portraiture that best suited his talents – the conversation piece. He was one of the most prolific and successful book illustrators of the mid-eighteenth century who, with the aid of his friend Gravelot, elevated that medium from its crude origins in the early years of the century to a significant art-form. Finally, he abandoned these relatively trivial though lucrative genres for the 'higher Walks of History' as his obituarist put it, that type of art for which he had been trained early in life but which, ironically, least suited his talents. While Hayman may not have achieved greatness as a history painter, his pioneering efforts smoothed the path for his pupil Nathaniel Dance and a generation of artists trained in Rome – Gavin Hamilton, Benjamin West and Angelica Kauffman among them.

CHAPTER 2

THE THEATRE

By Hayman's day, scene painting and decorative painting had enjoyed a long stand-
ing relationship, beginning with John de Critz, Robert Streeter and Isaac Fuller
in the seventeenth century, and continuing through Thornhill to Hayman himself.[1]
The same illusions, artifices and *trompe l'oeil* effects were used in both genres of art;
ingenious foreshortening, play of perspective and painting of false architecture and
sculpture. Even the subject matter – predominantly classical scenes – did duty for
both stage backdrops and ceilings.

Unfortunately, with a few notable exceptions, graphic illustrations of scene paint-
ings are rare, especially from the seventeenth and eighteenth centuries in England
and we have no idea what Hayman's sets looked like.[2] Apart from the work of Inigo
Jones, there is nothing in England to compare with the mass of prints and drawings
which survive from the numerous European court theatres.

The English stage was kept in the mainstream of development, as indeed was the
wider world of art, by the continuing influx of foreign artists. The popularity of
Italian opera resulted in the engagement of Italian and foreign scene painters, mainly
at the King's Theatre in the Haymarket. The Italians Marco Ricci, Pellegrini and
Servandoni, the Frenchman Goupy and the Fleming Tillemans are just a few of
the foreign names employed at the King's Theatre before 1725. These men brought
with them the experience of the great period of baroque scene painting from the
Continent.

Among the first of the native born scene painters to gain some reputation was
Hayman's friend George Lambert, employed at Lincoln's Inn Fields Theatre in the
mid-1720s. Lambert moved to the newly opened Covent Garden theatre in 1732
and, despite his subsequent success as a landscape painter, he retained his rôle at
the theatre until his last years.[3]

In England, scene painters were less highly regarded than their continental
counterparts and were seldom acknowledged on the playbills or advertisements until
the last quarter of the century. There was three basic categories of employment for
the scene painter; the regular house painters engaged by the season at a fixed salary;
assistants or apprentices usually paid by the day; and painters paid by the piece
for a particular production. Salaries varied according to experience but were gener-
ally lower than those of actors.[4] It should also be remembered that a substantial
portion of the scene painter's time was taken up by freshening or renewing the stock
sets which suffered a great deal of wear and tear.

Hayman's early career as a scene painter coincided with the development of new
types of drama, notably the topical satirical comedies and the domestic tragedy. The

success of Gay's *The Beggar's Opera* and Vanbrugh's *The Provok'd Husband*, both produced in the spring of 1728, emphasised the need to expand the playhouses. The playwright Thomas Odell (1691–1749) erected a new theatre, opened in an old warehouse in Ayliffe Street, Goodman's Fields, on 31 October 1729 with a performance of George Farquhar's *The Recruiting Officer*. For the first time since the Restoration three regular companies were playing legitimate drama in London.[5] Soon after Odell disposed of Goodman's Fields Theatre to his friend Henry Giffard (1694–1772)[6] whose administrative abilities made a success of the venture. Giffard commissioned the architect Edward Shepherd[7] to construct a new playhouse and this was underway by early summer 1732. It is here that we encounter Francis Hayman's first recorded work for the Theatre.

The Daily Advertiser reported on 14 July that the structure would be ready for occupation in September. It was in fact opened on 2 October 1732 with a performance of *Henry IV, Part 1*.[8] Much of the theatre's interior decoration was Hayman's work and was noticed by *The Daily Advertiser* of 4 October, whose correspondent recorded a large oval picture, over the pit representing 'His Majesty [George II], attended by Peace, Liberty and Justice . . . trampling Tyranny and Oppression under his Feet' (CL. 78i). Surrounding the oval were painted heads of Shakespeare, Betterton, Congreve and Dryden (CL. 78ii). Painted on the coving to the left was the scene from Shakespeare's *Julius Caesar* in which Cato points to the dead body of his son Marcus (CL. 78iii); in the centre was 'the stabbing of Julius Caesar' (CL. 78iv), while to the right were Mark Antony and Octavia with their children from Dryden's *All for Love* (CL. 78v). *The Daily Advertiser* does not specifically name Hayman as the painter but both J. P. Malcolm[9] and E. W. Brayley in the early nineteenth century attributed the works jointly to him and William Oram.[10]

The other major work undertaken by Hayman at Goodman's Fields by the autumn of 1732 was a large painting of *Apollo and the Nine Muses* (CL. 78vi). *The Daily Advertiser* of 12 September 1732 attributed it to Oram and 'Hyman' and states that it was 'on the sounding board over the stage.' It was perhaps no coincidence that the Venetian painter Amigoni had simultaneously painted 'over the stage ceiling'[11] at Rich's new Covent Garden Theatre, also designed by Edward Shepherd; a picture of *Apollo and the Muses* 'dignifying Shakespeare with the laurel.'[12] This was apparently in place by September 1732, although the theatre did not open until 7 December.[13] This is one of the clearest indications of the rivalry between Giffard and Covent Garden's proprietor Rich.

Hayman used the subject of *Apollo and the Muses* for another ceiling painting at Goodman's Fields Theatre that was *in situ* by 11 February 1734 (CL. 79ii). On that date a performance of the anonymous farce *The Constant Couple* was given, followed by an afterpiece, *Britannia; or, the Royal Lovers*, written in celebration of the marriage of William, Prince of Orange with Anne, Princess Royal, eldest daughter of George II. The theatre on this occasion was adorned by Hayman with portraits of the Royal Family and the Prince of Orange (CL. 79i).[14]

Although Goodman's Fields Theatre was burnt down on 3 June 1802, a watercolour copy of the ceiling by William Capon (1757–1827), himself a scene painter at Drury Lane, survives in the British Museum (fig. 3). Capon's drawing depicts the ceiling of the pit with the four heads of Shakespeare, Betterton, Congreve and Dryden on the border and, within an oval of about twenty two feet at its widest

Fig. 3 William Capon, *Apollo and the Muses* (Ceiling of Goodman's Fields Theatre). Watercolour over Indian ink, 5 × 9⅜ (12.7 × 23.8). London, The British Museum (CL. 79 (ii))

diameter, a painting of *Apollo and the Nine Muses by The Castalian Spring in a Landscape with Mount Helicon* is clearly visible. This picture was evidently painted by Hayman, possibly with the help of William Oram, and it must have been either painted over his own allegorical picture of George II, which is described as being 'over the pit' and surrounded by the heads of Shakespeare etc. or, possibly, the earlier picture of this subject was on canvas and was moved from its previous location 'on the sounding board'.

Capon confuses this already complex issue further by noting on a preliminary sketch for his watercolour: 'I have reason to believe the ceiling was painted by W. Oram and so I was told by his youngest daughter Mrs Peto . . .,'[15] However, a contemporary press cutting, dated 30 March 1734,[16] perhaps a little more reliable source than the much later claim by Oram's daughter, attributes the work to Hayman alone.

Henry Giffard moved to Drury Lane in 1736, ostensibly for reasons of space, but more likely because he foresaw the passing of the Theatre Licensing Act of 1737 which confined plays to the patent houses.[17] Perhaps prompted by the impending closure of Goodman's Fields,[18] Hayman had also moved to Drury Lane, which since 1735 had been managed by Charles Fleetwood.[19] Hayman is first credited with painting scenery there in 1736, for the first performance of William Pritchard's 'New Dramatic Masque' *The Fall of Phaeton*, set to music by Thomas Arne (CL. 80). *The London Daily Post and General Advertiser* of 28 February tells us that Hayman's scenes were 'much admired'.[20] Inevitably, no visual record of this production survives, but the

subject would have lent itself well to pictorial representation for it was a common theme in Renaissance and Baroque painting, especially in the latter where it was used for the decoration of ceilings.[21]

A few months later, on 22 May 1736, Hayman's name appears again at Drury Lane as the designer and painter of sets for 'A New Entertainment after the Manner of Spring Garden, Vaux-Hall, with a scene representing the place' (CL.81).[22] This would appear to be Hayman's earliest association with Vauxhall Gardens, pre-dating by several years the elaborate series of paintings executed for the supper boxes (see pp. 107–9).

This 'Vauxhall Entertainment' at Drury Lane Theatre was typical of a growing tendency towards elaborate sets depicting specific places. In this direction Hayman probably learnt much from his more established, older colleague, John Devoto. Devoto (fl. 1708–1752) was of mixed French and Italian stock and had, like many of his contemporaries, started out as a decorative painter but was later employed at Drury Lane, Lincoln's Inn Fields and other London Theatres. In Devoto's case his two activities are recognised by the inscription *Johannes Devoto. Historicus Scenusque Pictor* which appears at the foot of the younger Faber's mezzotint portrait of him, published in 1738.[23] A book of his sketches in the British Museum,[24] and other surviving drawings, several of which are signed and dated, show that he worked in the flamboyant baroque tradition.[25] Some of them are adaptations from Juvarra and Pietro Righini, two of the outstanding Italian set designers of his day, and they show how carefully he had studied their work.

Precedents for Hayman's scenic use of specific locations like Vauxhall are readily found in Devoto's work. *The Daily Courant* of 24 September 1723 announced a performance at Drury Lane of Shakespeare's *Julius Caesar* '. . . With an entire Sett of Scenes representing Ancient Rome, painted by Mons. Devoto.' As Edward Croft-Murray pointed out, this must be one of the earliest, if not *the* earliest record of scenery for a Shakespeare play.[26]

Hayman's activities as a scene painter in his earlier years were probably a great deal more extensive than can be judged from the few documented cases. Vertue remarked in 1745 that Hayman was 'a Painter very excellent in his Art, whose Sceenes at Drury Lane Theatre, have always met with the greatest approbation from the Spectators'[27] and supported his view by quoting the following verses from an anonymous *Essay on the Theatre or the Art of Acting*:

> Actors and Poets have an equal right
> by bold attempts our pleasure to excite,
> both sometimes please, but this is not their place
> consult propriety alone for grace.
>
> *Hayman* by scenes our Senses can controul
> and with creative Power charm the Soul
> his easy Pencil flows with just command
> and nature starts obedient to his hand.
>
> we hear the tinkelling Rill, we view the Trees
> cast dusky shades and wave the gentle Breeze
> There shoots thro leafy Bowers a sunny Ray,
> that gilds the Grove and emulates the day.[28]

These verses, which must pre-date 1741, suggest that Hayman was an early exponent of naturalistic landscape in scenery, and complement the visual evidence surviving in the form of some of his early portrait groups set in landscape settings which will be discussed later.

Hayman probably abandoned scene painting, although certainly not his theatrical connections, in the mid-1740s. By then his reputation in other spheres of art like book illustration was sufficient to make his living and he was developing a keen interest in adapting theatrical scenes to the academic conventions of history painting.

Before the 1740s there was very little tradition of theatrical painting outside the realm of scenography. Even during the fruitful years of Restoration drama remarkably little was reflected in the visual arts. The great actor of that age, Thomas Betterton (1635–1710) was portrayed in the guise of a poet by Kneller towards the end of the seventeenth century,[29] and although a pastel drawing by Greenhill of 1663 shows him in costume for the rôle of Solyman in Davenant's *The Siege of Rhodes*,[30] Betterton's acting, perhaps because it depended on recitation rather than gesture, seems never to have been recorded in paint.

Kneller's portrait of Anthony Leigh (d. 1692) 'Comedian to His Majesty', signed and dated 1689 is at least a portrait of an actor on stage, in this case in the rôle he created: Father Dominic in Dryden's *The Spanish Friar*,[31] and it is an important precedent for the type of work by Hogarth, Hayman and Zoffany which became popular in the next century.

The few theatrical paintings surviving from the first three decades of the eighteenth century are mainly products of foreign artists. Grisoni's portrait of Colley Cibber as Lord Foppington in Vanbrugh's *The Relapse*, for instance, now in the Garrick Club,[32] is, with its exaggerated and affected gestures, in the tradition of the French Baroque court portrait.[33] But until Hogarth and Hayman developed the genre there was nothing in English painting comparable to the Dutch depiction of either the professional Schouwbourg Theatre in Amsterdam or the amateur players, or Rederijkers, painted by Jan Steen and his contemporaries.[34]

By the time Hogarth executed his *Beggar's Opera* paintings and *Falstaff reviewing his Recruits* in the late 1720s[35] the relationship between painting and the theatre was beginning to take root. Betterton had advised the actor to study history painters for their accuracy of expression, remarking on the talents of Le Brun and Coypel in their use of gesture and facial modifications.[36] Coypel himself, Director of the Academy in Paris, had, in his *Discours* of 1721 conversely urged painters to seek their inspiration in the theatre.[37] In England at about the same time, Jonathan Richardson, in his influential *Theory of Painting* also drew comparison between painting and theatre.[38]

Hayman's earliest datable theatrical pictures are exactly contemporary with his illustrations for Sir Thomas Hanmer's edition of Shakespeare (i.e. 1741–42, see cat. no. 82). Some of the Hanmer illustrations, closely supervised by the editor himself, clearly recall actual theatrical performances. During these productive years Hayman was also at work on the Vauxhall supper-box pictures and in that context the theatre provided subject matter for a number of the pictures. The theatrical pictures for Vauxhall consisted not only of episodes from modern drama, with scenes from Dodsley's *The King and the Miller of Mansfield* (cat. no. 63); Fielding's *The Mock Doctor* and Charles Coffey's *The Devil to Pay* but Shakespeare was also plundered

in the form of two of Falstaff's more amusing escapades; *Falstaff in the Buck-Basket* from *The Merry Wives of Windsor* (cat. no. 68), adapted from the illustration originally designed for Hanmer, and *Falstaff's Cowardice Detected*, the scene in the Boar's Head Tavern (II) from *Henry IV*, wherein Poins and Prince Henry reveal that they had engineered the highway robbery to which Falstaff had fallen victim. Both compositions, with their panelled backdrops and carefully arranged props recall the staging techniques of the mid-eighteenth century.

Despite its horizontal 'Vauxhall' proportions, the charming *Wrestling Scene from "As You Like It"*, probably originally in Jonathan Tyers's private collection (cat. no. 37), does not relate to any of the supper-box pictures, but is also a modification of the upright design for Hanmer's *Shakespeare*. It is quite likely that this small picture was a sort of test-piece for the subsequent Vauxhall pictures – an appetiser for Tyers – since, stylistically, it must date from the early 1740s. As recently as 1950 it passed as a work by J. F. De Troy and, with its sharp, bright colours it is indeed one of the most spirited and French-inspired productions to come from Hayman's brush during those years when he was working alongside the Frenchman Gravelot.

Tyers was evidently sufficiently pleased with the supper-box pictures to commission from Hayman four even larger pictures to decorate the Prince of Wales's Pavilion at Vauxhall and Vertue noted that three of these were complete in 1745.[39] Alas, none of them survive. Three of them, which must be those recalled by Vertue: *King Lear in The Storm*; *The Play Scene in "Hamlet"* and the *Scene from "Henry V"* (CL. 128, 130, 133) appear, judging from contemporary descriptions, to have been adapted from the recently published illustrations for Hanmer.[40] Only the *Scene from "The Tempest"* (CL. 134), perhaps completed slightly later and without the Royal allusions of the other three, was an independent design, although it probably owed something to Hogarth's picture of the same subject now at Nostell Priory.[41]

Hogarth apart,[42] there was no tradition of painted illustrations to Shakespeare before the 1740s. Illustrated editions of Shakespeare, a genre which was to reach gigantic proportions by the end of the eighteenth century,[43] had begun modestly in 1709 with Tonson's six-volume octavo edition, edited by Nicholas Rowe. The forty-three engravings in this edition are rather artless performances but they do, at least, provide evidence about contemporary attitudes to Shakespeare and the interpretation of his plays.[44] Over thirty years later Hubert Gravelot produced a series of thirty-six designs for the second printing of Theobald's eight-volume octavo edition, in sharp contrast to the crude plates which had served for Tonson.[45] Gravelot's light, rococo manner is best judged from the original drawings – many survive in the Albertina, Vienna and in the Huntington Library, California[46] – rather than van der Gucht's engravings, but his elegant figure style was not always entirely suitable for tragedies like *Hamlet*.

It has been convincingly suggested that the publication record of Shakespeare's plays in the first half of the eighteenth century had a strong bearing on the increased offerings of the plays on the London stage.[47] Rowe's early edition had been printed three times; Pope's edition had gone through two printings (1725 and 1728). Theobald's *Shakespeare* with the Gravelot illustrations in the 1740 edition, had first appeared in 1733 and the luxurious six-volume quarto edition published for Hanmer with Hayman's and Gravelot's illustrations was published in 1743–4. (cat. no. 82).

By this time Hayman had completed the Shakespeare pictures for the Prince's

Pavilion at Vauxhall he was already on good terms with David Garrick. Hayman's double portrait of *Garrick and William Windham* (cat. no. 10) was probably begun in the summer of 1745. Late that year Garrick shed light on his relationship with the painter in a letter written from Lichfield.

(*post* 10 October 1745)[48]

Dear Franck

I should have perform'd my Promise of writing to You sooner could I have sent You a Lettr either of Fun or Business; The Dullness of this place does not afford Matter for the first & I have been too much hurried by Visitings, feastings &c to Sit down to ye last. Mr Windham is now with Me; We have had much talk about You & Your Performances, & both agree the Scheme of the Six Pictures from Shakespeare will be an excellent & advantagious One; I sent him some few Remarks upon 'em some time ago, but you was not in Town & he has not seen You since: I am every getting Subscribers & You may depend upon all Mr Windham's Services in ye Affair; You are a very great Favourite in Panton Square & I would not have You loose Ground there by Neglect or Indolence. If You intend altering the Scene in Lear (wch bye the bye cannot be mended either in Design or Execution) what think You of the following one? Suppose Lear Mad upon the Ground with Edgar by him; His Attitude Should be leaning upon one hand & pointing Wildly towards the Heavens with his Other, Kent & Fool attend him & Glocester comes to him with a Torch; the real Madness of Lear, the Frantick Affectation of Edgar, and the different looks of Concern in the three other Characters will have a fine Effect; Suppose You express Kent's particular Care & distress by putting him upon one Knee begging & entreating him to rise & go with Gloster; but I beg pardon for pretending to give You advice in these Affairs, You may thank Yourself for it, it is Your Flattery has made Me Impertinent. the Scene You chose for Othello strikes me more & more & I think cannot be alter'd for the better, 'tis a glorious Subject & You will do it Justice: I have Many thousand Things to say upon his Head, most of wch I must defer till I see You, wch I am afraid will not be for Some Time; however go on & prosper, I need not wish you Success, You must have it, & all my Endeavours to forward it are most Sincerely at Your Service . . .

I have forgot to tell you at ye Bottom that I am most Sincerely yr Friend & humble Servant.

D. Garrick[49]

It appears from this delightfully intimate letter that Hayman was planning a set of six prints of Shakespearean subjects, perhaps encouraged by the success of the large pictures in the Prince's Pavilion at Vauxhall, which were generally well received. Nothing came of the project but it is interesting to note Garrick's remark: 'I am every day getting Subscribers & You may depend upon all Mr Windham's Services in ye Affair.' Even more fascinating are Garrick's suggestions to Hayman about altering his scene from *King Lear*. Garrick was clearly referring to the existing Hanmer illustration (cat. no. 82b, fig. 4) and the large Vauxhall picture, which was a modification of the same design. His suggested modifications reflected, of course, his own stage practice. Garrick first appeared as Lear on 11 March 1742 at Goodman's Fields[50] and one of his innovations was the introduction of Lear lying down and falling asleep during the storm scene which required him to be carried off-stage

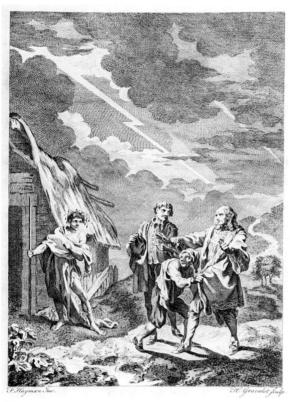

KING LEAR. Act 3. Sc. 6.

Fig. 4 Hubert Gravelot after Francis Hayman, *The Heath Scene from 'King Lear'*
(cat. no. 82b)

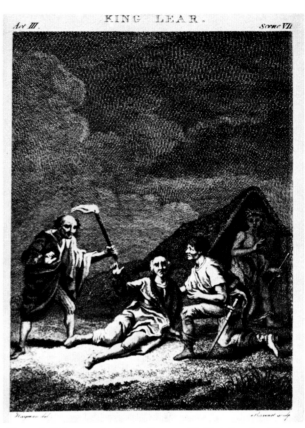

Fig. 5 S. F. Ravenet after Francis Hayman, *The Heath Scene from 'King Lear'* (CL. 315)

by Gloucester and Kent for an even more dramatic exit.[51]

Although the proposed series of prints never materialised, Hayman retained Garrick's instructions and implemented them later when designing his frontispieces to Charles Jennens's edition of *King Lear*, which remained unpublished until 1770 (fig. 5). In this small illustration and in a small, rather crude oil sketch, painted late in Hayman's career (CL. 128), Hayman places Lear on the ground pointing to the heavens flanked on either side by Kent, on one knee, and Gloucester with a torch. The fool, who appeared in the Hanmer plate had been removed, as in the Garrick/Nahum Tate staging of *King Lear*.[52] The pose of Lear is similar to Hogarth's *Garrick as Richard III*, with the left hand supporting the weight of the body. The positioning of Lear's legs, curiously inappropriate for the flat ground on which he sits, seems to be derived from the figure of Diogenes, reclining on the steps in the centre of Raphael's celebrated *The School of Athens* in the Vatican. Neither the painting nor the Jennens frontispiece suggest a portrait of Garrick as Lear but another painting of the same subject, now lost, but originally executed by Hayman as an overdoor for Dr Cox Macro's Little Haugh Hall in Suffolk, was recorded in an eighteenth-century inventory as 'Garrick in the Character of King Lear' (CL. 129).[53]

Only one other letter from Garrick to Hayman, dated August 1746 has survived, but it is equally instructive about the visual interpretation of *Othello* (see cat. no. 94) and continues to offer encouragement and support for the proposed 'Scheme of Six prints from Shakespeare'. Wrote Garrick:

in my opinion (which stands for nothing) You cannot possibly spend Yr Time better; Profit and Reputation must be the Consequence, & the sooner You begin the better: You have often flatter'd me by approving of some Notions of Mine upon that Affair, You shall command Me whenever You please (bodily and Mentally) & nothing will give me so much satisfaction as Contributing My Mite to so agreeable an Undertaking.[54]

Hayman later followed Garrick's advice, even though *Othello* had not been one of the actor's great successes,[55] and produced the frontispiece for the Jennen's edition of *Othello*, published in 1773 (cat. no. 94) which had nothing in common with his earlier design for Hanmer.

In this same letter Garrick had observed what he termed Hayman's 'late application to ... Business', urging him to 'employ almost every Moment ... in the next ten Years'. This is significant since the 1740s were undoubtedly Hayman's most productive years. The decorations for Vauxhall Gardens were behind him; his reputation as an illustrator was considerably enhanced with the success of his plates for Richardson's *Pamela*, Hanmer's *Shakespeare* and Newton's edition of Milton's *Paradise Lost*, published in 1749 but begun before 1745 (see cat. no. 85). The Foundling Hospital's *The Finding of Moses in the Bulrushes* (cat. no. 46) boosted his reputation as a history painter after 1747, and we can assume that he was in demand as a portrait painter at this time since a high proportion of his single portraits and conversation pieces date from these years. Hayman's interest in theatrical illustration continued throughout his career and he maintained his intimate friendship with Garrick for the remaining thirty years of his life.

As we have seen, Garrick was deeply concerned with the technical aspects of his profession and he must have been familiar with the many eighteenth-century textbooks in which the psychological and creative techniques of acting and oratory are

Fig. 6 C. Grignion after Francis Hayman, *The Passions*. Engraving from Dodsley's *The Preceptor* (cat. no. 84)

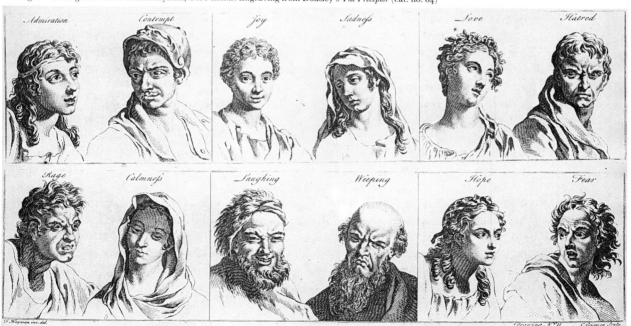

discussed almost exclusively in terms of the passions.[56]

Hayman also had more than a passing interest in these matters and evidence for this is the elaborate folding plate that he designed, depicting twelve heads adapted from Le Brun's *Treatise on the Passions* which appeared in Dodsley's *The Preceptor* in 1748 (cat. no. 84, fig. 6).

A fascinating letter from the dramatist Aaron Hill to Garrick, written in 1749, draws analogies between acting and painting and may even have encouraged Garrick to make his trip to France in 1751:

> If ever any *Painter, statuary* or *engraver*, in the world, had such *creative* power, as one *life-painter* has, whom *nature* lodged in Mr Garrick's fancy, 'tis in *France*, he must be looked for. They have their innumerable *prints*; all filled in masterly perfection with whatever is, or was, most celebrated, in the *history pieces*, and *fine statues* of antiquity. And a well chosen *collection*, from the *best* of these, would furnish infinite *supply* of *hints* to so compleat a *judge* of *attitudes*, as I here, wish 'em *viewed* by. I say *hints*, because, in many of the very *finest* of 'em all, there are defects, which *you* could rectify. For you will see with pleasure, they grew chiefly (as I observed in Italy) from some *unnerved* remissness, in the joints, that lamed the purposed animation in the posture; and you cannot fail to draw a proof from that remark, how much the *painters* may improve, by copying Mr *Garrick*, and what little room there is, for *his* improving, by the painters . . .[57]

Garrick did indeed build up a comprehensive collection of prints but in view of his already well-established relationships with the leading artists of the day, Hill's advice was probably only adding to ideas already formulated.[58] Garrick was only too aware of the potential for publicity and promotion that his association with painters could engender. Not only did he provide painters with the opportunity of working for models outside the realm of history painting by having his portrait painted on numerous occasions *en rôle*, but he inspired perhaps more portraits than any other figure of his age.[59]

Hayman's earliest portrait of Garrick on stage is the *Scene from "The Suspicious Husband"* of which two almost identical versions survive. The earlier and more distinguished version, now at Yale (cat. no. 39) was probably painted soon after the comedy by Benjamin Hoadly was first performed at Covent Garden in February 1747, with Garrick and Mrs Hannah Pritchard in the leading rôles.[60]

In view of his influence on other pictures, one suspects that Garrick had views on Hayman's "Suspicious Husband" and he evidently liked it well enough to ask Hayman to produce a replica, now in the Museum of London, for which he paid twenty guineas in May 1752 (CL. 137).

Hayman's best known portrait of Garrick is the small picture in the Maugham Collection at the National Theatre depicting *Garrick as Richard III* (cat. no. 42). Garrick was particularly associated with the part of Richard III since it was in that rôle that he made his London debut on 19 October 1741.[61] Hayman's picture, signed and dated 1760, was shown at the first exhibition of the newly established Society of Artists which opened in April of that year. The picture is almost certainly based on a revival of the play for a command performance given for the Prince of Wales at Drury Lane on 8 March 1759.

Hayman's favourite Shakespearean personality was not, however, Richard III but

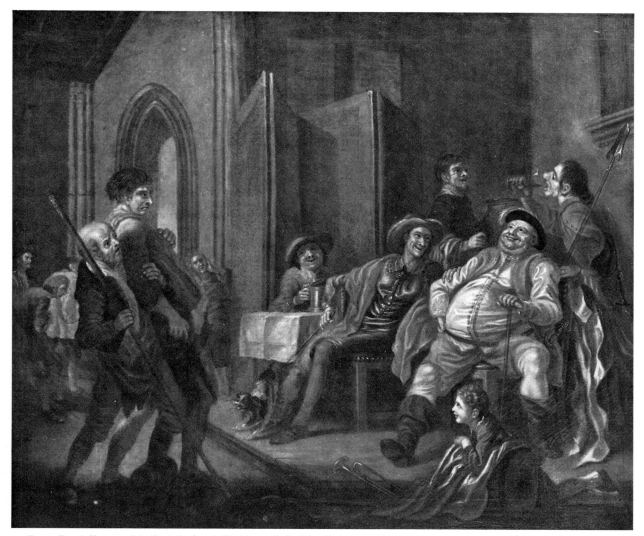

Fig. 7 Francis Hayman, *Falstaff reviewing Recruits*. Washington, D.C., Folger Shakespeare Library (CL. 142)

the outrageous Sir John Falstaff. As we have seen, two of the early Vauxhall pictures depicted the fat Knight's more amusing escapades in *Henry IV, Pt. 1* and *The Merry Wives of Windsor*. Hayman seems to have developed a particular affinity with Shakespeare's bawdy and boastful glutton. The physical resemblance between Hayman and the traditional image of Falstaff can hardly go unnoticed and it is surely no coincidence that in Zoffany's *The Academicians of the Royal Academy* (fig. 2), the corpulent figure of Hayman is seated, legs apart, surveying the assembly of artists as if they were his recruits. Even Hayman's sense of humour was Falstaffian. One early nineteenth-century commentator remarked: '*Apropos*, the humour of Hayman, *jocularly satirical*, and sometimes *affectedly morose*, was something similar to that of the fat knight his favourite.'[62]

It is not clear how many versions of *Falstaff Reviewing His Recruits* Hayman painted, but as the critic in *The Public Advertiser* of 10 May 1765 noted: 'This is a favourite subject of Mr Hayman's' – a remark occasioned by the exhibition in that year of

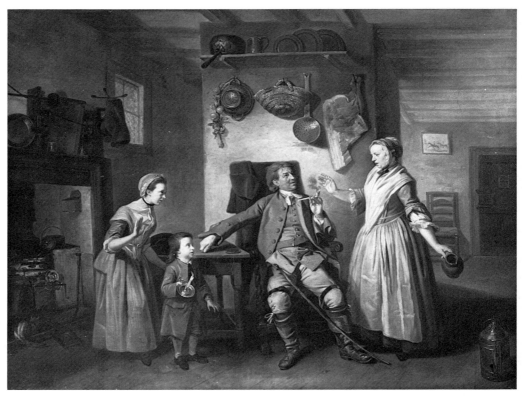

Fig. 8 Johan Zoffany, *Garrick in 'The Farmer's Return'*. Canvas, 40 × 50 (101.6 × 127). Private Collection

one of the versions at the Society of Artists. Hayman's solitary exhibit in 1761 had also been a version of this subject, although presumably a different one. The composition originated with the design for the Hanmer *Shakespeare* in the early 1740s and, with slight modifications, this proved the basis for all the later painted versions, which probably all date from the late 1750s and early 1760s. Of the four versions of which there is some record, three are paintings and the fourth a large print, presumably after yet another painted version, engraved by W. W. Ryland and published a few weeks after Hayman's death in 1776. Without precise descriptions it is impossible to identify which, if any, of the surviving versions were exhibited during Hayman's lifetime.

The Dublin version (cat. no. 43) and the Folger Library version (CL. 142, fig. 7) are the same size and, compositionally, have the most in common. There is an attempt in both, and indeed in the other versions, to create a rather gloomy gothic background, like a stage-set. Once again contemporary stage practice and the lack of knowledge about historical costume are exemplified by Justice Shallow's 'Van Dyck' costume, while Falstaff wears a bizarre combination of contemporary eighteenth-century combined with early sixteenth-century dress. Hayman probably knew Hogarth's painting of the subject, one of his earliest works in oil, executed just before 1730, and later acquired by Garrick. Hogarth's picture, based on a drawing taken in the pit at a performance of the play,[63] is compositionally similar, and perhaps the chalk drawing at Yale (cat. no. 75), which is closest to the Folger version, also originated as a study done from the pit?

22

The three known painted versions, including the small picture at Birmingham (CL. 143), are stylistically typical of Hayman's later years where the tightness and controlled precision of his early conversation pieces has given way to a rather clumsy broadness of handling and dense 'facture' that almost falls short of the acceptable limits of what the eighteenth century considered 'finish'. Like much of his later work, including the *Don Quixote* pictures (cat. nos. 44, 45), the superficial appearance is more like an oil sketch.

In 1762 Hayman must have been disheartened to discover a serious rival in the field of theatrical illustration. In that year Johan Zoffany, recently arrived in London after a short interval at the court at Ehrenbreitstein, exhibited his *Garrick in "The Farmer's Return"* at the Society of Artists (fig. 8). In successive years, until transferring to the Royal Academy in 1770, Zoffany exhibited a theatrical scene characterised by a startling realism that could not be matched by Hayman's failing powers. The same challenge was confronting Hayman in the sphere of history painting with the younger generation of Anglo-Romans, led by Gavin Hamilton and Benjamin West gradually eclipsing his dwindling reputation.

One further intriguing possibility adds a significant new dimension to Hayman's work for the Theatre. Giffard announced a performance of *The Beggar's Opera*, scheduled for the 14th February 1743 with the unusual announcement that Macheath would be played by 'a Gentleman who never appeared on any Stage before.'[64] This gentleman, named as 'Hayman' was immediately signed by John Rich for Covent Garden and over the next three seasons made sporadic appearances in a variety of minor rôles at both Covent Garden and Drury Lane. There is no documentary evidence to link this 'Hayman' positively with our artist – even the Covent Garden Account Books fail to record a Christian name[65] – but a glance at the repertoire of plays in which he acted lends weight to the idea that this is our artist taking his passion for the theatre to its logical conclusion. Apart from *The Beggar's Opera*, 'Hayman' took part in several other plays that the painter had already, or was later to illustrate, including *The Devil to Pay*, *The Mock Doctor*, both parts of *Henry IV*, *Henry V* and *Hamlet*, all of which figured in the Vauxhall decorations. As well as Shakespeare there were appearances in near-contemporary works like Congreve's *Way of the World*, some years before the five frontispieces by Hayman to the 1753 edition of Congreve's *Works* were published (cat. no. 90). His final performance, alongside the illustrious James Quin, was as Sylvius in *As You Like It* at Covent Garden on 19 October 1746 and after this his name disappears altogether. Perhaps by the late 1740s Hayman had turned seriously towards history painting and could not spare the time for his more frivolous hobby.

CHAPTER 3

PORTRAITURE

It is a surprising fact that a considerable portion of Hayman's surviving œuvre is in the form of single portraits and conversation pieces: surprising because his contemporary reputation was based on his historical and literary subjects and he was never considered a portrait painter in the eighteenth-century sense of the term. Hayman was conspicuously absent from a list of the most promising portrait painters 'that make the best figure' compiled by George Vertue in 1743.[1]

Unlike the prolific practices of Hudson, Highmore and Ramsay, who dominated fashionable portraiture in the mid-century and figured prominently in Vertue's list, Hayman's clientele, like Hogarth's, was drawn mostly from a small circle of friends and acquaintances in the professional and artistic worlds. With the exception of the lost portraits of King George III and Queen Charlotte, painted in the early 1760s for Jonathan Tyers's Rotunda at Vauxhall Gardens (CL. 9, 20), Hayman's sitters were consistently of the middle rank – a phenomenon to be examined later. In the early and mid-eighteenth century, portrait painters were frequently dependent for their success on the patronage of an important sitter who could instantly establish a reputation for the painter in society. Writing in the mid-1740s, Robert Campbell, the author of *The London Tradesman* – a sort of guidebook for parents intending to apprentice their offspring – criticised this iniquity in a few paragraphs devoted to portrait painting.:

> ... The Good Face-Painter must have the Name of having travelled to *Rome*; and when he comes Home, he must be so happy as to please some great Personage, who is reputed a Connoisseur, or he remains in Continual Obscurity. If he should paint a Cobbler, with all the Beauties of Art, and the most glaring likeness, he must paint only Cobblers, and be satisfied with their Price; but if he draws a Duke, or some Dignified Person, though his features should prove so strong that the mere Signpost Dauber could not fail to hit the likeness, he becomes immediately famous and fixes what Price he pleases on his Work ...[2]

Hayman never made the trip to Rome, and alongside those who did, like the more cosmopolitan Ramsay, his portrait style would always appear mannered and comparatively provincial. Compared to the French painter J. B. Van Loo, who showed the English public, accustomed to the stylised masks of Kneller, Richardson and their followers, that it was perfectly reasonable to expect more of a likeness from a portrait painter, Hayman could never seriously hope to compete. Whatever one's reason for choosing Hayman as a portraitist, the ability to capture a likeness cannot have been paramount. Horace Walpole, who seems to have nurtured a profound

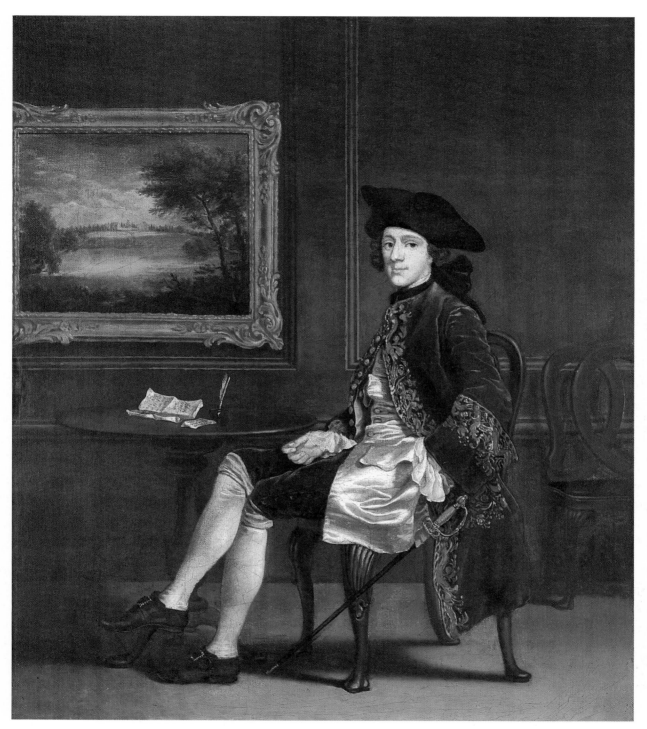

Plate III *John Conyers* (cat. no. 15)

dislike of Hayman's work, noted in his *Anecdotes . . . &tc.* that he was 'a strong manner-ist, and easily distinguishable by the large noses and shambling legs of his figures.'[3] Unfortunately, that was a pretty accurate summary of Hayman's figure style. Hay-man's mannerisms also attracted the attention of the poet Charles Churchill, whose disagreements with Hogarth led to the publication in 1763 of his satirical *Epistle to William Hogarth*.[4] Churchill satirised Hayman in the first book of his poem *Gotham*:

> The *Months*, twelve Sisters, all of diff'rent hue,
> Tho' there appears in all a likeness too,
> Not such a likeness, as, thro' HAYMAN'S works,
> Dull Mannerist, in Christian, Jews and Turks,
> Cloys with a sameness in each female face,
> But a strange Something, born of Art and Grace,
> Which speaks them All, to vary and adorn,
> At diff'rent times of the same Parents born
> All One and All, shall in this Chorus join,
> And, dumb to others' praise, be loud in mine.[5]

Hayman's inability, except on very rare occasions, to achieve a consistently con-vincing individual likeness was legendary and inspired one of the more amusing of those many anecdotes which shed light on his self-effacing character. According to Reynolds's biographer Edmond Malone:

Hayman, the Painter, though but an ordinary artist, had some humour . . . Mendez, the Jew poet, sat to him for his picture [CL. 34], but requested he would not put it in his show-room, as he wishes to keep the matter a secret. However, as Hayman had but little business in portraits, he could not afford to let his new work remain in obscurity, so it went out with a few others he had to display. A new picture being a rarity in Hayman's room, the first friend that came in took notice of it and asked whose portrait it was. "Mendez", "Good Heavens!" said the friend, "your are wonderfully out of luck here. It has not a trait of his coun-tenance. "Why to tell the truth," said the painter, "he desired *it might not be known*."[6]

Although early in his career his principal work lay outside the sphere of portraiture, it is a reflection of the current state of patronage that any artist might find it difficult to survive by history painting alone. Most of Hayman's portraits are either small-scale full-lengths, or, conversation pieces; although there are some exceptions.

Hayman's earliest known portrait is probably the small *Self Portrait* at Exeter (cat. no. 1), arguably his earliest surviving work in any medium. Judging from the artist's apparent youth, it cannot have been painted later than the mid-1730s, and was poss-ibly done before 1730. Even at this early date many of Hayman's distinguishable mannerisms are already present: the warm flesh tints, the softly modelled *sfumato* of the facial features as well as the ubiquitous seated cross-legged pose. As in most of Hayman's portraits, the most striking mannerism are his sitter's eyes. Almost without exception they are hard and button-like and the lids are frequently accentu-ated in the Augustan manner that he no doubt learnt from his master Robert Browne. By comparison with the later *Self Portrait at the Easel* of *c.* 1750 (cat. no. 21), the earlier work reveals a youthful lack of confidence, but the juxtaposition of the two neatly summarises Hayman's progress in the intervening years.

Towards the end of the 1730s Hayman began to apply himself more seriously to portraiture. It may have been the effect of the Theatre Licensing Act of 1737, which temporarily closed Goodman's Fields and Lincoln's Inn Fields Theatres, that made Hayman re-evaluate his security of employment as a scene painter, since it was virtually impossible for all but a handful of artists to obtain a living through decorative painting and scenography alone. Although he had moved with Giffard to Drury Lane Theatre, the later 1730s must have seemed an appropriate moment to diversify. The end of that decade was an exciting moment to turn to portraiture. British painters, particularly Hogarth and Ramsay, who had returned from Italy in 1738, were reacting to the presence in England of French painters like Van Loo.

The careers of other European painters who had enjoyed domination of the English scene were on the wane. The Italian Cavaliere Rusca's last visit to London ended in 1740, his compatriot Amigoni left for the Continent in 1739 and Philip Mercier, active in London for almost a quarter of a century, went off to work in Yorkshire at the same time. Similarly, the careers of many of the long-established English painters were drawing to a close. Jonathan Richardson retired due to ill-health in the early 1740s; John Vanderbank died in 1739 and the Swede Michael Dahl only survived until 1743. Sir Robert Walpole's fall in 1742 brought a new generation of men to power and opened up new avenues of patronage for the painters of Hayman's generation. Hogarth, meanwhile, had already demonstrated that there was a buoyant market for small-scale group portraits, or conversation pieces as they were known.

The conversation piece was the first real break with the stereotyped portraiture of the early eighteenth century.[7] It was essentially a private rather than a public art form. European portraiture in the eighteenth century was still dominated by Renaissance ideals and French seventeenth-century Classicism which promoted ideal portraiture. In effect there was also a hierarchy among portraits which basically concluded that the greater the idealisation the more the portrait would be esteemed. The resulting stylisation produced numerous near-identical portraits between Restoration and the early decades of the eighteenth century.[8] Like the history painter, the moral rôle of the portrait painter was to praise virtue and to describe ideal types of Kings, statesmen, soldiers, etc. The inevitable result was that all sitters, even merchants and sea-captains, were made to look like Augustan noblemen. At the end of the seventeenth century when it became customary for professional men, who later formed the bulk of Hayman's sitters, to have their portraits taken, it was not usually in the attire of their professions but in that of the gentry that they were painted. All this was to change.

The aim of the conversation piece was to catch the sitter with family and friends in action, and Hogarth, in particular, succeeded extremely well at this. Hayman must have been keenly aware of his friend Hogarth's work for if we examine one of his earliest conversation pieces, *The Wagg Family*, which probably dates from the later 1730s (cat. no. 2), the debt to Hogarth becomes immediately apparent. Indeed, this is as close as Hayman ever comes to Hogarth's early style. The seated figure of Mrs Wagg is particularly Hogarthian and the group as a whole can be compared with works like Hogarth's *Ashley Cowper with His Wife and Daughter* of 1731 in the Tate Gallery. Mr and Mrs Wagg have an awkward stiffness, uncharacteristic of Hayman's more vivacious works of just a few years later.

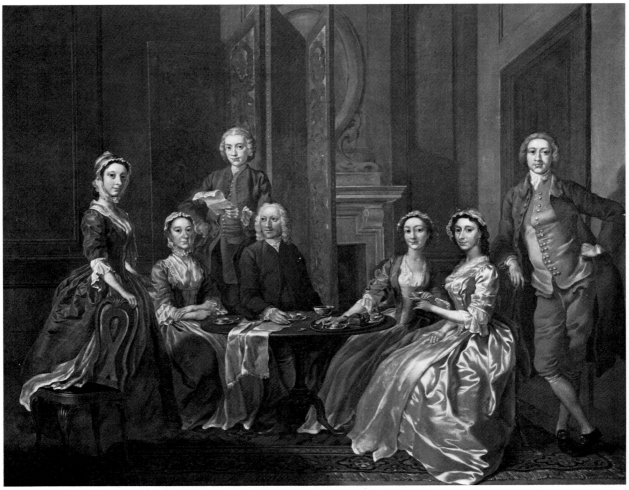

Fig. 9 Francis Hayman, *The Gascoigne Family*. San Marino, Càlif., Henry E. Huntington Library and Art Gallery (see CL. 19)

The major difference between Hayman and Hogarth's conversation pieces, and indeed between his and those by a host of other contemporaries such as Gawen Hamilton, Charles Phillips and Arthur Devis, is the scale of his figures in relation to the picture space. Hayman's figures almost invariably occupy a relatively large portion of the picture space and the background plays a lesser rôle than in the work of these other exponents of the genre. *Jonathan Tyers and His Family*, signed and dated 1740 (cat. no. 3), makes this point particularly well.[9] Here the sitters, grouped closely together around a tea-table, dominate the picture-space, leaving little scope for the sort of elaborate and usually capricious architectural settings that are commonly found in the work of Gawen Hamilton or even Devis. Hayman's middle-class interiors are, more often than not, merely variations on the panelled interior of his own studio, occasionally enlivened by a decorative feature such as an elaborate chimney-piece or a folding screen. Chimney-pieces with splendid overmantels often loom large in Hayman's indoor settings, but they are usually of his own invention. Examples can be seen in the so-called *Gascoigne Family* (CL. 19, fig. 9) and *Grosvenor Bedford with His Wife Jane and Son Charles* (CL. 6).

28

Hayman made the transition from scene painting and decorative painting to portraiture with surprising ease in the early 1740s and some of his most charming and delightful works date from the years 1740–45. In fact, an inordinately high proportion of Hayman's surviving works date from these years, including the Vauxhall Gardens supper-box pictures. The essentially frivolous subject matter of the Vauxhall pictures spills over into his outdoor conversation pieces of the early 1740s. For instance, in the *Atkins Brothers*, dating from *c.* 1740–42 (CL. 1, fig. 10), the motifs of the kite in the foreground and the bird's nest in the hand of the younger boy are an echo

Fig. 10 Francis Hayman, *The Atkins Brothers*. Private Collection (CL. 1)

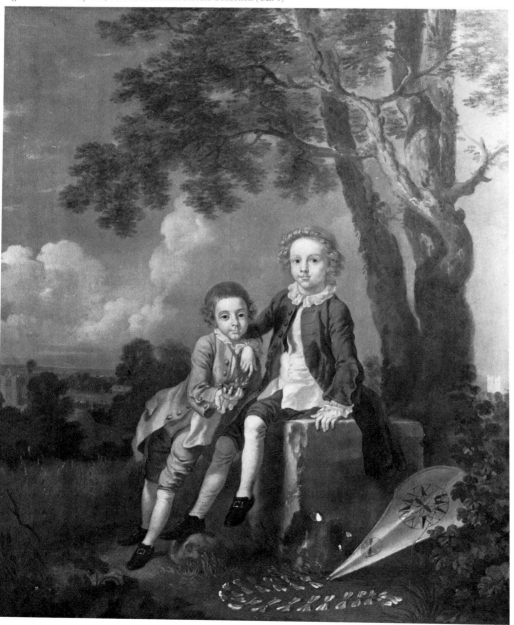

Fig. 11 Francis Hayman, *Samuel Richardson and his Family*. Private Collection (CL. 43)

of the playful themes of Vauxhall. Here the landscape backdrop, precisely what the young Thomas Gainsborough would have seen as a pupil in Hayman's studio at the time, has, for a change, some basis in reality for a change with an identifiable view of the twin-towers of Westminster Abbey to the extreme right of the tree trunk.

Similar in type is another of Hayman's early works, *Samuel Richardson and His Family* (CL. 43, fig. 11), which must have been painted towards the end of 1740, that is to say soon after the publication of the author's phenomenally successful *Pamela, or, Virtue Rewarded* (see cat. no. 81). The poses in this case recall Van Dyck but the shimmering and highly individual virtuoso handling of the women's clothes indicates Hayman's considerable skill as a painter with no recourse to the specialist drapery painter.

With the Richardson family group Hayman introduced and established a formula for outdoor group portraiture which served him consistently for the next decade. In essence it consisted of disposing the figures in the near foreground under the umbrella of a tree with, in most cases, an imaginary landscape backdrop. It is a sort of anglicising of the French *fête galante*, modified to suit the British propensity for portraiture. Figure groups, like the girls in the left foreground of the Richardson family, are only a short remove from the indolent, languid figures of Watteau's or Lancret's pastorals, but distilled into a more English idiom through the influence of his friend Gravelot.[10]

Gravelot's considerable importance is primarily in the field of draughtsmanship rather than painting, which, as we shall see, he evidently found much more difficult to master. William Blake tells us that Gravelot once said to his [Blake's] master,

the engraver James Basire: 'De English may be very clever in deir own opinions but dey do not de draw.'[11] By the time Gravelot returned to Paris in October 1745 his own efforts as a teacher, at both the St. Martin's Lane Academy and his own drawing school in James Street, Covent Garden,[12] had done much to correct this apparent deficiency (see fig. 12).

It was as a book illustrator that Gravelot found, as the Goncourts noted 'son aise et son vrai terrain.'[13] His illustrations for Theobald's *Shakespeare* (1740), Richardson's *Pamela* (the 1742 edition in collaboration with Hayman) and Fielding's *Tom Jones*, the latter executed in Paris in 1750, demonstrate his gift for capturing the fleeting elegant gesture, inherited ultimately from Watteau.[14]

Hayman's particular talent in these early group portraits is his ability to inject a convincing air of relaxed informality, a skill learnt from Gravelot which foreshadows the best of Gainsborough's early works. Nowhere is this more apparent than in the double portrait of *David Garrick and William Windham* of *c.* 1745 (cat. no. 10). Windham's reclining pose is a favourite of Hayman's and he seems to have used it first in the Vauxhall pictures *The Wapping Landlady* and *Stealing a Kiss*.

It is not always easy to date Hayman's portraits, which range from the late 1730s to the early 1760s, on stylistic grounds alone since they show relatively little technical progress and only a very subtle change of style. Perhaps the clearest indication of stylistic progression is that some of the later groups are more flexible in pose and more animated in expression. In early works like the *Gascoigne Family*, the *Bedford*

Fig. 12 Hubert Gravelot, *Seated Man*. Black chalk, heightened with white, on buff paper, 12 × 8½ (30.5 × 21.6) London, The British Museum

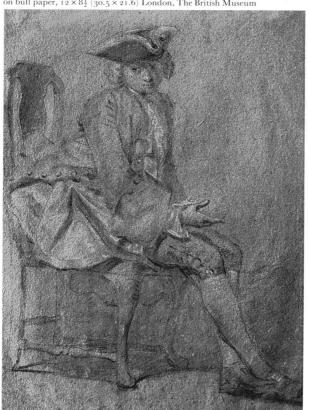

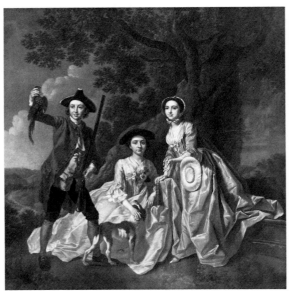

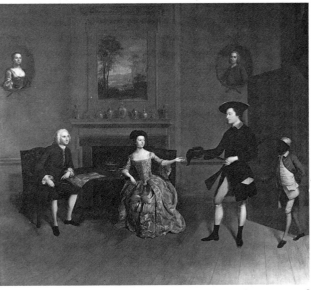

Fig. 13 Francis Hayman, *Margaret Tyers and Her Husband George Rogers and His Sister Margaret Rogers*. New Haven, Conn., Yale Center for British Art, Paul Mellon Collection (cat. no. 24)

Fig. 14 Arthur Devis, *William Orde's Return from the Shoot*. Canvas, $37 \times 37\frac{7}{8}$ (94×96.2) Collection of Mr & Mrs Paul Mellon

Family or the earliest of the Tyers family portraits, all of which date from *c.* 1740, there is nothing to relieve the nervous expressions of the sitters. By the end of the 1740s Hayman has learnt how to animate his group portraits. Take for instance the Tyers family portraits which, with the exception of the indoor group which is signed and dated 1740, appear to date from the late 1740s and early 1750s. Although the figure grouping remains a constant factor, in *Jonathan Tyers with His Daughter Elizabeth and Her Husband John Wood* (cat. no. 23) the sitters are given greater animation and expression than in those earlier works. The influence of Gravelot's draughtsmanship has given Hayman a greater assurance and confidence lacking in the early works.

Tyers's other daughter, Margaret, married an amateur artist George Rogers,[15] and they were painted with Rogers' sister (also Margaret) by Hayman in a delightful landscape setting *c.* 1750 (cat. no. 24, fig. 13). The spontaneous good humour with which George Rogers holds aloft his pheasant, for instance, contrasts with the solemn decorum of William Orde's return from the shoot in Devis' painting (fig. 14)[16].

The freer poses and gestures in Hayman's work *c.*1750 probably also reflect the experience gained as a book illustrator which required a livelier touch than traditional portraiture.

If Hayman's formula for outdoor conversation pieces can be said to remain relatively consistent throughout the 1740s, so too do his interior groups. The Tyers, Bedford and Gascoigne families, all dating from *c.* 1740, are variations on the same theme. In each the figures are choreographed in an intricate variety of polite poses using a tea-table and studio props like the chairs with the interlaced back and cabriole legs, which appear in several other later portraits as compositional aids. In all three the picture space is abruptly limited, as if the setting were the type of stage-set that Hayman was still decorating for Drury Lane Theatre.

While Hayman's speciality was undoubtedly the conversation piece, he was regularly commissioned to produce single portraits. Many of these also date from

the 1740s and early 1750s and mostly take the form of small full-lengths – as if figures extracted from conversation pieces – like those that comprise the bulk of Devis' or Edward Haytley's œuvre. But there are some early portraits by Hayman on the scale of life and we should mention them first.

The portrait of the young and politically ambitious *Viscount Perceval, later Second Earl of Egmont* (cat. no. 6, fig. 15) is unusual for several reasons. The three-quarter pose on a 50 × 40 inch canvas is one of only two examples known in Hayman's œuvre. It is also one of the few portraits by Hayman to be engraved in mezzotint, no doubt because Lord Perceval was Hayman's grandest sitter to date.[17] It is interesting to note that despite the inscription on Faber's mezzotint, identifying Hayman as the painter, it passed as a work by Batoni as recently as 1946.[18] A more revealing comparison is with the work of the French painter Jean-Baptiste Van Loo (fig. 16) who was nearing the end of his successful sojourn in London – he returned to Paris because of failing health in October 1742[19] – when Hayman painted this picture. It is entirely consistent with Hayman's style at the beginning of the 1740s and was almost certainly painted to celebrate the sitter's election to the House of Commons as member for Westminster in December 1741.

Hayman never got closer to the conventions of the fashionable portraiture of his contemporaries than with this portrait of a politically ambitious young nobleman. Like Hogarth, he might, at this stage of his career, have contemplated portraiture as the main branch of his profession, but there does not appear to have been a sufficient number of clients of Lord Perceval's standing prepared to divert their patronage from the fashionable studios of Hudson, Ramsay or Highmore for Hayman

Fig. 15 Francis Hayman, *John, Viscount Perceval (later Second Earl of Egmont)*. Dublin, National Gallery of Ireland (cat. no. 6)

Fig. 16 Jean-Baptiste Van Loo, *Stephen Poyntz of Midgeham*. Canvas, 50 × 40 (127 × 101.5). New Haven, Conn., Yale Center for British Art, Paul Mellon Fund

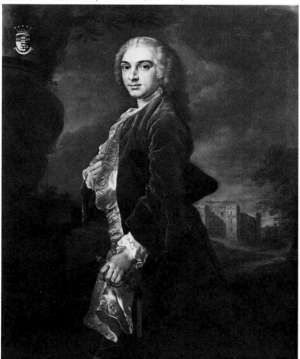

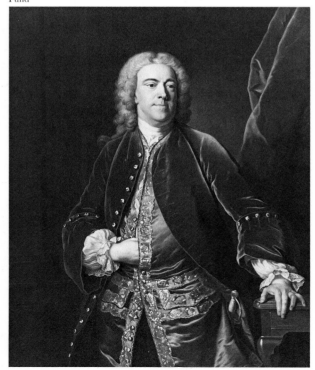

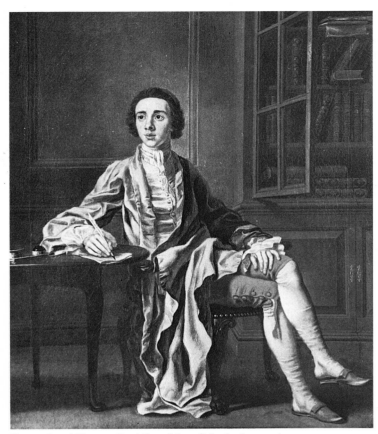

Fig. 17 Francis Hayman, *Joseph Henry*. Private Collection (cat. no. 9)

Fig. 18 Louis-François Roubiliac, *Handel*. London, Victoria & Albert Museum

to make a living. The only other comparable portrait is that of *Dean Alured Clarke* (cat. no. 5) of about the same date which is also an essay in the style of Van Loo.

Let us examine some of Hayman's small full-length portraits. One of the most splendid and unusual of these, *A Young Lady at a Spinning Wheel* (cat. no. 11) offers an intriguing combination of Vauxhall-type genre with portraiture and landscape. Hayman was surely aware of Mercier's Chardin-like domestic genre scenes, a number of which were engraved in mezzotint by Faber *c.* 1745. In particular, Mercier's *Young Woman With a Distaff*, one of a series entitled *Rural Life*,[20] seems to have much in common with the Hayman, while the figure of the young woman is similar to those found in engravings after Boucher published in London in the middle years of the century.[21]

In several of his best small full-lengths Hayman uses a seated cross-legged pose for his sitter. Hogarth had used the pose as early as 1731 in his portrait of *Sir Robert Pye*, now at Marble Hill House,[22] but it effectively became Hayman's stock-in-trade. The small full-length of *Joseph Henry of Straffan* of about 1745 (cat. no. 9, fig. 17) is a particularly good example of its usage by Hayman. At first glance this picture has superficial similarities to works like Devis' *Gentleman seated at Table*, also dating from the mid-1740s[23] but a closer examination of the Henry portrait reveals some startling analogies with the sculpture of Hayman's friend and contemporary, Louis-François Roubiliac. We know that Hayman had frequent contact with the French sculptor, through both Old Slaughter's Coffee House and the St. Martin's Lane

Academy where they both taught.[24] We also know of at least one decorative commission – Jonathan Tyers's country estate Denbies in Surrey – where they collaborated (see cat. no. 72).

If we compare *Joseph Henry* with Roubiliac's celebrated statue of the composer Handel, completed in 1738 (fig. 18), not only do we find the same heavy, deeply folded draperies in both works, but Hayman even employs the sculptor's device of the precariously balanced slipper on Henry's stockinged foot. The way in which Henry's dressing gown tumbles to the floor is curiously unnatural, its deep folds suspended liked carved marble. The common factor may well lie in the following anecdote about Roubiliac's technique, related by J. T. Smith, whose father Nathaniel was at one time Roubiliac's assistant:

> Roubiliac seldom modelled his drapery for his *monumental* figures, but carved it from the linen itself, which he dipped into warm starch-water, so that when he had pleased himself he left it to cool and dry, and then proceeded with marble; this my father assured me he did with all the drapery in Nightingale's monument.[25]

Roubiliac's skill in modelling draperies was remarked upon by Vertue in May 1749 after he had seen the Duke of Argyle's monument, recently installed in Westminster Abbey. Wrote Vertue 'the Draperys and foldings truely natural and excells all other in skill and softness of plaits, really more like silk than Marble.'[26] Conversely, perhaps, Hayman's draperies can be said to be more like marble than silk but this may have been the result of using similarly starched linen for the lay-figures which we know he employed. These lay-figures, or wooden dolls, were a standard studio prop for many artists, their prime usage being as supports for drapery.[27]

The extravagant baroque figures from Roubiliac's funerary monuments may well have exercised a more profound influence on contemporary painting than has been acknowledged. Hogarth's celebrated *Garrick as Richard III* of *c.* 1745 looks to the type of dramatic, gesticulating figure found commonly in Roubiliac's work rather than any painted source and I have argued elsewhere for further affinities between Hayman and the sculptor.[28] Hayman may have been deliberately attempting to exploit the current popularity of sculpture, for according to Robert Campell writing in *The London Tradesman* in 1747:

> The Taste for Busts and Figures in these materials [clay, wax, plaster of Paris etc.] prevails much of late years, and in some measure interferes with Portrait Painting. The Nobility now affect to have their Busts done in that Way rather than sit for their Pictures, and the Fashion is to have their Apartments adorned with Bronzes and Figures in Plaister and Wax.[29]

The popularity of sculpture in the 1740s is perhaps not so surprising since it was in that medium that the first real break with the Kneller pattern of portraiture had emerged. The sculpted portrait bust had the innate advantage of echoing antiquity in a much more authentic way than painting; a factor which meant much to Englishmen, who liked to think of themselves as reincarnated Romans. Burlington had imported the Italian Guelfi as early as *c.* 1715 for precisely this purpose,[30] only to replace him with Rysbrack when he saw that the Fleming did a better job. In 1732 alone Rysbrack had some sixty sitters[31] and only a few years later Vertue noted that none could equal Rysbrack 'for truth of likeness'.[32] The portrait painters had to take

Fig. 19 Attributed to James Seymour, figures by Francis Hayman, *The St. John Family in Dogmersfield Park*. Private Collection (CL. 44)

notice. Summing up his remarks on the year 1738 Vertue said '. . . as to sculpture that has of late years made greater advances. In many great and rare workes of several hands. Masters ⟨Rysbrak Schmakr Rubullac⟩ . . .'[33]

It is not a coincidence that Hayman – and indeed Hogarth – began to be seriously interested in portraiture immediately after the unveiling of Roubiliac's first major success, the Vauxhall Handel statue.

Hayman's specific interest in sculpture is made apparent not only in his crisp and brittle draperies, executed quite consciously in the style of Roubiliac, but also by the regular inclusion in his pictures of pieces of sculpture and casts after celebrated sculptures (see cat. nos. 16, 22).

If Hayman was acutely aware of the latest developments in sculpture, he was also willing to capitalise on the specialist skills of some of his fellow members of the St. Martin's Lane Academy. Collaboration among artists of the Academy was probably a good deal more common than has been acknowledged. In 1766 a newspaper correspondent who signed himself 'T.B.', whom we shall encounter again, made some fascinating observations on this intriguing subject:

It is customary to employ brother artists to finish particular parts of their performances. Mr Lambert, for instance, never painted the figures in his own landscapes; Mr Hayman's backgrounds have frequently been executed by a variety of hands;

36

and it is well known that Mr Hudson, Mr Cotes, and several other painters of the first reputation seldom, if ever, finish an atom more than the face of their portraits, notwithstanding that the drapery of their pictures – which is generally the production of indigent excellence – acquired them such uncommon approbation from the public.[34]

If 'T.B.' is taken at his word one wonders who the 'variety of hands' were who executed Hayman's backgrounds. We know, for instance, that Hayman painted the figures in some of George Lambert's landscapes (see cat. no. 15) and the involvement of the young Gainsborough with Hayman in this context will be discussed a little later. Conversely there are certainly pictures wherein Hayman's contribution would appear to be solely the figures, but they are the exception rather than the rule. Colonel Grant's claim that Hayman contributed figures to Richard Wilson's historical landscapes was quite properly rejected by W. G. Constable,[35] although it is known J. H. Mortimer was employed to paint the figures in his *Meleager and Atalanta* and *Apollo and the Seasons*.[36]

Which artist, for example, painted the landscape background in the enormous group portrait *Sir Paulet St. John and His Family in Dogmersfield Park*, which dates from the late 1740s (fig. 19)? This large canvas has had a chequered history. It has recently been attributed, not altogether convincingly, to James Seymour.[37] Seymour may have painted the horses but the figures are certainly Hayman's work. The extensive landscape, however, is quite incompatible with those painted by Hayman in his contemporary conversation pieces. The foreground and middle distance of this sweeping panorama with its undulating parkland is not unlike several rather broad, featureless tonal landscapes which have been attributed to Seymour, but the background with its pattern of fields and hedgerows seems too sophisticated for him and we might suspect another hand.

The large Dogmersfield Park picture with its Hayman figures is easily his most ambitious piece of collaborative work but it is not the most hybrid. We must turn instead to that extraordinary picture at Ickworth, *Augustus Hervey Taking Leave of His Family* (fig. 20), which seems to have been the work of five artists.

Although begun in Paris in 1750 by Gravelot, who had recently returned to his native land from London, the French artist admitted that he was having trouble with the picture in a letter to Lady Hervey, who appears on the extreme right of the composition with her son, Augustus. Not only did Gravelot employ an assistant for the architectural elements within the picture but he also persuaded Jean-Etienne Liotard to work up the four figures on the left. In view of Lord Hervey's patronage of the maritime painter Dominic Serres a few years later, it has been convincingly suggested that the two-decker ship in the background was his work.

At Lady Hervey's request, the picture was apparently sent to her in London unfinished early in 1751 and, perhaps on Gravelot's recommendation, Hayman was commissioned to complete the two figures on the right: Augustus Hervey (1724–79), later Third Earl of Bristol and the seated figure of his mother Lady Hervey, better known by her maiden name Molly Lepel. These two figures are markedly different in handling from the other group to the left and are characterised by Hayman's softness of modelling which is quite unlike Liotard's hard-edged style.[38] The result, not surprisingly, is a most unsatisfactory composition. The group as a whole lacks the cohesion of a good conversation piece but, if nothing else, it confirms a suspicion that

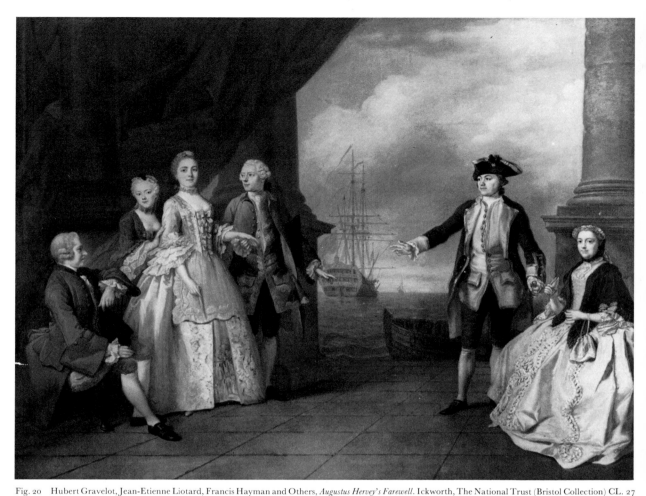

Fig. 20 Hubert Gravelot, Jean-Etienne Liotard, Francis Hayman and Others, *Augustus Hervey's Farewell*. Ickworth, The National Trust (Bristol Collection) CL. 27

Gravelot was unhappy working on a scale larger than book illustration size and that Hayman, well enough established in London by 1751, was still prepared to work piecemeal, especially for the sort of sitters who did not normally grace his studio.

St. Martin's Lane with its Academy and coffee houses was the common ground on which Hayman had mingled with artists like Gravelot, and many of his commissions derived from contacts made in that lively environment which, until the later 1760s, remained the centre of the London art world. It was probably there that Hayman met one of the most prominent figures in the cabinet-making and upholstery trades in the middle years of the century, William Hallett (1707–81).

In 1753 Hallett moved his business premises from Great Newport Street to St. Martin's Lane and Long Acre, alongside other notable firms like Vile & Cobb and Chippendale.[39] It was soon after this date that Hayman painted one of his most ambitious group portraits, *The Hallett Family* (cat. no. 27).

Few group portraits post-date *The Hallett Family* and the prime reason is that Hayman was channelling his energies into history painting. Another reason for the apparent reduction in his portrait practice after these years was the marked decline in the technical quality of his work. The delicacy of colour and lightness of touch that characterise his earlier works gave way to an earthier, rather coarse application

of paint which, when compared to the highly polished performances of Ramsay, or even the young Reynolds recently back from Italy, must have made Hayman's work an increasingly unattractive proposition to potential patrons. Hayman's output decreased markedly by the mid-1750s. A disproportionate quantity of his œuvre dates from one decade – the 1740s – and it is not a coincidence that Garrick remarked upon his industry and encouraged his diligence during those fertile years in a letter written in August 1746:

> . . . It is with the Greatest Pleasure I have observ'd Yr late application to yr Business; I beg you will continue it for yr own Sake, You are now at Ye Time of Life, You should employ almost every Moment of it in Yr Business, & in the next ten Years, make yrself Easy in Fame & Fortune : Yr Stre[ng]th of Body & Mind is now at the heigth, & Every Avocation from yr Business, is so much Money & Immortality lost; . . .[40]

By the mid-1750s Hayman was increasingly involved in the political machinations which led to the establishment of the Society of Artists and this must have diverted his attention from the more mundane aspects of portraiture. The versatility that enabled him to explore a range from portraiture to book illustration and genre subjects was abandoned in favour of a deliberate move towards history painting. Although most of his history paintings, ranging from biblical subject matter to contemporary history, have not survived, the bulk of them were produced after the mid-1750s. When Hayman occasionally returned to portraiture it was with works like *Garrick as Richard III* (cat. no. 42), which is more accurately described as a history painting.

Before examining the few later portraits let us explore Hayman's relationship with his more illustrious pupil Thomas Gainsborough. By the early 1750s there is visual evidence to suggest that influences may have been reciprocal. Let us first trace the relationship between the two artists to its origins in London a decade earlier. Despite Edward Edwards' statement that on his arrival in London the young Gainsborough was 'placed under the tuition of Mr Hayman', a statement he later amended, it seems more likely that he was placed with Gravelot.[41] Nevertheless, in the orbit of the St. Martin's Lane Academy in the early 1740s, where both Gravelot and Hayman taught, the young Gainsborough must certainly have seen Hayman's work at close quarters and he may even have assisted (as did Gravelot) with the design and execution of some of the Vauxhall pictures.[42] Gainsborough's figure style in his earliest works like the *Young Gentleman with a dog* of c. 1744–5 and *Mr Clayton Jones in a Wooded Landscape* of about the same date suggest, as John Hayes has recently put it, that 'Gainsborough was schooled in landscape painting as well as in the painting of the human figure by Hayman, and that his treatment of the portrait-in-little, and his emphasis on the rôle of the landscape background in these pictures, derived largely from the the latter's [Hayman's] example.'[43] It would certainly appear that the young Gainsborough's drapery painting is handled in a manner adapted from Hayman's method of painting in white over the colour of the drapery and using the canvas ground as a middle tone to give, economically, a convincing impression of the shimmer of material formed into folds.

It is now possible to prove that Hayman and Gainsborough worked much more closely together than has been realised, for Gainsborough painted landscape back-

grounds in some of Hayman's pictures in the later 1740s. Hayman's letter to Grosvenor Bedford about the portrait of his son and daughter specifically states that he intends to ask Gainsborough to paint the landscape and on examination of the finished picture there can be no doubt that this happened, confirming T.B.'s comments in the newspaper twenty years later that 'Mr Hayman's backgrounds have been executed by a variety of hands' (see cat. no. 12, colour plate II).

Hayman's influence on the young Gainsborough remained strong even in the ensuing years. The figure style in small group portraits like *Peter Muilman, Charles Crockett and William Keeble* (fig. 21) is still predominantly dependent on Hayman's formula.[44] Hayman and Gainsborough continued to see each other long after Gainsborough

Fig. 21 Thomas Gainsborough, *Peter Muilman, Charles Crockett and William Keeble*. Canvas, 29½ × 24½ (69.3 × 62.2) Private Collection

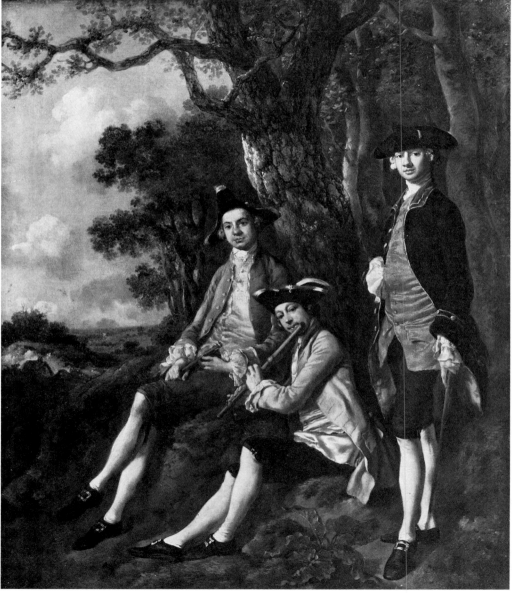

Fig. 22 Francis Hayman, *Philip Thicknesse (?)*. St. Louis, Miss., St. Louis Art Museum
(CL. 53)

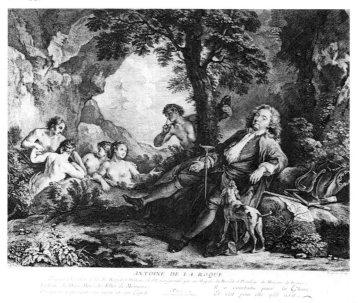

Fig. 23 Lépicié after Antoine Watteau, *Antoine de la Roque*. Engraving. London, The
British Museum

left London in 1748, and Joseph Farington tells us that Nathaniel Dance told him
that he (Dance) 'went to Italy in 1755, having before that period been abt. 2 years
with Hayman, as a pupil, where he became acquainted with Gainsborough.'[45]
Gainsborough's nineteenth-century biographer, G. W. Fulcher, tells us that two
Gainsborough landscapes from the mid-1750s and early 1760s were said to have been
painted for Hayman.[46]

 The influence was not all one way. As John Hayes points out, some of Hayman's
pictures demonstrate his awareness of the younger artist's fresh interpretation of land-
scape scenery. For instance, the small portrait in the St. Louis Art Museum of a
man reclining on a sandy bank in a landscape, dating from the early 1750s, was

41

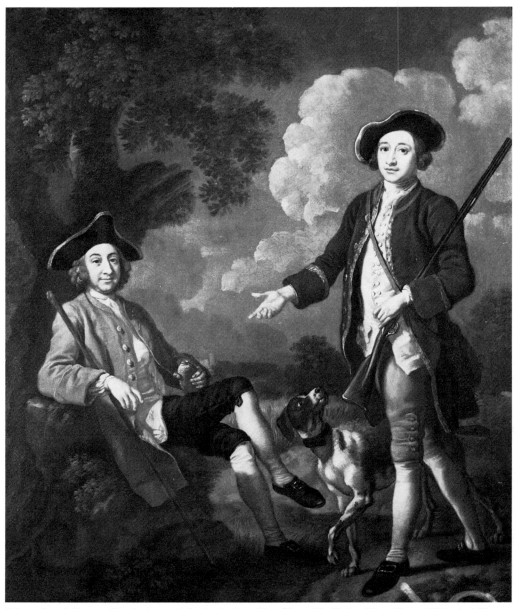

Fig. 24 Francis Hayman, *Two Gentlemen and a Dog in a Landscape*. Upton House, The National Trust (Bearsted Collection) CL. 75

for many years attributed to Gainsborough and, by tradition, identified as *Philip Thicknesse* (CL. 53, fig. 22). The pose is a favourite of Hayman's, used by him in *Stealing a Kiss* and *The Wapping Landlady* and its origin is possibly an engraving of *c.* 1734 by Lépicié after Watteau's portrait of *Antoine de la Roque* (fig. 23).[47] Hogarth used a similar pose for Tom Rakewell in the third scene of *The Rake's Progress* as early as 1733 and for Hayman it remained one of his stock poses.[48] The most instructive comparison is with Gainsborough's usage of it for his well-known portrait of *John Plampin* from the National Gallery, recently dated by John Hayes to *c.* 1754–5. The landscape in Hayman's portrait of Thicknesse is executed in the airy style of Gainsborough with its realistically wrought tree trunks and gracefully mannered foliage. Even the soft sandy bank, common to both portraits, is similar although,

as Hayes rightly points out, Hayman's touch is 'wholly un-Gainsboroughesque'.[49]

The Thicknesse portrait is not an isolated example of a Gainsboroughesque Hayman in the mid-1750s. In the double portrait of *Two Gentlemen and Dog in A Landscape* of the mid-1750s in the Bearsted Collection at Upton House (CL. 75, fig. 24), a similar figure to Thicknesse sits cross-legged on a grassy bank while his younger companion beckons towards him from the right. The sitters are not, as they have been mistakenly labelled, Hambleton Custance and Thomas Nuthall, whom Hayman did paint in 1748 (cat. no. 18); but, as with Custance and Nuthall, there seems to be an East Anglian connection in view of the presence of a church with a round tower, just to the right of the flask in the left hand of the seated figure, an architectural feature exclusive to Norfolk and Suffolk. A useful comparison can be made with the small Gainsborough full-length, recently identified by Judy Egerton as *Major Dade in his Shooting Dress, with His Pointers, in a Suffolk landscape*, now in the collection of Mr Paul Mellon which, like the Hayman, delights in the informal treatment of sportsmen in a fresh, atmospheric landscape.[50]

Sporting pictures are not commonly found in Hayman's work but other examples painted about this time include the *Young Man with a Horse and Groom* at Waddesdon Manor (CL. 70, fig. 25) and the *Gentleman with A Gun and His Dog in a Landscape*, last seen at Christie's in 1936 (CL. 68).

Very few portraits post-date the mid-1750s. Apart from *Garrick as Richard III*, the only portraits dating from *c.* 1760 known at present are the fascinating *Joseph Wilton*

Fig. 25 Francis Hayman, *A Gentleman with a Horse and Groom*. Waddesdon Manor (James A. de Rothschild Collection) CL. 70

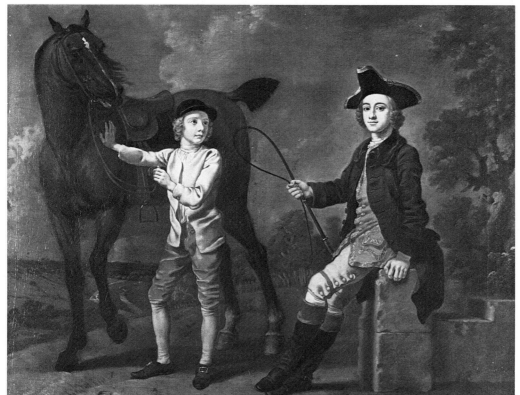

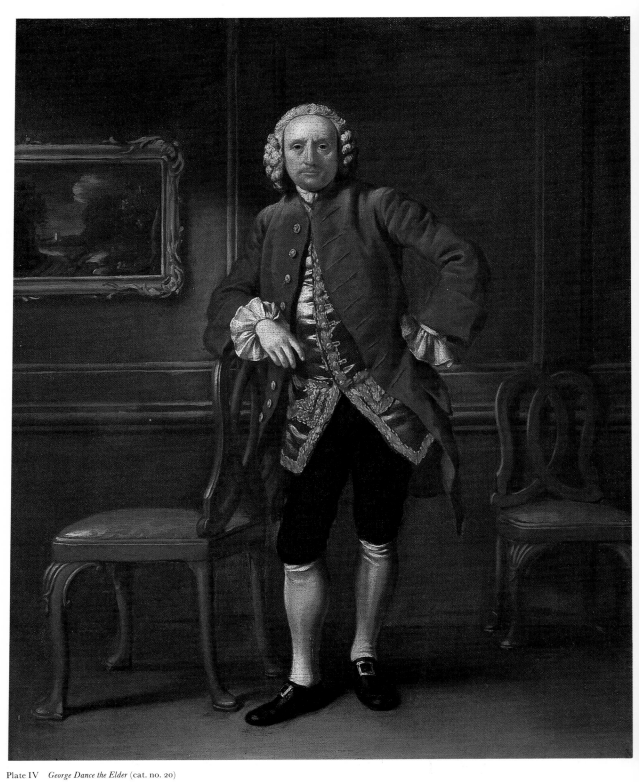

Plate IV *George Dance the Elder* (cat. no. 20)

and His Family (cat. no. 28), painted in 1760, about which I have written at length elsewhere,[51] and the enigmatic *Berkeley Family* (cat. no. 29), also from the early 1760s.

Only one of Hayman's exhibits at the Society of Artists exhibitions during the 1760s was a portrait but this has not been identified. Hayman must have been increasingly aware of the ideas being introduced by the younger generation, particularly Reynolds. For not only was history painting being purged of its more frivolous decorative elements by those earnest Anglo-Romans led by Gavin Hamilton and Benjamin West but portraiture too was undergoing change. Hayman was simply unable to adapt his style, established by the early 1740s, to the more formal and pyschologically penetrating manner epitomised by the best of Reynolds. David Garrick hints that by the end of his career Hayman felt his inadequacies as a portrait painter all too painfully. In some jocular verses composed by Garrick in 1776, only a few months after Hayman's death, entitled 'The Old Painter's Soliloquy upon see[ing] Mr Bunbury's drawings', his agonies are exposed:

> Shall I so long, old Hayman said, and swore
> > Of Painting till the barren soil,
> While the young *Bunbury* not twenty four
> Gets fame for which in vain I toil:
>
> Yet he's so whimsical, perverse, & idle,
> > Tho Phoebus self should bid him stay,
> He'll quit the magic Pencil, for the Bridle
> > And gallop Fame, and Life away.
>
> With *Reynolds* matchless Grace, and Hogarth's pow'r
> > (Again He swore a dreadful Oath)
> This Boy had rather trot ten Miles an hour,
> > And risk his Neck, than paint like both.
>
> Fix but his Mercury, He'd join the two,
> > And be my boast, Britannia cry'd:
> *Nature* before him plac'd her Comic Crew
> > Fortun plac'd Beauty by his Side.[52]

By the early 1760s much of Hayman's energy was devoted to executing the four enormous history paintings, glorifying the victories of the Seven Years War, for Tyers's Rotunda at Vauxhall Gardens. These contained numerous portraits for which we know Hayman was given sittings, but they do not survive.

With a few exceptions, there is a definable pattern of patronage for Hayman's portrait practice. Most of his sitter's were from that fast-expanding sector of society – the professional middle class. Men of medicine and science like Barrowby, Chauncey, Ellis and Hoadly are found alongside fellow artists, architects and craftsmen like Dance, Paine and Hallett. Men of letters like William Mason, Moses Mendez, Samuel Richardson, James Ralph, Charles Jennens, John Hoadly and Maurice Greene all sat for their portraits. As we might expect, there is a liberal sprinkling of figures from the theatrical world among his clients, including Garrick, Woodward, Milward and William and Hannah Pritchard. Sir Edward Littleton, John Conyers and Sir Paulet St. John are typical of the middle rank of wealthy country gentry with seats in the House of Commons and a taste for St. Martin's

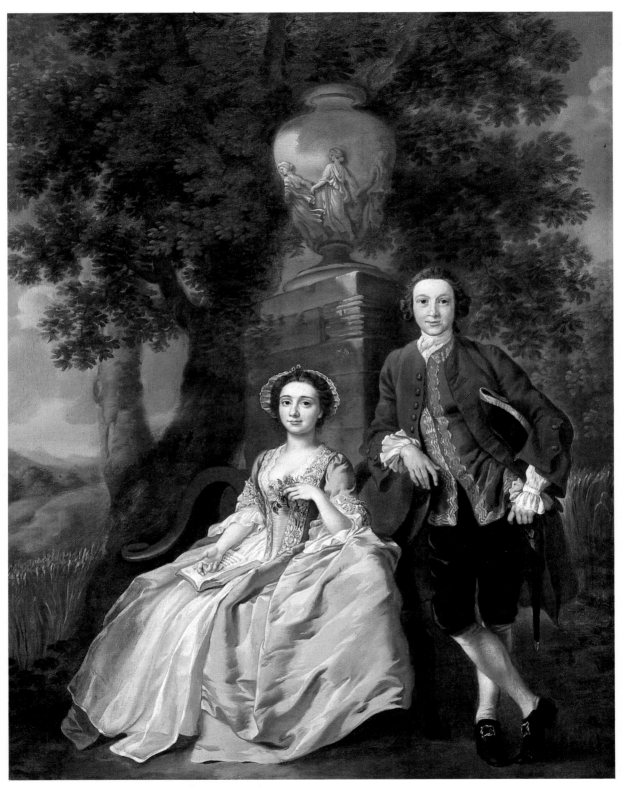

Plate V *Margaret Tyers and Her Husband George Rogers* (cat. no. 25)

Lane art who were important Hayman patrons. Yet it is unrewarding to attempt to establish consistent political leanings from Hayman's clientele. While there appears to be some truth in the notion that many devotees of the rococo style which emanated from St. Martin's Lane were associated with opposition politics and the household of Frederick, Prince of Wales, there is not sufficient consistency among Hayman's patrons for any firm conclusions to be drawn about their political persuasions, despite the fact that men like Viscount Perceval (cat. no. 6) fit the latter stereotype. One suspects that most of Hayman's sitters chose him on the basis of recommendation from friends, colleagues or acquaintances rather than for the usual reasons of status and fashion since in the enclosed literary and artistic world of the mid-eighteenth century the former factor was of greater significance.

CHAPTER 4

HISTORY PAINTING

At the beginning of the nineteenth century, a brief summary of Hayman's career by Edward Edwards included the statement that he was 'unquestionably the best historical painter in the kingdom, before the arrival of Cipriani.'[1] Considering how few history paintings by Hayman now survive, these remarks might not be taken too seriously were the same sentiments not expressed by other commentators. Hogarth's friend André Rouquet had drawn attention to the plight of history painters in this country half a century before Edwards in the following remarks:

> History Painters have so seldom an opportunity of displaying their abilities in England, that it is surprising there are any at all who apply themselves to this branch: Whosoever happens to fall into this business, very rarely meets with a rival. Those who are acquainted with the force of emulation, will therefore readily conclude that it is impossible there should be such able history painters in that country, as might be, if they had more emulation. Mr Hayman, who professes this branch, is master of every qualification that can form a great painter.'[2]

For want of information, art historians in pursuit of history painting have tended to leap from William Kent in the 1720s to the study of the generation of West and Copley after the 1760s. Few have drawn any attention to the important rôle played by Hayman in the intervening three decades. Our knowledge of Hayman's historical works has, until recently, been limited to the decorative paintings by which his reputation was established in the 1740s. Apart from the four large Shakespeare pictures in the Prince's Pavilion at Vauxhall, the earliest surviving free-standing history painting is *The Finding of The Infant Moses in The Bulrushes*, executed for the Foundling Hospital in 1747 (cat. no. 46).

We know that Hayman was apprenticed to the decorative painter Robert Browne (d. 1753) in 1718. Browne's origins are not documented, but it appears that he was probably Hayman's maternal uncle.[3] According to Samuel Redgrave, who gives no authority for his statement, Browne worked as an assistant to Verrio and Laguerre, and his training in the baroque tradition is alluded to by George Vertue who states that he was one of 'the Present History painters' to have learnt Laguerre's manner.[4] Browne subsequently became chief assistant to Sir James Thornhill, but his contribution to the latter's work is a matter of conjecture. He may have acted in the not unimportant rôle of drapery painter since Horace Walpole tells us that Browne was 'admired for his skill in painting crimson curtains, apostles, and stories out of the New Testament.'[5]

Of his own work, the only extant examples are the *grisaille* spandrels in the nave

Fig. 26 James McArdell after Robert Browne, *Precursor Domini*. Mezzotint.
London, The British Museum

of St. Andrew's Undershaft Church in Leadenhall Street executed in 1726, but these
are in such poor condition that it is impossible to judge their merit.[6] Browne's other
commissions seem to have been mainly ecclesiastical,[7] although Walpole records two
tavern signs that were much admired.[8] Browne apparently painted 'fancy pictures',
also in a religious vein, which give some indication of his style and sources of inspira-
tion. Although no easel pictures have been identified, two mezzotints by James
McArdell after paintings by Browne, inscribed *Salvator Mundi* and *Precursor Domini*,
seem to be inspired by Italian Renaissance prototypes but justify Walpole's sobering
remark that Browne 'was no Correggio!'[9] The last we hear of Browne is in January
1749 when he makes an unsuccessful application for the vacancy of Drawing Master to
Christ's Hospital, a position eventually given to a younger man, Alexander Cozens.[10]

It is not hard to make a visual transition from works like Browne's *Precursor Domini*
(fig. 26), with its Titianesque landscape backdrop, to the early conversation pieces
of the young Hayman. Browne's mannerisms, the rounded fleshy forms and large
eyes are the unmistakeable trademarks that he appears to have passed to his more
illustrious pupil. Hayman must have learnt from Browne the rudiments of decorative
painting for we are told that during his apprenticeship Hayman 'was employed in
painting the ornamental parts of the interior of many very superb civic mansions.'[11]

Hayman presumably completed his apprenticeship with Browne *c.* 1725 but we
know nothing of his career as an independent painter until he is recorded painting
scenery at Goodman's Fields Theatre in 1732 (see Chapter 2). This move towards
scene painting was probably one of economic necessity, or at least prudence, since
by the 1730s commissions for the type of decorative work for which Hayman had

been trained were increasingly scarce. In the convivial environment of the playhouse Hayman flourished. The friendships and contacts made in that world were to provide numerous avenues of employment in years to come.

Although a few specific decorative schemes undertaken by Hayman are recorded (e.g. CL. 123) none of them survive. One project that we do know something about was commissioned by John Robartes, Fourth Earl of Radnor in 1743 for his residence, Radnor House at Twickenham. On 12 July 1743 Lord Radnor wrote to his friend, the Suffolk Antiquary and collector Dr Cox Macro: 'Mr Hayman is at present at work for me here',[12] and continued by praising the artist's character and his skills. Although Lord Radnor was unspecific about the nature of the work that Hayman was undertaking at Twickenham, Edward Croft-Murray suggested that Hayman painted the ceiling in a ground-floor room off the long hall,[13] an attribution made not so much on stylistic criteria but because it appeared to be the only surviving work that could possibly correspond to Lord Radnor's remark in his letter to Macro.

Radnor House was, unfortunately, destroyed by enemy action in 1940 and its interior decoration must now be judged solely from photographs taken a few years before. In 1937 Mrs Hilda Finberg could find no trace of Hayman's work surviving and the present author firmly rejects Croft-Murray's attribution to Hayman of that ground-floor ceiling in favour of a foreign hand, perhaps Amigoni.[14] Similarly, the painted ceiling of the staircase of Yotes Court in Kent which has also been given to Hayman is not his work.[15]

The prime reason for removing with confidence both the Radnor House and Yotes Court ceilings from Hayman's œuvre is the survival of an authentic ceiling painting executed by Hayman about the same date.

Fig. 27 Francis Hayman, *Apollo and the Muses Crowning Archimedes*. Oil on plaster. Staircase ceiling at Little Haugh Hall, Norton, Suffolk (CL. 84)

Lord Radnor's friendship with Dr Cox Macro – they were contemporaries at Christ's College, Cambridge – played a significant part in Hayman eventually obtaining the commission to paint the ceiling of the staircase at Macro's Suffolk residence, Little Haugh Hall at Norton, near Bury St. Edmunds (fig. 27). By the early 1730s Macro was Chaplain to King George II and, commensurate with his rising status, had set about modernising the house purchased by his father, probably at the end of the seventeenth century.[16]

The order of events relating to this decorative scheme is a little confusing, but it would seem that by 12 July 1743, when Lord Radnor wrote to Macro from Twickenham,[17] Hayman had already been approached to undertake work at Little Haugh but had quoted too high a price for Macro's liking. Lord Radnor's letter to Macro is worth quoting in full:

I am favord with yours and Hope this may find you in good health at Norton. Mr Hayman is at present at work for me Here. He is I observe a little vex'd and ashamed of his late conduct towards you, and is now very willing to wait upon you when you please, upon your own terms – as He wil be very Happy in your family if you think proper to employ Him, So you wil I assure you be quite easy with him, he is a very quiet Good temperd man and will not cause the least trouble in your Family, which you know is no bad circumstance, and not quite the case with a late friend of ours, I realy think him a Genius, and if He Had not fool'd away many years at the beginning of life painting Harlequins, trap doors, &c. for the playHouse, he would certainly by this time be the greatest man of His Age, as He is now of His Country.[18]

This was followed by an extremely contrite and mildly paranoid letter to Dr Macro from the artist, dated 28 July [1743], presumably in reply to a renewed approach from the patron:

Sr:

My Lord Radnor has I find done me the Honour to mention me to you, Perceiving me uneasy at breaking of[f] so abruptly, With a Gentleman with whom I should fair be better acquainted with: this is the first time I have ever Attempted to drive what they call a hard Bargain, & shall be the Last, for tis plain I have no Genius for the thing; so to cutt the matter short, if you please to let the House painter prime the Ceiling &c.; twice, in light Stone Colour which will save me a day or two, & send me word when you would have me come down I shall show you that I have nothing more at heart than to please and Oblidge you on the terms you mentioned in your Letter to my Lord, viz. 28 guineas.

I am Sr Yr most Humble Sert.
F. Hayman

28th July

I hope the favour of an Answer soon.

I fear you have conceived so bad an Opinion of me that you think me encroaching when I mention the house painter tis a trifle & my boy can do it but it is alwayes done for us.[19]

Macro was apparently still wary of Hayman for he had already approached a local artist of German origin, the Norwich-based J. T. Heins.[20] Heins's response to

Macro's overtures, by letter dated 24 August 1743, was a polite but firm refusal:

Sir:

I beg leave to wait on You with these lines to acknowledge myself greatly Oblig'd for the favourable opinion you have honour'd me with in preferring on the execution of the designs You have formed for Your Stair-Case. But as I have never been engaged in such kind of performance which requires Scaffolding I am afraid that my head would not bear it, and – consequently run great hazard of acquitting myself to my great disadvantage; therefore, Sir, must beg leave to decline it; besides at present it would not be convenient leaving the business engaged in, having my hands pretty full. Yet I shall always keep in grateful remembrance the honour design'd, for

<div style="text-align:center">

Sir
Your most humble and most Obedient Servant
J. Heins

</div>

Norich 24th Aug. 1743[21]

Hayman was evidently engaged soon after Heins's refusal since the ceiling at Little Haugh Hall is unquestionably his work. He was paid the very modest sum of £26. 5. od plus seven guineas for 'filling up the vacancies of the black and white colours'.[22]

It is significant in Heins's letter that he refers to the 'designs You have formed for Your Stair-Case' – a rare indication that the iconography was planned by the patron himself. The subject matter of Hayman's ceiling painting has perplexed several modern commentators, with the exception of Robert Raines who drew attention to Macro's own description of the subject as 'The History of Archimedes'.[23] The central oval (fig. 21) covering the dome depicts *Apollo and the Muses crowning Archimedes with a laurel wreath*. The iconography is also described in an inventory of Macro's possessions compiled by his nephew in 1766, a year before Macro's death:

The best Staircase is finely carved & stuccoed, & is said to have cost 800 £. The ceiling and dome painted by Hayman. In ye Dome is represented a Council of the Gods and around ye Alcoves ye Sciences, Architecture, Sculpture, Writing, Mechanics ye force of which is represented by a Man heaving a large Stone &c. on one side is represented Sr Isaac Newton, on ye other Professor Saunderson The Nine Muses. Apollo crowning Archimedes.[24]

Although some forty years later Biagio Rebecca was to paint the head of Archimedes in one of the panels on the ceiling of the Council Chamber at the newly completed Somerset House,[25] the subject matter was highly original and no doubt reflects Macro's interests and early friendships at Cambridge University. Macro may well have known Newton, who died in 1727, during his undergraduate days. In the alcove Hayman depicted Newton appropriately flanked on either side by putti experimenting with an orrery and a telescope, a motif possibly borrowed from a sculpted relief on Newton's monument in Westminster Abbey of 1731 by Macro's friend, John Michael Rysbrack.[26] The Professor Saunderson, mentioned by Macro's nephew, was another Cambridge don, the mathematician Nicholas Saunderson (1682–1739) who had taught at Macro's alma mater, Christ's College. Hayman's medallion portrait of Saunderson resembles that by Vanderbank in the Old Schools, Cambridge.[27]

Deborah Lambert has convincingly suggested that both Macro and Hayman were influenced in their conception of the design by the Rubens ceiling in the Whitehall Banqueting House.[28] In plan, the Little Haugh ceiling is constructed around a decorated stucco compartment resembling the central section of the Whitehall ceiling and several of Hayman's putti seem to be derived from Rubens. It may not be a coincidence that the Rubens canvases on the Whitehall ceiling had recently been cleaned, and some of their former glory restored, as part of the general repairs undertaken during the Surveyorship of William Kent in the early 1730s.[29]

Unlike that at Radnor House, the Little Haugh ceiling, even if it were not documented would have been instantly recognisable as Hayman's work. The medium employed is oil on plaster, presumably over the ground coating of 'light Stone Colour' which Hayman mentioned. The range of colours employed by Hayman – the soft pinks and greens and the warm flesh tints – are precisely those employed in the many conversation pieces executed in the early 1740s. His inability to disguise those strange mannerisms, the 'large noses and shambling legs', to use Horace Walpole's rather unkind remark,[30] is overwhelmingly apparent. It is inconceivable that the same painter could have been responsible for the Radnor House ceiling with its dry, chalky colouring and obviously Venetian figures.

The ceiling painting was not the only work done by Hayman at Little Haugh Hall, though nothing besides the ceiling survives. Cox Macro had been one of Peter Tillemans' most munificent patrons from about 1715 until the painter's death in 1734. Tillemans had collaborated with a local artist, Thomas Ross,[31] on the canvases which lined the walls of the staircase.[32] According to Macro's nephew the subject matter of these consisted of 'Archimedes amongst the Shepherds. He is sent for to defend Syracuse' on the sides of the staircase, and, at the bottom 'Sea Gods and Goddesses, among ye rest Neptune with his Trident'.[33] Tillemans' involvement with the Archimedes subject, almost a decade before Hayman was involved, suggests that Macro had almost certainly intended the project to be entirely the work of the Flemish artist but that his death in 1734 had brought proceedings to a halt.[34] Tillemans also provided several overdoor paintings, including a set of four portraits of dogs for the Hall which had not been completed at his death, for Macro records in his manuscript catalogue of his collection: 'The Hall . . . Three of the Dog pieces over the Doors. P. Tillemans infinish'd. The fourth Dog piece wherein is the Mastiff. Hayman.'[35] These overdoors survive, although not in their original settings (the Hall was remodelled in the 1830s by then-owner Peter Huddleston) and the one by Hayman (cat. no. 34, fig. 28) is a charming essay in a genre that bears comparison with Gainsborough's *Bumper* (fig. 29) of the same date.[36]

Hayman's next recorded appearance as a decorative painter is at the newly completed Foundling Hospital. Established by Captain Thomas Coram in 1739, the Foundling Hospital was one of the great philanthropic ventures of the eighteenth century.[37] Like Hogarth, Hayman must have had an interest in hospitals if his friendship with medical men, who formed a significant part of his portrait practice, is a reliable guide.

As at Vauxhall Gardens (see pp. 107–9), Hogarth's entrepreneurial streak seems to have been the motivating factor in determining the future contributions to the Foundling Hospital by artists of the St. Martin's Lane Academy. By October 1745 the west wing of the new hospital building was complete and the temporary premises

Fig. 28 Francis Hayman, *A Portrait of a Mastiff*. Private Collection (cat. no. 34)

in Hatton Garden were abandoned.[38] Here was a new building awaiting, or so Hogarth thought, appropriate decorations. Precise details of the negotiations with the Hospital's governors (of whom Hogarth was a founding member[39]) are not known, but Hogarth's friend André Rouquet tells us that the artists only volunteered to decorate the building after 'the governors refused to apply any of the charitable contributions to this use.'[40] George Vertue then conveniently provides us with an accurate chronology of the ensuing events:

> the beginning of the year [1746/7] was put up. three Historical pictures painted & presented to the Foundling Hospital by three English Painters – Highmore, Hogarth, Wills, the fourth not yet quite finisht. – to be done by Hayman . . .[41]

Fig. 29 Thomas Gainsborough, *Bumper – A Bull Terrier*. Canvas, $13\frac{3}{4} \times 11\frac{3}{4}$ (34.9 × 29.8) Private Collection

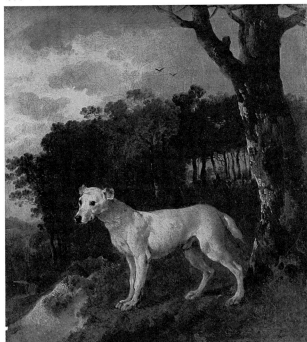

A few months later Vertue noted:

> Wensday the first of April. 1747. at the Foundling Hospital was an Entertainment, or publick dinner. of the Governors and other Gentlemen that had inclination – about 170 persons great benefactions then givens towards the hospital – at the same time was seen the four paintings newly put up, done Gratis by four eminent painters – by Hayman, Hogarth, Hymore. & Wills –[42]

The four paintings to which Vertue refers were all appropriately based on the theme of the rescue of young children. Highmore's *Hagar and Ishmael*, James Wills' *Little Children Brought Unto Christ*, Hogarth's *Moses Brought Before Pharoah's Daughter* and Hayman's *Finding of Moses in The Bulrushes* (cat. no. 46) were furnished with identical frames and hung in the newly completed Court Room of the west wing. In return for donating paintings the artists were elected to governorships of the hospital, and, before the establishment of the Royal Academy provided titles for artists, this was a reasonable reward for painters determined to raise their social standing.[43]

Hogarth realised, as he had done in conceiving the Vauxhall Gardens decorations, that the opportunity to see works of art by contemporary artists in a public setting would not only be a potential inducement for Londoners to visit the Foundling Hospital but might also encourage further commissions in this direction. Whether, as John Brownlow, the hospital's first historian, has suggested, the four pictures in the Court Room were the result of a 'conjoint agreement' between the artists is not clear,[44] but Hogarth and Hayman must have discussed the matter closely since they illustrated consecutive verses from the Book of Exodus. Brownlow, however, later hints that Coram himself probably dictated the subject matter, for at the very first meeting of the General Committee of the Hospital, held on 29 November 1739, Coram had presented the first seal of the Corporation from his own design. The idea, he explained, came to him from 'the affair Mentioned in the Second of Exodus of Pharoah's daughter and her Maids finding Moses in the ark of Bulrushes which I thought would be very appropos for a hospital for foundlings, Moses being the first foundling we read of'.[45]

Although as Vertue remarked 'its Generally said and allowed that Hogarth's peece gives most striking satisfaction – & approbation',[46] Hayman's effort compares favourably with both the insipid picture by Wills and Highmore's *Hagar and Ishmael* with its stilted figures and dull landscape.[47]

It may well have been on the strength of the Foundling picture that Hayman was asked by his good friend, the architect James Paine (1717–89) to provide *The Good Samaritan* altarpiece, now at Yale (cat. no. 47, colour plate 9), for William Wrightson's private chapel at Cusworth Hall, near Doncaster. Although at this stage of his career the young James Paine's practice was based mainly in Yorkshire and the north-east, he had been a pupil at the St. Martin's Lane Academy in the later 1730s and must have come into contact with Hayman, already one of the Academy's leading lights. Paine and Hayman were to work together on a number of schemes, mostly in the north of England, in the 1740s and 1750s, before the arrival in England of the later wave of Italian decorative painters led by Cipriani in 1755. The earliest hint of a partnership forged between Hayman and Paine can be traced to the mid-1740s.

In 1744 the Corporation of Doncaster commissioned the young Paine to design

Fig. 30 Attributed to Francis Hayman, *Design for a painted ceiling for the Banqueting Room at the Mansion House, Doncaster.* Engraving from James Paine's *Plans, Elevations, Sections . . . &tc . . . of the Mansion House, Doncaster* (cat. no. 89)

a Banqueting or Mansion House as it became known. Paine was perhaps a surprising choice.[48] He was only twenty-seven years old in 1744, and his only previous assignments were at Nostell Priory near Wakefield and a small job at nearby Heath House.[49] The Doncaster Mansion House was built between 1745 and 1748[50] and Paine made the most of his coup by publishing in 1751 a lavish folio volume on the building with a series of engraved plates and an explanatory text (see cat. no. 89). Had he not hopelessly exceeded his estimated costs for the project, the decorative painting that Paine planned with Hayman's assistance might well have been executed. When the book was published, three years after the completion of the building, Paine was still trying to persuade the penurious Doncaster authorities to complete the decoration.

Hayman's authorship of the proposed decorations is suggested not only by stylistic criteria visible in the engravings (fig. 30), but also by the title page of the book which incorporates a medallion portrait-vignette of Paine by Hayman. When the volume was published Hayman was, significantly, at work on the altarpiece for a private chapel at Cusworth Hall, only two miles from Doncaster.

Soon after the completion of the Mansion House, Paine was commissioned by William Wrightson to add two wings, containing a chapel and a library to a Palladian style house, Cusworth Hall, built in the early 1740s to the designs of the local architect, George Platt of Rotherham.[51]

Wrightson (*c.* 1676–1760), about whom remarkably little is known, had succeeded to the family estate in 1724, having already served as M.P. for Newcastle-upon-Tyne and Northumberland.[52] His choice of Paine as architect for the alterations may well have been prompted not only by the proximity of a splendid example of his work

56

but also by the architect's second marriage in 1748 to Charlotte, youngest sister of Richard Beaumont of Whitley Beaumont and Wrightson's niece by marriage.

At Cusworth, Paine's Chapel (fig. 31) formed the southern extremity of the new west wing and was sumptuously decorated with elaborate rococo plasterwork by Joseph Rose.[53] It was surely on Paine's recommendation that Hayman was commissioned to paint the altarpiece *The Good Samaritan* (cat. no. 47, colour plate IX) which dominated the apsidal space behind the altar.[54] *The Good Samaritan*, one of the few biblical pictures by Hayman to survive, must have been finished early in 1752 since Hayman was paid £26.5.od in March (see cat. no. 47) but it may not have been installed for some time because the magnificent rococo plaster frame by Joseph Rose, which sadly now stands empty in the Chapel, was not paid for until November 1754. Hayman's prices had risen dramatically in the course of a decade since a single picture by him now cost as much as the entire ceiling at Little Haugh.

The subject matter of Hayman's altarpiece (Luke 10:30–37) already had a very public precedent in the form of the large canvas painted by Hogarth in 1737 for the staircase of St. Batholomew's Hospital in London,[55] but there is nothing to indicate that it had any particular significance for Wrightson. Given the subject's limitations in pictorial terms it is not surprising that the two works have several compositional similarities. Both artists depict the moment when the Samaritan pours oil on the wounds. Hogarth, typically, introduces a dog – not mentioned in Luke's Gospel – and the passing Levite. Hayman adheres more strictly to the text and incorp-

Fig. 31 The Chapel of Cusworth Hall, near Doncaster (designed by James Paine) with Hayman's altarpiece *The Good Samaritan* (cat. no. 47) *in situ*

orates both the Levite and the priest in the distance, the latter given a distinctly Roman Catholic appearance. Lurking behind the tree to the left, Hayman introduces an uncompromisingly forthright portrait of an ass, confronting the viewer in a manner reminiscent of a similar animal in the lower left of Watteau's *Gilles* of about 1720 in the Louvre.[56]

The reclining figure of the victim of the robbers, receiving the good Samaritan's attentions, has its origins in a fine, large life-drawing, now in the Royal Academy, which is a pleasing display of Hayman's draughtsmanship and the only drawing of its kind known at present. (cat. no. 70).

It should also be pointed out in this context that, despite consistent attribution to Hayman, the ceiling of the Chapel – *Christ in Glory* – and the ceiling of the Breakfast Room – *Diana and Endymion*, both executed in oil on plaster, are in fact the work of Hayman's friend and associate Samuel Wale (*c.* 1720–1786). Wale's career as a decorative painter in partnership with Hayman is completely uncharted but would be worthy of further investigation.[57]

Hayman's reputation as an historical painter seems to have been at its peak in the early to mid-1750s, when there was both little competition from native-born artists and a comparative lull in the influx of more talented foreign painters. In an article published in *The Gray's Inn Journal* in 1754 a certain 'Charles Ranger' [pseud.] – who may have actually been Garrick's biographer Arthur Murphy, who regularly contributed to this journal – lamented the lack of native talent in history painting but noted:

> the taste has prevailed for many years in the Kingdom ... The Transfiguration by Raphael, the Nativity by *Corregio*, and the last Judgement by *Michael Angelo* will perhaps never be matched anywhere else; but it is unfair to deduce a Conclusion from thence that we have no Genius for this excellent imitative Art in England ... WHOEVER, has observed with Attention the Performance of *Hayman*, must be convinced that Voltaire's Charge of a want of taste is perfectly groundless.[58] Everything is put out of Hand by this excellent Artist with the utmost Grace and Delicacy, and his History-Pieces have, besides their beautiful Colouring, the most lively Expression of Character . . .[59]

This is not an isolated puff in praise of Hayman's history paintings. The author 'T.B.', whom we have encountered before (see p. 36–7), published in 1761 a pamphlet entitled *A Call to the Connoisseurs . . . &tc.* and was similarly extravagant in his praise:

> Mr HAYMAN is beautiful in his Conceptions, and correct in his Design; no Artist has ever more happily united the Ideas of the Antique. to the easy Elegance of beautiful Nature than this excellent Master; for though his figures are the result of much study from the Antique, we are pleas'd to find that they have none of that inanimate marble solidity, that is but too often observ'd and but too justly complain'd of, in the Works of N. POUSSIN and Others: this with an excellent Stile of Colouring unites so many Perfections in this Master, as render him esteem'd by his Cotemporaries [sic], and an Honour to his Country.[60]

These 'puffs' in the press, usually inspired by friends and associates of the artist, almost invariably give an exaggerated impression of the standing of Hayman through the eyes of his contemporaries. Perhaps a more accurate guide to his reputation at

the end of the 1750s, at least among his more critical fellow artists, can be gleaned from a letter written by Hayman's former pupil Nathaniel Dance to his father George Dance the elder, from Rome in July 1759. Nathaniel described for his father the work on which he was currently engaged, his *Death of Virginia*, finally exhibited in London at the Society of Artists exhibition in 1761, and noted:

> I have endeavoured to get a hue of colouring very different from anything you have seen of mine or my master, Hayman. I am sorry to find they look on him [Hayman] with contempt because I *must* think him [a] man of merit. Though he is very deficient in point of colouring and correctness of drawing, yet he certainly has genius and a great facility of invention.[61]

Dance's loyalty to his former master is praiseworthy but the contempt in which Hayman was apparently held in some quarters was evidently alarming to his younger student. In the 1760s Hayman was to attempt to compete not only with more foreigners – to which he was accustomed – but also with the new breed of young British history painters, Dance among them, who had benefited from a Roman education. Despite Mrs Esdaile's assertion (see Chapter 1), Hayman did not make a trip to Rome and it was increasingly apparent.

By the early 1760s Hayman's activity as a decorative painter was significantly curtailed. Not only had his health begun to fail – he was plagued by prolonged attacks of gout, making decorative work seemingly more arduous – but the competition from accomplished foreign artists also proved too sustained a challenge. Cipriani's arrival from Florence in the company of the architect William Chambers and the sculptor Joseph Wilton in May 1755 was the first significant blow, and the influx of Biagio Rebecca (1761), Angelica Kauffmann, Antonio Zucchi (both in 1766) and G. B. Colombo (c. 1769), all artists whose style was much more in sympathy with the delicate, geometric low-relief of the ascendant Adam and Wyatt style in architecture, effectively heralded the end of the Hayman's career as a decorative painter.

Even James Paine, who was still collaborating with Hayman in the early 1760s,[62] and remained a loyal friend, had to abandon him in favour of younger and more fashionable decorators. In 1770, for example, Paine turned to Giovanni Battista Colombo for the decoration of Sir Henry Bridgeman's Temple of Diana at Weston Park in Staffordshire[63] and a year later employed the young John Hamilton Mortimer, Francis Wheatley and James Durno to paint the ceiling of the Saloon at Brocket Hall in Hertfordshire.[64]

Throughout the 1760s Hayman continued, in his easel paintings, to attempt to meet the challenge of the Anglo-Romans led by Hamilton and West, but he was still rooted in a style formulated a quarter of a century before which subsequently had undergone only subtle modifications.

Hayman's style as a decorative painter is extremely difficult to describe or even summarise because so few examples of his work survive. The sole authentic ceiling painting at Little Haugh Hall is too modest a scheme for any useful comparisons to be drawn with the efforts of Verrio, Laguerre or Thornhill from the previous generations. Had the Doncaster Mansion House, for instance, received its decorations, which the engravings suggest would have been altogether grander than Little Haugh, then we might have been able to assess Hayman's standing with greater confidence.

Fig. 32 Francis Hayman, *Peter denying Christ*. St. Oswald's Church, Malpas, Cheshire (CL. 103)

The institution of annual public exhibitions in 1760 came too late to boost Hayman's reputation. By that date his output had declined with his health. Yet the beginning of the new decade was a moment of great optimism for artists in London. King George II died on 25 October 1760 and was succeeded by his grandson George, Prince of Wales. As the son of Frederick, Prince of Wales, who had shown considerably more interest in the visual arts than his father or grandfather, the new young King was courted as a potential patron of the arts. As a visiting Italian who had access to many of London's leading artists remarked in 1762: 'Great things are expected of the present prince upon the throne if he patronises the English artists.'[65]

Hayman exhibited intermittently at the annual exhibition of the Society of Artists throughout the 1760s. With the exception of one unidentified portrait all Hayman's exhibits were history paintings. At the first exhibition in 1760 he showed *Garrick as Richard III* (cat. no. 42) which Charles Jennens acquired and the following year his solitary exhibit was one of the versions of *Falstaff Reviewing His Recruits*. In 1762 he failed to exhibit but this is almost certainly because his energies were devoted to the four large history paintings for the Rotunda at Vauxhall and the large *Peter denying Christ* (CL. 103, fig. 32), the most ambitious of Hayman's paintings to have survived.

The subject matter of *Peter denying Christ* closely follows the Gospel according to St. Luke (chap. 22, v. 54–61) and depicts the moment after the crowing of the cock. The early history of the picture is a fascinating example of the links between many of Hayman's most important patrons. Its first owner appears to have been William

Hanmer of Iscoid in Cheshire,[66] a cousin of Sir Thomas Hanmer who had employed Hayman at the beginning of the 1740s to design the illustrations for his edition of the works of Shakespeare (cat. no. 82). William Hanmer had married Elizabeth Jennens, only sister of Charles Jennens, who was also his first cousin.[67] Their grandson, Penn Assheton Curzon, M.P. for Clitheroe in Lancashire (1784–90) and for Leicestershire (1792–7),[68] bought the picture at the sale of his grandparents' estate in Flintshire in late September (?) or early October 1778[69] and presented it to St. Oswald's Church, Malpas, Cheshire where it has remained ever since. Details of the transaction were fortunately recorded in a letter from Roger Kenyon to Mrs Lloyd Kenyon dated 8 October 1778:

> The sale at Iscoyd has continued for this last week, but I was there only one day and bot. nothing except pictures, which if you or my Broth'r [wish] you shall have at the price. I think they were very low the day I was there, but am told they advanced greatly afterwards. The large picture in the saloon of Peter denying Christ was bot. by Mr Curzon as a present for Malpas Church for 29 guineas and a half. but few of the paintings exceeded a couple of guineas.[70]

The picture was originally placed over the altar in St. Oswald's,[71] until the introduction of a large stained glass window c. 1840[72] required removal to its present location, high above the chancel arch.

The striking composition may owe something to the work of Murillo. The Spanish artist's *Christ Healing The Paralytic at The Pool of Bethesda* in the National Gallery is the type of composition which Hayman may have had in mind when designing *Peter denying Christ*. A similar repertoire of poses and dramatic gesture can be found in both works; although Hayman cannot specifically have known this painting by Murillo, executed as one of a series for the church of St. Jorge, known as La Caridad, at Seville in the late 1660s, he may have known other similar works.[73] The dramatic lighting and handling of Christ's inquisitors to the left may owe something to Rembrandt's *The Tribute Money*, then in the collection of John Blackwood and scraped in mezzotint by McArdell,[74] while to the right Peter, illuminated by the glow from the brazier, starts back in fear along with the reclining soldier in a manner reminiscent of Caravaggio. The orange robes of Christ and the red sleeve of the reclining soldier are the strongest colour accents emerging from the gloomy chiaroscuro.

In the 1760s Hayman produced a significant number of biblical paintings which have all disappeared. His most prolific patron in this direction was Charles Jennens (1700–73). Jennens, one of England's wealthiest men, is best remembered as Handel's librettist and, in his last years, as the much-maligned editor of some of Shakespeare's tragedies for which Hayman, incidentally, designed frontispieces (see cat. no. 94).[75] In 1747 Jennens succeeded to the family estate at Gopsall in Leicestershire and proceeded to build a new mansion there.[76] In the ensuing years he filled both Gopsall and his London house in Great Ormond Street with a spectacular collection of Old Masters as well as an impressive selection of contemporary art with a distinct bias for works by artists of the St. Martin's Lane circle. Lambert, Monamy, Gainsborough, Roubiliac and Hayman were all represented.[77]

By 1760 Jennens had in his London house *The Cure of Saul* and *The Resurrection of Christ* (CL. 92, 93) by Hayman, which are both now lost. At Gopsall Jennens also had *The Prodigal Son*, exhibited at the Royal Academy exhibition in 1770, and *Judas*

Betraying Christ (CL. 110, 117), both of which were sold by his heir Penn Assheton Curzon at Langford's in 1774.[78] He also owned one of the versions of *Falstaff Reviewing His Recruits* and *Garrick as Richard III* (cat. no. 42).

Jennens' rather unusual predilection for Hayman's work was a source of bewilderment to his most ardent detractors and he was sneered at unmercifully by George Steevens in his articles in *The Critical Review*. As Steevens sarcastically put it:

> The Reviewers might indeed have made their fortunes out of his [Jennens's] purse, could they have been bribed to applaud his editorial abilities . . . [and] . . . prefer Hayman to Raffaele . . . He Generally took care to patronise such tradesmen and such artists as few other persons would employ . . . and his walls [were] discoloured by the refuse of Hayman's miserable pencil.[79]

Jennens was not the only patron to retain a loyalty to Hayman. The proprietor of Vauxhall Gardens, Jonathan Tyers, was always looking for ways of keeping his fashionable London nightspot in the public eye. By 1760 the work that Tyers had commissioned from Hayman in the early 1740s, the group of fifty or so supper box pictures (CL. 171–216), must have looked both passé in stylistic terms and, with their essentially frivolous subject matter, out of tune with the mood of a country at war. It is not known if the impetus for the production of the four enormous history paintings with the current Seven Years War as the theme came from Tyers or Hayman, but the artist must have relished a return to the theatrical environs of Vauxhall with its enormous fashionable captive audience.

Fig. 33 H. Roberts after Samuel Wale, *The Inside of the Elegant Music Room at Vaux Hall Gardens* (detail). New Haven, Conn., Yale Center for British Art, Paul Mellon Collection (cat. no. 96)

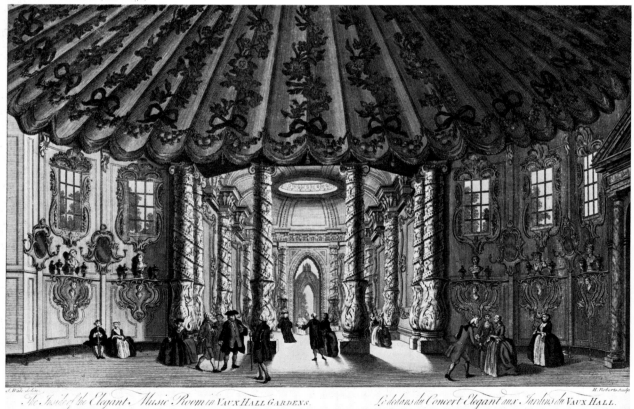

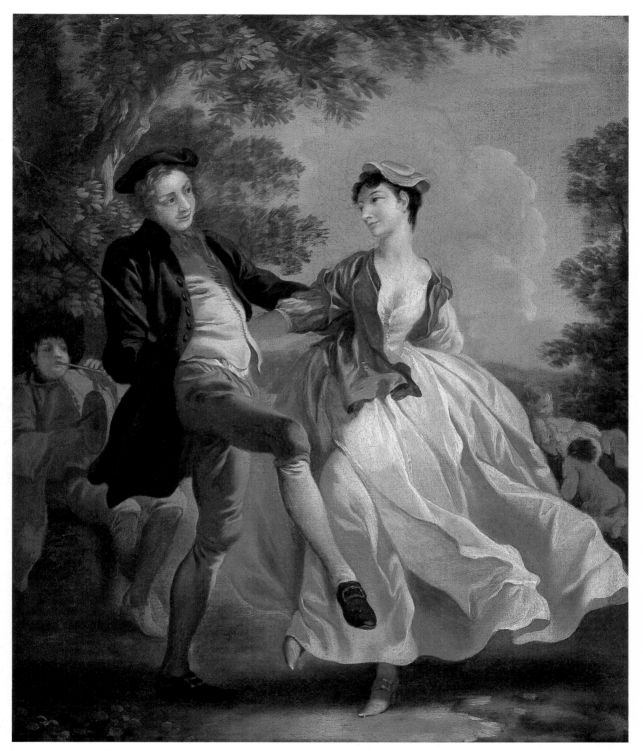

Plate VI *Rustic Figures Dancing* (cat. no. 35)

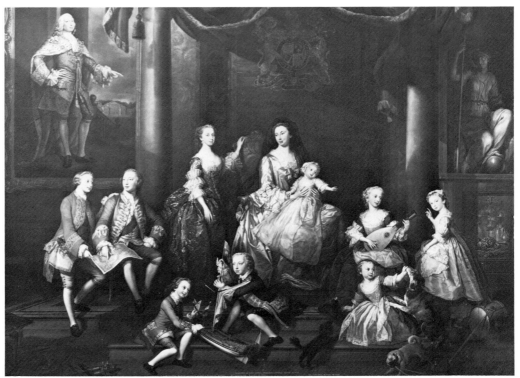

Fig. 34 George Knapton, *The Family of Frederick, Prince of Wales*. Canvas, 138 × 181½ (350.6 × 462.3) Copyright reserved to Her Majesty Queen Elizabeth II

These four giant canvases were placed in 'four grand elegant Frames'[80] in the Saloon or annexe to the Rotunda which Tyers had built on the north side of the Grove at Vauxhall, behind the supper boxes on the so-called 'Grand Walk' that greeted the spectator entering the Gardens via the main water gate (see cat. no. 96, fig. 33). The Rotunda and Saloon were part of the major redecoration which Tyers undertook at Vauxhall in the late 1740s in an attempt to counteract competition from the attractions of nearby rival Ranelagh Gardens.[81]

According to a contemporary source – a guidebook to Vauxhall Gardens published in 1762[82] – the four large frames were originally intended to house portraits of Frederick, Prince of Wales and his family. It should be explained that since Vauxhall Gardens had been constructed on land controlled by the Duchy of Cornwall, Prince Frederick was the ground landlord as well as Tyers's most prominent patron. The Prince's special relationship with Vauxhall was immediately apparent to any visitor to the Gardens since the grandest supper box of all – the Prince's own Pavilion[83] – dominated the west side of the central grove. It was surely the Prince's untimely death in 1751 which prevented the execution of the proposed family portraits.

However, it is possible that the scheme was further advanced than has been realised when the Prince died. One of the proposed portraits may have been completed and a second designed. The enormous group portrait of *The Family of Frederick, Prince of Wales* in the Royal Collection by George Knapton is now hung at Marlborough House (fig. 34). It is signed and dated 1751[84] and was presumably commissioned by Princess Augusta, the Prince's widow, immediately after the Prince's death. Knapton was in favour with the Prince just before his death. In 1750 he had been commissioned with Vertue to compile a report on the pictures in the Royal Palaces[85] and

by that date had already produced some pastel portraits of the Prince's children.[86] In the large family group in oils the Prince is represented in a portrait on the wall – a common enough conceit for portrayal of the dead – overlooking his wife and children engaged in the pursuits and hobbies which he had encouraged. Apart from the coincidence of date, there would be little reason to associate this ambitious picture with the Rotunda scheme at Vauxhall were it not for size corresponding with that of the 'grand elegant Frames' which the author of the 1762 guide to Vauxhall describes. By a stroke of good fortune the size of these frames is known. One of the four large pictures by Hayman which subsequently occupied these frames – *The Triumph of Britannia* – was engraved by Ravenet and the letterpress specifically notes the size of the original picture as twelve by fifteen feet (see cat. no. 79, fig. 35). Although Knapton's picture is eleven feet six inches by fifteen feet one and a half inches, the loss of six inches in height is possibly the result of cropping since the positioning of the frame of the Prince's portrait within the picture certainly suggests that it has been cropped slightly along its top edge.[87] This is a not uncommon fate of many large pictures.

The other work which may be related to the proposed scheme is a small oil sketch by Hayman – *The Artists presenting a Plan for an Academy to Frederick, Prince of Wales and Princess Augusta* (cat. no. 48, fig. 36). The proportions of this work, though not of course its dimensions, correspond precisely to the Vauxhall frames, and the subject of Frederick apparently receiving a plan for a proposed Academy was uppermost in the thoughts of Hayman and his colleagues at the St. Martin's Lane Academy.

Fig. 35 S. F. Ravenet after Francis Hayman, *The Triumph of Britannia*. Engraving. New Haven, Conn., Yale Center for British Art. Paul Mellon Collection

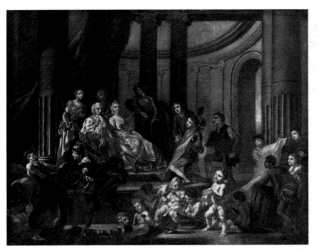

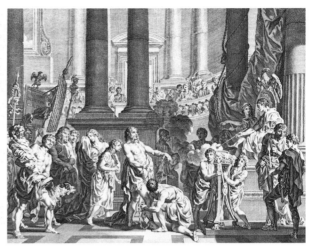

Fig. 36 Francis Hayman, *The Artists presenting a Plan for an Academy to Frederick, Prince of Wales and Princess Augusta*. Exeter, Royal Albert Memorial Museum (cat. no. 48)

Fig. 37 C. Grignion after Francis Hayman, *The Noble Behaviour of Caractacus Before the Emperor Claudius*. Engraving. New Haven, Conn., Yale Center for British Art (cat. no. 78a)

The composition is very similar to Hayman's design, of exactly the same date, for *The Noble Behaviour of Caractacus Before The Emperor Claudius*, one of the set of six prints published in 1751 (see cat. no. 78a, fig. 37). For both compositions Hayman may have been influenced by Verrio and Laguerre's great canvas, *James II Giving Audience to The Governors . . . &tc. of Christ's Hospital* then on the south wall of the Hall in Christ's Hospital in London (fig. 38). Hayman's design never got beyond an oil sketch but, had it been completed, it would have successfully complemented Knapton's effort.

As it transpired the frames remained uncomfortably blank, as can be seen in fig. 33, until they were filled between 1761 and 1764 with the four large canvases by Hayman. Although none of the four original canvases survive, with the aid of an engraving after one of them, modellos for two of the others and a lengthy printed description of the fourth picture, it is possible to reconstruct an accurate idea of their appearance.

The first to be completed was *The Surrender of Montreal to General Amherst*, unveiled by November 1761.[88] The design is known through two small modellos; one with Sidney Sabin (CL. 97), the other, which corresponds more closely to the original painting, is in the Beaverbrook Art Gallery, Fredericton, New Brunswick (CL. 96, fig. 39). Hayman must have worked at haste on the large canvas since Amherst had only captured Montreal on 8 September 1760.[89] The surrender of Montreal was of the greatest significance for the war since, combined with Wolfe's victory at Quebec, Canada had effectively become British.

Hayman chose to depict the moment of Amherst's magnanimous gesture of feeding his captives who had endured weeks of siege. The analogy was, of course with the great Generals of antiquity; Scipio and Alexander, episodes from Classical history that were widely familiar. According to contemporary descriptions, on a stone in one corner of the picture was the inscription:

POWER EXERTED,
CONQUEST OBTAINED,
MERCY SHOWN
MDCCLX[90]

The continence of Scipio Africanus, as related by Livy, had as its basic tenet the

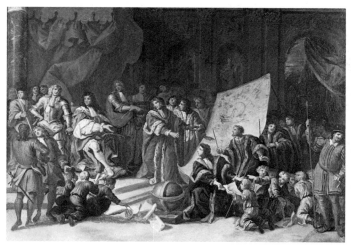

Fig. 38 Antonio Verrio, *Study for 'Charles II Giving Audience at Christ's Hospital'*. Canvas, 36½ × 49½ (92.7 × 125.7) London, Victoria & Albert Museum

notion of righteousness triumphing over needless sacrifice and, by association, the British public were to be left in no doubt about the validity and wisdom of British rule in the North American continent.[91] Hayman undoubtedly knew the story well not only through Livy's text but also through *The Tatler*, an edition of which he had embellished with frontispieces only a short while before (CL. 305).

It is immediately apparent that the source for Hayman's composition is Charles Le Brun's well-known *The Family of Darius before Alexander*. The composition was well

Fig. 39 Francis Hayman, *The Surrender of Montreal to General Amherst*. Fredericton, New Brunswick, Beaverbrook Art Gallery (CL. 96)

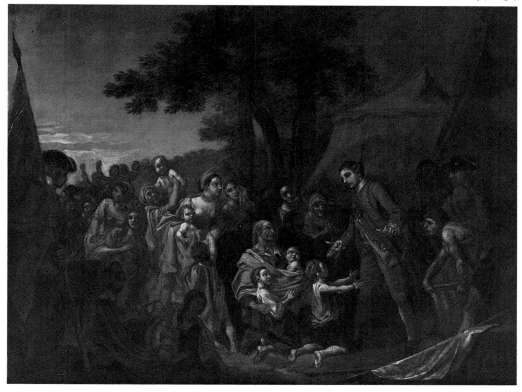

known in England through engravings by Audran and others and it was frequently copied by reputable artists.[92] Hayman had already modified Le Brun's composition for his illustration to *Corialanus* for the Hanmer *Shakespeare*, but its use for such a large-scale public image was particularly appropriate. Hayman appears to have been the first to revive this aspect of humanitarian military leadership in painting, a vogue that must have influenced Edward Penny in his conception of works like the immensely popular *The Marquis of Granby giving alms to a Soldier*.[93]

The second picture to be completed – *The Triumph of Britannia* – was ready by June 1762[94] and was placed alongside *The Surrender of Montreal*. It is now known only solely through Ravenet's large engraving, published by Boydell on 1 January 1765 (cat. no. 79, fig. 35).

Hawkes's victory over the French at Quiberon Bay on 20 November 1759 was one of the most decisive actions of the War. Unlike *The Surrender of Montreal*, Hayman treated the subject allegorically with Neptune in his chariot driving Britannia who bears a medallion portrait of George III across the waves. Below are the victorious Admirals: Pocock, Boscawen, Hawke, Anson, Saunders, Keppel and Howe, also represented by portrait medallions 'as large as life' borne by nereids. Hayman must have been given sittings for these convincing portraits, perhaps with the exception of Admiral Howe who is obscured by a triton on the extreme right.[95] In the background is 'the engagement between the Royal George commanded by Admiral Hawke in person, and the Soleil Royal commanded by Admiral de Conflans.'[96]

In this instance Hayman seems to have looked to Annibale Carracci or even Raphael's *The Triumph of Galatea*, from the Villa Farnesina in Rome. The rearing horses and the tritons blowing their conches can, for example, both be found in Raphael's fresco. James Barry must surely also have been aware of Hayman's composition when he designed his equally large *Commerce, or the Triumph of the Thames*, one of the paintings for the Great Room of the Royal Society of Arts.[97]

Later in 1762 the third picture, *Lord Clive Receiving The Homage of The Nabob*, was placed directly opposite *The Surrender of Montreal*. On the basis of a lengthy descriptive account of the picture,[98] a reduced version of this work, recently acquired by the National Portrait Gallery, has been identified (cat. no. 100, fig. 40). Hayman's picture of the aftermath of Clive's victory at the Battle of Plassey on 23 June 1757 takes the viewer to the other extremes of the expanding British Empire and was a most suitable subject for its exotic setting at Vauxhall. Indeed, Hayman was among the first British artists to exploit Indian subject matter, a genre that which was to become increasingly popular towards the end of the century in the hands of artists who actually travelled to India such as Zoffany and Tilly Kettle.[99] Neither was the Clive picture Hayman's only effort in this direction for about the same time he painted a similar picture; *The Surrender of Pondicherry to Sir Eyre Coote* (cat. no. 50). This composition may have been intended as one of the four Vauxhall pictures – it has the same proportions – but was possibly rejected by Tyers either because a second Indian subject would have created an imbalance in the iconographical programme, or, more likely, because Pondicherry was eclipsed by more illustrious military victories in Canada. As it transpired, Coote was honoured in the last of the four large Vauxhall pictures, the military allegory *Britannia Distributing Laurels to The Victorious Generals*.

This last picture is the only one of the four of which no visual record survives and our knowledge of it derives exclusively from a lengthy descriptive account pub-

lished in June 1764, presumably soon after the picture was put on view.[100] It must have been designed to complement the other allegorical picture, *The Triumph of Britannia*, opposite which it hung. In this instance the subject matter concerned the military rather than the naval victories of the War. In *The Triumph of Britannia* the naval heroes were depicted as portrait medallions, but in *Britannia Distributing Laurels* the generals were apparently portrayed as full-length figures in 'Roman habits',[101] reflecting the change towards a more neo-classical taste.

We know that one of the Generals, the Marquis of Granby, sat for his portrait since the sitting resulted in one of the most amusing Hayman anecdotes,[102] and it seems highly probable that the other Generals (Monckton, Albemarle, Coote and Townshend) sat too. The portrait of the deceased General Wolfe was presumably copied from an existing likeness, although Hayman may have been able to seek the advice of Townshend, who was with Wolfe at Quebec and was himself an amateur artist. Townshend had in fact made a watercolour portrait drawing of Wolfe which he later presented to Isaac Barré, Wolfe's adjutant-general.[103]

Nothing comparable to Hayman's scheme had been undertaken in England since Laguerre had covered the hall and staircases at Marlborough House with episodes from the War of the Spanish Succession, half a century earlier. Laguerre's scheme by comparison lacked the originality of Hayman's for he had used as his models van der Meulen's paintings of the victories of Louis XIV. Furthermore, they were never seen by the public at large.[104]

Vauxhall Gardens' proprietor Jonathan Tyers, characteristically, did not await the cessation of hostilities before commissioning Hayman. Three of the four pictures

Fig. 40 Francis Hayman, *Lord Clive receiving the Homage of the Nabob*. London, National Portrait Gallery (CL. 100)

were on view before a large and enthusiastic audience well before that dramatically successful war was over. Tyers would no doubt have endorsed Edmund Burke's words that during these years of conflict commerce had been 'united with, and made to flourish with war'.[105] They were the first genuinely popular history paintings and the public was eager to welcome pictures glorifying their contemporary history in the same way that the theatre audiences welcomed a similarly jingoistic repertoire. Two of David Mallet's plays, *Britannia* and *Elvira* were, for instance, inspired by contemporary events. *Britannia*, a masque set to music by Thomas Arne, was first performed at Drury Lane on 9 May 1755.[106] With England on the brink of war it was specifically written to rouse the national spirit. *Elvira*, first performed at Drury Lane on 26 November 1762,[107] contained an attack on Lord Bute at the time he had negotiated a peace treaty with France that many politicians considered disadvantageous to British interests.[108] Dr John Brown's *Athelstan*, first performed in the year war broke out (1756), was described as 'an excellent warning to every insurgent' who might be tempted to aid the French in an invasion of England.[109] There are numerous other examples of authors and playwrights using episodes from England's historical and legendary past for drama in the mid-century.

Under Pitt's leadership the heroes of the classical past were replaced in the minds of the common people by Wolfe, Clive and Hawke,[110] and Hayman's pictures captured the public imagination at precisely the right moment. It should also be remembered that they could be seen almost a decade before Benjamin West completed his *Death of General Wolfe*, so often promoted as the exemplar of the modern history painting. Hayman's Vauxhall series received the sort of lavish praise which he rarely achieved at the public exhibitions. In 1765, soon after the last picture was complete, the Frenchman Pierre Grosley saw them and remarked: 'The national antipathy of the English . . . [towards the French] . . . seems to have raised the imagination and the hand of Mr Hayman, the painter, above what the pencil of an Englishman is capable of producing.'[111] When Sophie von la Roche saw them twenty years later she noted in her diary that they offered 'further insight into national character . . . and . . . spirit of patriotism.'[112]

It is perhaps not surprising that Hayman failed to exhibit at the Society of Artists exhibition in 1764 since the Vauxhall histories must have occupied all his energies for the previous three years. By way of compensation and to reflect his recent re-election to the Presidency of the Society of Artists, Hayman made the effort to exhibit three pictures at the exhibition in the Spring of 1765, including the lost *Sigismunda* (CL. 104).

The appearance of Hayman's *Sigismunda* was surely not a coincidence in view of Hogarth's death the previous October.[113] Hogarth's ill-fated picture of that subject, now in the Tate Gallery, was exhibited in 1761 and had been an obsessive concern of the artist. Hayman must have been aware of the agonies its production had caused Hogarth.[114] Apart from Walpole's comment scribbled in his exhibition catalogue describing all three Hayman exhibits as 'all execrable', not even a contemporary description of Hayman's *Sigismunda* survives, although if we are to believe the young James Barry, writing to Dr Sleigh at the time of the exhibition, it was as controversial as Hogarth's version. Wrote Barry 'Hayman has been torn to rags and the whole Society of Spring Garden, of which he is president, on account of a wretched picture of his the death of Sigismund.'[115]

Much more interesting, although again we have no idea of its appearance, was

Fig. 41 Nathaniel Dance, *Timon of Athens*. Canvas, 48 × 54 (121.9 × 137.2) Copyright reserved to Her Majesty Queen Elizabeth II

another of Hayman's 1765 exhibits, *Aeneas Carrying His Father Anchises* (CL. 105). Hayman can hardly have been unaware of the young Gavin Hamilton's *Andromache Weeping Over The Dead Body of Hector*, exhibited in 1762 and recently engraved by Cunego. At the exhibition in 1765 Hamilton showed, alongside Hayman's Homeric effort, his *Achilles lamenting the Death of Patroclus*, recently acquired by the National Gallery of Scotland, as well as a 'Head of Achilles . . . in crayons'. Hamilton's pictures were part of a series of six illustrations to Homer's *The Iliad* executed in Rome from before 1760 until 1775 or later.[116]

There is however no evidence to suggest that Hayman had in hand, or was planning an entire series of Homeric pictures to rival Hamilton's. The picture he exhibited at the special exhibition in 1768 for the King of Denmark[117] – *Aeneas Carrying His Father Anchises From The flaming Troy* – was almost certainly the picture shown in 1765.

Aeneas Carrying His Father Anchises was a final effort by Hayman to keep up with his younger rivals, Gavin Hamilton, Benjamin West and Nathaniel Dance. Although Dance's *The Death of Virginia*, exhibited in 1761, shows traces of Hayman's manner,[118] the younger artist could adapt to the prevailing neo-classical style with relative ease while Hayman still struggled to cast aside his habitual rococo mannerisms.

Dance returned to England from Italy in 1766 and was followed within weeks by Angelica Kauffman. Benjamin West, who arrived in August 1763, was already well established and was fêted by the leading artists.[119] One cannot help sensing that

71

Fig. 42 Francis Hayman, *Diana and Actaeon*. Sidney Sabin Collection (CL. 108)

Hayman's *Cymon and Iphigenia* (cat. no. 51), exhibited in 1767, was in some way a response to West's pictures of that subject exhibited in 1764 and 1766.[120] It is also tempting to connect the picture with Garrick's play *Cymon*, loosely based on Dryden's *Cymon and Iphigenia* which opened at Drury Lane on 30 December 1766 and proved sufficiently popular to sustain over thirty performances by the time the exhibition opened in May 1767.[121] However, Garrick's musical extravaganza was such a corrupt version of Boccaccio's tale that Iphigenia did not even appear and Hayman is unlikely to have been directly inspired by it.

Hayman's *Cymon and Iphigenia* is a lifeless and languid affair that deserves Walpole's comment 'very bad', written in the margin of his exhibition catalogue.[122] It is all too characteristic of his failing powers in the later 1760s. The increasingly broad, almost sketchy handling of the paint and the pronounced *sfumato* shadows that he uses are typical of these later works. In the company of Dance's *Timon of Athens* (fig. 41) at the same exhibition, the gap between the teacher and his rising pupil must have been painfully apparent.[123] Dance's Italianate style, seasoned with a dash of Batoni and Imperiali, highlights the feeble provinciality of Hayman's last works.

It is perhaps unfair to judge Hayman on the strength of his later exhibition pieces with which he felt obliged to live up to his long-standing reputation as a history painter. Those few that survive suggest that ill-health was beginning to take its toll on the quality as well as the quantity of his work. Although probably only a sketch for a large picture of the subject, Hayman's *Diana and Actaeon* (CL. 108, fig. 42), from

the late 1760s or after, is so coarsely conceived and executed that we must be thankful that not too many works of this kind survive.

Pierre Grosley, who left us his interesting comments on the London of the mid-1760s, thought that Hayman 'surpassed himself' in the four large histories for the Rotunda at Vauxhall but he considered that the three pictures at the Society of Artists exhibition of 1765 'can by no means come in competition with them'.[124] By 1767 a large amount of Hayman's time must, as President, have been given to the increasingly strained politics of the Society of Artists (see Chapter 1).

Hayman did exhibit at the first exhibition of the newly established Royal Academy, which opened on 26 April 1769. However, with his active career drawing to a close, his two exhibits, both scenes from *Don Quixote* (cat. nos. 44, 45), were a light-hearted antidote to the serious historical and biblical subjects that he had self-consciously exhibited since 1760. It is almost as if he had decided to revert to his former manner and abandon his challenge to the neo-classicists. These two pictures must have looked decidedly odd in the exhibition in the company of West's *Regulus departing from Rome* and the most self-conscious of Reynolds' didactic efforts, *Lady Blake as Juno* and *The Duchess of Manchester and Her Son*.[125] Hayman was content to accept the librarianship of the new Royal Academy and drift into a well-earned retirement.

NOTES

INTRODUCTION

1. See Nikolaus Pevsner, *Academies of Art Past and Present* (Cambridge, 1940).
2. See Lawrence Lipking, 'The Uncomplicated Richardson', Chapter Five in *The Ordering of the Arts in Eighteenth-Century England* (Princeton, 1970).
3. For the rise of the professional man see Geoffrey Holmes, *Augustan England Professions, State and Society 1680–1730* (London, 1982).
4. For Defoe's stratification of English Society in the early eighteenth century see Roy Porter, *English Society in the Eighteenth Century* (London, 1982), pp. 67–68.

Chapter 1 Biography

1. There is nothing to compare with the manuscript material which exists for Hayman's contemporary Arthur Pond. See Louise Lippincott, *Selling Art in Georgian England The Rise of Arthur Pond* (New Haven & London, 1983) The only serious work on Hayman to date is Deborah Lambert's 'The Career of Francis Hayman with Special Reference to his decorative work and History Paintings', unpublished M.A. Report, University of London (Courtauld Institute of Art) 1973 and my PhD thesis 'Francis Hayman and the English Rococo', University of London (Courtauld Institute of Art) 1984.
2. I have assembled many of these anecdotes as an appendix to my thesis, loc. cit., pp. 486–494.
3. See A. Rouquet, *The Present State of the Arts in England* (London, 1755), pp. 21–22, 26.
4. *The Autobiography and Correspondence of Mary Granville, Mrs Delany . . . &tc.*, ed. Lady Llanover, 3 vols., 1st series, (London, 1861), II, p. 505.
5. Edward Edwards, *Anecdotes of Painters . . . &tc.* (London, 1808), p. 51.
6. Edwards for instance (op. cit., 50) says that he was 'born in, or near Exeter'.
7. Horace Walpole, *Anecdotes of Painting in England . . . &tc.*, with additions by Rev. *James Dallaway*, 3 vols. (London, 1876), III, p. 324.
8. In a letter to Hanns Hammelmann dated 9 July 1954 the Exeter City Librarian wrote: 'after considerable search I can find no contemporary evidence to confirm that Hayman was an Exonian' (from the Hammelmann Papers in the Library of the Courtauld Institute of Art). A more recent search by the present owner has also proved fruitless.

9. See Lambert, loc. cit., 1 and *Devon and Cornwall Record Society*, 'Exeter Registers', vol. I – Exeter Cathedral; vol. II, All Hallows, Goldsmith Street, St. Pancras, St. Paul's. Transcribed and ed. by H. Tapley-Soper (Exeter, 1908–1929). Most of the references to Haymans in these registers are in the second half of the seventeenth century.
10. 'Exeter Registers', loc. cit., 'Ottery St. Mary'.
11. 'Index of Apprentices 1710–1762', vol. XIV, 7/13 in Guildhall Library, London.
12. Lambert, loc. cit., p. 2.
13. See Adrienne Corri, 'Gainsborough's early career; new documents and two portraits', *Burlington Magazine*, CXXV (April 1983) p. 213. Miss Corri has also discovered Hayman's account at Drummond's Bank.
14. See Ronald Paulson, *Hogarth, His Life, Art and Times*, 2 vols., (New Haven & London, 1971), I, pp. 356–59 and also W. Arnold, *The Life and Death of the Sublime Society of Beefsteaks* (London, 1871) p. xviii.
15. See for instance Ephraim Hardcastle [pseud. for W. H. Pyne], *Wine and Walnuts; or, After Dinner Chit-Chat*, 2 vols. (London, 1823) II, pp. 6–11, 37–39.
16. First suggested by John Nichols and George Steevens, *The Genuine Works of William Hogarth*, 3 vols. (London, 1808–1817) III, p. 241.
17. *The New Monthly Magazine or Universal Register*, VI (September 1816) p. 136.
18. 'Vertue Note Books III', *Walpole Society*, XXII (1933–4) 141–2.
19. Katherine Esdaile, *The Life and Works of Louis-François Roubiliac* (Oxford, 1928) p. 87. Mrs Esdaile gives as her source for this information an account by Flaxman in *The Artist; A Collection of Essays relating to Painting, Poetry, Sculpture . . . &tc.*, 2 vols. (London, 1810), I, no. XII, but there is no mention of Hayman in these essays.
20. 'Vertue Note Books III', op. cit., pp. 161–162.
21. According to W. H. Pyne [Ephraim Hardcastle], op. cit., II, p. 37.
22. 'Register of Baptisms and Marriages, Petersham Church'.
23. For Fleetwood see Philip Highfill, Kalman Burnim & Edward Langhans, *A Biographical Dictionary of Actors, Actresses, Musicians, Dancer, Managers & Other Stage Personnel in London 1660–1800*, vol. 5, (Carbondale, 1978) pp. 297–301.
24. *The New Monthly Magazine . . . &tc.*, op. cit., p. 136.
25. See *The Somerset House Gazette and Literary Museum; or Weekly Miscellany of Fine Arts, Antiquities and Literary Chit-*

Chat, ed. Ephraim Hardcastle [W. H. Pyne], I, (London, 1824) 92. By his will 20 July 1743 Charles Fleetwood left all his land, manors and other property in Chester, Stafford, Middlesex and Herts to his wife Susanna and his two sons Charles and Thomas, in trust to be sold to pay his mortgage (see Highfill, Burnim & Langhans, op. cit., 301).

26. Edward Croft-Murray noted that Hayman 'did not leave a will, but his "natural and lawful Daughter and only child" Susannah, granted administration of his "Assetts, Chattels and Credits" in August 1777' (from Croft-Murray's ms. notes, preparatory biographies of artists for the forthcoming section of the *Catalogue of Drawings by British Artists in the Department of Prints and Drawings at the British Museum*).

27. Edwards, op. cit., p. 52.

28. *Wine and Walnuts . . . &tc.*, op. cit., II, p. 37.

29. *The Diary of Joseph Farington*, ed. Kenneth Garlick and Angus Macintyre (New Haven & London, 1979), IV, 1558.

30. I have charted Hayman's involvement with the various artists' committees in my thesis, loc. cit., pp. 350–96.

31. 'Vertue Note Books III', p. 123.

32. Ibid., p. 76: 'this Winter 1735 an Academy for drawing from the Life sett up in St Martins lane where several artists go to Draw from the life. Mr Hogarth principally promotes it'.

33. For a contemporary account of the Academy's activities see Robert Campbell, *The London Tradesman . . . &tc. . . . being a Compendium of all the Trades, Professions, Art . . . now practised in the Cities of London & Westminster* (London, 1747) pp. 95–98.

34. What little is known about the St. Martin's Lane Academy is best outlined by Michael Kitson in his introduction to 'Hogarth's "Apology for Painters"', *Walpole Society*, XLI (1966–1968) 64 ff. and Ronald Paulson, op. cit., I, pp. 369–75, II, 137–44. The earliest list of its members, although not complete, appears in the list of subscribers prefacing the 1754 edition of Joshua Kirby's *Dr Brook Taylor's Method of Perspective Made Easy . . . &tc.* (Ipswich, 1754). A more extensive list, completed with the assistance of Hayman's pupil John Taylor, was published in *Wine and Walnuts . . . &tc.*, op. cit., I, pp. 177–204.

35. See A. Ellis, *The Penny Universities. A History of the Coffee Houses* (London, 1956) 150–153; Bryant Lillywhite, *London Coffee Houses. A Reference Book of Coffee Houses of the Seventeenth, Eighteenth and Nineteenth Centuries* (London, 1963) pp. 529–30. See also Smith, *Nollekens and his Times . . . &tc.*, op. cit., II, pp. 208–222.

36. Mark Girouard, 'Coffee at Slaughter's. English Art and the Rococo – I', *Country Life*, CXXXIX, (13 January 1966) 58–61; 'Hogarth and his Friends. English Art and the Rococo – II', *Country Life*, CXXXIX (27 January 1966) pp. 188–190 and 'The Two Worlds of St. Martin's Lane. English Art and the Rococo – III', *Country Life* CXXXIX (3 February 1966) pp. 224–227.

37. See Paulson, op. cit., II, p. 286.

38. Also printed in *The London Daily Advertiser*, 23 October 1753.

39. Edwards, op. cit., p. xxiii.

40. See F. G. Stephens, *Catalogue of Prints and Drawings in the British Museum, Division I, Political and Personal Satires (No. 2016–3116, vol. III, Part I – March 28, 1734 to c. 1750* (London, 1877) pp. 924–25, no. 3278.

41. Hayman was elected a Fellow of the Society of Arts, Manufactures and Commerce on 13 April 1757, 'proposed by Mr Rogers', probably George Rogers, Jonathan Tyers's son-in-law (see cat. no. 25). See the Society of Arts 'Subscription Book' in the Library of the Royal Society of Arts.

42. For negotiations with the Dilettanti Society see Lionel Cust, *The History of the Dilettanti Society* (London, 1898) 52–56.

43. See *The Royal Magazine*, I (November 1759) p. 265. The activities of the artists, commencing with the meeting of 12 November 1759, are documented by the 'Minutes of the General Committee Meetings of the Artists and of the Committee for Managing the Public Exhibition', which form part of the 'Society of Artists Papers', now in the Library of the Royal Academy of Arts [SA/1]. The minutes from 12 November 1759 to 31 July 1761 were published (with notable omissions) by the *Walpole Society*, VI (1917–18) pp. 113–130.

44. See Paulson, op. cit., II, pp. 345–353.

45. Ibid., II, p. 350. See also Robert Folkenflik, 'Samuel Johnson and Art' in *Samuel Johnson: Pictures and Words* by Paul Alkon and Robert Folkenflik (William Andrews Clark Memorial Library, University of California at Los Angeles, 1984) pp. 81–82.

46. The date of Hayman's election is given by W. T. Whitley, *Artists and their Friends in England 1700–1799*, 2 vols. (London, 1928) I, 203. Whitley's source for this information is not clear since the Minutes of the Society of Artists between 19 November 1764 and 11 March 1765 are destroyed.

47. See Anon. [William Thompson], *The Conduct of the Royal Academicians . . . &tc.*, (London, 1771) pp. 12–13.

48. 'Memoirs of Thomas Jones', ed. A. P. Oppé, *Walpole Society*, XXXII (1946–8) pp. 13–14.

49. See Robert Strange, *An Enquiry into the Rise and Establishment of the Royal Academy of Arts . . . &tc.* (London, 1775) 90.

50. For details see John Pye, *Patronage of British Art, an Historical Sketch* (London, 1845) 129–30 and Whitley. op. cit., I, p. 224.

51. The original letter is in the Society of Artists papers in the Library of the Royal Academy of Arts [SA/34/3].

52. See John Galt, *The Life, Studies and Works of Benjamin West*, 2 parts (London, 1816–20), II, p. 36.

53. Royal Academy of Arts, Instrument of Foundation, Clause IX (see Sidney Hutchison, *The History of the Royal Academy 1768–1968* (London, 1968) p. 211.

54. The Visitors were paid 'out of the Treasury ten shillings and sixpence for each time of attendance, which shall be at least two hours, and shall be subject to a fine of ten shillings and sixpence whenever they neglect to attend, unless they appoint a proxy from amongst the Visitors for the time being, in which case he shall be entitled to the reward' (Instrument of Foundation, Clause IX).

55. This letter has been transcribed from ms. notes by W. T. Whitley relating to the Royal Academy which forms part of the 'Whitley Papers', in the Dept. Prints & Drawings,

British Museum. Whitley gives his source as 'Platt's Turner BM v. 6'. I have been unable to find this publication.

56. Royal Academy of Arts, 'General Assembly Minutes', vol. 1, 1 October 1770 (Library, Royal Academy of Arts).

57. The catalogue of the Society of Artists exhibition of 1765 gives his address as St. Martin's Lane but by 1767 he is listed as resident in Dean Street, Soho.

58. The picture sale was originally scheduled for 23 May 1776 but was postponed before that date. I am most grateful to Mrs Clare Lloyd-Jacob for providing me with these references.

CHAPTER 2 THE THEATRE

1. See Edward Croft-Murray, *Decorative Painting in England 1537–1837*, 2 vols. (London, 1962 & 1970).

2. For earlier work by Inigo Jones and Thornhill see Stephen Orgel and Roy Strong, *The Theatre of the Stuart Court*, 2 vols. (London, 1973) and Graham Barlow, 'Sir James Thornhill and the Theatre Royal, Drury Lane, 1705', in *Essays on the Eighteenth Century Stage. The Proceedings of a Symposium sponsored by the Manchester University Department of Drama*, ed. K. Richards and P. Thomson (London, 1972) pp. 179–193.

3. For Lambert's activities as a scene painter see Elizabeth Einberg, *George Lambert 1700–1765*, The Iveagh Bequest, Kenwood (1970) pp. 6–7.

4. Sybil Rosenfeld, *A Short History of Scene Design in Great Britain*, (Oxford, 1973) 62 and the same author's *Georgian Scene Painters and Scene Painting* (Cambridge, 1981).

5. See *The London Stage 1660–1800, Part 3: 1729–1747*, ed. Arthur Scouten, 2 vols. (Carbondale, 1961), I, pp. v–vii.

6. For Giffard see Highfill, Burnim and Langhans, op. cit., IV, 186–195.

7. Edward Shepherd (d. 1747) is best known as the proprietor of Shepherd's Market and other buildings in Mayfair. See Howard Colvin, *A Biographical Dictionary of British Architects 1600–1840*, rev. ed. (London, 1978) pp. 731–32.

8. *The London Stage, Part 3*, op. cit., I. xxii. For a history of the theatre see ibid. xxiii–xxvii; F. T. Wood, 'Goodman's Fields Theatre', *The Modern Language Review*, XXV (1930) pp. 443–456; Sybil Rosenfeld, 'Theatres in Goodman's Fields', *Theatre Notebook*, I, no. 4 (July 1946) 48–50; R. Eddison, 'Capon and Goodman's Fields', *Theatre Notebook*, XIV, no. 4 (Summer 1960) pp. 127–132 and L. Kennedy-Skipton, 'Notes on a copy of William Capon's Plan of Goodman's Fields Theatre, 1786 and 1802, and on a copy of one of the ceiling paintings, in the Folger Shakespeare Library', *Theatre Notebook*, XVII, no. 3 (Spring 1963) pp. 86–89.

9. J. P. Malcolm, *Anecdotes of the Manners and Customs of London during the Eighteenth Century* (London, 1808) p. 348.

10. E. W. Brayley, *Historical and Descriptive Accounts of the Theatres of London* (London, 1826) p. 77. For Oram see Sybil Rosenfeld and Edward Croft-Murray, 'A Checklist of Scene Painters working in Great Britain and Ireland in the 18th Century', *Theatre Notebook*, XIX, no. 4 (Summer 1965) p. 139.

11. A version of this subject by Amigoni was recently sold at Christies, 30 Nov. 1983 (28).

12. *The Daily Journal*, 16 September 1732.

13. The Covent Garden Theatre opened with a performance of Congreve's *The Way of the World* (see *The London Stage, Part 3*, I, pp. 253–54).

14. *The London Stage Part 3*, op. cit., p. 367.

15. E. Eddison, loc. cit., p. 127.

16. 'The Enthoven Collection of Theatrical Cuttings', National Art Library, Victoria & Albert Museum.

17. See W. Nicholson, *The Struggle for a Free Stage in London* (Boston, 1906) and John Loftis, *The Politics of Drama in Augustan England* (Oxford, 1963).

18. It finally closed on 27 May 1742 (see F.T. Wood, loc. cit.).

19. *The London Stage Part 3*, op. cit. p. xciii.

20. Ibid., p. 556.

21. Pellegrini, for instance, had painted a *Fall of Phaeton* (now destroyed) in the cupola of the Hall at Castle Howard (see Croft-Murray, *Decorative Painting in England . . . &tc.*, II, p. 254.

22. *The London Daily Post and General Advertiser*, 22 May 1736.

23. Illustrated by Edward Croft-Murray in 'John Devoto. A Baroque Scene Painter', *Society for Theatre Research*, Pamphlet series no. 2 (1953).

24. An album containing 91 drawings for stage scenery and decorative paintings (B.M. 1891–6–27–1).

25. For a list of Devoto's known drawings see Croft-Murray, loc. cit.

26. Ibid., p. 8.

27. 'Vertue Note Books III', op. cit., p. 126.

28. *Harleian Miscellany*, V, 544. The Miscellany was a reprint of a selection of tracts from the library of Edward Harley, Second Earl of Oxford, edited by his secretary, William Oldys and Samuel Johnson. They were published between 1744 and 1746 by Thomas Osborne.

29. There is a version in the National Portrait Gallery (NPG 752). See David Piper, *Catalogue of Seventeenth-Century Portraits in the National Portrait Gallery 1625–1714* (Cambridge, 1963) pp. 27–28, repr. pl. 21i.

30. See John Woodward, *Tudor and Stuart Drawings* (London, 1951), no. 53.

31. Piper, op. cit., p. 199, repr. pl. 21h.

32. C. K. Adams, *A Catalogue of Pictures in the Garrick Club* (London, 1936), p. 4, no. 11.

33. For Grisoni as a portrait painter see John Woodward, 'A Portrait by Grisoni', *Burlington Magazine*, CII (1960) p. 71.

34. See A. Heppner, 'The Popular Theatre of the Rederijkers in the Works of Jan Steen and his Contemporaries', *Journal of the Warburg and Courtauld Institutes*, III (1939–40) pp. 22–48. The tradition of theatrical painting continued in Holland in the eighteenth century (see J. W. Niemeijer, 'Pictures and Plays – Painters and the Stage in Eighteenth-century Holland', *Apollo*, CX (December 1979) pp. 507–512).

35. See Paulson, op. cit., I, pp. 182–90.

36. See B. Rogerson, 'The Art of Painting the Passions', *Journal of the History of Ideas*, XIV, no. 1 (January 1953) p. 78. See also Dolores B. Yonker, 'The Face as an Element of Style: Physiognomical Theory in Eighteenth-Century British Art', unpublished PhD dissertation, University of California (1969).

37. Antoine Coypel, *Discours prononcez dans les conferences de*

l'Académie royal de Peinture et sculpture (Paris, 1721) p. 167.

38. Jonathan Richardson, *An Essay on the Theory of Painting*, 2nd edition (London, 1725) p. 4.

39. 'Vertue Note Books III', op. cit., p. 126.

40. For contemporary comments on the Shakespeare pictures see the anonymous *A Description of Vauxhall Gardens* (London, 1762), pp. 11, 19.

41. Paulson, op. cit., I, 388, pl. 144.

42. See Robin Simon, 'Hogarth's Shakespeare', *Apollo*, CIX (March 1979) pp. 213–220.

43. See T. S. R. Boase, 'Illustrations of Shakespeare's Plays in the Seventeenth and Eighteenth Centuries', *Journal of the Warburg Courtauld Institutes*, X (1947) pp. 83–108 and Moelwyn Merchant, *Shakespeare and the Artist* (Oxford, 1959).

44. For Rowe's edition of Shakespeare see Hanns Hammelmann, 'Shakespeare's First Illustrators', *Notes on British Art – II*, supplement to *Apollo*, LXXXVIII (August 1968) pp. 1–4.

45. For Theobald's edition see Hanns Hammelmann, 'Shakespeare Illustration: The earliest known originals', *Connoisseur*, CXLI (April 1958) pp. 144–159.

46. For those in the Huntington Library see Robert R. Wark, *Drawings for the Turner Shakespeare* (Los Angeles, 1973).

47. See Arthur Scouten, 'The Increase in Popularity of Shakespeare's Plays in the Eighteenth Century: a *Caveat* for Interpretors of Stage History', *Shakespeare Quarterly*, VII (Spring 1956) p. 197. Also J. Lynch, *Box, Pit and Gallery, Stage and Society in Johnson's London* (Berkeley & Los Angeles, 1953) esp. Chapter 6 'The Shakespeare Revival'.

48. The original is in the Folger Shakespeare Library, Washington D.C. and was first published by Kalman Burnim in 'The Significance of Garrick's Letters to Hayman', *Shakespeare Quarterly*, IX (Spring 1958) pp. 149–152. See also *The Letters of David Garrick*, ed. D. M. Little & G. M. Kahrl, 3 vols. (London, 1963), I, pp. 52–55, no. 33. The dating of the letter has been deduced by Little & Kahrl from a progression of cross-references. The allusion to the Jacobite Rebellion provides the year, and that to Dr Newton the month and day following the preceding letter.

49. Hayman evidently did not reply to Garrick for in a letter to Somerset Draper, written from Dublin a few weeks later (dated 1 December 1745), Garrick asks tersely, 'Where is Hayman? he has used me ill and never answered my letter' (Little & Kahrl, op. cit., I, pp. 68–71, no. 40).

50. Kalman Burnim, *David Garrick Director* (Pittsburgh, 1961) p. 143 and *The London Stage Part 3*, II, op. cit. p. 974.

51. Charles Macklin always claimed that this device was used by Garrick to gain advantage over his great rival, Spranger Barry, who was too large to be carried off-stage with the same ease (see J. T. Kirkman, *Memoirs of the Life of Charles Macklin*, 2 vols. (London, 1799), II, p. 261).

52. See George Stone, 'Garrick's Production of King Lear', *Studies in Philology*, XLV (January 1948) pp. 89–103.

53. Ms. catalogue of Cox Macro's paintings (Castle Museum, Norwich) n.d. In an earlier ms. catalogue (also at Norwich) the picture was called 'King Lear near Mad Tom's Hovel a Doorpiece Hayman'. Another overdoor painted by Hayman at Little Haugh had as its subject a scene from *Timon of Athens* (CL. 126)

54. The original is in the Folger Shakespeare Library, Washington D.C. Case II, folder 6,746 (see Little & Kahrl, op. cit., I, pp. 81–3, no. 47).

55. By the time of writing to Hayman, Garrick had played the part for last time at Covent Garden on 20 June 1746 (see *The London Stage Part 3*, II, op. cit., p. 1243).

56. For the theory of acting in the eighteenth century see G. Taylor, '"The Just Delineation of the Passions": Theories of Acting in the Age of Garrick', in *Essays on the Eighteenth-Century English Stage*, op. cit., pp. 51–52.

57. Hill to Garrick, 3 August 1749 (see Aaron Hill, *The Works of Aaron Hill*, 4 vols. (London, 1753) II, 378 ff.)

58. Garrick's prints were sold by Christie's on 5 May 1825 (Lugt 10887).

59. Freeman O'Donoghue's *Catalogue of Engraved British Portraits . . . in the Department of Prints and Drawings in the British Museum*, 4 vols. (London, 1908–25), II, pp. 276–286 lists 176 prints of Garrick: 80 in private dress and 96 in character. The runner-up with 162 entries, is King George III. For a Garrick iconography see Martyn Anglesea, 'David Garrick and the Visual Arts', unpublished M.A. Thesis, University of Edinburgh (1971). A long list of portraits is also appended to the entry on Garrick in Highfill, Burnim & Langhans, op. cit., VI, pp. 1–116.

60. *The London Stage Part 3*, p. 1287.
Benjamin Hoadly was very much a part of the Hogarth/Garrick/Hayman clique. His special expertise in medicine – in 1736 he had become a Fellow of the Royal College of Physicians – was centred on the organs of respiration and circulation and he was to assist Hogarth, especially in his use of medical terminology, in correcting a draft of *The Analysis of Beauty*. Hogarth had already painted his portrait twice; and his namesake father, the Bishop of Winchester, and his brother, the dramatist and clergyman Dr John Hoadly, had also both sat to him for their portraits. Hayman also painted members of the family: *Dr Benjamin Hoadly and His Wife*, now in the Wellcome Institute of the History of Medicine (CL. 28), was probably painted about the same date as the *Scene from 'The Suspicious Husband'*, and a double portrait of *Dr John Hoadly and Dr Maurice Greene*, the composer, is also from these years (cat. no. 17).

61. *The London Stage Part 3*, p. 935.

62. From an anonymous review of Northcote's *Life of Reynolds* in *The European Magazine*, LXIV (November 1813) p. 415.

63. Hogarth's drawing (in The Royal Library, Windsor Castle) is reproduced in A. P. Oppé, *The Drawings of William Hogarth* (London, 1948), pl. 21.

64. *The London Stage Part 3*, cxxx, p. 1034.

65. The Account Books for Covent Garden Theatre are incomplete for the period, but between Friday, 3 October 1746, and 2 January 1747 'Hayman' was paid a regular weekly sum, varying from 6/8d to £1 for unspecified work. 'Hayman' is listed alongside the actors and no reference is made to scene painting ('Accounts of Covent Garden Theatre', vol. III, September 1746 – December 1747, British Museum, Dept. Manuscripts, Egerton Ms. 2268)

CHAPTER 3 PORTRAITURE

1. 'Vertue Note Books III', p. 117.
2. Robert Campbell, *The London Tradesman . . . &tc.*, op. cit., p. 97.
3. Horace Walpole, *Anecdotes of Painting . . . &tc.*, op. cit., II, p. 325.
4. Paulson, op. cit., II, pp. 385–90.
5. Charles Churchill, *Gotham*, Book 1, Lines 367–376. See *The Poetical Works of Charles Churchill*, ed. D. Grant (Oxford, 1956) pp. 302–3. Churchill's use of the term 'mannerist' is no doubt consistent with Dryden's usage of it in his translation of Du Fresnoy's *De Aret Graphica* of 1695: 'Those [Painters] whom we call Mannerists, and who repeat five or six times over in the same Picture the same Hairs of a Head (Dryden [trans.], Du Fresnoy, *The Art of Painting* [1695] p. 151).
6. Sir James Prior, *Life of Edmond Malone . . . with selections from his Manuscript Anecdotes* (London, 1860) p. 406.
7. The best recent study of the conversation piece is Ellen D'Oench's *The Conversation Piece: Arthur Devis & His Contemporaries*, Yale Center for British Art (New Haven, 1980).
8. See David Piper, *The English Face*, rev. ed. (London 1978), esp. Chaps. 5 & 6; also J. Douglas Stewart, 'Pin ups or Virtues, the Concept of the "Beauties" in late Stuart Portraiture' in *English Portraits of the Seventeenth and Eighteenth Centuries* (William Andrews Clark Memorial Library, University of California at Los Angeles, 1974) pp. 3–43.
9. See John Ruch, 'A Hayman Portrait of Jonathan Tyers's Family', *Burlington Magazine*, CXII (August 1970) pp. 495–97.
10. For Gravelot see V. Lauckoronoska, 'Gravelot in London', *Philobiblion*, X (1938) pp. 97–113; Yves Bruand, 'Hubert Gravelot et l'Angleterre . . . &tc.', *Gazette des Beaux-Arts*, LV (1960) pp. 35–44; Hanns Hammelmann, *Book Illustrators in Eighteenth Century England* (New Haven & London, 1975) pp. 38–46 and Victoria & Albert Museum, *Rococo, Art & Design in Hogarth's England* (1984).
11. 'Public Address', see *William Blake's Writings*, ed. G. E. Bentley Jr., 2 vols. (Oxford, 1978) II, p. 1038.
12. 'At the Sign of the Pestle and Mortar' (see Whitley, op. cit., I, 94).
13. Edmond & Jules de Goncourt, 'Gravelot', *Gazette des Beaux-Arts*, XXIV (1868) pp. 152–168. This essay was reprinted in the Goncourts' *L'Art du Dix-Huitième Siecle* (Paris, 1874) pp. 3–42.
14. See Brian Allen, 'Watteau and his Imitators in Mid-Eighteenth Century England', *Colloque Watteau* (Paris, 1987) pp. 259–267.
15. George Rogers of Southampton is probably identical with the amateur landscape painter who exhibited at the Society of Artists in 1761 and 1762.
16. See D'Oench, *The Conversation Piece . . . &tc.*, op. cit., p. 60, cat. 31, repr. in colour.
17. John Chaloner Smith, *British Mezzotinto Portraits . . . being a descriptive catalogue of these engravings . . . &tc.* (London, 1883) I, pp. 409–410.
18. When it was sold by Christie's on 31 May 1946 (lot 43).
19. 'Vertue Note Books III', op. cit., p. 82.

20. See John Ingamells and Robert Raines, 'A Catalogue of the Paintings, Drawings and Etchings of Philip Mercier', *Walpole Society*, XLVI (1976–78) p. 46, cat. 178–184 inc.
21. See the frontispiece to *A NEW-BOOK of Figures from BOUCHER* (London, Robert Sayer, 1753).
22. Paulson, op cit., I, p. 430 and *The Suffolk Collection Catalogue of Paintings* (1975) no. 33, repr.
23. Dated by Ellen D'Oench to *c.* 1744–6 (op. cit., p. 48, cat. 12).
24. 'Vertue Note Books III', op. cit., pp. 123, 127.
25. Smith, *Nollekens . . . &tc.*, op. cit., II, p. 86.
26. 'Vertue Note Books III', op. cit., p. 149.
27. The best discussion of the lay-figure is found in Ellen D'Oench, op. cit., pp. 13–14 and Museum of London, *The Quiet Conquest: The Huguenots* (1985), cat. no. 83.
28. Brian Allen, 'Jonathan Tyers's Other Garden', *Journal of Garden History*, I, no. 3 (July–September 1981) esp. pp. 228–232.
29. Robert Campbell, op. cit., p. 139.
30. For an account of Guelfi's works see Margaret Webb, 'Giovanni Battista Guelfi: an Italian Sculptor working in England', *Burlington Magazine*, XCVII (1955) pp. 139–145, 260.
31. 'Vertue Note Boots III', op. cit., p. 56.
32. Ibid., p. 84.
33. Ibid., p. 85.
34. Quoted by Whitley, op. cit., I, p. 219.
35. W. G. Constable, *Richard Wilson* (London, 1953) p. 117. The notion that Hayman collaborated with Wilson seems to have its origin with Wilson's nineteenth-century biographer Thomas Wright, who stated that 'On various occasions, Wilson did not scruple to take advantage of the talents of Mortimer, and, sometimes, of Hayman, for the introduction of his figures'. See *Some Account of the Life of Richard Wilson Esq., R. A., Collected and Arranged by T. Wright Esq.* (London, 1824) p. 20.
36. See Constable, op. cit., pp. 166–67, pls. 25b, 26a and 26b. See also Robin Simon, 'New Light on Richard Wilson', *Burlington Magazine*, CXXI (July 1979) pp. 437–39.
37. See John Harris, *The Artist and the Country House – A History of Country House and Garden View Painting 1540–1870*, (London, 1979), p. 240. Mark Girouard had previously suggested an attribution to the 'School of Wootton' (*Country Life*, XXXV (2 January 1964) p. 200).
38. See R. St. John Gore in National Gallery of Art, Washington, D.C., *The Treasure Houses of Britain: Five Hundred Years of Private Patronage and Art Collecting* (New Haven & London, 1985) p. 244, cat. no. 165.
39. See R. W. Symonds, 'Three London Craftsmen', *Connoisseur*, CI (April 1938) pp. 189–190.
40. See Little & Kahrl. op. cit., I, pp. 81–83, no. 47
41. Edward Edwards, op. cit., p. 130 and note. Edwards amended his comments in a footnote, where he noted that 'Mr Gainsborough received his first instructions on the rudiments of art from Mr Gravelot'.
42. See Lawrence Gowing, 'Hogarth, Hayman and the Vauxhall Decorations', *Burlington Magazine*. XCV (January 1953).
43. See John Hayes, *The Landscape Paintings of Thomas Gainsborough*, 2 vols. (London, 1982) I, p. 34.
44. Ellis K. Waterhouse, *Gainsborough* (London, 1958) p. 98

no. 747, repr. pl. 19.

45. *The Diary of Joseph Farington*, ed. Kathryn Cave, IX (New Haven & London, 1982) p. 3192.

46. G. W. Fulcher, *Life of Thomas Gainsborough R. A.*, (1856) p. 174. The two landscapes in question are Hayes, op. cit., pp. 405–6, cat. 68 and 417–19, cat. 79.

47. See Emile Dacier & Albert Vuaflart, *Jean de Jullienne et les Graveurs de Watteau au XVIIIe Siécle*, 4 vols. (Paris, 1921–9) III, cat. 269 and IV, pl. 269. For a discussion of the use of this pose in the work of Watteau and Lancret see Jean Cailleux, 'L'Art du Dix-Huitieme Siécle – Invalids, Huntsmen and Squires', *Burlington Magazine* (advertisement supplement) CVI (February 1964) pp. i–iii.

48. Hayman uses it again for the seated figure of Dr Askew in the engraved title-vignette for *Poetic Essays, on nature, men and morals* published in 1750 (see CL. 283).

49. Hayes, op. cit., I, p. 36.

50. See Judy Egerton, 'Four Shooting Paintings by George Stubbs' in *Essays in Honor of Paul Mellon Collector and Benefactor* (Washington, D.C., National Gallery of Art, 1986) repr. p. 90.

51. See Brian Allen, 'Joseph Wilton, Francis Hayman and the Chimneypieces from Northumberland House', *Burlington Magazine*, CXXV (April 1983) pp. 195–202.

52. Quoted in Little & Kahrl, op. cit., III, pp. 1128–129. 'young Bunbury' is the caricaturist Henry William Bunbury (1750–1811) who enjoyed great celebrity from the 1770s (see John Riley, 'Henry William Bunbury: The Amateur as Caricaturist' in *Henry William Bunbury 1750–1811* Sudbury, Gainsborough's House (1983).)

CHAPTER 4 HISTORY PAINTING

1. Edwards, op. cit., p.51.

2. Rouquet, op. cit., p. 21–22.

3. Lambert, loc. cit., p. 2. Samuel Redgrave, *A Dictionary of Artists of the English School*, 2nd edition (London, 1878) p. 59, states that he was born in London.

4. 'Vertue Note Books II', *Walpole Society*, XX (1931–2) p. 126.

5. Walpole, op. cit., II, p. 283.

6. See Croft-Murray, *Decorative Painting . . . &tc.*, op. cit., II, p. 322 for a description.

7. Ibid., I, 264.

8. Walpole, op. cit., II, p. 283.

9. Ibid.

10. 'Christ's Hospital Court Book', 18 January 1749 (see Croft-Murray I, p. 264).

11. *The European Magazine and London Review*, LV (Jan-June 1809) p. 443.

12. 'Literary Correspondence of Rev. Cox Macro D.D.', vol. II, 1741–1764. Lord Radnor to Cox Macro 12 July [1743]. B.M. Add. ms. 32557 f. 19.

13. Croft-Murray II, pp. 37, 220.

14. Hilda Finberg, 'Radnor House, Twickenham: A Drawing by Samuel Scott', *Burlington Magazine*, LXXI (October 1937) pp. 168–171.

15. John Cornforth, 'Yotes Court, Kent – II', *Country Life*, CXXXVI (25 June 1964) p. 1649.

16. See Norman Scarfe, 'Little Haugh Hall, Suffolk', *Country Life*, CXXIX (5 June 1958) pp. 1238–1241.

17. Although the letter is not dated by year it can be safely assumed that it was written in 1743, and not 1741 as several scholars have suggested. The confusion arises because the Macro correspondence is not bound consecutively as has been assumed. Each of the letters quoted here has a number added by Macro himself which enables us to deduce the correct order. Lord Radnor's and Hayman's letters (nos. 162 and 164 respectively) should precede Heins's dated letter.

18. 'Literary Correspondence of Rev. Cox Macro D.D. . . . &tc.', loc. cit., p. f. 19.

19. Ibid., p. 21–22.

20. For Heins see Trevor Fawcett, 'Eighteenth-Century Art in Norwich', *Walpole Society*, XVLI (1976–78) pp. 72–75.

21. 'Literary Correspondence of Rev. Cox Macro . . . &tc.', loc. cit., f. 57.

22. Payment is recorded in Cox Macro's 'Diary of Purchases' (Bodleian Library, University of Oxford, English Miscellany e. 346 f. 261).

23. In a manuscript catalogue of Cox Macro's paintings (in his own hand), compiled after 1734 (in the Castle Museum, Norwich). See Robert Raines, 'An Art Collector of Many Parts', *Country Life*, CLVII (24 June 1976) pp. 1692–4. Another painting entitled *Archimedes Court* by Thomas Ross was an overmantel in the Green Bedchamber at Little Haugh. This is recorded in another ms. catalogue of Macro's collections (also in the Castle Museum, Norwich) not in Macro's hand and compiled later than the one mentioned above.

24. 'A List of Curiosities in (my Uncle) the rev'd Doctor Cox Macro Possession of Norton, near St. Edmunds Bury, in Ye County of Suffolk 1766', B. M. Add. ms. 25473 f. 29.

25. Croft-Murray II, 261b.

26. In the ms. cat. referred to in n. 32 above Macro records ownership of the terracotta models for the figures of *Clio* and *History*, used by Rysbrack for the monument to Matthew Prior in Westminster Abbey of 1723.

27. Photograph in Archives of the National Portrait Gallery.

28. Lambert, loc. cit., p. 36.

29. See J. Charlton, *The Banqueting House, Whitehall* (London, 1964) p. 66.

30. Walpole, op. cit., p. 325.

31. For Ross see Croft-Murray II, pp. 271–72.

32. Macro records in his ms. catalogue (loc. cit.) 'Staircase "The History of Archimedes" T. Ross & Hayman, with a figure or two by P. Tillemans. The Ceiling entirely by Hayman'.

33. 'A List of Curiosities . . . &tc.', loc. cit., f. 29.

34. The staircases canvases were in such a state of disrepair that they were removed during comparatively recent redecorations; see Scarfe, loc. cit., p. 1240.

35. 'ms. catalogue', loc. cit.

36. Signed and dated 1745, see Waterhouse, *Gainsborough*, op. cit., p. 106, no. 817, pl. 5.

37. See David Owen, *English Philanthropy* (Cambridge, Mass., 1965) p. 53; W. H. McMenemy, 'The Hospital Movement of the Eighteenth Century and its Development' in *The Evolution of Hospitals in Britain*, ed. F. N. L. Poynter (London, 1964) pp. 43–71. For the Foundling Hospital in particular see R. H. Nichols & F. A. Wray,

The History of the Foundling Hospital (London, 1935) and Ruth McClure, *Coram's Children: The London Foundling Hospital in the Eighteenth Century* (New Haven & London 1981).

38. For the architectural history of the hospital, which was demolished in 1928 see *The Architectural Review*, LVIII (1925) pp. 127–132 and *The Survey of London*, XXIV (London, 1952) pp. 10–24, pls. 11–41.

39. Paulson, op. cit., II, p. 37.

40. Rouquet, op. cit., p. 24.

41. 'Vertue Note Books III', op. cit., p. 134.

42. Ibid., p. 135.

43. All these works of art are reproduced in Benedict Nicolson, *The Treasures of the Foundling Hospital* (Oxford, 1972).

44. See John Brownlow, *Memoranda: or, Chronicles of the Foundling Hospital . . . &tc.* (London, 1847) p. 15.

45. John Brownlow, *The History and Design of the Foundling Hospital with a Memoir of the Founder* (London, 1858) pp. 20–21.

46. 'Vertue Note Books III', op. cit., p. 135.

47. Highmore also painted at some point before 1762 a version of *The Finding of Moses*, see Alison Lewis, 'Joseph Highmore: 1692–1780', unpublished PhD dissertation (Harvard University, 1975) p. 592, no. 96.

48. For Paine see Peter Leach, 'The Life and Works of James Paine', unpublished D. Phil thesis (Oxford University, 1975).

49. See Colvin, op. cit., pp. 565–66.

50. See Peter Leach, 'Doncaster Mansion House, Yorkshire', *Country Life*, CLIX (6 July 1978) pp. 18–21.

51. For Paine's work at Cusworth see Leach, 'The Life and Works of James Paine', loc. cit., pp. 260, 262, n. 7. For George Platt see Colvin, op. cit., p. 640.

52. Romney Sedgwick, *The History of Parliament – The House of Commons 1715–1754*, 2 vols. (London, 1970) II, p. 559.

53. For Rose see Geoffrey Beard, 'The Rose Family of Plasterers', *Apollo*, LXXXV (April 1967) pp. 266–277 and the same author's *Decorative Plasterwork in Great Britain* (London, 1975) p. 237.

54. The altarpiece was removed c.1957 to St. Hubert's Church, Cusworth Village, and was acquired by the Yale Center for British Art at Sotheby's in 1977 (see cat. no. 47).

55. See Paulson, op. cit., I, pp. 382–87, pls. 141, 143.

56. Repr. in colour in *Watteau 1684–1721*, Galeries du Grand Palais (Paris, 1984) p. 430, no. 69.

57. Wale's decorative work is discussed in my thesis, loc. cit., pp. 114–19.

58. The author had earlier quoted a letter from Voltaire to Masser – the author of an Italian tragedy similar to Voltaire's *Merope* – in which he stated that despite English writers and poets and the stage, the Fine Arts were in an unhappy state.

59. *The Gray's Inn Journal*, no. 20 (Saturday 9 February 1754) pp. 116–17.

60. T. B., *A Call to the Connoisseurs, or Decisions of Sense with Respect to the Present State of Painting & Sculpture & Their Several Professors . . . &tc.*, (London, 1761) pp. 37–38. There is a copy in the library of the V & A (press mark 41.E.3). It has been suggested that the author may have been the painter Thomas Bardwell (see J. Dobai, *Die Kunstliteratur des Klassizismus und der Romantik in England*, 4 vols. (Bern, 1974–85) II, pp. 1124–5) For another brief reference to Hayman's prowess as a history painter see Samuel Boyce's poem *The Progress of the Sister Arts* (1757), reprinted in *The London Magazine*, XXVI (November 1757) pp. 558–59.

61. The letter is in Sir John Soane's Museum among the George Dance drawings (Slider no. 2, set 13) See David Goodreau, 'Nathaniel Dance: An Unpublished Letter', *Burlington Magazine*, CXIV (October 1972) pp. 712–15 and the same author's 'Pictorial Sources of the Neoclassical Style: London or Rome?' in *Studies in Eighteenth-Century Culture*, ed. Harold Pagliaro, IV (1975) pp. 247–70.

62. The last scheme on which they worked together was at Hardwicke Park, near Sedgefield, Co. Durham (CL. 91).

63. Croft-Murray II, p. 195.

64. See Mary Webster, *Francis Wheatley* (London, 1970) pp. 8–9, 118, repr. fig. 9.

65. A translation of a letter from an Italian dated 'London March 1762' appeared in *The Gentleman's Magazine*, XXXI (March 1962).

66. The Hon. W. T. Kenyon, *Malpas, Parish Town and Church. A Paper by the Rector of Malpas* (Chester, 1895) p. 9. The author suggested that the picture hung formerly at Hampton Hall in Shropshire.

67. A detailed Jennens genealogy is provided in John Nichols, *The History and Antiquities of the County of Leicester*, 4 vols. (London, 1811), IV, p. 857.

68. See Lewis Namier and John Brooke, *The History of Parliament – The House of Commons 1754–1790*, 3 vols. (London, 1964) II, p. 288.

69. No precise details or catalogue survive from the Hanmer/Iscoid sale. It is not recorded by Lugt. However, a few months earlier some pictures belonging to the late Mrs Elizabeth Hanmer had come up for sale at Christie's (15–16 May 1778, Lugt 2857). It is worth recalling that four years earlier Penn Assheton Curzon had sold two biblical pictures by Hayman that had been in Charles Jennens' collection (see CL. 110, 117).

70. This section of the letter was quoted by W. T. Kenyon, op. cit., 15. The original letter is still in the Kenyon Papers at Gredington.

71. It is recorded above the altar by G. Ormerod, *The History of the County Palatine and City of Chester . . . &tc.*, 3 vols. (London, 1819) II, p. 615.

72. Alterations were made to Malpas Church c. 1840 by George Latham, a local architect (see *Journal of the Chester and North Wales Archaeological Society*, XXXVII, 2 (1949) pp. 38–39.

73. See Neil Maclaren, *National Gallery Catalogues, The Spanish School*, Second edition, rev. by Allan Braham (London, 1970) no. 5931.

74. I suggested this to Christopher White for inclusion in his essay 'Rembrandt's Influence on English Painting' in *Rembrandt in Eighteenth Century England*, Yale Center for British Art (New Haven, 1983) p. 21.

75. CL. nos. 311–315 inc.

76. For Gopsall see L. G. Ramsey, 'Destruction walks by noonday at Gopsal Hall', *Connoisseur*, CXXVIII (1951) pp. 160–62 and John Harris, *The Palladians* (London,

1981) p. 96. For Jennens' association with Handel see *Handel: A Celebration of his Life and Times*, ed. by Jacob Simon (London, National Portrait Gallery, 1985) p. 201, no. 181.

77. A list of paintings in the London house can be found in Dodsley's *London and its Environs described . . . &tc.*, 6 vols.(London, 1761) V, pp. 76–97.

78. After Jennens' death on 20 November 1773 his estate and collections passed to the Hon. Penn Assheton Curzon, father of Richard William Penn, First Earl Howe. Penn Assheton Curzon sold 147 of Jennens' pictures at Langford's on 27–28 April 1774 (Lugt 2280). The remainder of the collection descended through the family of Earl Howe and much was finally dispersed in two sales at Gopsall by George Trollope & Sons, 21–22 October 1918 and 21 June (and following days) 1920.

79. Quoted by John Nichols, *Literary Anecdotes of the Eighteenth Century . . . &tc.*, 6 vols. (London, 1812) III, pp. 121, 123.

80. [John Lockman], *A Sketch of Spring-Gardens, Vauxhall, in a Letter to a Noble Lord* (London, n.d. [1752]) p. 11.

81. See my article 'The Landscape' in *Vauxhall Gardens*, Yale Center for British Art (New Haven, 1983) pp. 18–19.

82. [Anon.] *A Description of Vauxhall Gardens* (London, 1762) p. 24.

83. An engraved view of the Prince's Pavilion, taken from the Grove, appears on the verso of the so-called Vauxhall Fan (see *Vauxhall Gardens* (1983), op. cit., fig. 16 and *Rococo Art & Design in Hogarth's England*, op. cit., 83, F. 5.

84. See Oliver Millar, *The Tudor, Stuart and Early Georgian Pictures in the Collection of Her Majesty the Queen*, 2 vols. (London, 1963) I, p. 189.

85. 'Vertue Note Books I', *Walpole Society*, XVIII (1929–1930) pp. 12, 13 and 'Vertue Note Books III', op. cit., p. 154.

86. Millar, op. cit., I, pp. 189–190, cat. nos. 574–6 inc., II, pl. 214.

87. Millar (ibid., p. 189) does not record any evidence of cutting but it is possible that a strip along the top was removed when the picture was relocated from Hampton Court Palace, where it hung in the latter part of the nineteenth century, to Marlborough House.

88. It was seen in the Rotunda on 14 November 1761 by Count Kielmansegge ('General Amherst raising the inhabitants of Canada, who had thrown themselves at his feet') See *The Diary of a Journey to England in the Years 1761–1762*, translated by Countess Kielmansegg (London, 1902) p. 167.

89. See H. C. B. Rogers, 'Major General Jeffery Amherst in the Seven Years War', Chap. 9 of *The British Army of the Eighteenth Century* (London, 1977) p. 151.

90. *A Description of Vauxhall Gardens* (1762) p. 26.

91. For the most comprehensive recent discussion see Ann Uhry Abrams, *The Valiant Hero Benjamin West and Grand Style History Painting*, (Smithsonian Institution, Washington, D.C., 1985) pp. 127–29.

92. It was re-engraved in London by R. Sheppard and published by Bowles. Tillemans was one of a number of artists to make copies of Le Brun's painting. Hogarth, for *Garrick as Richard III* and Reynolds for his *Continence of Scipio* both also used it as the basis of their compositions.

93. For Penny's picture see David H. Solkin, 'Portraiture in Motion: Edward Penny's *Marquis of Granby* and the Creation of a Public for British Art' in *Essays on British Narrative Art*, Huntington Library Quarterly (49) (San Marino, 1986) pp. 1–23.

94. The author of *A Description of Vauxhall Gardens*, op. cit., pp. 26–27 noted that 'when the picture was finished, admiral Anson was not dead'. Anson died on 6 June 1762.

95. It may be that Howe's obscurity in the painting was a deliberate snub reflecting his public standing since his two earlier expeditions – capturing the island of Aix in 1757 and against St. Malo the following year – had turned out to be fiascos which damaged his reputation (see Sir J. Barrow, *The Life of Earl Howe* [London, 1838]).

96. *A Description of Vauxhall Gardens*, op. cit., p. 27.

97. See William Pressly, *The Life and Art of James Barry* (New Haven & London, 1981) p. 104.

98. Printed in *The Public Advertiser* (V & A Press Cuttings, [P.P.17.G], vol. 1, pp. 37–38) and in *The London Magazine, or Gentleman's Monthly Intelligencer*, XXXII (May 1763) pp. 233–34.

99. See Mildred Archer, *India and British Portraiture 1770–1825* (London, 1979) pp. 66–7, 130–177; also Sir William Foster, 'British Artists in India 1760–1820', *Walpole Society*, XIX (1930–1931) pp. 1–88.

100. Unidentified cutting, dated 12 June 1764 in 'Wroth Collection of Cuttings related to Vauxhall Gardens', Museum of London Library (L. 75, 85), Vol. III, p. 7.

101. Ibid.

102. See Anthony Pasquin [pseud. John Williams], *Memoirs of the Royal Academicians; being an attempt to Improve the National Taste* (London, 1796) pp. 132–33.

103. It is now in the McCord Museum at McGill University, Montreal and is reproduced by John Kerslake, *National Portrait Gallery Early Georgian Portraits*, 2 vols. (London, 1977) I, p. 319, II, pl. 904.

104. Croft-Murray I, pp. 64, 252–53.

105. From an inscription composed by Burke for John Bacon's statue of William Pitt the Elder in the Guildhall (see Linda Colley, 'The English Rococo – Historical Background' in *Rococo Art & Design in Hogarth's England*, op. cit., p. 10 n. 5.

106. See *The London Stage 1660–1800 Part 4: 1747–1776*, ed. G. W. Stone, 3 vols. (Carbondale, 1962) I, p. 486.

107. Ibid., II, p. 965.

108. See Arthur Murphy, *The Life of David Garrick*, 2 vols. (London, 1801), I, p. 386.

109. Ibid., p. 291.

110. For an interesting discussion of the mythology of General Wolfe see Ann Uhry Abrams, op. cit., pp. 161–65.

111. Pierre Grosley, *A Tour to London: or, New Observations on England, and its Inhabitants*, 2 vols., trans. from the French by T. Nugent (London, 1772) I, p. 103.

112. *Sophie in London 1786 being the Diary of Sophie v. la Roche*, trans. from the German with an introductory essay by Claire Williams and a foreword by G. M. Trevelyan (London, 1933), p. 281.

113. Paulson, op. cit., II, pp. 421–22.

114. Ibid., pp. 270–78.

115. Barry to Dr Sleigh 'at the time of the Society of Artists exhibition 1765' (see *The Works of James Barry*, ed. E.

Fryer, 2 vols. (London, 1809) I, p. 23.)

116. See Lindsay Errington, 'Gavin Hamilton's Sentimental Iliad', *Burlington Magazine*, CXX (January 1978) pp. 11–13.
117. See Whitley, op. cit., I, p. 223.
118. See Goodreau, loc. cit.
119. See Helmut von Erffa & Allen Staley, *The Paintings of Benjamin West* (New Haven & London, 1986) p. 23.
120. Ibid., 264–66, cat. nos. 195–96.
121. See *The London Stage Part 4*, op. cit., II, p. 1208.
122. Horace Walpole's Society of Artists catalogues are in the Lewis Walpole Library, Farmington, Connecticut (see Hugh Gatty, 'Notes by Horace Walpole ... on the Exhibitions of the Society of Artists and the Free Society of Artists, 1760–1791', *Walpole Society*, XXVII [1938–1939]).
123. For Dance's *Timon of Athens* see David Goodreau, *Nathaniel Dance 1735–1811* (The Iveagh Bequest, Kenwood, 1977) cat. 16.
124. Grosley, op. cit., II, p. 59.
125. See Ellis K. Waterhouse, *Reynolds* (London, 1941) pls. 125–26.

THE CATALOGUE

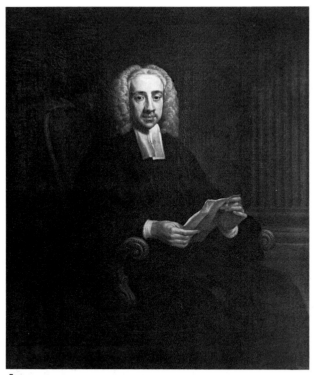

5.

I and II and he became a confidant of Queen Caroline with whose religious opinions he was in unison. He was installed as Prebendary of Winchester in 1723 followed by Westminster in 1731. His last appointment was as Dean of Exeter in 1741. While at Winchester he founded the Royal Hampshire Hospital in 1736 before establishing the Royal Devon and Exeter Hospital on his arrival in Exeter in 1741.[1]

This previously unattributed portrait is one of only two half-length canvases by Hayman known at present. Although it is not documented it is likely to have been painted *c.* 1741–2, probably to mark his appointment as Dean of Exeter a short time before his premature death. The other half-length of *Viscount Perceval* (cat. no. 6) was painted about the same time when Hayman, like Hogarth, apparently began to contemplate formal portraiture in rivalry to Van Loo, Ramsay, Hudson and a host of other fashionable portrait painters. (see Chapter 3).

We can only speculate as to whether Hayman's Exonian background had any bearing on Clarke's choice of artist but Hayman was no doubt pleased to have the opportunity to paint an ambitious cleric with a philanthropic record to match Captain Coram. As it transpires it is Hayman's only clerical portrait, although Hogarth briefly exploited this sector of the market *c.* 1743–4.[2]

It is possible that Hayman was aided or encouraged by his fellow Devonian Thomas Hudson who, as one of the founding Governors of the Devon and Exeter Hospital, attended a number of its early meetings.[3] Since the hospital was founded to provide medical care for the governors and their relatives Hayman may have hoped for some preferment in this direction that might be of benefit to his family in Devon.

This is the most conventional portrait that Hayman ever

executed and the panelled interior of his studio – so often the setting for his smaller conversation pieces or portraits in little – gives way here to the sort of classical architectural interior more commonly seen in the work of Ramsay or Hudson.

Another portrait of Dean Clarke by Hayman's St. Martin's Lane Academy colleague James Wills still hangs in the Royal Devon and Exeter Hospital.[4]

1. See P. M. G. Russell, *The History of the Exeter Hospitals*, (Exeter, 1976) 20–22, p. 39.
2. See Ellen Miles, 'Thomas Hudson (1701–1799): Portraitist to the British Establishment', unpublished PhD dissertation, 2 vols., Yale University (1976) I, p. 36.
3. Paulson I, pp. 443–48.
4. Photograph in the archives of Paul Mellon Centre for Studies in British Art, London.

6. JOHN, VISCOUNT PERCEVAL, LATER SECOND EARL OF EGMONT
c. 1742 Fig. 15, p. 33

Oil on canvas, $49 \times 39\frac{1}{4}$ (124.5×100)

Prov: by descent through Earls of Egmont; Egmont sale, Christie's, 12 December 1930 (70) as Batoni, bt. W. Sabin; Anon. sale, Christie's 31 May 1946 (43) as Batoni, bt. Martin Crabbe; his sale, Sotheby's 14 March 1984 (41) when acquired by present owners.

Exh: Birmingham, City Art Gallery, *The Friends of the Art Gallery*, 1962 (73)

Engr: In mezzotint by John Faber, Jr. (Chaloner Smith, I, pp. 409–410)

Coll: Dublin, National Gallery of Ireland

Viscount Perceval (1711–1770) was the eldest son of the First Earl of Egmont. By the age of twenty he had published several anonymous political pamphlets and acquired a seat representing Dingle Icouch, Co. Kerry, in the Irish Parliament. On 31 December 1741 he was returned, unopposed, as M.P. for Westminster, a seat he held until 1747. Before 1748, when he became chief adviser (Lord of the Bedchamber) to Frederick, Prince of Wales, he had changed his political allegiances several times and had made more enemies than friends, including Sir Robert Walpole, the Pelhams, the Duke of Cumberland and Henry Fox (see cat. no. 4); he apparently nurtured a particular hatred of Pitt.[1] As Horace Walpole wryly observed he was 'as good humoured as it was possible for a man to be who was never known to laugh; he was once indeed seen to smile, and that was at chess'.[2]

Lord Perceval was a staunch supporter of the feudal system and maintained some extraordinary anachronistic ideas. As a young man he devised a scheme for reconstituting a Jewish nation with himself as king. Years later he was still petitioning George III to grant him the island of St. John where he proposed to revive the feudal system.[3]

Hayman's portrait is an early work and is one of only two half-length portraits now known and one of the few to be engraved. It was probably painted in 1742 to commemorate the sitter's election to Westminster. Significantly, Hayman places his sitter in a landscape setting with a view of the Jacobean Kanturk Castle, Co. Cork, in the background.[4] Perceval's family had settled in Ireland in the 17th century

and the First Earl had been created Viscount Perceval of Kanturk in 1723.[5]

Along with the portrait of Dean Clarke (cat. no. 5) this is a rare excursion into the sphere of fashionable portraiture in the early 1740s when Hayman may have fancied his chances of success. In style and composition it owes much to the highly successful formula of the Frenchman J. B. Van Loo (1684–1745) who in 1742 was nearing the end of his profitable five year stint in England (see fig. 16).

1. See Sir Lewis Namier and John Brooke, *The History of Parliament The House of Commons 1754–1790*, 3 vols. (London, 1964), III, p. 266.
2. Horace Walpole, *Memoirs of the Reign of George II*, 3 vols. (London, 1847), I, p. 36.
3. See Namier and Brooke, op. cit., p. 266.
4. There is an inscription above the castellated roof-line visible in the picture. For Kanturk see Mark Bence-Jones, *Burke's Guide to Country Houses, I, Ireland*, (London, 1978) p. 162, repr.
5. For the 1st Earl of Egmont see Romney Sedgwick, *The History of Parliament: The House of Commons 1715–1754*, 2 vols. (London, 1970) II, pp. 336–38.

7. THE JACOB FAMILY *c.* 1743–4

Oil on canvas, $38 \times 42\frac{1}{2}$ (96.5 × 108)

Prov: by descent through Elizabeth Jacob who married John Buxton; Major Gerard Buxton; Egbert Barnes

Exh: Arts Council, Bath et. al., *Thomas Gainsborough* 1949 (210) as Gainsborough; Bath, Victoria Art Gallery, *Paintings and Drawings by Thomas Gainsborough*, 1951 (not in cat.); London, Royal Academy of Arts, *British Portraits*, 1956–7 (210); Liverpool, Walker Art Gallery, *Painting and Sculpture in England 1700–1750*, 1958 (13); Kenwood, 1960 (9)

Coll: Private Collection

7.

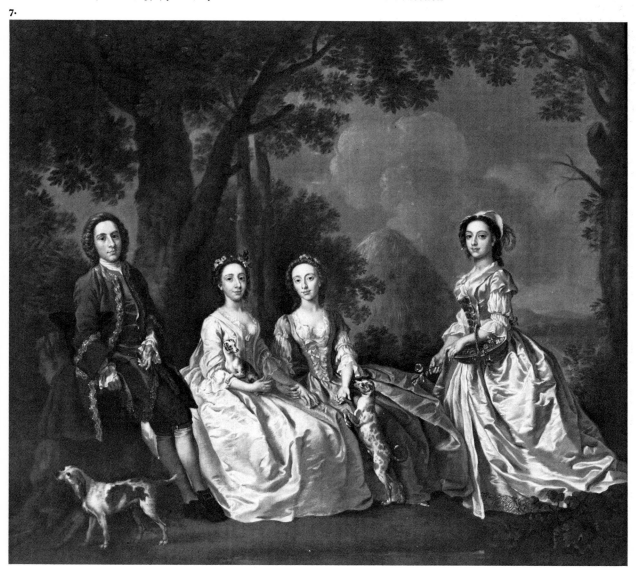

The sitters are the four children of John Jacob of The Rocks near Bath, and of Norton, Wiltshire, and his second wife Mary, née Smith of Tockenham, Wiltshire. They are (from the left) John Jacob (1723–1776) who became High Sheriff of Wiltshire in 1756; Anne (1712–1787); Mary (d. 1790) who married James Clutterbuck; and Elizabeth (1720–1765) who married John Buxton and through whom the picture has passed by descent to its present owner.[1] Judging from the age of the sitters and stylistic criteria a date of execution *c.* 1743–4 is probable.

Hayman's formula for these outdoor conversation pieces set in imaginary pastoral landscapes was established by the early 1740s and is a conscious anglicising of the French *fête galante* of Watteau and his followers modified to suit the English propensity for portraiture. The uncommon motif of a large haystack in the background is an echo of the rural subject matter of some of the recently completed Vauxhall pictures, which might have pleased Horace Walpole who complained that 'our ever verdant lawns, rich vales, fields of haycocks, and hop-grounds are neglected as homely and familiar objects' in favour of the grandeur of classical landscape.[2]

For many years this picture was thought to be by Gainsborough and it is in fact precisely the sort of work by Hayman that had such a profound influence on the younger man in the 1740s when he was under the tutelage of Hayman and Gravelot. A comparison with Gainsborough's *Gravenor Family* of *c.* 1747, now in the Yale Center for British Art, illustrates this point well.[3]

1. See F. Duleep Singh, *Portraits in Norfolk Houses*, 2 vols. (Norwich, 1927) II, pp. 421–22.
2. Horace Walpole, *Anecdotes of Painting in England . . . &tc., with additions by Rev. James Dallaway, revised by Ralph Wornum*, 3 vols. (London, 1876) II, p. 333.
3. See John Hayes, *The Drawings of Thomas Gainsborough*, 2 vols. (London, 1970) I, 297 and the same author's *Gainsborough* (London, 1975) 203, n. 11, pl. 12.

8. WILLIAM ELLIS AND HIS DAUGHTER ELIZABETH *c.* 1744–5

Oil on canvas, 30 × 25 (76 × 63.5)

Inscribed lower right: *Hayman pinxit*

Prov: Leggatt Bros. from whom it was purchased in 1959

Coll: Newcastle-upon-Tyne, Laing Art Gallery

An old label on the back of the picture identifies the sitters in this charmingly intimate portrait as William Ellis (1707–1771) of Kiddal Hall, near Leeds and his only child Elizabeth (1740?–1795). William Ellis married Mary Bourne in 1739 but her untimely death on 24 May 1740 (probably whilst giving birth to Elizabeth) explains her absence from the portrait.[1] Young Elizabeth appears to be about 4–5 years old in the picture providing a date of execution *c.* 1744–5. The landscape backdrop is typical of Hayman's portraits in the mid-1740s and the birds feeding in the foreground are reminiscent of Hayman's illustrations for Moore's *Fables for the Female Sex* which were published in 1744 (cat. no. 83). It is this sort of treatment of landscape which had such a profound effect on the young Thomas Gainsborough in these, his formative years.[2] Ellis is typical of the sort of man who sat for Hayman. He was a surgeon, one of the many medical

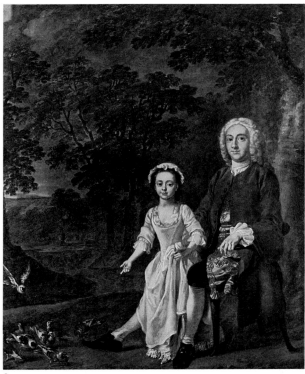

8.

men with whom Hayman was acquainted (see also cat. no. 13) with a London house in Great Pulteney Street, Soho – a short distance from Hayman's studio and the St. Martin's Lane Academy and coffee houses.

Elizabeth Ellis married the Rev. Randall Burroughs of Long Stretton in Norfolk in 1763 and her young son Ellis (1764–1831) was painted with his father by Zoffany.[3]

1. I am grateful to Andrew Greg, Keeper of Fine Art at the Laing Art Gallery for drawing this label to my attention. For Ellis' genealogy and a brief biography see 'Dugdale's Visitations of Yorkshire', ed. J. W. Clay in *The Genealogist*, n.s. XIV, (London, 1898) p. 108.
2. See John Hayes, *The Drawings of Thomas Gainsborough*, 2 vols. (London, 1970) I, 56, II, cf. pls. 56, 57.
3. Sold Christie's 23 June 1978 (144).

9. JOSEPH HENRY *c.* 1745 Fig. 17, p. 34

Oil on canvas, $23\frac{1}{4} \times 19\frac{1}{4}$ (59 × 49)

Prov: by descent to Miss Henry; Sir Giles Sebright, whose grandmother was the daughter of John Joseph Henry of Straffan

Exh: Brussels, *Exposition Universelle*, 1935 (4); Kenwood, 1960 (1)

Coll: Margery, Lady Sebright

Joseph Henry of Straffan, Co. Kildare (d. 1795) was the son of Hugh Henry, a Dublin merchant and banker, and the nephew of Joseph Leeson (1711–1783), later First Earl of Milltown, with whom he travelled to Rome in 1751. He

remained in Italy throughout much of the 1750s but returned to sit in the Irish House of Commons as member for Longford (1761–1768) and for his native Kildare borough (1770–1776). In Rome he developed a passion for caricature and acquired or possibly even commissioned from Reynolds in 1751 the large *Parody of the School of Athens*, in which he appears in replacement of Diogenes the Cynic reclining on the steps.[1] He also appears seated in the smaller Reynolds caricature, also now in Dublin, *Four Learned Milords*, gaping at an open folio volume which contains an engraving of the ancient Roman sewer, the *Cloaca Maxima*.[2] In a splendid pen and ink caricature by Pier Leone Ghezzi, done at about the same date, he is seen amidst the ruins of ancient Rome clutching a guide-book.[3] In all these images, as well as in a fine Batoni portrait,[4] Henry's protruberant lower lip is his most distinguishable physical feature and we can also see it here in Hayman's portrait executed *c.* 1745, some five years before his departure from Italy.

Hayman portrays Joseph Henry as an earnest young scholar. The open bookcase in the background reveals expensive quarto and folio leatherbound volumes and Henry evidently saw himself as a man of some erudition. The inscription of Ghezzi's caricature described him as 'huomo assai erudito nella Antichita e en lettera' with a mount bearing the words 'Cavaliere Inglese dilettante della Antichita'.[5]

This is one of the first occasions when Hayman employs the relaxed cross-legged pose which was to become his stock-in-trade and I have argued that the pose and the treatment of the draperies is much influenced by Roubiliac's celebrated statue of Handel, unveiled in Vauxhall Gardens in the spring of 1738 (see fig. 18, p. 35).[6]

1. See Denys Sutton, 'The Roman Caricatures of Reynolds', *Country Life Annual* (1956) pp. 114–116 and Cynthia O'Connor, 'The Parody of the School of Athens', *Bulletin of the Irish Georgian Society*, XXVI (1983) pp. 4–22.
2. See *Reynolds* ed. Nicholas Penny (London, Royal Academy of Arts, 1986) p. 176, no. 14.
3. Ghezzi's caricature is now in the Metropolitan Museum of Art, New York (see Victoria & Albert Museum, *English Caricature 1620 to the Present* (1985), p. 31. no. 8. Another Ghezzi caricature of Henry with others is in the Philadelphia Museum (see O'Connor, loc. cit., p. 19, fig. 9).
4. See Anthony M. Clark, *Pompeo Batoni – A Complete Catalogue of his Works with an Introductory Text*, ed. E. P. Bowron (Oxford, 1985) cat. 147, pl. 137.
5. In Italy Henry built up a collection of works by Old Masters and contemporary paintings by Richard Wilson, Vernet and Antonio Joli. For a brief description of Henry's collection see R. Twiss, *A Tour Through Ireland in 1775* (London, 1776) pp. 24–5, also Michael Wynne, 'The Milltowns as Patrons', *Apollo*, XCIX (1974) pp. 104–111, and John Kenworthy-Browne, 'Matthew Brettingham's Roman Account Book 1747–1754', *Walpole Society*, XLIX (1983) p. 118.
6. See Brian Allen, 'Jonathan Tyers's Other Garden', *Journal of Garden History*, I, no. 3 (July–September 1981) p. 231.

10. DAVID GARRICK AND WILLIAM WINDHAM *c.* 1745

Oil on canvas, 33½ × 40 (85 × 102)

Prov: Painted for David Garrick and sold at Mrs Garrick's sale, Christie's 23 June 1823 (45) bt. Peter Norton (dealer); listed in 1860 in a privately printed account of Lord Dover's

paintings; with Viscountess Clifden in 1867; Fourth Viscount Clifden's sale, Robinson & Fisher, 25 May 1895 (718) bt. Davis on behalf of Lady Annaly, sister of the Fourth Viscount; by descent to Capt. G. Lowther, grandson of Lady Annaly; his sale, Sotheby's 17 November 1971 (97), bt. Leggatt Bros. by whom sold to the present owner.

Exh: London, National Portrait Gallery, *National Portrait Exhibition*, 1867 (437); Kenwood, 1960 (14); Northampton, *Pictures from Northamptonshire Houses*, 1966 (25); Norwich, Castle Museum, *Norfolk and the Grand Tour*, 1985 (59)

Coll: Private Collection

David Garrick (1717–1779), seated on the fence, probably met William Windham of Felbrigg (1717–1761) seen here reclining on a grassy bank to Garrick's left, soon after the latter's return to England from his protracted Grand Tour, mostly in Italy and France, in October 1742.[1] Windham's love of the theatre brought him into contact with Garrick with whom, according to Garrick's biographer Murphy, he was certainly on friendly terms by the end of 1743.[2] Garrick stayed at Windham's hunting lodge in Suffolk in 1744 and they were together again at Bath the following year.[3] This picture was probably executed in 1745 for not only does *it* correspond closely to other works produced about that time, such as *William Ellis and his daughter Elizabeth* (cat. no. 8), but it is almost certainly the picture referred to in a letter written in the autumn of 1745 by Garrick to Hayman. In this fascinating letter (see p. 17) Garrick offers Hayman advice about a proposed series of six Shakespeare prints and assures him that he can 'depend upon all Mr Windham's Services in ye Affair'. He also asks the painter in the same letter 'Have you finish'd My Picture Yet? Dr Newton has been here & prais'd it extravagantly'.[4] Hayman is not known to have painted any other picture of Garrick at this date.

In this charmingly informal double portrait of two friends, the irrepressible Garrick, seated nonchalantly on the fence, gestures towards an imaginary audience as if reciting lines from the book held in his left hand. Windham meanwhile lounges on a grassy bank in that favourite pose of Hayman's

10.

first employed by him in several of the Vauxhall supper box pictures (see CL. nos. 196, 209).

Hayman's already well-established relationship with Garrick flourished in the ensuing years resulting in a number of commissions from the actor (see p. 20). Windham may also be the sitter in the small full-length portrait of a man in Hungarian Hussar costume (CL. 64).

1. See R. W. Ketton Cremer, *The Early Life and Diaries of William Windham* (London, 1930) p. 37 and the same author's *Felbrigg – The Story of a House* (London, 1962) pp. 112–122.
2. See Arthur Murphy, *The Life of Garrick*, 2 vols. (London, 1801) I, pp. 67–68.
3. See Carola Oman, *David Garrick* (London, 1958) p. 80.
4. See *The Letters of David Garrick*, op. cit., I, no. 33, pp. 53–54. The editors mistakenly suggest that the picture referred to is *Garrick as Richard III* (cat. no. 42) which was painted in 1760.

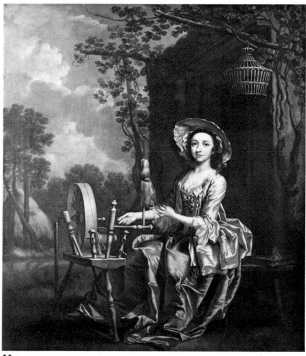

11.

11. A LADY AT A SPINNING WHEEL *c*. 1745

Oil on canvas, $35\frac{1}{2} \times 29$ (90.2 × 73.7)

Prov: purchased by the Christie-Miller family in 1891; by descent; sold privately to Kenwood in 1984

Exh: London, Burlington Fine Arts Club, 1932 (3); *Country Life Exhibition*, 1937 (2); London, Royal Academy of Arts, *European Masters of the Eighteenth Century*, 1954–55 (128).

Coll: The Iveagh Bequest, Kenwood

An old label on the back of the picture is inscribed 'Portrait of Miss Hood by Hogarth' but since the identity of the artist is mistaken the possibility of this being Miss Hood should be treated with suspicion.

This fashionably attired young lady seated at a spinning wheel beneath a vine-covered cottage door suggests that the playful subject matter of the Vauxhall pictures also began to pervade Hayman's portraits in the mid-1740s. A scene of such contrived rococo artifice is a timely reminder that Hayman was aware of the latest developments in French painting for similar figures to this seated woman can be found in engravings after Boucher published in London in the mid-century.[1] But one also wonders if Hayman was influenced by the sort of rustic, domestic genre subjects based loosely on Chardin prototypes that Philip Mercier had engraved in mezzotint by the younger Faber in the mid-1740s. Indeed, one of Mercier's series *Rural Life* was entitled *Girl Spinning*.[2]

1. See Angus after Boucher, *The Female Gardner*, frontispiece to *A NEW BOOK of Figures from BOUCHER*, published by Sayer in 1753.
2. See John Ingamells & Robert Raines, 'A Catalogue of the Paintings, Drawings and Etchings of Philip Mercier', *Walpole Society*, XLVI (1976–78) p. 46, no. 181.

12. ELIZABETH AND CHARLES BEDFORD IN A LANDSCAPE WITH A ST. BERNARD DOG *c*. 1746–1747 Colour Plate II

Oil on canvas, 30 × 25 (76.2 × 63.5)

Prov: painted for the children's father Grosvenor Bedford; by descent

Coll: Private Collection

The sitters in this newly discovered portrait are two of the children of Grosvenor Bedford (see cat. no. 4), Elizabeth (1736–1776) and Charles Bedford (1743–1814). Charles, the Bedford's eldest surviving son,[1] appears in another portrait with his parents painted about a year later (CL. 6) and again with his mother and brother Richard Earle in a picture executed *c*. 1755 (CL. 7). Nothing is known about Elizabeth Bedford but young Charles was to become a clerk in the office of the Usher of the Exchequer in 1762,[2] and in 1774 became deputy Usher,[3] the post his father had held as Horace Walpole's deputy from 1755 until his death in 1771 (see cat. no. 4). Horace Walpole left Charles Bedford a legacy of £2000 in his will.[3]

This picture is documented by a fascinating letter from Hayman to Grosvenor Bedford which, apart from shedding light on the artist's apparent alarmingly poor state of health, finally provides conclusive evidence that Gainsborough occasionally painted the landscape backgrounds in Hayman's pictures:

Saturday mo.

Dear Bedford
Send me & Bearer the picture of your infant, I have an opportunity of getting the landscape done by Gainsborough whilst he is in Town: & methinks I would fain see it finish'd before I dye: Seriously I have had 2 or 3 such fitts of the megrims that I have thought myself very near going out; what else but sickness or death think you could have hindred [sic.] my meeting Mr Parsons, Mr Salter, & you, last Wednesday night, just as I was setting out my resolution was so stagger'd by one of those fitts that I did not recover it in two hours.

Dear Bedford whither sick or well I am most Faithfully your friend & Servt.

F: Hayman

I hope the Family are all well[4]

Although the letter is undated, the watermark on the paper reads 'Dettingen Culloden', a reference to the battles of the years 1743 and 1746 respectively, indicating a date for the picture of some time after 1746. Young Charles, seated rather precariously on the St. Bernard dog was born on 20 March 1743 and appears to be about 3–4 years old confirming a date *c.* 1746–1747.

A close examination of the landscape confirms that Hayman did indeed 'have an opportunity of getting the landscape done by Gainsborough' for it is quite clearly by the younger man's hand. The attention to botanical detail, the carefully wrought foliage is so much more particular than Hayman's more generalised treatment of natural phenomena and is entirely characteristic of Gainsborough's landscape style of the mid-to-late 1740s, confirming the comments of 'T.B.' in the press years later that 'Mr Hayman's backgrounds have frequently been executed by a variety of hands' (see pp. 36–7).

1. Information from Bedford family archives with the picture's owner.
2. See *Court and City Register* (1763) p. 116.
3. Walpole's will is printed as Appendix 8 in *The Correspondence of George Selwyn*, Vol. 30 of Yale edition of Horace Walpole's correspondence, ed. W. S. Lewis (New Haven, 1961) p. 359.
4. The letter has remained with the present owner of the picture.
5. Genealogical details from the Bedford family archives.

13. CHARLES CHAUNCEY M.D. 1747

Oil on canvas, 25 × 17 (63.5 × 43.2)
Inscribed lower right (on base of plinth): *F. Hayman pinx 1747*

Prov: presumably painted for the sitter; later at Dane End, Ware, Herts; by family descent through a Miss Chauncey; Lady Gladstone (née Paget), widow of Viscount Gladstone; Lady Paget (née Surtees, whose mother was a Chauncey); Sylvia Paget (Mrs John Chancellor); John Chancellor; sold to Marco Grassi; Eugene Thaw (dealer), New York from whom it was acquired in 1974 by Paul Mellon

Coll: Yale Center for British Art, Paul Mellon Collection

Charles Chauncey M.D. (1709–1777) was one of a number of medical men painted by Hayman in the 1740s (see also CL. 2, 16, 28). Chauncey graduated from Corpus Christi College, Cambridge, as M.B. in 1734 and M.D. in 1739.[1] He was elected as a Fellow of the Royal Society on 29 January 1740 and became a Fellow of the College of Physicians on 30 September of the following year.[2] Apart from his career as a physician, Chauncey developed a considerable reputation as an antiquary and collector. The Chauncey family had a long-established tradition as dissenting scholars and the present sitter's great-grandfather was Charles Chauncey (1592–1672), the famous Vicar of Ware, Pilgrim Father and later Second President of Harvard College.[3]

Charles Chauncey's enormous collections, inherited by his brother Nathaniel (1716–1790), were dispersed in a number of sales in March, April and May of 1790. On the second day of the picture sale[4] Hayman's *Venus at her Toilet* (CL. 120) was sold alongside works by Wootton, Lambert, Oram, Tull and Barrett which gives a fairly clear indication of his taste for landscape painting. Edward Edwards informs us that Chauncey at one time owned the splendid drawings, now at Waddesdon, for Moore's *Fables for the Female Sex* (see CL. 220).[5] Despite his reputation as a connoisseur of prints and drawings, Dr Chauncey was one of those eminent men duped by the celebrated fake Rembrandt etchings in 1751.[6]

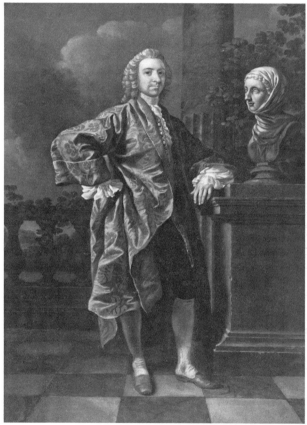

13.

Hayman's portrait, signed and dated 1747, depicts Chauncey dressed informally in a sumptuous blue brocade dressing gown and slippers. His scholarly interests are alluded to by the antique bust on the plinth to the right which seems to be a copy of the *Farnese Vestal Virgin*. The original was described by Jonathan Richardson as 'the most engaging of all those I have seen in *Rome*, *Florence*, or elsewhere, and which struck me so much that it detain'd me from the paintings of *Caracci* a considerable time.'[7] It was commonly reproduced in England and a good example can be found at Stourhead. The type had also been adapted by Roubiliac for his busts of *Lady Grisel Baillie* (1747) and *Lady Murray of Stanhope* (1746) in the collection of Lord Binning at Mellerstain[8] and this may well have prompted its inclusion here, since during the mid-

1740s Hayman was acutely aware of the French sculptor's work. Indeed, the dazzling manner in which Chauncey's brocade dressing gown is painted with its deeply cut, starchy folds is ultimately derived from the sculptor's technique with terracotta and marble (see p. 35).

The likeness of Chauncey is confirmed by Caroline Watson's engraving after the lost pastel portrait by Cotes, which was signed and dated 1750.[9] Dr Chauncey's wife Mary also sat for Hayman in 1748 (see cat. no. 14).

1. See J. Venn and J. A. Venn, *Alumni Cantabrigienses ... &tc.*, Part 1, vol. 1 (Cambridge, 1922) p. 319.
2. See S. Tucker, *Pedigree of the Family of Chauncy* (London, 1884) p. 9.
3. See W. Chauncy Fowler, *Memorials of the Chaunceys, Including President Chauncey, his ancestors and descendants* (Boston, Mass., 1858).
4. Christie's, 27 March 1790 (Lugt 4556). The enormous collection of prints and drawings was sold by Messrs. Greenwood on 3 May 1790 and 13 following days.
5. Edward Edwards, *Anecdotes of Painters ... &tc.* (London, 1808) p. 52.
6. See W. T. Whitley, *Artists and their Friends in England 1700-1799*, 2 vols. (London, 1928) I, 124 and Ellen D'Oench in *Rembrandt in Eighteenth Century England*, Yale Center for British Art (1983) pp. 67-68.
7. Jonathan Richardson, *An Account of some of the Statues, Bas-reliefs, Drawings & Pictures in Italy &tc., with Remarks*, (London, 1722) p. 132.
8. See Malcolm Baker, 'Roubiliac's portraits of Lady Grisel Baillie and Lady Murray', *Burlington Magazine*, forthcoming. A similar prototype is the *zingara*, a full-length figure with a scarved head which Scheemakers, Cheere and Charles Harris all copied in the mid-eighteenth century (see Vertue Note Books III, op. cit., 139 and Haskell & Penny, *Taste and the Antique ... &tc.*, op. cit., pp. 339-344 for further details).
9. See Edward Mead Johnson, *Francis Cotes Complete Edition* (London, 1976) 51, 103, cat. 11.

14.

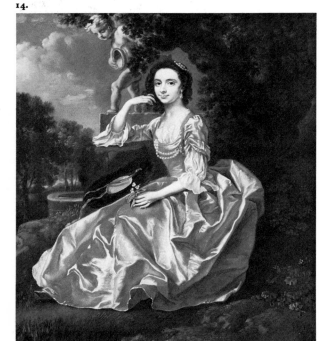

14. MARY CHAUNCEY 1748

Oil on canvas, $23\frac{3}{4} \times 20$ (60.3 × 50.8)
Inscribed lower centre: *F. Hayman P. 1748*

Prov: as for cat. no. 13

Coll: Yale Center for British Art, Paul Mellon Collection

Charles Chauncey married Mary (d. 1755), daughter of Gabriel Touhardin 'a refugee from Anjou', on 20 January 1735-1736.[1] Mrs Chauncey sat for Hayman a year later than her husband and although this portrait is of slightly differing dimensions it should effectively be seen as its companion piece (see cat. 13).

The vigorous application of pink on gold in the folds of Mrs Chauncey's dress is an exceptionally good example of Hayman's virtuosity as an artist with no recourse to the stereotyped productions of the drapery painter. The female figure seated in a landscape appears regularly in Hayman's work in the later 1740s. Whilst her husband is shown flanked by his sculpted Vestal virgin, Mrs Chauncey is posed beneath a sculpted putto who empties his large vessel into a well. This figure is typical of the type of animated, almost caricatured garden sculpture which Hayman occasionally introduces into his outdoor portraits, and has its origins with similar figures in the pastorals of Watteau and his followers.

1. See cat. no. 13 n. 2.

15. JOHN CONYERS c. 1747 Colour Plate III

Oil on canvas, $21\frac{1}{4} \times 18\frac{1}{4}$ (54 × 46.4)

Prov: Painted for John Conyers; by family descent to J. N. Hylton Jolliffe; his sale, Christie's 23 June 1972 (96) with sitter incorrectly identified as Lord Pomfret; bt Lord Hesketh; purchased by the G.L.C. for Marble Hill House

Exh: Iveagh Bequest, Kenwood, *To preserve and enhance – Works of Art acquired for Kenwood, Marble Hill and Ranger's House 1964-1974*, 1975 (29)

Coll: English Heritage, Marble Hill House

John Conyers (1717-1775) was Tory M.P. for Reading from 1747 to 1754 and for Essex from 1772-1775.[1] He was also a Governor of the Foundling Hospital[2] where he may have come into contact with Hayman who had also been elected a governor after presenting his *Finding of Moses in the Bulrushes* to the Hospital in 1747 (cat. no. 46). This portrait was probably painted in 1747 to commemorate both his election to Parliament and his second marriage to his first cousin Lady Henrietta Fermor, daughter of the First Earl of Pomfret.[3]

The seated, cross-legged pose of Conyers is found in several other small portraits from the end of the 1740s as are the interlaced-back chairs with the cabriole legs which are studio props. Prominently placed on the wall in the background is a view of Conyers country seat, Copped Hall in Essex, which his father had acquired in 1739 and which he inherited in 1742.[4] This painting is a very accurate rendering of one of a pair of views of Copped Hall by George Lambert, both of which are signed and dated 1747.[5] As Elizabeth Einberg has pointed out, the Lambert views do more than just confirm the dating of the portrait. Hayman's rendering of Lambert's

landscape is so accurate, even down to the tonality of the picture that it can be assumed that he must have worked with the original in front of him. However, there are several important details missing, notably the fishermen in the foreground and the boats and swans on the lake. When the Lambert pictures were exhibited at Kenwood in 1970 it was suggested that the figures were by someone close to Hayman, possibly Samuel Wale. It can now be confidently suggested that the figures were added by Hayman himself, probably immediately after he completed Conyers' portrait.

Hayman and Lambert were well acquainted, since not only were they both professional scene painters but they were also members of the Beefsteak Club (see pp. 2–3). This sort of collaboration amongst members of the St. Martin's Lane Academy was not uncommon.[6]

Apart from his desire to be shown as the owner of an impressive estate, Conyers had another reason for requiring Hayman to include a view of Copped Hall in the picture at this time – he was in the process of demolishing it to make way for a modern building.[7] Conyers was known as an amateur architect of some ability, as was his brother-in-law Sir Roger Newdigate, with whom he personally supervised the improvements.[8]

1. The identity of the sitter was established by Elizabeth Einberg, whose article 'A Portrait by Francis Hayman Identified', *Burlington Magazine*, CXV (March 1973) pp. 157–8 is the basis of this catalogue entry.
2. Conyers was elected a Governor of the Foundling Hospital on 30 June 1742 (see R. H. Nichols & F. A. Wray, *The History of the Foundling Hospital* (London, 1935).
3. The sitter in this portrait was formerly identified as Lord Pomfret (see Einberg, loc. cit., 158).
4. For Old Copped Hall see *The Victoria County History of Essex*, V (1965) 119 ff. and *Country Life*, XXVII (29 October & 5 November 1910) p. 610.
5. See [E. Einberg], Iveagh Bequest, Kenwood, *George Lambert* (1970) cat. 18, 19.
6. Elizabeth Einberg, *Burl. Mag.*, loc. cit., p. 158 suggests that there are other Lamberts with figures by Hayman, beginning with a *Classical landscape with Figures by a Waterfall* (1741, photo Witt Library).
7. For an account of Copped Hall and the survey drawings made before demolition in 1753 see John Newman, 'Copthall', in *The Country Seat . . . &tc.*, ed. Howard Colvin & John Harris (London, 1970) pp. 18–30.
8. See Michael McCarthy, 'Sir Roger Newdigate, Arbury Hall, Copped Hall and John Conyers', *Burlington Magazine*, CXXI (June 1979) p. 382.

16. GROSVENOR BEDFORD AND FRANCIS HAYMAN c. 1748–50

Oil on canvas, $28\frac{1}{4} \times 36$ (71.8 × 91.5)

Prov: Grosvenor Bedford; Bedford sale, Christie's 1 March 1861 (28); Farrer, his sale, Christie's, 15 June 1866 (93); acquired by N.P.G.

Exh: London, National Portrait Gallery, *National Portrait Exhibition*, 1867 (262); Exeter, 1951 (5); Liverpool, Walker Art Gallery, *Painting and Sculpture in England 1700–1750*, 1958 (11); Iveagh Bequest, Kenwood, *The Conversation Piece in Georgian England*, 1965 (22); London, National Portrait Gallery, *Artists at Work*, 1982 (1).

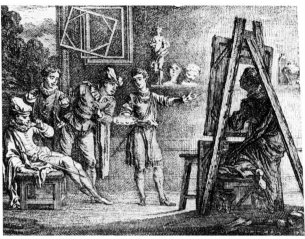

Fig. 43 After Claude Gillot, *Le Portrait*, headpiece for *Fable Cinquiesme* of Antoine Houdard de la Motte's *Fables Nouvelles* (Paris, 1719)

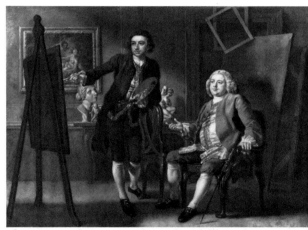

16.

Coll: London, National Portrait Gallery

Although the identity of the artist has never been in question, the corpulent seated figure of Grosvenor Bedford[1] has been mis-identified as Sir Robert Walpole and Dr Martin Folkes.[2] John Kerslake was the first to tentatively propose the correct identity, based primarily on the provenance of the picture.[3]

As in the *Self-Portrait at the Easel* (cat. no. 21). Hayman depicts himself in his studio. He holds in his right hand a porte-crayon, and his palette and brushes are held firmly in the left hand allowing us to examine the setting in some detail. It contains six colours. The vermilion is placed immediately below the thumb aperture and three flesh tints of varying degrees of strength, light, middle and dark, are shown near the centre of the palette before the artist began work. On the outer edge (from left to right) can be seen flake white, yellow ochre, light red, crimson lake, raw umber and ivory black.[4]

To the right the plump figure of Bedford sits in a sturdy mahogany armchair and gestures towards Hayman as if commenting on his work. The setting of the artist's studio is a device used by Hayman for sitters with whom he was on intimate terms (see also cat. no. 22). Behind Bedford two

empty stretchers hang on a wooden peg above the door-casing and the large canvas underneath these has the ground laid in; some of the underpainting of an historical or mythological painting are just visible. Partly obscured on the wall in the background can be seen the same mythological picture – *Venus and Mars* – that appears in the *Self-Portrait at the Easel* (cat. no. 21).

Although there is no record of the contents of Hayman's studio, the frequency with which he introduces pieces of sculpture, plaster models and casts etc. into the backgrounds of his pictures suggests that he must have had an extensive collection. On the side-table which stands against the panelling are several pieces including what appears to be a variation on the Uffizi's celebrated *Crouching Venus*.[5]

It has been convincingly suggested that this composition is based on an engraved illustration after Claude Gillot for the *Fables* of Houdard de la Motte (see fig. 43). Although Hayman disguises his borrowing by reversing Gillot's composition and removing two of the figures the similarities are surely too close for coincidence. Even the empty canvas stretchers are lifted from the Frenchman's design.[6]

In formal terms Hayman is extremely aware of arranging his studio props in a manner that best utilises the available space and avoids the uncomfortable blank areas that sometimes punctuate Arthur Devis' conversation pieces. This compositional sensitivity is almost certainly the result of years working in the theatre where the placing of props on the stage was a vital component of good scenography.

1. For biographical information about Grosvenor Bedford see cat. no. 4.
2. See Mark Girouard 'Hogarth and his Friends – English Art and the Rococo – II', *Country Life*, CXXXIX. (27 January 1966) p. 189. I have also mistakenly published this picture as Hayman and Folkes (see my article cited in cat. no. 28, n. 1).
3. John Kerslake, *National Portrait Gallery Early Georgian Portraits*, 2 vols. (London, 1977) I, pp. 137–38.
4. See F. Schmid, 'Some Observations on Artists' Palettes', *Art Bulletin*, XL (December 1958) p. 335.
5. See Francis Haskell and Nicholas Penny, *Taste and the Antique* (New Haven & London, 1981) 321, fig. 171.
6. See Antoine Houdard de la Motte, *Fables Nouvelles* (Paris, 1719), headpiece for 'Fable Cinquiesme', Book IV, 220, entitled 'Le Portrait'. The connection was first made by Rose Isepp in *The Conversation Piece in Georgian England*, Iveagh Bequest, Kenwood (1965) cat. 22.

17.

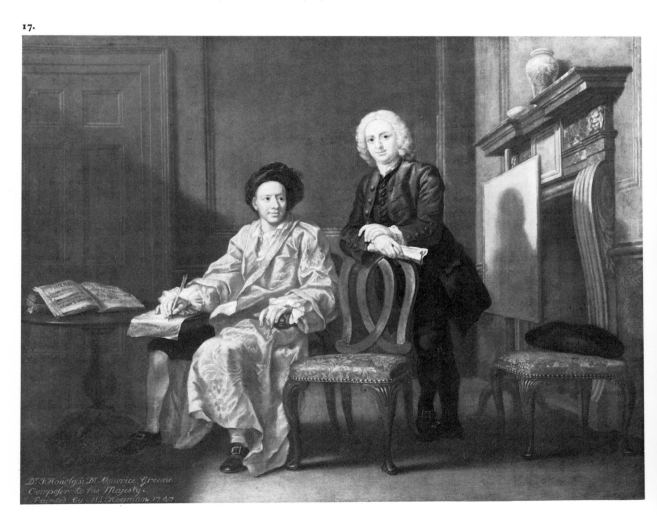

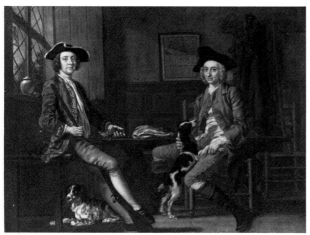

18.

17. REV. DR JOHN HOADLY AND DR MAURICE GREENE 1747

Oil on canvas, $27\frac{1}{2} \times 35$ (69.8 × 90.2)

Inscribed in gold script bottom left:
Dr: J: Hoadly & Dr: Maurice Greene
Composer to His Majesty
Painted by Mr: Hayman, 1747

Prov: presumably painted for John Hoadly; with Hoadly's widow in 1781; Hoadly sale, Christie's, 10–11 January 1812 (37), sale postponed (?); Christie's, 21 January 1812 with same lot no.; with the Street family by 1885; purchased by the N.P.G. in 1925 from Mrs Florence Street.

Exh: International Inventions Exhibition, Loan Collection, 1885 (103) lent by Mrs Street; *Music Loan Exhibition*, 1904 (229) lent by J. E. Street.

Coll: London, National Portrait Gallery

As the inscription on the picture indicates, the sitters are Dr Maurice Greene (1696–1755) the composer and organist and the Rev. Dr John Hoadly (1711–1776) the poet, dramatist and Chaplain to Frederick, Prince of Wales.

The painting was almost certainly commissioned by Hoadly to celebrate the publication in 1747 of the dramatic pastoral opera *Phoebe*, a joint work by Hoadly and Greene, for the open score of that work is clearly visible propped on the tea-table to the left. According to Hoadly's widow, her husband is shown 'repeating a song to Dr Greene, for him to compose'.[1]

By the later 1740s Greene had enjoyed a distinguished musical career. In 1718 he had been appointed organist to St. Paul's and in 1727 of the Chapel Royal. His appointment as Master of the King's Musick in 1735 meant that, before his fortieth birthday, he held every major musical appointment in the land.[2] He is best remembered for his church music but he also composed keyboard music, songs and extended secular vocal works like *Phoebe*.

Portraits of Hoadly, a great friend of Garrick, are frequently confused with those of his brother Benjamin (1706–1757), the physician and playwright to whom he bears a physical resemblance and with whom he collaborated in writing *The Suspicious Husband* (see cat. no. 39). Hayman also painted Benjamin Hoadly with his wife at about the same date in a small portrait now in the Wellcome Institute of the History of Medicine (CL. 28).

The sombre panelled interior with an elaborate marble chimneypiece is similar to the settings of several other contemporary pictures, particularly *Grosvenor Bedford with His Wife Jane and Son Charles* of *c.* 1747–8 (CL. 6).

1. See John Nichols, *Biographical Anecdotes of William Hogarth . . . &tc.* (London, 1781) pp. 98–9. Nichols mistakenly attributes the picture to Hogarth. Mrs Hoadly also owned the Yale version of *The Suspicious Husband* (cat. no. 39).
2. See *The New Grove Dictionary of Music and Musicians*, Vol. 7 (1980) pp. 684–7.

18. THOMAS NUTHALL AND HAMBLETON CUSTANCE 1748

Oil on canvas, 28 × 36 (71 × 91.5).

Prov: by descent to Miss Ida Nuthall; Ernest Cook by whom bequeathed through the N.A.C.F. to the Tate in 1955.

Coll: London, Tate Gallery

Two labels on the back of the canvas give the names of the sitters as 'Custon [sic.] (Weston House, Norwich) and Nuthall (New Lodge, Enfield Middlesex)'. Their ages are recorded in both cases as thirty-three and this enables dating of the picture to 1748.

Thomas Nuthall (1715–1775) and Hambleton Custance (1715–1757) were close friends. Nuthall (on the left) held a number of public appointments including Registrar of Warrants (1740), Receiver-General for hackney carriages (1749) and later Solicitor to the East India Company (1765). He was for many years intimately acquainted with William Pitt, whose marriage settlements he was to draw up in 1754.[1] Hambleton Custance, who became High Sherriff of Norfolk in 1753, married Susannah Press and their son was the 'Squire' of Woodforde's *Diary*. Nuthall married Custance's widow in 1757.

This informal double portrait of two friends is similar in spirit to the earlier *David Garrick and William Windham* (cat. no. 10). The presence of guns and dogs and the bird in Nuthall's left hand suggests that both men were fond of traditional country pursuits – as indeed was Hayman if we are to judge from his letter to Sir Edward Littleton (see cat. no. 22). Nuthall was the Ranger of Enfield Chase and the rather spartan interior with its basic furnishings has a simplicity reminiscent of Dutch or Flemish seventeenth-century genre painting and is probably a hunting lodge . Nevertheless, Hayman still articulates the space in his usual way by using simple country furniture as if it were the sort of fashionable interior in which many of his portraits are set. Instead of a painting on the half-panelled wall the space is enlivened by a framed almanack and a coat-rack.

It is extremely unlikely that the picture by Hayman in the Bearsted Collection at Upton House dating from the early 1750s is, as is often stated, of the same sitters (CL. 75, fig. 24).[2] Not only is there a considerable age gap between these two but there is also a marked lack of resemblance to the men seen here.

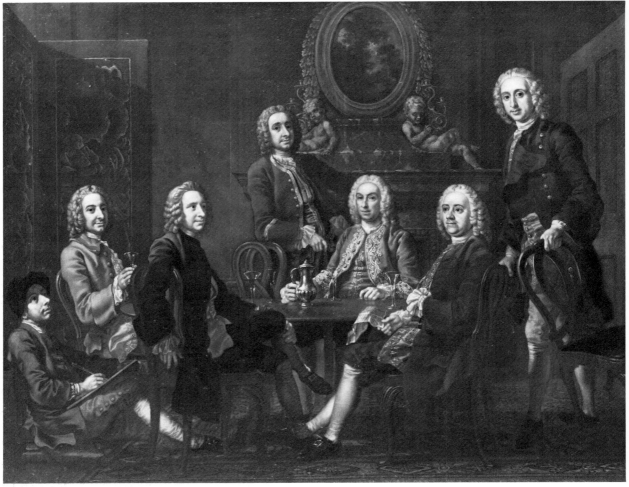

19

1. See the *Dictionary of National Biography*.
2. See *The Bearsted Collection from Upton House, Banbury* (London), Whitechapel Art Gallery, 1955 (5).

19. THE ARTIST AND HIS FRIENDS *c.* 1745–8

Oil on canvas, 44 × 55½ (112 × 141)

Prov: poss. J. Howard Galton in 1857; with Colnaghi in 1897; Viscountess St. Cyres; probably Christie's, 23 March 1910, bt. Cohen 85 gns.; Charles Morrison sale, Christie's, 20 July 1956 (113) bt. Agnew; sold to Tooth in 1957; Mortimer Brandt Gallery, New York; with Tooth again by October 1958; Leggatt Bros. from whom acquired by Paul Mellon in 1960.

Exh: poss. 'A Convivial Party' lent by J. Howard Galton to Manchester Art Treasures Exhibition, 1857 (27); London, A. Tooth, 1959 (3); Kenwood, 1960 (15a); Richmond, Va., Virginia Museum of Fine Arts, *Painting in England. 1700–1850 Collection of Mr & Mrs Paul Mellon*, 1963 (217); London, Royal Academy, *Painting from the Collection of Mr and Mrs Paul Mellon* 1964–5 (9); ibid., Yale University Art Gallery, 1965 (109); Richmond, Va., *William Hogarth*, 1967 (12); Washington, D.C., National Gallery of Art, *William Hogarth*, 1971; Yale Center for British Art, *The Pursuit of Happiness*, 1977 (115).

Coll: Yale Center for British Art, Paul Mellon Collection.

This is the most enigmatic of Hayman's group portraits and has traditionally been called 'Lord Chesterfield and his Friends'. The only figure identifiable with any certainty is the artist himself seated to the lower left apparently sketching the convivial scene in front of him. Hayman's likeness is confirmed by his other self-portraits (cat. nos. 1, 21). The other sitters, according to a tradition of fairly recent origin,[1] have been identified as (from the left): the Duke of Newcastle, the Bishop of Waterford, Sir William Dormer, the Fourth Earl of Chesterfield, Sir Robert Walpole and, pulling up the chair from the right, his son Horace Walpole. The identity of Sir Robert Walpole is certainly incorrect. This picture is likely to have been painted after his death in 1745, and he was invariably shown wearing his Garter insignia.[2] However, this man does bear a remarkably strong resemblance to Grosvenor Bedford (see cat. nos. 4, 16), Hayman's friend and consistent patron. Although C. K. Adams and W.S. Lewis could not detect any resemblance between the putative Horace Walpole

on the extreme right and other known portraits of him, this may well in fact be him.[3] It is not unlike the figure which I have tentatively identified as young Horace in the other Bedford family group (see cat. no. 4) and given his close connection with Grosvenor Bedford and his family we might take the tradition seriously. Similarly, the so-called figure of Lord Chesterfield, seated in the centre with his hand on the jug, does bear a resemblance to other portraits of him.[4] However, since Bedford was very much in the Walpole camp politically we might be inclined to doubt the identity of Lord Chesterfield, given the history of political friction between him and Sir Robert Walpole. The identity of the other three figures on the left has not been satisfactorily resolved but their traditional identities should not be entirely disregarded.

This composition has its origin in the type of small-scale professional or club portraits popularised by Hogarth and Gawen Hamilton after 1730. On the grounds of style and comparison with other datable examples a date of execution *c.* 1745–8 is likely. The veined marble chimneypiece and overmantel with its oval picture frame is very similar to the one in the earlier Bedford group (cat. no. 4).

It is worth noting that Hayman's frontispiece for Volume I of the 1747 edition of *The Spectator* showing 'Sir Roger de Coverley and his Friends' (CL. 272 (1)) is basically this composition in reverse and modified to suit the upright format of a book illustration.

1. The supposed identity of sitters seems to have been suggested just prior to the Hayman exhibition at Kenwood in 1960 although the information arrived too late for inclusion in the catalogue.
2. See John Kerslake, *National Portrait Gallery Early Georgian Portraits* 2 vols. (London, 1977) I, pp. 197–204.
3. See C. K. Adams & W. S. Lewis, 'The Portraits of Horace Walpole, *Walpole Society*, XLII (1968–70) p. 31, C. 12.
4. See Kerslake, op. cit., I, 49–52.

20. GEORGE DANCE THE ELDER *c.* 1749–50 (?) Colour Plate IV

Oil on canvas, $21\frac{5}{8} \times 17$ (53.4 × 43.1)

Prov: Anon. sale (Mrs Metges), Sotheby's 6 June 1935 (4), bt. Agnew; sold to R. F. Lambe who bequeathed it to the Fitzwilliam Museum in 1951.[1]

Exh: London, Geffrye Museum, *George Dance the Elder 1695–1768, the Younger 1741–1825,* 1972 (1); Rococo 1984 (D23)

Coll: Cambridge, Fitzwilliam Museum.

George Dance the Elder (1695–1768) was Surveyor to the City of London and is best known as the architect of the Mansion House and a number of City Churches.[2] Significantly, Dance sent his son Nathaniel to study with Hayman *c.* 1749–50 and this may have prompted this commission.[3]

Hayman's portraits often suffer from a tendency to make his sitters look alike but in this instance he has produced an unusually forthright and individual portrait. Dance leans against one of those curious chairs with the interlaced backs that Hayman kept in his studio and another stands against the panelling in the background.

The landscape painting on the wall is very close to the work of the young Gainsborough in the late 1740s and is a reminder

of the close ties between the two artists at this date (see cat. no. 12).[4]

1. A written label on the back of the picture, giving details about Dance and his children, is signed B. F. Scarlett. The Scarlett Smiths trace their descent through Hester Smith née Dance, George Dance the elder's only daughter (see J. W. Goodison, *Fitzwilliam Museum Cambridge, Catalogue of Paintings Volume III: The British School* (Cambridge, 1977) pp. 99–100).
2. See Dorothy Stroud, *George Dance Architect 1741–1825* (London, 1971) pp. 57, 74.
3. See *The Diary of Joseph Farington,* ed. Kathryn Cave, IX. p. 3192.
4. Compare with Gainsborough's *Wooded landscape with Peasant resting Beside a Winding track* of 1747 (see John Hayes, *The Landscape Paintings of Thomas Gainsborough,* 2 vols. (London, 1982) II, p. 349, cat. 22).

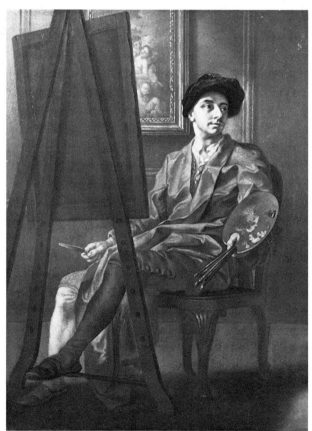

21.

21. SELF-PORTRAIT AT THE EASEL 1750

Oil on canvas, $23\frac{1}{2} \times 16\frac{1}{2}$ (59.7 × 41.9)

Prov: believed to be a gift from the artist to Sir Edward Littleton; by descent to Lord Hatherton; his sale, Christie's, 6 November 1953 (7) unattributed, bt. Davey; presented to Exeter by the N.A.C.F.

Exh: London, Royal Academy, *British Portraits,* 1956–7 (208); Arts Council, *British Self-Portraits,* 1962 (20); Liverpool, Walker Art Gallery, *N.A.C.F. Gifts to Galleries,* 1968 (42);

London, Royal Academy, *Bicentenary Exhibition*, 1968 (39); Exeter, Royal Albert Memorial Museum, *Treasures of the Exeter Museums*, 1969 (91); Exeter, Royal Albert Memorial Museum, *Early Devon Painters 40 years on*, 1972–3 (18).

Coll: Exeter, Royal Albert Memorial Museum.

This self-portrait was painted as the companion to *Sir Edward Littleton* which was completed in the summer of 1750 (see cat. no. 22) Hayman shows himself seated in front of his easel at work on a picture. He looks to the left as if glancing at a sitter and holds a palette knife in his right hand and his brushes and palette in his left. His informal attire in wig cap, open-neck chemise, dressing gown and slippers is distinctly reminiscent of Roubiliac's figure style for sculpture (see pp. 34–5). Hanging on the wall in the background and almost entirely obscured by the canvas and easel is the same mythological picture (*Venus and Mars*) that appears in the *Self-Portrait with Grosvenor Bedford*. (cat. no. 16).

22. SIR EDWARD LITTLETON 1750

Oil on canvas, $23\frac{1}{4} \times 16$ (59 × 40.6)

Prov: painted for the sitter, thereafter by descent.

Exh: London, Royal Academy, *British Portraits*, 1956–7 (212).

Coll: Private Collection.

22.

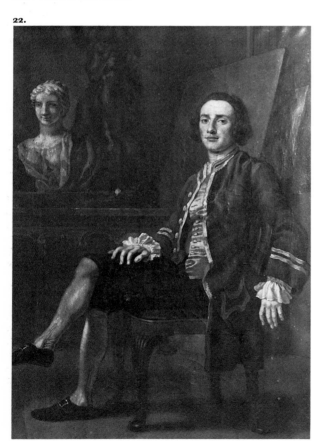

The sitter has formerly been mis-identified as Fisher Littleton (1730–1800), the younger brother of Sir Edward Littleton, Fourth Baronet (1727–1800). It is however, Sir Edward who is here portrayed. Edward Littleton inherited his title as a minor from his uncle, the Third Baronet, who died on 6 January 1741–2. He went up to Cambridge in 1744 but his studies were interrupted in 1745 when he raised a company and captained it against the Jacobite rebels. After 1745 he was firmly ensconced in the Tory camp but he did not play an active rôle in party politics at a national level. He was Sheriff of Staffordshire 1762–3 and M.P. for Staffordshire from 1784 until his death.[1]

Hayman may well have come into contact with Littleton through their common friend Edward Macro, son of the Suffolk antiquary the Rev. Dr Cox Macro, whose staircase ceiling at Little Haugh Hall Hayman had painted *c.* 1743 (see pp. 51–3). Littleton later enlisted the help of Edward Macro when planning the building of his new country house, Teddesley Hall in Staffordshire in the late 1750s.[2] But Hayman also knew Littleton's tutor and mentor at Cambridge, Richard Hurd (1720–1808) the scholar and cleric who, like Littleton, was a Staffordshire man.[3]

Evidence for the revised identification and a precise dating of the picture[4] is provided in a fascinatingly gossipy and amusingly intimate letter written by Hayman to the sitter dated 4 August 1750 which is worth quoting here in full:

Dear Sir

I have the Pleasure to tell you that the Picture is at last finish'd, & shall be sent to the Waggon Monday morng: I hope it will please for faith I have exerted my utmost having to do with such a Critick & Connoisseur. the back Ground is suppos'd to be the inside of a Painters room, so there is a Statue, a Bust, and some Canvas's scatterd about. to shew you I have no Mercenary Views in expediting this great Work I acquit you of your Promis'd Venison for to let you into a Secret the Waggoner tells me that it will hardly come sweet.

How do I envy you the Pleasures of the Country? while I poor dog lize sweating at the Easel you are ramping over hedge & Ditch knocking down Partriges or Country girls the better of the two, all our solace in town this hot Weather is getting drunk, for Madam Douglas, Johnson &c. with their Families are now all Country Ladys the only affair of gallantry that has lately happen'd is the Elopement of Mrs Pope (the Bristoll Beauty) with Little Hammond of Teddington, her Husband lay ill of a broken leg at Hammonds House so she took this opportunity to show him she had the use of hers, her father overtook 'em at an Inn in the City, there had like to have been Murder but finding she persisted in protesting her love for her Man & hatred of her Husband he gave her up.

When should I have done prating if my paper did not warn me that I am almost at the end of my letter? the Conclude then I am & shall ever be

Your most Obiged [sic.]
Obedt: Humble Servt:
Fr: Hayman

London, Saturday Augst. 4: 1750:

Hayman evidently did not receive a reply and a second letter to Sir Edward, written a month later, indicates that his jocular

mood has given way to somewhat irate anxiety:

Dear Sir

'tis about five Weeks agoe since I wrote you word that the Picture was finish'd, pack'd up and sent according to order by Aspley's Waggon, since that I have not had the honour of a line from you, whither you think you wrote letter enough before for such a trifle, whither you have lost yourself in the Woods a Shooting, & can't find your way home again, or whatever else may be the cause, your Silence has made me very uneasy. I thought the picture might be left at the Inn, & made a Damn'd racket about it, for which I got abused by the Warehouse keeper.

 Pray let me hear something from you good, bad, or indifferent, & youll oblige.

Yr Most Humble Servant
Fr. Hayman

Sepr 4th 1750[5]

These letters suggest that Hayman was on remarkably intimate terms with his distinguished young patron since the usual obeisances are noticeably absent. But apart from trading gossip and confirming the painter's reputation as a *bon viveur*, it is clear that they describe this portrait and that it is Sir Edward and not his brother Fischer who is portrayed here. The first letter also confirms our suspicions that Hayman's interiors are of his own invention – 'the back Ground is suppos'd to be the inside of a Painter's room' writes Hayman, suggesting that his sitter would not know what to expect in advance.

The inclusion of pieces of sculpture on the table would probably have pleased Littleton, although we do not know his reaction. Like the Macros, Littleton was a prominent patron of the Flemish sculptor John Michael Rysbrack. On 10 February 1755 Littleton wrote to Edward Macro stating that he intended to decorate his study at Teddesley Hall with about a dozen terracotta busts by Rysbrack 'of the most eminent persons of my country'.[6]

The bust in the background of Littleton's portrait with its distinctive plaited hairstyle appears to be a copy of the so-called *Younger Faustina*, now in the Capitoline Museum in Rome.[7] Several copies of the Faustina by Bartolomeo Cavaceppi (1716–1799) found their way into English collections in the eighteenth century. Henry Blundell of Ince Hall, for instance, had two copies, one of which is probably that now in the Walker Art Gallery, Liverpool.[8] There is also a plaster copy in the Dining Room of Sir John Soane's Museum. The other statue (perhaps a plaster model) seems to be a reverse variation of the *Farnese Hercules*, possibly derived from an engraving.[9]

Hayman presented his own portrait to Littleton as a companion piece. (cat. no. 21).

1. All biographical material relating to Littleton has been taken from Kathleen M. Wain, 'Sir Edward Littleton's Financial Affairs 1742–1812', unpublished PhD thesis, University of Liverpool (1975).
2. See Littleton's correspondence with Macro in the 'Macro Letter Book', deposited at the Ipswich and East Suffolk Record Office.
3. In 1757 Hurd dedicated to Littleton his edition of *Ars Poetica* (see *The Correspondence of Richard Hurd and William Mason . . . &tc.*, Leonard Whibley (Cambridge, 1932) pp. 4, 5, 8).
4. There is also an early label on the back of the picture with the date 1750 inscribed.
5. Both Hayman letters are bound into a mutilated volume of letters *c.* 1750–1765 from various artists to Sir Edward Littleton, which is now with the Hatherton Papers in the Staffordshire Record Office (Ref. no. D 1178/3). The bulk of the letters are from Benjamin Wilson and describe in detail work undertaken for Littleton.
6. 'Macro Letter Book', loc. cit. Some of Littleton's extensive correspondence with Rysbrack (removed from the vol. of letters mentioned above) has been published by M. I. Webb, *Michael Rysbrack Sculptor* (London, 1954) Appendix 1, pp. 192–209.
7. I am grateful to Dr Nicholas Penny for drawing this to my attention. See *The Sculptures of the Museo Capitolino*, ed. H. Stuart Jones (Oxford, 1912) 198 ff., pl. 52.
8. See Walker Art Gallery, Liverpool, *Foreign Catalogue*, 2 vols. (Liverpool, 1977). I, p. 293, cat. 6628, also Seymour Howard, 'Bartolomeo Cavaceppi and the Origins of the Neo-Classic Sculpture', *Art Quarterly*, XXXIII (1970) p. 132.
9. For the Farnese Hercules see Francis Haskell and Nicholas Penny. *Taste and the Antique* (New Haven & London, 1981) pp. 229–232.

23. JONATHAN TYERS WITH HIS DAUGHTER ELIZABETH AND HER HUSBAND JOHN WOOD *c.* 1750 (?)

Oil on canvas, 39 × 34 (99 × 86.3)

Prov: probably painted for Jonathan Tyers or John Wood; by descent through the Wood branch of the family to Mrs Emily Ogilvie who bequeathed it on her death in 1916 to her cousin Mrs Jessie Marshall; Sir George Sutton, Bart.; Mrs W. H. Miller; Sotheby's, 23 November 1966 (79); Arthur Tooth & Sons from whom acquired by Paul Mellon in 1968.

Exh: Yale Center for British Art, *Vauxhall Gardens*, 1983 (51).

Coll: Yale Center for British Art, Paul Mellon Collection.

This portrait was probably painted to celebrate the marriage of John Wood to Jonathan Tyers' younger daughter Elizabeth (1727–1802). The exact date of the marriage is not known but according to information from a descendant of the Wood family this took place *c.* 1750.[1] However, on stylistic grounds we might be inclined to date this picture slightly earlier.

Jonathan Tyers gestures towards the lap-dog, a symbol of fidelity, and the presence of the sculpted dolphin and putto with a dove (symbols of long life, love and peace) on the plinth above Elizabeth give weight to the theory that this is a marriage or betrothal portrait. To the left stands John Wood, posed like a figure from a contemporary fashion plate engraving.

This is one of the best examples of the influence of French Rococo art on Hayman's outdoor conversation pieces. The figures are unusually small in relation to the picture space, which allows the landscape to play a more prominent part, as in the *fête-galantes* of Watteau and his followers. Indeed, Watteau is the overall inspiration for the composition of the figures, particularly the reclining figure of Jonathan Tyers whose languid diagonal pose in relation to his daughter can be found in prints after Watteau like *Les Jaloux*, engraved by Scotin.[2] Other paintings by Watteau such as *La Partie Quarrée*, now in the San Francisco Museum of Fine Arts (fig. 44), engraved in 1731 by Moyreau, even have the putto riding

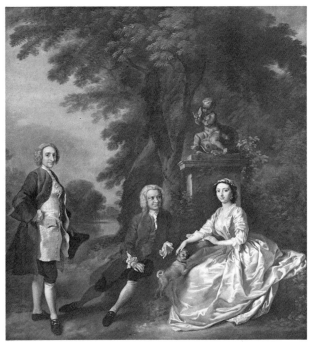

23.

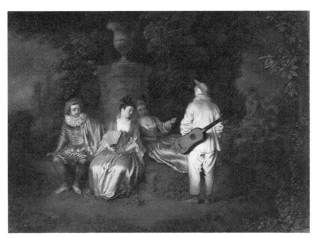

Fig. 44 Antoine Watteau, *La Partie Quarrée*. Canvas, $19\frac{11}{16} \times 25\frac{3}{4}$ (50×65.2) The Fine Arts Museum of San Francisco, Mildred Anna Williams Collection

the dolphin.[3] The idea of figures seated beneath a classical urn in a wooded grove is taken up by Hayman in another of the Tyers family portraits (cat. no. 25).

1. According to Mrs Dorothy Scobell Wood (a cousin of Mrs Ogilvie, see prov. above) who at one time owned *Jonathan Tyers with his Family* (cat. no. 3). Information in a letter written on 13 January 1953 to Mrs Robert Tritton who had just acquired cat. no. 3.
2. See E. Dacier and E. Vuaflart, *Jean de Jullienne et les graveurs de Watteau au XVIIIe siècle*, 3 vols. (Paris, 1922–1929) no. 137.
3. For Watteau's use of garden statuary see Calvin Seerveld, 'Telltale Statues in Watteau's Paintings', *Eighteenth Century Studies*, XIV, 2 (Winter 1980–81) pp. 151–181.

24. GEORGE ROGERS WITH HIS WIFE MARGARET TYERS AND HIS SISTER MARGARET ROGERS *c.* 1750–52 Fig. 13, p. 32

Oil on canvas, 41×39 (104×99)

Prov: probably painted for George Rogers; by descent through his grandson the Rev. Jonathan Tyers Barrett to Col. C. P. Boyd Hamilton, Brandon House, Suffolk; Mrs Boyd Hamilton; sale, Sotheby's, 25 February 1925 (66), bt. Agnew; Knoedler & Co. by 1926; sold to Mrs Derek Fitzgerald; her sale, Sotheby's, 29 May 1963 (56), bt. Leger; O. & P. Johnson from whom acquired in 1964 by Paul Mellon.

Exh: Exeter, Royal Albert Memorial Museum, *Early Devon Painters*, 1932 (269); London, Royal Academy, *British Art*, 1934 (364); London, Royal Academy, *Painting in England 1700–1850 from the Collection of Mr & Mrs Paul Mellon*, 1964–65 (20); Yale Center for British Art, *The Pursuit of Happiness*, 1977 (169); Yale Center for British Art, *The Conversation Piece: Arthur Devis and his Contemporaries*, 1980 (54).

Coll: Yale Center for British Art, Paul Mellon Collection.

Probably painted in the early 1750s, this portrait represents George Rogers (1718–1796) and his wife Margaret, née Tyers (1724–1786), eldest daughter of Jonathan Tyers seated in the centre. Standing to the right is probably Rogers' sister, also Margaret (1722–1806). If this is Margaret Rogers[1] then she is perhaps seen between marriages. She married first Richard Dawson and secondly Jonathan Tyers junior, the youngest of the Tyers' four children. This portrait passed to their daughter which strengthens the case for her supposed identity.

The relaxed informality and good humour of this group contrasts sharply, as Judy Egerton has observed, with the solemn decorum of similar contemporary works like Devis' *William Orde's return from shooting.* (fig. 14).[2]

In the area of sky to the centre right of the canvas are clearly visible *pentimenti*, apparently a putto seated on a plinth similar to the one which appears in cat. no. 23.

1. This figure has frequently been called Elizabeth Tyers (1727–1802), younger sister of Margaret Tyers but she bears little resemblance to the other portraits of her (see cat. no. 23).
2. See Judy Egerton, *British Sporting and Animal Paintings in the Paul Mellon Collection*, 2 vols. (London, 1978) I, p. 54.

25. MARGARET TYERS AND HER HUSBAND GEORGE ROGERS *c.* 1750–52 Colour Plate V

Oil on canvas, $35\frac{1}{2} \times 27\frac{1}{2}$ (90.25×69.75)

Prov: probably painted for George Rogers; by descent through his grandson, the Rev. Jonathan Tyers Barrett to Col. C. P. Boyd Hamilton, Brandon House, Suffolk; Mrs Boyd Hamilton; sale, Sotheby's, 25 February 1925 (65), bt. Agnew; by 1926 with Knoedler & Co.; Edward Speelman, from whom acquired in 1962 by Paul Mellon.

Exh: Ipswich, *Thomas Gainsborough Memorial Exhibition*, 1927 (10); Richmond, Va., Virginia Museum of Fine Arts, *Painting in England 1700–1850 Collection of Mr and Mrs Paul Mellon*, 1963 (222); London, Royal Academy, *Painting in*

England 1700–1850 from the Collection of Mr and Mrs Paul Mellon, 1964–5 (7); Yale University Art Gallery, *Painting in England 1700–1850 from the Collection of Mr and Mrs Paul Mellon*, 1965 (100).

Coll: Yale Center for British Art, Paul Mellon Collection.

Margaret Tyers (1724–1786) married George Rogers (1718–1792) and this may be a marriage portrait. The presence of the cornfield may be symbolic and so too may the large classical urn with the bas-relief of the three Vestal Virgins.

George Rogers seems to have been something of an amateur landscape painter who exhibited at the Society of Artists in 1761 and 1762, on the latter occasion showing a view of his native Southampton and the Isle of Wight.[1] According to Edward Edwards his landscapes 'possessed a considerable degree of merit'.[2] He appears to have remained on friendly terms with Hayman and is very probably the 'Mr Rogers' who in April 1757 proposed Hayman as a member of the Society of Arts, Manufactures and Commerce.[3]

The disposition of the figures in the landscape reminds us of the similarity between the work of Hayman and the young Thomas Gainsborough *c.* 1750. A comparison with the Kimbell Museum's Gainsborough of *Miss Lloyd (?)* who sits under a tree shading a classical urn is particularly instructive.[4]

1. Society of Artists Exhibition 1762 (224).
2. Edward Edwards, op. cit., p. 72.
3. See Chapter 1 n. 44.
4. See John Hayes and Lindsay Stainton, *Gainsborough Drawings* (International Exhibitions Foundation, 1983) p. 38, no. 7 repr.

26. SIR PAULET ST. JOHN AND HIS FAMILY *c.* 1753–4

Oil on canvas, 39 × 42½ (99.1 × 108)

Prov: by descent

Coll: Private Collection

Sir Paulet St. John (1704–1780) of Farley Chamberlayne and Dogmersfield Park, Hampshire, was M.P. for Winchester from 1734 to 1741. Thereafter he was returned for the County of Hampshire which he represented until 1747. He returned to Westminster in 1751 as member for Winchester and served the duration of that Parliament until 1754. In 1772 he became Mayor of Winchester. He married first, in 1731, Elizabeth, daughter of Sir James Rushout M.P., but produced no children. His second wife, seen here in this portrait immediately to his right, was Mary (d. 1758), daughter of John Waters of Brecon and widow of Sir Halswell Tynte, whom she had married in 1736.[1]

The sitters can here be identified (from the left) as Mary, Edward (holding battledores), John and William, the younger children; Lady St. John (or Lady Tynte as she preferred to be known) and Sir Paulet, both of whom appear in other portraits by Hayman (CL. nos. 44, 45, 48); seated on the extreme right is the eldest son and heir, Henry Paulet St. John (1737–1784). Henry also appears as a boy of about ten seated in the carriage with his mother in the large view of Dogmersfield Park (CL. 44, fig. 19) and was to sit for Hayman again *c.* 1760 (CL. 50). If Henry's age can be taken in this picture as about sixteen then we can establish a date of

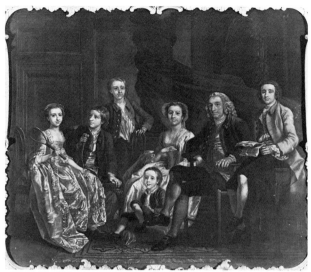

26.

execution *c.* 1753 and this is consistent with the increasingly heavy-handed application of paint which characterises Hayman's work after this date.

The elaborate swathe of green drapery wrapped around a classical column is, for Hayman, an unusually extravagant homage to the increasingly outdated baroque conventions and this mood is echoed in the magnificent carved Chippendale-style rococo frame.

The St. John family were consistent patrons of Hayman from the mid-1740s and a number of family members sat for him (see CL. nos. 46, 47).

1. See Romney Sedgwick, *The History of Parliament. The House of Commons 1715–1754*, 2 vols. (London, 1970) II, pp. 403–4.

27. THE HALLETT FAMILY 1756

Oil on canvas, 64 × 48 (162.6 121.9)

Prov: painted for William Hallett; by descent through his grand-daughter who married in 1779 Sir John Dolben of Finedon Hall, Leics.; Anon. sale, Christie's, 10 July 1925 (85) bt. Mason 38 gns. (bt. in ?); Mrs G. M. Hibbard sale, Sotheby's, 6 May 1926 (6) bt. G. F. Emanuel; his sale, Sotheby's, 24 February 1937 (52) bt Agnew who sold it to Lt. Col. Hughes-Hallett in January 1942

Exh: London, Thos. Agnew & Son Ltd, *Coronation Exhibition of British Pictures*, 1937 (71)

Coll: Private Collection

The sitters are (from the left): John 'Vulture' Hopkins, who made a fortune on successful speculation in South Sea Stock, and his wife Elizabeth;[1] William Hallett junior (d. 1767), patting the dog; William Hallett senior (1707–1781), holding in his right hand a plan for his villa built on the site of the great palace of Canons at Edgware; Hannah Hallett, daughter of

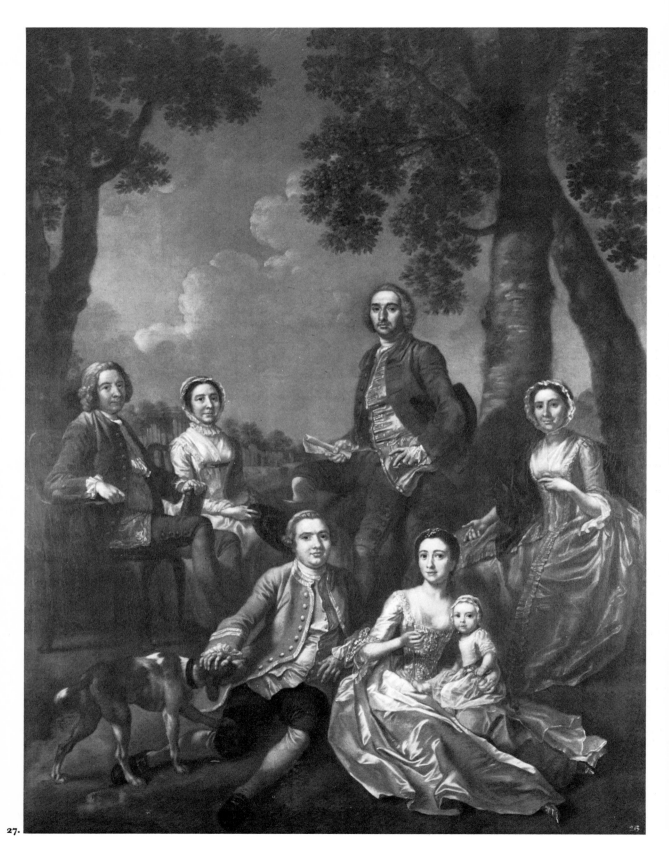

John and Elizabeth Hopkins, who married William Hallett junior in December 1753[2] and her small daughter Hannah (1755–1807)[3]. On the extreme right is Lettice Hallett (1714–1810), a cousin of William Hallett senior who became his second wife in 1756.

William Hallett senior was one of the most prominent figures in the cabinet-making and upholstery trades in the middle years of the century. Some indication of his prosperity can be gained from his purchase of the Canons estate at the sale in 1747, three years after the death of the Duke of Chandos, by whom he had been extensively employed.[4] Hallett took possession on 12 February 1748 of 'the site and estate together with large quantities of the materials which other purchasers refused or neglected to clear and with them built himself a house on the centre vaults of the old one'.[5]

It is not quite clear when Hallett's new house was completed, but considering that the dispersal of the Canons estate continued well into the 1750s, several years after Hallett had taken possession of the property, it is not likely to have been finished before the mid-1750s.[6]

This group portrait was almost certainly painted in 1756 to mark both his second marriage to Lettice and the completion of his villa. By the early 1750s Hallett senior had more or less retired from his business to become the Squire of Canons, and with both his advantageous marriage to his cousin Lettice, the heiress daughter of a wealthy London Goldsmith, and his son's financially astute match there was plenty of capital available when necessary.[7]

William Hallett senior is seen here holding in his right hand a plan for the house. Mysteriously, Hayman made considerable alterations to this figure and to the background. Originally Hallett senior was painted with his right arm outstretched pointing to the new house, and although the house was afterwards painted out and Hallett's arm lowered, *pentimenti* have come through the sky and are now clearly visible.[8]

This is one of Hayman's latest and most ambitious conversation pieces. From the mid-1750s his portrait practice declined and he began to devote his energies wholeheartedly to history painting. By contrast to the *Richardson Family* (fig. 11) painted fifteen years earlier, with its charming, doll-like figures, the sitters here appear more relaxed and animated within this larger canvas but, overall, the stylistic change over the period is minimal.

It is reasonable to speculate that the splendid carved wood frame is a product of Hallett's workshops.

1. See Geoffrey Beard, 'The Quest for William Hallett', *Furniture History*, XXXI (1985) p. 220.
2. Ibid. *The London Evening Post*, 15–18 December 1753 noted that she came with a fortune of more than £30,000.
3. Through whom ownership of the picture was passed to her husband's family. She married on 26 October 1779 John Dolben of Finedon in Leicestershire with a fortune of £70,000 (see *The Gentleman's Magazine*, XLIX p. 566). Young Hannah's brother, born some years later in 1764, is the young man who appears with his wife in Gainsborough's celebrated *Morning Walk* (National Gallery), painted in 1785.
4. For details of the dispersal of the Canons collection see C. H. Collins Baker and M. I. Baker, *The Life and Circumstances of James Brydges, First Duke of Chandos Patron of the Liberal Arts* (Oxford, 1949) pp. 436–450 and W. Myers, 'Canons, Edgware. An Historical

Study of the School's New Home' in *The North London Collegiate School 1850–1950. Essays in Honour of the Frances Mary Buss Foundation* (London, 1950) pp. 158–182.
5. See *The Gentleman's Magazine*, LII (1781) p. 45 (Wm. Hallett's obituary).
6. Collins Baker, op. cit. p. 445.
7. See Beard, loc. cit., pp. 223–24.
8. Compare with J. A. Gresse's drawing of Hallett's villa, engraved by Watts for *Seats of the Nobility and Gentry . . . &tc.* (1782).

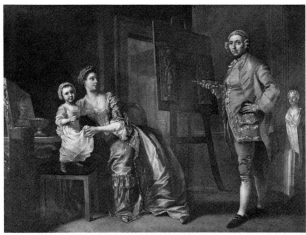

28.

28. JOSEPH WILTON AND HIS FAMILY 1760

Oil on canvas, 30 × 40½ (76.2 × 102.9)

Prov: Morrison family, Yeo Vale, Devon; by descent to Sir Robert Kirkwood; sale, Sotheby's, March 1985 (43); purchased by V & A

Exh: London, Victoria & Albert Musum, *English Caricature 1620 to the Present*, 1985 (not in catalogue)

Coll: London, Victoria & Albert Museum

This portrait of the prosperous sculptor Joseph Wilton with his wife and young daughter can be dated to 1760.[1] Wilton had returned to England in May 1755 in the company of the Florentine decorative painter Cipriani, the architect William Chambers and the sculptor Capizzoldi after years of study in Flanders, France and Italy.[2] In 1757 he married Frances Lucas and their eldest daughter, also named Frances, who is seen here in the picture as a two-year-old, was born the following year.

By 1760 Hayman had virtually abandoned portrait painting and this is one of only two portraits known at present which post-date the *Hallett Family* of 1756 (cat. no. 27). Hayman's style and compositional methods had changed remarkably little since the mid-1740s and he is still inclined to set his portraits in an austere panelled room. In this instance the setting is the sculptor's studio.

Hayman paints Mrs Wilton, on the left in her splendid turquoise silk dress, in a decidedly French style. The sharp diagonal thrust of her pose recalls Boucher portraits like those of Madame de Pompadour which Wilton may well have seen

and admired in Paris.[3] The young Miss Wilton, balanced rather precariously on a stool by her mother, clutches a sprig of cherries, a device used by Hogarth in the National Gallery's *The Graham Children* of *c*. 1742. A pair of cherries, with its erotic associations, might be seen to contain a warning against lust, even if the child is unaware of the implications, and the motif is commonly found in portraits of children, particularly in Dutch and French art from the sixteenth century onward.[4]

On the right Joseph Wilton is poised in front of an easel with a modelling tool in his right hand. Mounted on the easel is what appears to be a clay *modello* for a chimneypiece which on closer inspection is revealed as a design for one of two giant telamonic chimneypieces which graced the Gallery of Northumberland House in the Strand until its demolition in 1874.[5] This would clearly suggest that these chimneypieces were designed by Wilton although we know that their execution in marble was entrusted to Benjamin Carter.[6]

It is entirely possible that Hayman played some rôle in helping Wilton gain this commission, for the painter's close friend, the architect James Paine, with whom he had worked on several decorative schemes in the north of England (see pp. 55–7), was responsible for the completion of the Northumberland House Gallery between 1753 and 1757.[7] Hayman himself, however, seems to have nurtured a special interest in elaborate marble chimneypieces for fanciful examples, apparently of his own invention, appear regularly in his portraits and book illustrations.

Other enigmatic sculptural puzzles appear in the painting. To the extreme left, in shadow, is a truncated column behind which stands what appears to be an elaborate stone or marble-topped table, surmounted by a piece of bas-relief sculpture and a small urn. The relief represents a female head, as yet unidentified. To the right of Wilton, without any apparent relationship to the panelling behind, is a curious term-figure, like those frequently applied to chimneypieces. With its distinctive plaited hairstyle this appears to be adapted, like the bust in the background of the portrait of *Sir Edward Littleton*, from the so-called *Younger Faustina*, now in the Capitoline Museum, Rome (see notes to cat. no. 22). Wilton presumably made a copy of it, for a bust of 'Faustine' by him was among the items at the sale of a 'a man of fashion' at Christie's on 2 June 1779.

The dense facture of the paint surface and the coarser drapery painting are consistent with Hayman's looser style in his later years.

1. I have written about this portrait at length in 'Joseph Wilton, Francis Hayman and the Chimney-pieces from Northumberland House', *Burlington Magazine*, CXXV (April 1983) pp. 195–202.
2. See J. T. Smith, *Nollekens and his Times . . .&tc.*, 2 vols. (London, 1829) II, pp. 164–182.
3. A comparison with Boucher's portrait of Mme de Pompadour in the Jones Collection at the V & A (signed and dated 1758) is instructive (repr. in colour in A. Ananoff & D. Wildenstein, *L'Opera Completa di Boucher* (Milan, 1980) pl. XLVIII.
4. For an interesting discussion of the theme in French and Dutch painting see Ella Snoep-Reitsma, 'Chardin and the Bourgeois Ideals of his Time, 2', *Nederlands Kunsthistorisch Jaarboek*, 24 (1973) pp. 212–217.
5. The chimneypieces fortunately survive: one is in the V & A and the other is at Syon House. For a discussion of the use of *modellos*, etc., see Malcolm Baker, 'Roubiliac's models and 18th century English sculptors' working practices', *Entwurf und Ausführung in der*

Europaischen Barockplastik (Munich, 1986) pp. 159–184.
6. Allen, loc. cit., p. 200, n. 46.
7. See Peter Leach, 'The Life and Work of James Paine', unpublished D. Phil thesis, Oxford University (1975) p. 304.

29. THE FOURTH EARL AND COUNTESS OF BERKELEY WITH THEIR SON FREDERICK AUGUSTUS (?) *c*. 1766 (?)

Oil on canvas, 35 × 44 (88.9 × 111.8)

Prov: Messrs. Daniell, London (dealer) 1928; Arthur Ackermann & Sons Inc., Chicago, 1932; Dunham sale, Parke Bernet, New York, 9–10 May 1947 (302) as Highmore; Mr and Mrs Eric Eweson who sold it to the present owner

Coll: Private Collection, U.S.A.

Previously thought to be by Joseph Highmore, this group portrait can be attributed to Hayman on stylistic grounds. However, the sitters cannot all be identified with certainty.

The young man seated on the left is almost certainly Frederick Augustus, Fifth Earl of Berkeley (1745–1810) who succeeded his father in 1755. His instantly identifiable features, particularly his jutting jaw, can be seen in Batoni's splendid full-length portrait still at Berkeley Castle, which is signed and dated 1765,[1] and in another later portrait, ascribed to Gavin Hamilton from the same collection.[2] He wears a blue coat and breeches and across his chest is a green ribbon sash with a star just visible on his left breast which may allude to his military career. Next to him is his mother, Elizabeth, Countess of Berkeley (1720–1792) who wears a splendid yellow, flounced dress. Her likeness is confirmed by other portraits of her, particularly that by Reynolds of *c*. 1759 (still at Berkeley Castle) to which this portrait is so close that one wonders if Hayman did not work from it direct or from McArdell's mezzotint of it.[3] Lady Berkeley's right arm rests on an architectural drawing and she holds a whistle or small wind instrument in her right hand.

The middle-aged man standing on the right in the rich red military coat is somewhat more difficult to identify but the most likely candidate is her husband, the Fourth Earl, who died in 1755, a decade or so before this portrait was painted. Despite the fact that none of the usual conceits are used to suggest a posthumous portrait he is the most likely candidate. Although Lady Berkeley married again in January 1757, her second husband, Robert, Earl Nugent (1702–1788) was a politician with no known military affiliations and is unlikely to be the man represented here. Neither can it be Lady Berkeley's other son, George Cranfield Berkeley who was only born in 1753 and went on to have a distinguished naval career.

It may be that this portrait was painted to celebrate the coming of age of the Fifth Earl in the summer of 1766 since his inheritance, the family seat of Berkeley Castle,[4] is the focal point to which the man on the right gestures. Another possibility is that the picture was begun whilst the Fourth Earl was still living, and was completed or altered by Hayman a decade later.

1. See Anthony M. Clark, *Pompeo Batoni: A Complete Catalogue of his Works with an Introductory Text*, ed. and prepared for publication by E. P. Bowron (Oxford, 1985) p. 299, cat. 287, repr. pl. 263.
2. Photograph in Witt Library (Courtauld Institute neg. no. B71/1634.)

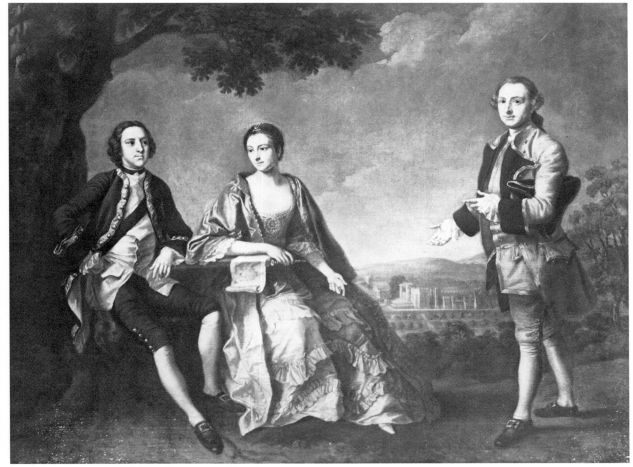

29.

3. See E. K. Waterhouse, *Reynolds* (London, 1941) p. 45 and G. Good-
 win, *James McArdell* (London, 1903) pp. 55–56.
4. This is confirmed by Leonard Knyff's *View of Berkeley Castle* (see
 John Harris, *The Artist and the Country House . . . &tc.* (London, 1979)
 pp. 64–65, repr. no. 59.)

Vauxhall Gardens

Vauxhall Gardens was situated close to the south bank of the
Thames, approximately opposite the modern-day site of the
Tate Gallery. Although the Gardens had opened in the seven-
teenth century (probably in 1661) their heyday was during
the proprietorship of the entrepreneurial Jonathan Tyers (see
cat. nos. 3, 23) who acquired the lease in 1728. Tyers reversed
Vauxhall's flagging fortunes, transforming it from a 'rural
Brothel' as one commentator suggested it had become by the
beginning of the eighteenth century,[1] into one of London's
most fashionable nightspots.[2]

Francis Hayman was certainly familiar with Vauxhall
Gardens by 1736, if not before, since in May of that year he
painted scenes for Drury Lane Theatre 'after the Manner of
Spring Garden, Vaux-Hall with a scene representing the
place' (see Chapter 2). It is not known if Hayman had met

Jonathan Tyers by this date but they were certainly
acquainted soon after since the National Portrait Gallery's
splendid portrait of Tyers with his family is signed and dated
1740 (cat. no. 3).

Soon after 1740 Hayman must have been commissioned
by Tyers, probably with the support of Hogarth, to execute
the now celebrated series of supper box paintings which were
unveiled at Vauxhall *c.* 1742 (cat. nos. 30, 32, 33). They are
first recorded in some verses by the lyric writer John Lockman
entitled *GREEN WOOD – HALL: or Colin's Description (to his
Wife) of the Pleasures of SPRING GARDENS* published as an
engraved plate with a headpiece like those from George Bick-
ham's *The Musical Entertainer.* Lockman's text was sub-
sequently reprinted in *The Gentleman's Magazine* for August
1742.[3] Of the fifty plus paintings recorded,[4] eighteen were
issued as large engravings with elaborate letterpress verses,
probably also composed by Lockman, in the spring and sum-
mer of 1743 (see cat. no. 62).

The supper box paintings were part of continual improve-
ments and refurbishment which Tyers undertook throughout
the 1740s, culminating in the exotically eclectic 'Chinese-
Gothick' style supper boxes which flanked the rectangular
grove or central piazza. Tyers was acutely aware of the com-

mercial fragility of his enterprise and was constantly looking for new attractions to lure the fashionable crowds which might be tempted to dally with rival attractions like Ranelagh Gardens, a short distance upstream.[5]

Few of the original supper box pictures survive and those that can still be accounted for are mostly in such appalling condition that they do little to enhance the artist's reputation. Much of their present disfigurement is the result of re-touching and over-painting to which they were more prone than even the most vulnerable pictures in less public settings. As early as 1755 *The Gentleman's Magazine* reported that 'At Vauxhall . . . they have touched all the pictures, which were damaged last season by the fingering of those curious Connoisseurs, who could not be satisfied without *feeling* whether the figures were alive.'[6] By the time surviving pictures were dispersed at auction in 1841, when the Gardens finally closed,[7] some of them were described as 'nailed to boards, and much obscured by dirt'.[8] It is not difficult to imagine the damage wrought upon them by a combination of immoderate behaviour and the effects of London's damp climate. Even though the pictures were removed in winter, it is unlikely that they were stored away each night during the Vauxhall season, which ran from the beginning of May through to the end of September.[9]

Despite many of the original canvases having perished, we are able to gain a good idea of the appearance of those lost with the aid of the 1743 engravings and a small group of Hayman's original designs, executed by him in pen and brown ink (see cat. nos. 55–61). These drawings provide a clue to the complex issue of authorship of the paintings. Several of the drawings are squared up for transfer and one of them, *Flying the Kite* (cat. no. 55) is inscribed in Hayman's own clear hand 'the Figures 2 ft. 5 In: or 6'. This is of some significance since it clearly suggests instructions to assistants employed to do the bulk of the painting. Drawings like these probably existed for all the Vauxhall pictures, as aids for Hayman's assistants since the sheer yardage of canvas (each one measured *c.* 50 × 96 ins.) was too great for one artist to undertake alone. Anyway, they were not meant to be seen as anything more ephemeral than the sort of scene painting that Hayman had been doing for years at Goodman's Fields and Drury Lane Theatres (see Chapter 2). Hayman's rôle, apart from supplying most of the designs, was probably mainly supervisory. An anonymous guidebook to Vauxhall published in 1762 states that the pictures were executed from the *designs* of Hayman and Hogarth.[10] The reference to Hogarth alludes to the copies of his four *Times-of-the-Day* which he authorised but did not execute himself. Although Hogarth had undoubtedly played an important rôle in persuading Tyers to import works of art into the Gardens, it is extremely unlikely, contrary to some scholarly opinion, that he executed any of the paintings himself.[11]

Tyers' audience at Vauxhall Gardens was largely comprised of the newly literate middle-class public to whom Richardson addressed his novels, and the remarkable variety of subject matter employed by Hayman and his assistants was in some respects a visual counterpart to those developments in literature.

Although for the most part, the subject matter of the pictures falls into a number of distinct and remarkably novel categories; children's games; scenes from popular plays and contemporary novels; rural traditions and popular pastimes, etc., there does not appear to be any adherence to a specific iconographic programme. T. J. Edelstein has convincingly suggested in a recent essay that the essential theme, if indeed there is one, appears to be have been the vanity of worldly pursuits depicted through games of risk and chance involving young men and women.[12] Indeed, the theme of youth is foremost in many of the Vauxhall paintings. By the mid-eighteenth century, parents were prepared to lavish considerable sums of money on children, not only for education but for amusement.[13] This is borne out in painting where, after about 1730, children are frequently shown playing, reading, fishing or picnicking with their parents. A glance at some of the earlier conversation pieces of Hogarth, J. F. Nollekens, Devis and Hayman himself is evidence of this shift in attitudes towards greater emotional involvement of parents with their children. A new social attitude towards children had begun to strengthen in the early years of the century, given substance by the works of philosophers like John Locke whose influential *Some Thoughts Concerning Education*, published in 1693, remained important throughout the eighteenth century for its educational theory.[4] Educational facilities, designed to amuse and instruct, especially for the commercial classes, grew steadily as did the numerous handbooks on the care and education of children 'to teach them the Government of themselves, their Passions and Appetites'.[15]

The Vauxhall pictures concentrated on the leisure aspect of children's lives. *Flying the Kite*, *Battledore and Shuttlecock*, *Sliding on the Ice*, *Leap-Frog* and *See-Saw* are all energetic examples of children and youth at play while *Thread my Needle*, *Hunt the Whistle*, *Bob-Cherry*, *Hot Cockles*, and *The Cutting of Flour* were traditional party-games with a particular, although not exclusive, appeal to the young.

French Rococo painting, with its emphasis on artifice and pleasure, provided numerous hints for Hayman and his assistants. The mildly erotic *Play of See-Saw* (cat. no. 32) is particularly French in spirit and *Blindman's Buff*, *Bird-nesting* and *Bird-catching* all have precedents in the art of Watteau and Lancret. Judging from the engravings, *Mademoiselle Catherina* and *The Gypsy Fortune Teller* (CL. 198, 212) were similar in manner; in both cases Hayman's conversation-piece style was adapted in imitation of the French *scéne-galante*.[16]

In the early 1740s the French taste in painting reached its peak in England.[17] Gravelot played a major rôle by injecting a distinct note of French elegance into the shaky tradition of English draughtsmanship. The Frenchman's characteristically sinuous, spidery line could enliven even the most mundane subject matter.

Given Hayman's debt to Gravelot, witnessed not only in his book illustrations but in his early figure style wherein the poses often derive from the example of the graceful and waspish elegance of the Frenchman's assured pencil, we might have been surprised if Gravelot had not been involved with the Vauxhall decorations in some way. Although he did not actually paint any of the large canvases, he certainly designed several of them which, even without other evidence, would be attributable to him on stylistic ground alone.

For a few brief years in the 1740s at Vauxhall Gardens could be found the most ambitious expression of that peculiarly elusive style – the Rococo – to be found in England.

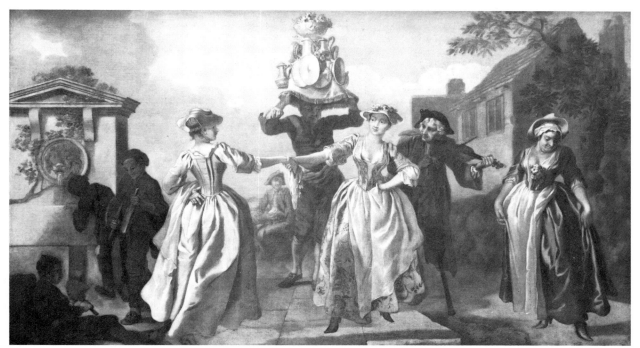

30.

1. [Lockman], op. cit. p. 28.
2. The most recent studies of Vauxhall Gardens include David Coke, *The Muse's Bower, Vauxhall Gardens 1728–1786* (Sudbury, Gainsborough's House, 1978); T. J. Edelstein & Brian Allen, *Vauxhall Gardens*, Yale Center for British Art (New Haven, 1983); David Coke, 'Vauxhall Gardens' in *Rococo Art & Design in Hogarth's England*, op. cit., pp. 74–98; John Dixon Hunt, *Theatre in Focus; Vauxhall and London's Garden Theatres* (1985) and Brian Allen, 'Francis Hayman and the Supper Box Paintings for Vauxhall Gardens' in *The Rococo in England* (Victoria & Albert Museum, 1987).
3. *The Gentleman's Magazine*, XII (August, 1742) p. 440.
4. The earliest listing is in the anonymous *A Description of Vauxhall Gardens* (London, 1762).
5. For Ranelagh Gardens see Mollie Sands, *Invitation to Ranelagh 1742–1803* (London, 1946) and recently Giles Worsley, '"I thought Myself in Paradise" Ranelagh and its Rotunda', *Country Life* (15 May 1986) pp. 1379–1383.
6. *The Gentleman's Magazine*, XXV (1755), p. 206.
7. Sale conducted by Messrs Ventom & Hughes, 12 October 1841 on the premises (the pictures comprised lots 180–201 and lot 206).
8. John Timbs, *The Curiosities of London . . . &tc.*, (London, 1876) p. 814.
9. Frederick Kielmansegge noted after his visit to Vauxhall in November 1761 that 'In most of them [the supper boxes] are said to be paintings by Hayman, which are removed in winter, especially the four large and fine pieces representing scenes from Shakespeare's plays, which are in the large pavilion' (Count Frederick Kielmansegge, *Diary of a Journey to England . . . &tc.*, op. cit., p. 167.)
10. *A Description of Vauxhall Gardens*, op. cit., p. 28.
11. Hogarth's involvement was the basis of Lawrence Gowing's important pioneering article 'Hogarth, Hayman and the Vauxhall Decorations', *Burlington Magazine*, XCV (January 1953) pp. 4–19.
12. T. J. Edelstein, 'The Paintings' in *Vauxhall Gardens*, Yale Center for British Art (1983) pp. 25–32.
13. The most useful general studies of childhood in the eighteenth century are J. Somerville, 'Towards a History of Childhood and Youth', *Journal of Interdisciplinary History*, III (1972) pp. 438–447; Ivy Pinchbeck and Margaret Hewitt, *Children in English Society*, 2 vols. (London, 1969–1973) and *The History of Childhood*, ed. L. de Manse (New York, 1974).
14. The best edition is *The Educational Writings of John Locke*, ed. J. L. Axtell (Cambridge, 1965).
15. [Anon.], *Dialogues on the Passions, Habits, Appetites and Affections, &tc., Peculiar to Children* (London, 1748) VIII, quoted by J. H. Plumb in his essay 'The New World of Children in Eighteenth-Century England', *Past and Present*, no. 67 (May 1975) pp. 64–93. See also N. Hans, *New Trends in Education in the Eighteenth Century* (London, 1951).
16. See my article 'Watteau and his Imitators in Mid-Eighteenth-Century England', loc. cit.
17. See Ellis K. Waterhouse, 'English Painting and France in the Eighteenth Century', *Journal of the Warburg and Courtauld Institutes*, XV (1952) p. 122 and Elizabeth Einberg, *The French Taste in English Painting During the First Half of the 18th century*, The Iveagh Bequest, Kenwood (1968).

30. MAY DAY OR THE MILKMAID'S GARLAND *c.* 1741–2

Oil on canvas, $54\frac{1}{2} \times 94\frac{1}{2}$ (138.5 × 240)

Prov: painted for Vauxhall Gardens; Earl of Lonsdale; sale, Lowther Castle, Maple & Co., 30 April 1947 (1900) as by Hogarth; acquired by the V & A with a grant from the N.A.C.F.

Exh: Montreal, Ottawa, Toronto and Toledo, *British Painting in the Eighteenth Century*, 1957–8 (24); Liverpool Walker Art Gallery, *Painting and Sculpture in England 1700–1750*, 1958 (12); Cologne, Wallraf-Richartz Museum, *Englische Malerei der Grossen Zeit*, 1966 (23); Iveagh Bequest, Ken-

wood, *The French Taste in English Painting During the First Half of the 18th century*, 1968 (34); Sudbury, Gainsborough's House, *The Muse's Bower Vauxhall Gardens 1728–1786*, 1978; Munich, Haus der Kunst, *Zwei Jahrhunderte Englische Malerei – Britische Kunst und Europa 1680 bis 1880*, 1979–80 (17); Marble Hill House, *May-Day or The Milkmaid's Garland*, 1982 (2).

Engr: by Charles Grignion, published 23 May 1743 (see cat. no. 31)

Coll: London, Victoria & Albert Museum

Until the early nineteenth century the Milkmaids of London took to the streets and danced on May Day and the days following. The tradition is explained in a *Spectator* essay published in 1712:

> It is likewise on the first Day of the Month that we see the ruddy Milk-Maid exerting her self in a most sprightly manner under a Pyramid of Silver Tankards, and like the virgin *Tarpeia* oppress'd by the costly Ornaments which her Benefactors lay upon her. These decorations of silver cups, tankards, and salvers, were borrowed for the purpose, and hung round the milk-pails, with the additions of flowers and ribbands, which the maidens carried upon their heads when they went to the houses of their customers, and danced in order to obtain a small gratuity from each of them.[1]

Hayman's lively composition shows not only the Milkmaid's Dance but also the young chimney sweeps, who as part of another May Day custom, beat their brushes and shovels in competition with the Milkmaids' fiddler.

Of the fifteen or so surviving Vauxhall paintings *May Day* is the least damaged and preserves a good deal of the lightness of touch which must have characterised Hayman's original canvases in their pristine state. It was J. T. Smith who first observed the similarity between Marcellus Laroon's *The Merry Milk Maid*, engraved for a series of *The Cryes of The City of London*, and the porter carrying the garland in this picture.[2] Laroon's series also includes *The Merry Fidler* and *The Chimney Sweep*, both of whom recur in Hayman's picture.[3] Another of the May Day customs, dancing round the May-Pole, was the subject of another of the Vauxhall canvases (CL. 179).

The composition of this picture is very similar to one of Hayman's contemporary designs for Sir Thomas Hanmer's edition of Shakespeare. Perdita in *The Winter's Tale* (CL. 219 (14)) is almost identical in pose with the milkmaid between the porter and the fiddler.

Hayman's design was later used by Robert Hancock for transfer printing on Worcester porcelain.[4]

1. *The Spectator*, no. 365, 29 April 1712. For other contemporary accounts of the custom see Jacob Simon, *May Day or the Milkmaid's Garland*, Marble Hill House (1982). It is also worth noting that a Milkmaid's Dance was occasionally performed at London theatres in the month of May (see *The London Stage Part 2 1700–1729*, 2 vols. (Carbondale, 1960) II, cf. entries for May 1728).
2. See J. T. Smith, *A Book for a Rainy Day ... &tc.* (London, 1845) pp. 15–16.
3. See Robert Raines, *Marcellus Laroon* (London, 1966) pp. 24–5.
4. See Cyril Cook, *The Life and Works of Robert Hancock ... &tc.* (London, 1948) item 68 repr.

31. (AFTER FRANCIS HAYMAN) MAY DAY OR THE DANCE OF THE MILKMAIDS *c.* 1743

Oil on canvas, $13\frac{1}{4} \times 17\frac{1}{4}$ (33.5 × 43.5)

Prov: Sale, Robinson and Fisher, *c.* 1934; Mrs James Byam Shaw; Christie's, 23 March 1979 (106)

Exh: London, Royal Academy, *English Taste in the 18th Century*, 1955 (108); Kenwood, 1960 (25); Marble Hill House, *May Day or the Milkmaids Garland*, 1982 (1)

Engr: by Charles Grignion, published 23 May 1743

Coll: The Iveagh Bequest, Kenwood

The squarer shape of this small picture suggests that it was almost certainly produced for the engraver Charles Grignion to use in making his plate for the series of engravings after the Vauxhall paintings (see cat. no. 62). It may even have been painted by Grignion himself. A number of small details, which must derive from the original Vauxhall supper box picture (cat. no. 30) indicate that it is not a copy made from the engraving.

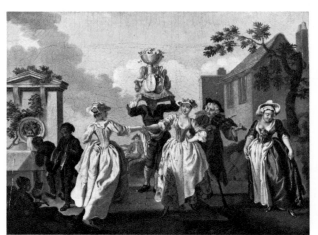

31.

32. THE PLAY OF SEE-SAW *c.* 1741–2

Canvas, 54 × 95 (137 × 241)

Prov: painted for Vauxhall Gardens; Earl of Lonsdale; his sale, Lowther Castle, by Maple & Co., 30 April 1947 (1897) as 'English School'; A. Carysfort, Blackburn; with Appleby Bros. (dealer) by 1960; acquired by Tate Gallery in 1963

Exh: Victoria & Albert Museum, *Rococo Art & Design in Hogarth's England*, 1984 (F.25)

Engr: by L. Truchy, published 1 February 1743

Coll: London, Tate Gallery

Beneath the apparently frivolous subject matter lies a moral lesson about the fragility of life. The see-saw is a precarious structure, pieced together from a few bits of rough timber. On an axis almost parallel to its fulcrum a ruined medieval tower rises in the background, whilst to the right this theme

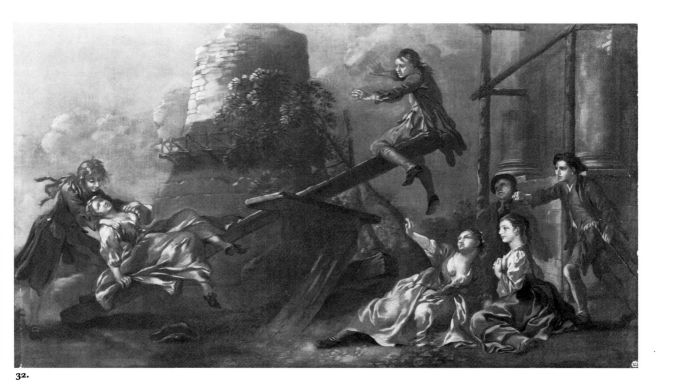

32.

is echoed by the decaying classical structure supported by scaffolding, intended to suggest the transience of these manifestations of human civilisation.[1]

The young woman riding the lower end of the see-saw is saved from a fall by the young man who comes to her rescue. The youth at the top meanwhile is stranded and holds out his hands in alarm to regain his balance, a gesture echoed by the young woman beneath. The apparently playful intimacy of the couple on the left has angered the youth on the right who approaches with clenched fist to challenge his rival suitor. The inscription on Truchy's engraving of the picture appropriately reads:

> Where at the top of her advent'rous Flight
> The frolick Damsel tumbles from her Height:
> Tho her Warm Blush bespeaks a present Pain
> It soon goes Off – she falls to rise again;
> But when the Nymph with Prudence unprepared,
> By pleasure sway'd – forsakes her Honours Guard:
> That slip once made, no wisdom can restore,
> She falls indeed! – and falls to rise no more.

Hayman must have known his friend Gravelot's *See-sawing* of the late 1730s from his series of engravings entitled *Jeux d'Enfants* since he borrows but reverses several motifs directly from it, including the boy with outstretched arms balanced on the top of the see-saw.

Despite its rather battered condition – it has been much overpainted in places – there are still strong traces of Hayman's hand, particularly in the handling of the young girl on the right.

1. Truchy's engraving elaborates on the painting by introducing a section of a ruined column and further foreground vegetation.

33. SLIDING UPON THE ICE *c.* 1741–2

Oil on canvas, 55 × 96 (139.7 × 243.8)

Prov: painted for Vauxhall Gardens; Earl of Lonsdale; his sale, Lowther Castle, by Maple & Co., 30 April 1947 (1902); bt. Baron Hugo von Grundherr; acquired by the V & A in 1947

Engr: by R. Parr, published 23 May 1743

Coll: London, Victoria & Albert Museum

Seasonal pastimes provided the subject matter for several of the Vauxhall pictures (see cat. no. 30). As Joseph Strutt noted in 1830 'sliding upon the ice appears to have been a very favourite pastime among the youth of this country in former times; at present the use of skates is so generally diffused throughout the kingdom that sliding is but little practised, except by children and such as cannot afford to purchase them'.[1]

33.

T. J. Edelstein has argued that the iconography of those supper box paintings depicting games of chance and risk can be traced back to the moral epigrams in traditional emblem books,[2] and John Lockman, who composed the following verses that appeared beneath Parr's engraving of this picture, must have been aware of that tradition:

> Shew what Man in life's maturer Course,
> An Infant still in purpose – but a Worse;
> He trips his foremost down with joy of mind,
> Nor sees th'impending danger from behind.

The viewer is presumably meant to associate a life of futile pleasure with ultimate disaster.

Despite recent conservation, *Sliding upon the Ice* is typical of the poor condition of most of the surviving supper box pictures. It is very thinly painted, rather in the manner of the stage scenery with which Hayman began his career, but has suffered extensively from the re-touching and overpainting that was done regularly to prepare the pictures for the new season in the open-air at Vauxhall.

1. Joseph Strutt, *The Sports and Pastimes of the People of England* (London, 1830) p. 86.
2. Yale 1983, p. 28.

34. A PORTRAIT OF A MASTIFF *c.* 1743–4 — Fig. 28, p. 54

Oil on canvas, $17\frac{3}{4} \times 39\frac{1}{2}$ (45 × 103)

Prov: Dr Cox Macro; by descent to John Patteson; Miss Patteson; acquired by Norwich Castle Museum in 1984

Coll: Norwich, Castle Museum

This portrait of a mastiff, a Charles II spaniel and a pug was one of a set of four overdoor paintings of dogs done for the Suffolk antiquary and collector, Dr Cox Macro (see pp. 51–3). The other three in the series were executed by Macro's friend Peter Tillemans, but he had presumably not begun the last one on his death in 1734.[1] Hayman was probably asked to complete the series in 1743 when he was employed by Macro at Little Haugh Hall to complete the decorative paintings also begun by Tillemans a decade earlier. Conveniently, Macro confirms this in a manuscript catalogue of his collection which he compiled himself: 'The Hall . . . Three of the Dog pieces over the doors P. Tillemans unfinish'd. The fourth door Piece wherein is the Mastiff. Hayman'.;[2] In his 'Diary of Purchases' Macro also recorded payment for this and two Shakespearean pictures (CL. nos. 126, 129) which Hayman had also apparently completed: 'Pd. Hayman . . . for the three pieces. viz. The Dogs, Timon and Lear £8-8-0'.[3]

Although dogs appear regularly in Hayman's outdoor conversation pieces, this is the only animal painting in his œuvre and it recalls the work of the seventeenth-century painter Francis Barlow, whose works must have been known to Hayman in the original or through engravings.[4] However, it is also worth comparing this with one of the young Thomas Gainsborough's earliest dateable works, *'Bumper' – a bull terrier* of 1745 (fig. 29), as a reminder of the close links between the artists in the mid-1740s.

1. See Robert Raines, 'An Art Collector of Many Parts', *Country Life* (24 June 1976) 1693 and the same author's 'Peter Tillemans, Life

and Work, with a list of representative paintings', *Walpole Society*, XLVIII (1978–80) pp. 39, 43.

2. 'Ms. Catalogue of Cox Macro's paintings, in his own hand', (after 1734), Castle Museum, Norwich.
3. 'Cox Macro's Diary of Purchases', Bodleian Library, English Miscellany e.346, f.261.
4. See, for example, some of the drawings by Barlow, engraved by Hollar between 1659 and 1663 for *Variae Quadrupedum species* (see Edward Croft-Murray & Paul Hulton, *Catalogue of British Drawings Vol. 1: XVI & XVII Centuries*, 2 vols. (London, British Museum, 1960) I, p. 102, no. 13, pl. 56.

35.

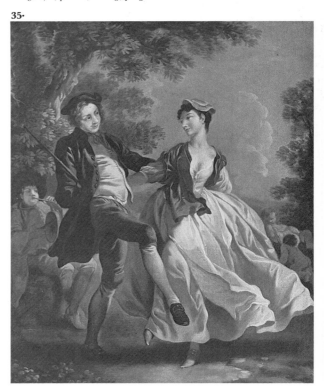

Fig. 45 Antoine Watteau, *La Danse Champêtre*. Canvas, $19\frac{1}{2} \times 25\frac{5}{8}$ (49.4 × 65) Indianapolis Museum of Art: Gift of Mrs Herman C. Krannert

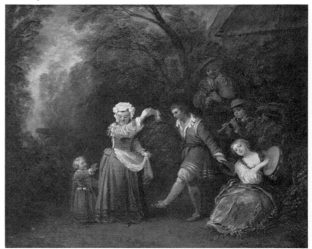

35. RUSTIC FIGURES DANCING early 1750s Colour Plate VI

Oil on canvas, $25\frac{1}{4} \times 20\frac{1}{4}$ (64.1 × 51.4)

Prov: London, Leger Galleries

Exh: London, Leger Galleries, *The Gracious Age, An Exhibition of English Painting,* 1967 (6)

Coll: Private Collection

Probably painted in the early 1750s, this charming picture reflects the subject matter of some of the Vauxhall supper box decorations like *May Day or the Dance of the Milkmaids* (cat. no. 30) or *Dancing round the May-Pole* (CL. 179). It has its stylistic origins in those early pictures by Watteau executed in the manner of peasant scenes by Netherlandish seventeenth-century masters like David Teniers or Adrian Van Ostade. Works like *La Danse Champêtre* by Watteau, engraved by Dupin, depict similar rustic figures in a wooded glade with musicians in the background (fig. 45). Like Watteau's, Hayman's images differ from their seventeenth-century prototypes in that his peasants are dressed in their best clothes and their surroundings are relatively neat and decorous. This atmosphere of pastoral fancy is paralleled in mid-eighteenth century France in the imaginative works of Boucher. A similar pair of figures appear in an early drawing by Gainsborough.[1]

1. See John Hayes, *The Drawings of Thomas Gainsborough,* 2 vols. (London, 1970) I, p. 110, cat. 3, pls. 7, 8.

36. A LECHEROUS MONK (POSSIBLY LORD DESPENCER) early 1760s

Oil on canvas, 21 × 19 (53.3 × 48.2)

Prov: believed to have been purchased by Fourth Earl of Egremont in the 1830s; thereafter by descent

Coll: Private Collection

Although there is no evidence to support the theory, this amusing portrait probably represents Sir Francis Dashwood (1708–1781), later Lord le Despencer and one of the most notorious rakes of his day, fondling one of the 'nuns' of Medmenham Abbey.[1]

In about 1746 Dashwood founded a club, the Knights of St. Francis, which initially met at the George and Vulture in Cornhill and later at Medmenham Abbey on the banks of the Thames near Marlow, which was rented *c.* 1751 and renovated by Dashwood to house his licentious play-acting. The Rabelasian motto 'Fay ce que voudras' was placed above a doorway in the Abbey and the grounds were full of caves where the 'friars' could endulge their fantasies with the 'nuns', usually well-known courtesans or prostitutes transported to Buckinghamshire in great secrecy.

The members were mostly supporters of Frederick, Prince of Wales and, after his death in 1751, of his son the future George III. In 1762 the brotherhood was torn apart by conflicting political opinions. The radical politician John Wilkes (1727–1797) who became a member in 1758 was, characteristically, one of the most vociferous rebels and penned a spiteful satirical publication that exposed the order's sexual debauchery and gave it widespread notoriety. After this disruption, Dashwood abandoned Medmenham and trans-

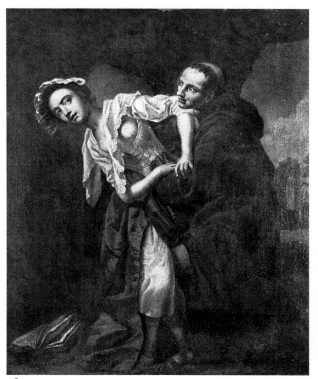

36.

ported his materials to the so-called 'Hellfire Caves' on his nearby estate at West Wycombe.[2]

It may have been news of these events that prompted Hayman's painting which stylistically dates from the early 1760s. Nothing whatever is known about the circumstances of its production except that Hayman painted another version, which is now in the Musée Magnin at Dijon, until recently attributed to Hogarth (CL. 164). Indeed, it is Hogarth whom we more commonly associate with the type of 'special commission' that resulted in pictures like *Before* and *After*.[3] In the late 1750s Hogarth, of course, had also painted Dashwood as a monk in *St. Francis at his Devotions*[4] but we should recall the much earlier painting done by George Knapton for the Dilettanti Society, in which Dashwood is shown in Franciscan habit gazing fixedly at the middle of the Medici Venus.[5]

In Hayman's picture the setting is a cave beyond which can be seen the medieval gateway, presumably meant to represent Medmenham Abbey. The manic, wide-eyed figure of Dashwood is seen fondling a young woman who vainly tries to restrain him as he attempts to push her towards the day-bed immediately behind her.

1. See Betty Kemp, *Sir Francis Dashwood; an Eighteenth-Century Independent* (London, 1967).
2. See Donald McCormick, *The Hell-Fire Club* (London, 1958) pp. 164–181.
3. See Paulson, op. cit., I, pp. 229–234.
4. Ibid., II, pp. 255–57, repr. pl. 269.
5. See Cecil Harcourt-Smith, *The Society of Dilettanti, Its Regalia and Pictures* (London, 1932) 52, no. 6, pl. XI.

37. THE WRESTLING SCENE FROM 'AS YOU LIKE IT' *c.* 1740–42
Colour Plate VII

Oil on canvas, 20¾ × 36¼ (52.7 × 92.1)

Prov: possibly the 'Scene from As You Like It' sold at the
Jonathan Tyers Jr. sale, Christie's, 28 April 1830 (28), bt.
Gilmore; Anon. sale (=Sir Alec Martin), Christie's, 19
November 1948 (131) as by De Troy, bt. Jameson (bt. in
?); Dr Brian Rhodes; his sale, Christie's, 28 July 1950 (173)
as De Troy (bt. in.); Anon sale, Christie's, 18 December
1953 (77) as Hayman, bt. Agnew from whom acquired by
the Tate Gallery

Exh: Kenwood, 1960 (16); Arts Council, *Shakespeare in Art*,
1964 (12)

Coll: London, Tate Gallery

Although this is not one of the designs used for a supper box
painting at Vauxhall Gardens, its horizontal format cor-
responds to those large pictures and it may even have been
painted for Jonathan Tyers to demonstrate what Hayman
had in mind for that ambitious decorative scheme. On the
basis of style a date of execution very early in the 1740s is
likely, and the composition has been adapted from the design
made *c.* 1740–41 for the Hanmer edition of Shakespeare (see
cat. no. 82a). The upright format of the book illustration gives
way to a horizontal composition in which a few minor modifi-
cations have been made, primarily the introduction of a classi-
cal colonnade in the top left of the composition and the
necessary addition of a few more figures.

Hayman illustrates the moment in Act I, Scene VI
(Hanmer edition) when Orlando has thrown Charles, the
Duke's wrestler, on the ground whilst Celia, the Duke
Frederick and others watch. The influence of contemporary
French painting, imparted in this instance through Hayman's
friend Gravelot, is especially marked and as recently as 1950
it passed as a work by De Troy.

It is worth noting that a 'Mr Hayman', probably our pain-
ter, appeared in the rôle of Silvius in *As You Like It* at Covent
Garden Theatre on three occasions between 1744 and 1746.[1]

1. See *The London Stage 1660–1800 Part 3: 1729–1747* (Carbondale,
1961) pp. 1127, 1182 and 1273.

38. THE PLAY SCENE FROM HAMLET *c.* 1745

Oil on canvas, 13 × 10½ (33 × 26.7)

Prov: purchased from Betts in 1927

Coll: Washington D.C., Folger Shakespeare Library

Hayman was evidently in the habit of making small oil
sketches for his historical pictures and this is the *modello* for
one of the four large Shakespeare pictures which Vertue tells
us were placed in the Prince of Wales's Pavilion at Vauxhall
Gardens in 1745 (see p. 16). It corresponds closely to the
design for the lost large picture which was described in an
early guidebook to Vauxhall Gardens. Although Hayman
had illustrated the same episode in the play for the Hanmer
edition of Shakespeare (CL. 219 (30)), he made considerable
modifications for the version in paint. In the Hanmer plate
the King and Queen are at the left, Hamlet, Ophelia and

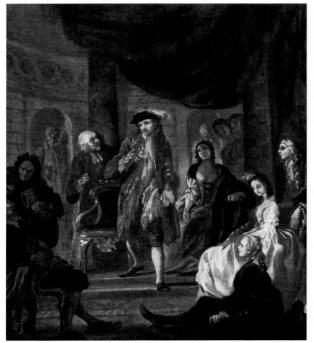

38.

Horatio at the right, and the players back centre with musi-
cians on a gallery above them, but in this sketch and the large
finished oil, the King is shown rising from his throne which
is set on a dais in the centre of the composition with Polonius
and the Queen on either side of him. The players enact the
murder to the lower left as described in the Vauxhall guide-
book: 'On one side of the painting is seen Lucianus pouring
the poison into Gonzago's ear while he is a sleep in the
garden'.[1]

Professor Moelwyn Merchant argued that Hayman's inter-
pretation corresponded to contemporary staging of *Hamlet*
where the play scene was enacted down-stage in front of the
king and facing the audience.[2] Hayman was certainly familiar
with the latest staging techniques since he apparently played
the rôle of the priest in *Hamlet* at Covent Garden on four occa-
sions in the mid-1740s.[3] One wonders if, as is the case with
King Lear and *Othello*, David Garrick offered some timely
advice that occasioned these subtle changes?

The composition of this and another reduced version of the
Vauxhall picture (CL. 132) may owe something to engrav-
ings after Watteau's theatrical scenes such as *Comédiens Italiens*,
engraved by Baron.

Some years later Hayman painted the closet scene from
Hamlet (cat. no. 41).

1. See *A Description of Vaux-Hall Gardens* (London, 1762) pp. 12–14.
2. Moelwyn Merchant, *Shakespeare and the Artist* (Oxford, 1959) 47.
 Also K. A. Burnim, 'Eighteenth Century Theatrical Illustrations
 in the Light of Contemporary Documents', *Theatre Notebook*, XIV,
 2, (Winter 1959) pp. 53–54.
3. See *The London Stage 1660–1800 Part 3: 1729–1747*, 2 vols. (Car-
 bondale, 1961), II, pp. 1078, 1170, 1182 and 1251.

39. A SCENE FROM 'THE SUSPICIOUS HUSBAND' *c.* 1747

Colour Plate VIII

Oil on canvas, 28 × 36 (71.25 × 91.5)

Prov: painted for Benjamin Hoadly; Mrs Hoadly in 1781; T. Harris; his sale, Robins' Rooms, 12 July 1819 (53); Rowland Stephenson; sale by Shuttleworth, 13 April 1829 (18); Charles Mathews; bt. from Mrs Mathews by J. R. Durrant for the Garrick Club *c.* 1835; sold by Garrick Club in 1970 to Paul Mellon

Exh: London, Queen's Bazaar, 1833 (22); London, Royal Academy, *British Art*, 1934 (77); London, Tate Gallery, *Pictures from the Garrick Club*, 1951 (22); Yale Center for British Art, *The Pursuit of Happiness . . . &tc.*, 1977 (54)

Coll: Yale Center for British Art, Paul Mellon Collection

Benjamin Hoadly's comedy *The Suspicious Husband* was first performed at Covent Garden on 12 February 1747 with David Garrick (1717–1779) and Mrs Hannah Pritchard (1709–1768) in the leading rôles of Ranger and Clarinda.[1] Their appearance together was, as Garrick's biographer Arthur Murphy tells us, a sensational success:

> The play had a considerable run. The public were glad to see the revival of true comedy, after a long Gothic night, without one star of genius left in the hemisphere. Clarinda was performed by Mrs Pritchard with that spirit, grace and elegance, which distinguished all her fine ladies. Ranger, as Garrick presented him, was the most sprightly, gay, frolicksome young rake that had ever been seen on the stage.[2]

Hayman depicts the moment from Act IV, Scene IV when Ranger, a young rake out on the town, has mistaken Clarinda for a woman of easy virtue. He is alarmed to discover as she unmasks that she is in fact his cousin Clarinda:

> Ranger: Oh! your humble Servant Madam! you had liked to have beholden to your Mask, Cousin! I must brazen it out [aside][3]

A pencil and red chalk drawing of this episode which may have been done from the life (cat. no. 69) shows that Hayman slightly modified his original ideas. In the drawing, which follows the text closely, Clarinda's maid is present to the right, and she may have originally been included in the painting for there is a suggestion of *pentimenti* to the right above the chair.

This version was apparently painted for Hoadly himself soon after the play was first performed but in 1752 Garrick paid Hayman twenty guineas for a rather inferior replica which is now in the Museum of London (CL. 137).[4] There are no visible signs of *pentimenti* in the later version and it is possible that Hayman made alterations to this the Hoadly version on Garrick's advice. Garrick probably felt that the presence of the maid detracted from the presence of the stars.

Hayman painted two other portraits of Mrs Pritchard which still hang in the Garrick Club (CL. nos. 39, 40).

1. See *The London Stage Part 3*, op. cit., II, p. 1287. For Mrs Pritchard see Anthony Vaughan, *Born to Please; Hannah Pritchard Actress 1711–1768 A Critical Biography* (London, 1979) pp. 42–43.
2. Arthur Murphy, *The Life of David Garrick* (London, 1801) 81, cited

by Vaughan, op. cit., p. 43.
3. See [Benjamin Hoadly], *The Suspicious Husband* (London, 1747) p. 56.
4. The autograph collector William Upcott was in possession of a receipt dated 26 May 1752 from Hayman to Garrick. A copy is bound into J. H. Anderdon's extra-illustrated copy of Edward Edwards, *Anecdotes . . . &tc.*, in the Dept. of Prints & Drawings at the British Museum.

40. ROBERT LOVELACE PREPARING TO ABDUCT CLARISSA HARLOWE *c.* 1753–4

Oil on canvas, 24½ × 29½ (62.2 × 74.9)

Prov: Curzon collection (= Anon. sale), Christie's, 10 July 1931 as Zoffany, bt. Gerault; Rev. A. J. Elgar; Thos. Agnew & Sons Ltd.; purchased by Southampton in 1965

Exh: Bournemouth, Russell Cotes Art Gallery & Museum, *The Art of 1740–1840 lent by local collectors*, 1943 (888) as Zoffany; London, Wildenstein, *Pictures from Southampton*, 1970 (17)

Coll: Southampton Art Gallery

Samuel Richardson's *Clarissa* was first published in 1747–48 and this picture illustrating an episode from the book was painted just a few years later.[1]

Hayman already had experience of illustrating Richardson's work, and his and Gravelot's designs for *Pamela* had been published in 1742 (cat. no. 81). The episode represented here is when Robert Lovelace persuaded Clarissa to elope with him in order to avoid being married to one of her suitors, Mr Solmes. In Letter XCIV, Clarissa writes to her friend and confidante Miss Anna Howe:

> I stepped to the garden door; and seeing a clear coast, unbolted the ready-unlocked door – and there was he, all impatience, waiting for me!
>
> A panic next to fainting seized me when I saw him. My heart seemed convulsed; and I trembled so, that I could hardly have kept my feet had he not supported me.

40.

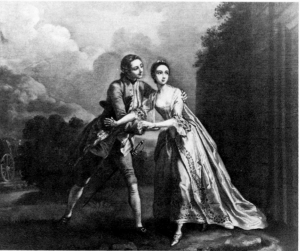

115

Fear nothing, dearest creature, said he! – Let us hasten away! – The chariot is at hand! – And by this sweet condescension, you have obliged me beyond expression, or return!

Recovering my spirits a little, as he kept drawing me after him, Oh Mr Lovelace, said I, I cannot go with you! – *Indeed I cannot!* . . .[2]

Slightly later in the novel Lovelace recalls the same event in a letter XCIX to John Belford and describes Clarissa's attire:

Her morning gown was a pale primrose-coloured paduasoy: the cuffs and robings curiously embroidered by the fingers of this ever charming Arachne in a running pattern of violets and their leaves; the light in the flowers silver; gold in the leaves[3]

Hayman followed the text quite closely in painting Clarissa's dress except for the petticoat which is embroidered to match the gown.

The composition is similar to one of Hayman's illustrations for *Pamela – Pamela Fleeing to the Coach from Lady Davers* – which was also adapted to one of the large Vauxhall supper box pictures (cat. no. 81).

1. I am grateful to Dr Aileen Ribeiro of the Courtauld Institute for help with the dating of Clarissa's costume.
2. Samuel Richardson, *Clarissa, or The History of a Young Lady*, edited with an Introduction and notes by Angus Ross (Harmondsworth, 1985) p. 374.
3. Ibid., p. 400.

41. SPRANGER BARRY AND MRS MARY ELMY IN "HAMLET" *c.* 1755–60

Oil on canvas, 50½ × 43 (128.3 × 109.2)

Prov: probably T. Harris sale, Robins' Rooms, 12 July 1819 (32); Charles Mathews; bt. 1835 for the Garrick Club

Exh: London, Queen's Bazaar, 1833 (168); London, Tate Gallery, *Pictures from the Garrick Club*, 1951 (21); Kenwood, 1960 (18); Arts Council, *Shakespeare in Art*, 1964 (13)

Coll: London, The Garrick Club

Most of Hayman's Shakespearean pictures are adapted from his designs made at the beginning of the 1740s for the Hanmer edition of Shakespeare but, perhaps because he had already adapted the Hanmer plate for an oil painting (see cat. no. 38), he chose in this instance a different episode: the closet scene from Act III, Scene IV in which Hamlet, having just killed Polonius behind the arras, reproaches his mother the Queen for remarrying. Unseen by the Queen, the Ghost appears to the left in armour holding a baton:

Queen [to Hamlet]: '. . . Whereon do you look?'
Hamlet: 'On him! on him! look you, how pale he glares'

The actors are identified, by a tradition dating back to at least 1819,[1] as Garrick's great rival Spranger Barry (1719–1777) as Hamlet; Mrs Mary Elmy, née Morse (1712–1792) as the Queen and Lacy Ryan (1694–1760) as the Ghost. All three performed these parts together on a number of occasions

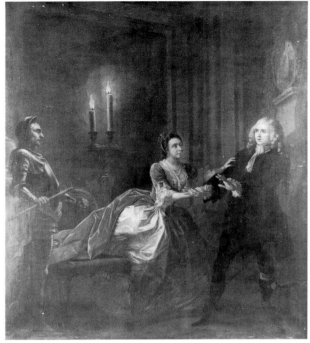

41.

between 1751 and 1754. A few years earlier Hayman had occasionally played the part of the Priest alongside Lacy Ryan as Hamlet.[2]

The Thomas Harris sale catalogue of 1819 (see *Prov* above) states that this picture was executed in 1757 and this is consistent with style. If the identity of Lacy is correct then we should certainly expect a date of execution prior to his death in 1760 and Mrs Elmy also retired in the same year.

The composition is not entirely original and seems, in general terms, to owe something to Kirkall's engraving after Boitard's drawing of the same episode, which appeared in Nicholas Rowe's edition of Shakespeare, published in 1709.[3] The arrangement of the figures, the twin candles and the overturned chair can all be found in the earlier engraving but perhaps they both owe their origin to contemporary ideas about the staging of the play.

A lively chalk drawing in the Folger Library shows Hayman's first ideas for the picture (cat. no. 74). Years later Grignion engraved this composition, substituting Garrick's features for Barry's, as the frontispiece for Charles Jennens' edition of *Hamlet* (CL. 311].

1. See Harris sale cat. referred to in Prov. above.
2. See *The London Stage Part 3*, op. cit., pp. 1078, 1170, 1182 and 1251.
3. See Montague Summers, 'The First Illustrated Shakespeare', *Connoisseur* CII (938) pp. 305–9.

42. DAVID GARRICK AS RICHARD III 1760

Oil on canvas, 36¼ × 28 (89.5 × 64.1) strips, 7¼ ins. at the top and 1¾ ins. at each side have been added
Inscribed lower left: *FH 1760*

Prov: Charles Jennens; by descent to Baroness Howe, who

owned it by 1811; Earl Howe in 1857; sale, Gopsall Hall by Messrs. Trollope, 21–22 October 1918 (1165) bt. W. Somerset Maugham and bequeathed by him to the National Theatre in 1951.

Exh: Society of Artists 1760 (25); Manchester, *Art Treasures Exhibition*, 1857 (11); Stratford Town Hall, *Theatrical Paintings and Relics*, 1864 (145); Kensington, Leighton House, *History of Shakespearean Production*, 1953; Lichfield, *Garrick, Johnson and the Lichfield Circle*, 1953 (4); Kenwood, 1960 (19); Twickenham, Orleans House Gallery, *Garrick to Kean; The Theatre and Theatrical Personalities of Richmond-upon-Thames*, 1974 (7); London, Hayward Gallery, *The Georgian Playhouse . . . 1730–1830*, 1975 (20).

Engr: In stipple by William Bromley, published 1811

Coll: London, The National Theatre

It is significant that Hayman chose to exhibit this small picture at the first exhibition of the Society of Artists in 1760 because it is the climax to the type of theatrical genre painting which he exploited with the advice of Garrick in the 1740s and 1750s, and a foretaste of the grander historical subjects that he aspired towards at the beginning of the new decade.

Hayman and Garrick have chosen the moment from Act V, Scene VIII of Shakespeare's *Richard III* when Richard on Bosworth Field cries out: 'A Horse, a Horse! My Kingdom for a horse'. Garrick was especially associated with the part

42.

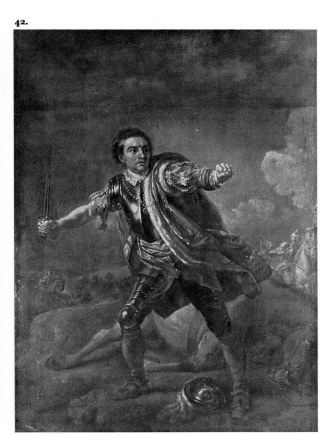

of Richard III since he had made his formal debut in the rôle at Lincoln's Inn Fields Theatre on Monday 19 October 1741.[1] His appearance in this, the Colley Cibber version of the play, was a sensation and he was later engaged to perform the part at Drury Lane.

Hayman's painting was probably prompted by Garrick's revival of the play at Drury Lane in October 1759, twenty-eight years to the day after his celebrated debut.[2] However, unlike Hayman's earlier theatrical pictures, such as the *Scene from The Suspicious Husband* (cat. no. 39), which closely follow actual theatrical productions and are meant to be set on stage, here we see the terror-stricken king on Bosworth Field next to the corpse of his horse. This attempt at historical veracity is more in keeping with the strictures of history painting than theatrical illustration and is partly the result of Hayman's experiments in the sphere of historical prints and book illustrations (see cat. nos. 78, 92).

The figure of the King, markedly similar in pose to that of Gloucester in *King Lear in the Storm* (CL. 219 (15), fig. 4) is almost identical to the much-admired antique marble of the *Borghese Gladiator*,[3] except that Hayman has, rather awkwardly, brought the dramatically foreshortened left arm round nearly into the plane of the picture. The armoured figure on the right is presumably Ratcliff about to answer the King's call for another horse.

This picture was one of the few singled out for praise by the anonymous critic who reviewed the 1760 exhibition in *The Imperial Magazine*:

Mr Garrick in the character of Richard III . . . in all the agitation of mind and body which Shakespear [sic] has given him on the fatal but well fought day of Bosworth battle: a most charming piece, where passion, expression and sweetness of colouring are most happily blended.[4]

Hayman's picture is not the earliest rendering of Garrick in this rôle. A picture by Thomas Bardwell in the Russell Cotes Art Gallery in Bournemouth is signed and dated 1741. Hogarth's celebrated picture of the tent scene, now at Liverpool, dates from 1745 and Hayman's pupil Nathaniel Dance's interpretation of the subject of 1771 owes much to his master's work.[5]

1. *The London Stage Part 3*, op. cit., p. 935.
2. Ibid., Part 4, p. 750.
3. Copies were to be found in the grounds of many country houses in the 18th century (see Haskell & Penny, *Taste and the Antique*, op. cit., p. 220).
4. *The Imperial Magazine* (May 1760) p. 245.
5. See [David Goodreau], *Nathaniel Dance 1735–1811*, Iveagh Bequest, Kenwood, 1977 (29)

43. FALSTAFF REVIEWING RECRUITS *c.* 1760–65 (?)

Oil on canvas, $39\frac{1}{2} \times 49\frac{1}{4}$ (102.5 × 125)

Prov: at Denbies, Surrey; Lord Londesborough; his sale, Christie's, 7 July 1888 (3), acquired by Dublin

Exh: possibly one of the versions of the subject exh. Society of Artists, 1761 (88) or 1765 (49) ?; Belfast, Stranmillis Museum, *Loan exhibition of English Pictures*, 1960; Belfast, Ulster Museum, *Shakespeare in Pictures*, 1964 (18); Wexford, Theatre Royal, *Festival Opera Exhibition*, 1964; Dublin,

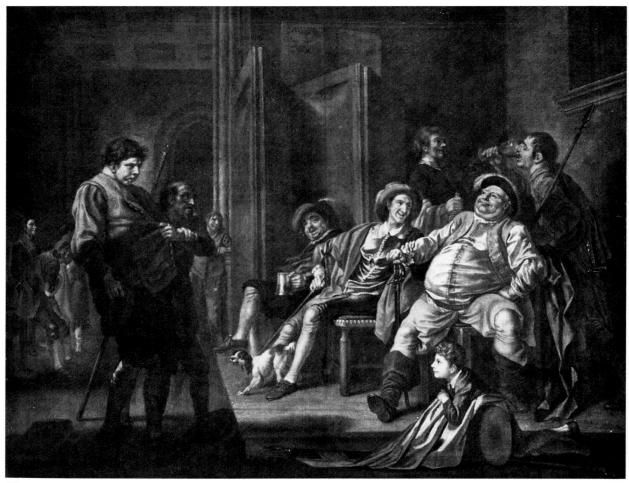

43.

National Gallery of Ireland, *Swift and His Age*, 1967 (52); Bordeaux, Galerie des Beaux-Arts, *Les Arts du Théâtre*, 1980 (29)

Coll: Dublin, National Gallery of Ireland

Several versions of this, Hayman's favourite subject, survive (CL. 142–144). All of these are basically similar to the much earlier drawing for Hanmer's Shakespeare (CL. 219 (19)) and illustrate Act III, Scene V of *Henry IV, Part II* (Hanmer edition) in which Falstaff inspects the motley band of recruits produced by Justice Robert Shallow and his cousin Silence. On the left is Bardolph who is pulling the reluctant Bullcalf towards Falstaff.

A label on the front of the frame suggests that the picture was painted in 1754 but this is improbably early since the darker palette and coarser handling of the paint is more consistent with Hayman's work from the 1760s. It is also known that he exhibited two versions of the subject at the Society of Artists in 1761 and again in 1765. The same label identifies 'Mr Quin as Falstaff' and 'Mr Beard as Justice Shallow' but there is no evidence to support this. Garrick's rival James Quin (1693–1766) was certainly well known for his interpret-

ations of Falstaff but had retired from acting in the early 1750s, although John Beard (1716?–1791) was still active in the 1760s. It is worth noting however that on two occasions in 1744 at Covent Garden Hayman played the part of Poins alongside Quin's Falstaff.[1]

1. See *The London Stage 3*, op. cit., pp. 1083, 1129.

44. THE BARBER RECLAIMING HIS BASIN FROM DON QUIXOTE late 1760s

Oil on canvas, $20\frac{5}{8} \times 24\frac{3}{4}$ (52.2 × 62.9)

Prov: Ronald Lee (dealer), sold to Exeter in 1963

Exh: probably Royal Academy 1769 (50) as 'The Dispute With the Barber upon Mambrino's Helmet'; Exeter, Royal Albert Memorial Museum, *Treasures of the Exeter Museums*, 1969 (f); Exeter University Library, *Cervantes and Don Quixote*, 1974, section II (6)

Coll: Exeter, Royal Albert Memorial Museum

This and cat. no. 45 are two of a set of six illustrations to *Don*

Quixote painted by Hayman in the late 1760s. Most of the set were adapted from the designs made by Hayman in the mid-1750s for Smollett's edition of Cervantes' text (see cat. no. 91). This episode basically follows the design of the book plate engraved by Grignion except that a horizontal format is substituted and a few changes are made to the background details. Don Quixote is shown attempting to convince the frustrated Barber that his basin is Mambrino's helmet.[1]

According to W. H. Pyne the sculptor William Collins (1721–1793) 'modelled the prototype bust for Hayman's Don Quixote'[2] and, although it cannot be substantiated, Edward Dayes claimed that Hayman's 'pictures of Don Quixote were so well received, that he had an order to paint two copies for Madrid'.[3]

The coarse texture and the darker palette seen here is typical of Hayman's last works when his powers were noticeably failing, and these canvases retain little of the vivacious comic charm of the earlier drawings.

1. See Vol. I, Book IV, Chapter XVIII of Smollett's translation of 1755.
2. Ephraim Hardcastle [W. H. Pyne], *Wine and Walnuts ; or, After Dinner Chit-Chat*, 2 vols. (London, 1823), I, p. 177.
3. [Edward Dayes], *The Works of the late Edward Dayes . . . &tc.* (London, 1805) p. 331.

45. DON QUIXOTE DISPUTING WITH THE MAD CARDENIO late 1760s

Oil on canvas, $20\frac{5}{8} \times 24\frac{3}{4}$ (52.2 × 62.9)

Prov : as for no. 44

Exh : probably Royal Academy 1769 (51) as 'Meeting Cardenio in the Black Mountain'; Exeter, Royal Albert Memorial Museum, *Treasures of the Exeter Museums*, 1969 (d) ; Exeter University Library, *Cervantes and Don Quixote*, 1974, Section II (4)

Coll : Exeter, Royal Albert Memorial Museum

The lovelorn Cardenio had taken to the mountains stricken with grief because of his unrequited passion for the beautiful Lucinda. Hayman here illustrates the moment when Don Quixote is enraged by Cardenio's slanderous remarks about Queen Madamisa,[1] whilst Sancho and the goatherd look on in astonishment. Hayman had not illustrated this episode in the Smollett edition of 1755 but instead chose the moment immediately following when Cardenio, in a fit of madness, attacks and fells Don Quixote and Sancho (CL. 230(9)].

1. Queen Madamisa is a character in a book of chivalry called *Amadis de Gaul*, given to Cardenio by Lucinda and much admired by Don Quixote. See Smollett's edition of *Don Quixote*, Vol. 1, Book III, Chapter X.

46. THE FINDING OF THE INFANT MOSES IN THE BULRUSHES 1746

Oil on canvas, $68\frac{1}{4} \times 80\frac{1}{2}$ (173 × 204)
Inscribed lower right : *Painted & given by F. Hayman, 1746*

Prov : at the Foundling Hospital since 1746

Exh : Kenwood, 1960 (28)

Coll : London, The Thomas Coram Foundation for Children

The subject is taken from the Book of Exodus, Chap. 2, vv. 3–9. Hayman's picture adheres closely to the text in which Pharoah's daughter has come down to the riverbank to bathe with her serving girls, two of whom are behind her ; the third is coming up from the water with the infant Moses in her arms. To the left of Pharoah's daughter, a woman kneels with her arms outstretched towards the child, and behind her stands a young girl with her hands together. These are Moses' mother and sister. The point illustrated in the narrative is verse 9:

Take this boy, Pharoah's daughter said, and nurse him for me ; I will reward thee for it. So the woman took the boy and nursed him till he was grown.

A more appropriate subject could hardly be chosen for the Foundling Hospital where this picture hung in the Court

44.

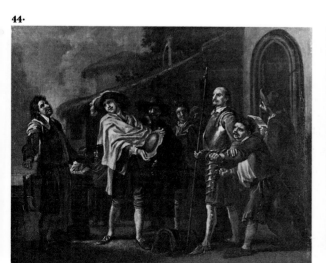

45.

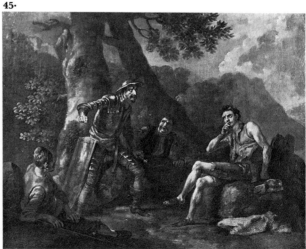

room, alongside works by Hogarth, Highmore and Wills (see pp. 54–5).

Hayman adopts a consciously Poussinesque style for this, his first 'public' picture. Although no precise model can be found in Poussin's œuvre, the general disposition of the figures and the restrained but determined classicism owe much to the French master's work. Hayman would also have seen this popular subject interpreted by other artists like, for instance, Sebastiano Ricci, whose version now hanging at Hampton Court was engraved in 1741 by J. B. Jackson.[1] This has several compositional elements in common with Hayman's painting, notably the arrangement of the figures under a tree as well as the architectural elements to the left. The same episode was also engraved by Vandergucht after Louis Chéron for the so-called 'Vinegar Bible' of 1717 but, unlike Hayman, Chéron makes little effort to render his scene authentically Egyptian. In the early 18th century, a new attitude towards ancient Egypt began to emerge. Precise on-the-spot observa-tion and investigation, hardly known before the 18th century, began as Egypt became fashionable, and travellers published scholarly reports. Among these pioneers was the Earl of Sand-wich, a prominent member of the Dilettanti Society who, while in Egypt, made a thorough investigation of several of the pyramids, including the step-pyramid which Hayman has attempted to paint here.[2] In November 1741, soon after his return, an Egyptian Society was founded in London which included amongst its members Dr Richard Pococke, whose *A Description of the East and Some Other Countries* (1743) had one of its two volumes devoted entirely to Egypt. Apart from an elaborate frontispiece by Gravelot, the illustrations included architectural details, plant life, artefacts and antiquities of the type shown by Hayman in the foreground of this picture.[3]

Hayman was in the habit of making small oil sketches for his historical pictures and one related to this composition was formerly in the collection of James Ralph (see CL. 87).

46.

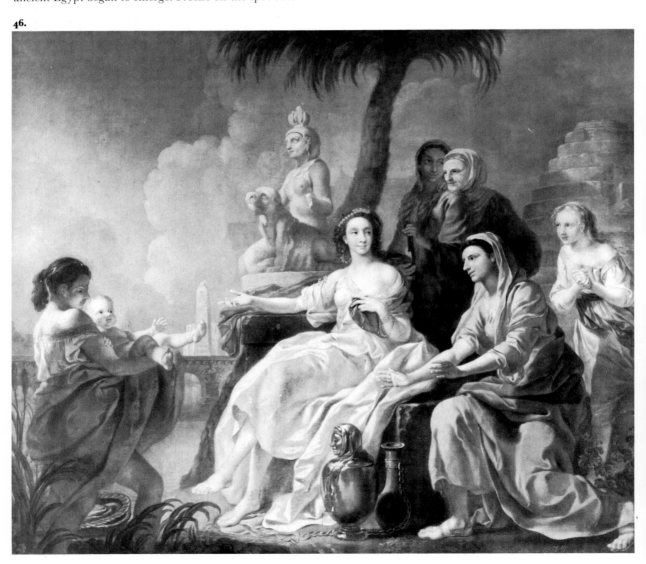

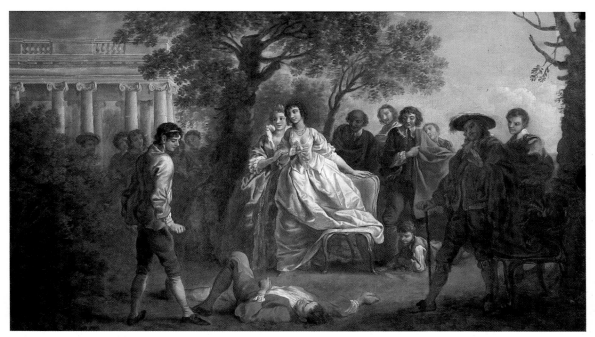

Plate VII *The Wrestling Scene from 'As You Like It'* (cat. no. 37)

Plate VIII *A Scene from 'The Suspicious Husband'* (cat. no. 39)

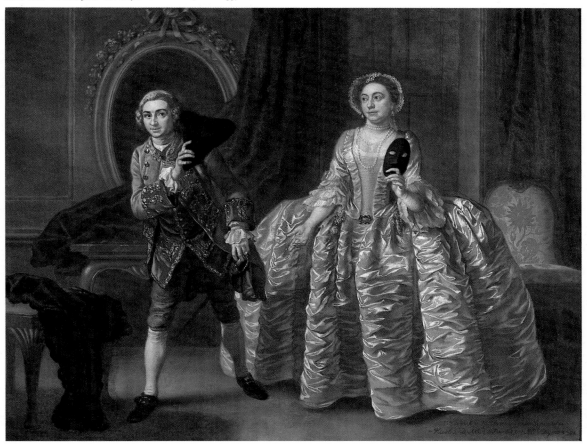

1. See Michael Levey, *The Later Italian Pictures in the Collection of Her Majesty the Queen* (London, 1964) p. 100, no. 647, pl. 94.
2. Patrick Conner, *The Inspiration of Egypt–Its Influence on British Artists, Travellers and Designers, 1700–1900*, Brighton Museum (1983) pp. 6–8; see also Rudolf Wittkower, 'Piranesi and the Eighteenth Century', *Studies in the Italian Baroque* (London, 1975) pp. 260–273.
3. See Pococke, op. cit., I, pl. LVII, facing p. 186.

47. THE GOOD SAMARITAN 1751–2 Colour Plate IX

Oil on canvas, 78¼ × 48 (198.5 × 122)

Prov: painted for William Wrightson; by descent through the Battie-Wrightson family; removed from the Chapel of Cusworth Hall c. 1957 to St. Hubert's Church, Cusworth Village; sale, Sotheby's, 6 July 1977 (78)

Coll: Yale Center for British Art, Paul Mellon Fund

The Good Samaritan is one of the few Biblical history paintings by Hayman to survive. It was painted as part of the re-decoration of William Wrightson's Cusworth Hall, near Doncaster, supervised by Hayman's friend the architect James Paine between 1749–1753 (see pp. 55–7).

Hayman's picture played a significant rôle in the decorative scheme at Cusworth since it dominated the space above the altar apse of Paine's exquisite private Chapel which formed the west wing of the house (fig. 31). The picture must have been finished early in 1752 since on 19 March of that year Wrightson recorded payment to Hayman of £26.5.0 'in full'.[1] However, it may not have been hung immediately since it was not until 22 November 1754 that Joseph Rose, who was responsible for the magnificent rococo plasterwork in the Chapel, was paid £4 for the elaborate plaster frame.[2]

The only known academy drawing by Hayman is closely related to the injured victim of the robbers seen here (see cat. no. 70) and a jotting on the verso of the drawing for *The Suspicious Husband* also appears to be connected with this composition. (cat. no. 69).

For a fuller discussion of this work see pp. 57–8.

1. 'Battie-Wrightson Trustee Papers' (Archives Dept., Leeds Central Library), Document set BW/A22.
2. Ibid., Document set BW/A30 'Plasterer's Work done at Cusworth, the seat of Willm. Wrightson Esq. for James Paine Joseph Rose'.

48. THE ARTISTS PRESENTING A PLAN FOR AN ACADEMY TO FREDERICK, PRINCE OF WALES AND PRINCESS AUGUSTA
c. 1750–51 Fig. 36, p. 66

Oil on canvas, 24 × 30 (63.5 × 76.2)

Prov: bt. c. 1965 by Michael J. Upsall; Sale, J. Bright & Sons, Brixham, Devon, 5 June 1973 (137), bt A. Ballard; Raymond Head, from whom acquired by Exeter

Coll: Exeter, Royal Albert Memorial Museum

The idea of a public Academy was in the air c. 1750. In 1749 Hayman's friend the architect John Gwynn had published his *Essay on Design: Including Proposals for Erecting a Public Academy ... &tc.* In this Gwynn noted that artists 'have wanted, while Young, the Assistance of an *Academy*, which should lead

them on from first Principles ... and make them conceive a true Standard of Excellence'.[1] Gwynn's companion Samuel Wale designed a frontispiece for his essay, engraved by Grignion, representing Mercury introducing Minerva to Britannia. In the background is a pillar with a medallion portrait of George II. No support for such a scheme was likely to be forthcoming from George II, but, significantly, his son Frederick, Prince of Wales seems to have been interested in the idea, for in July 1749 George Vertue records a conversation with the Prince in which the latter 'spoke much concerning the settlement of an Accademy for drawing & painting'.[2]

It is possible that this small oil sketch, presumably a *modello* for a proposed larger picture, is somehow connected with these events since Hayman was to become deeply involved in the artists' plans for an Academy in the years that followed (see pp. 4–7). It is also possible that Hayman planned a large picture of this subject for the Rotunda Annexe at Vauxhall Gardens but the Prince's untimely death in 1751 led to the abandonment of the idea (see pp. 64–6).

In this sketch a group of young artists present a plan for an Academy (?) to Prince Frederick and Princess Augusta who are flanked by personifications of Minerva and Britannia. In the lower left foreground Perseus fights off Envy, who has turned his back on Vice whilst in the centre a group of playful cherubs representing the Arts and Sciences allude to the infant Academy.

The composition is very similar to *Caractacus Before Claudius* (cat. no. 78a, fig. 37) of about the same date. The cavernous architectural setting is common to both and Hayman seems to have derived his setting for both from Verrio and Laguerre's *James II Giving Audience at Christ's Hospital* – a large group portrait executed in the 1680s commemorating the founding of the Royal Mathematical School in the Great Hall of Christ's Hospital, which Hayman must have known (fig. 38).[3] In this the King is surrounded by his ministers in much the same way that Hayman arranges his artists around the Prince. Even the architectural backdrop in the Verrio painting, with its paired pilasters and niches, is similar to Hayman's design.

In the event a large version of this subject does not seem to have been executed and the artists had to wait almost two more decades before their Royal Academy came into being.

1. See John Gwynn, *An Essay on Design ... &tc.* (London, 1749) pp. 17–18.
2. Vertue Note Books I, *Walpole Society*, XVIII (1929–30) p. 10.
3. The preparatory sketch for the final work illustrated here (fig. 38) shows Charles II giving audience but when the picture was completed the new King James II's features were substituted. Edward Croft-Murray noted that Verrio had been influenced in the sketch by Testelin's portrait of *Louis XIV Founding the Academy of Sciences* of 1666–67, now at Versailles (Croft-Murray, I, p. 238).

49. LORD CLIVE RECEIVING THE HOMAGE OF THE NABOB
c. 1761–2 Fig. 40, p. 69

Oil on canvas, 40 × 50 (101.6 × 127)
Inscribed: *Lord Clive and the Nabob of Arcot*
 25th June –
 1757 Battle of Plassey

Prov: Col. John Harvey, Biggleswade; Calcutta, Maharaja Bahadur Sir Prodyt Coomar Tagore; Private collection;

Anon. sale, Christie's 22 June 1979 (162) as 'English School *c.* 1795'; acquired by N.P.G.

Coll: London, National Portrait Gallery

A much larger version of this work was one of the four pictures illustrating episodes from the Seven Years War which hung in the annexe to the Rotunda at Vauxhall Gardens. The large picture disappeared *c.* 1840 but a lengthy description of it, published in the 1762 guidebook to Vauxhall, enabled identification of this reduced version when it appeared at Christie's in 1979. The same written account, printed some months later in *The Public Advertiser* and *The London Magazine*, reads as follows:

<div align="center">

A description of the Historical
Picture in the Great Room, painted
by Mr. HAYMAN

</div>

The subject of this picture is of the most interesting nature to every Briton, who regards the honour and prosperity of his country. For the better understanding it, it is necessary to observe that General *Clive*, after gaining the battle of *Plaissey* in the East Indies, which restored the English interest that had been ruined in those parts of the world, found himself under a necessity of deposing the reigning Nabob; for that purpose sent from the field of battle for *Meer Jaffer*, a principal General under the Subah or Nabob, and an enemy to the French. *Meer Jaffer* sent for, seeing the General surrounded by his victorious troops under their arms, approaches him with every symptom of doubt and dissidence in his countenance. The General is represented in the attitude of Friendship, by extending his hands to receive him. Behind the General stands his Aid de Camp with his spontoon in his hand; as bold but as graceful a figure as can well be conceived, the British colours are display'd in the hands of another English officer, with the like appearance as the former, but all of them in different attitudes. A bold horse, supposed to be the General's that seems startled at the sight of the elephant, closes to the fore ground of this compartment of the picture. It is but justice to the Painter to say, that no figures were ever better detached from the canvas than those are; that of the General, being the principal, is intimitably free, and in a most masterly stile of painting. The painter could with no propriety avoid representing the British figures in their uniform; but to prevent a sameness in the composition, he has with great judgment introduced the Indian groom in the habit of his country, which forms a most happy contrast. Meer Jaffer wears on his face strong remains of the emotions already mentioned, but his dejection seems to be faintly alleviated by the General's manner of receiving him. The extension of his arms and the inclination of his body is most movingly expressive of doubt, submission and resignation, which is heightened by an Indian officer laying the Subbah's standard at the General's feet. The future Subah or Nabob is attended by his son, a youth of about eighteen years of age, bewitchingly handsome, and painted with a masterly propriety. The other Indian figures behind Meer Jaffer are those of his friends and officers, and the countenances of them all strongly partake of the inquietudes of their principal. This co[m]partment is terminated by an elephant on the background, which the greatest judges from the East-Indies say is the best they ever saw in painting, both co[m]partments of the picture (for so they may be called on account of the diversity of the figures they exhibit) are surrounded by English soldiers in the back ground drawn up round the scene of interview. The painter has here taken advantage of the various dresses of the Indians, which, as well as their arms and all their other attributes, are preserved with the utmost precision, to introduce a beautiful play of colours, without departing from propriety.'[1]

This reduced version of the Vauxhall painting corresponds very closely to the printed description except that there is no 'Indian officer laying the Subbah's standard at the General's feet'.

Robert Clive's victory at Plassey in 1757 was followed by a consolidation of Mir Jafar's power and thus that of the East India Company in Bengal. He was completely successful and, on his return to England in 1760 with an enormous personal fortune, received official acclaim.[2]

Hayman's ignorance of the Indian scene – unlike a later generation including Tilly Kettle and Zoffany he never went there – is rather obvious and, if this small version gives an accurate impression of the lost picture, is rather at odds with the lavish praise bestowed on the picture in the written account. Although the costumes are reasonably accurate – they were probably based on Indian miniatures[3] – it is hard to equate Hayman's elephant with the statement in the published account that 'the greatest judges from the East-Indies say it is the best they ever saw in painting'.

A small oil sketch, a cruder earlier idea for the composition, was formerly with Spink (CL. 101). Hayman's only other Indian subject (cat. no. 50) was also painted about this time.

1. See *A Description of Vaux-Hall Gardens* (London, 1762) bound into the end of the British Library's copy. See also *The Public Advertiser*, no. 8905 (20 May 1763) and *The London Magazine*, XXXII (May 1763) pp. 233–34.
2. See Mark Bence-Jones, *Clive of India* (London, 1975)
3. See Mildred Archer, *India and British Portraiture 1700–1825* (London, 1979) p. 419.

50. THE SURRENDER OF PONDICHERRY TO SIR EYRE COOTE early 1760s

Oil on canvas, 48 × 60 (121.9 × 152.4)

Prov: probably acquired or commissioned by Sir Eyre Coote(?); by descent to Michael Coote-Kaye Esq.; in store at Queenborough Old Hall, Leics.; lent to Sandhurst

Coll: Private Collection, on loan to the National Army Museum (Sandhurst)

British magnanimity in victory was the theme of two of the four large Vauxhall history paintings (see pp. 66–9) and the same mood pervades this smaller picture which was probably inspired by their success. Perhaps Coote was sufficiently impressed by *Lord Clive Receiving the Homage of the Nabob* (cat. no. 49 and CL. 99 also appeared) to commission this similar picture from Hayman. Coote also appeared in the last of the Vauxhall histories, the allegory of the victorious generals. (CL. 102).

On Clive's recommendation, Sir Eyre Coote (1726–1783)

Plate IX *The Good Samaritan* (cat. no. 47)

50.

a blockade lasting eight months, the French surrendered.[1]

Hayman depicts the moment when the victorious Coote, mounted on horseback, is about to receive the sword of the French commander, the Comte de Lally, who gestures towards the humiliated Nabob and his wife or daughter. Lally is flanked by a fat French priest, an image which recalls Hogarth's overfed monk in *Calais Gate, The Roast Beef of Old England* of 1748 (Tate Gallery). In the background behind Coote are the ordered ranks of the victorious 84th Regiment facing the heavily fortified ramparts of Pondicherry.

Hayman appears to have painted over a different composition since a large area of *pentimenti* – a large bird on a branch – is clearly visible coming through the tower in the upper right.

1. See E. W. Sheppard, *Coote Bahadur* (London, 1956).

had been given command of the newly raised 84th Regiment at Madras in October 1759. Within months Coote led his troops to victories over the French at Wandiwash and Arcot. The final reduction of French power in India was achieved by the seige of Pondicherry where on 16 January 1761, after

51. CYMON AND IPHIGENIA *c.* 1767

Oil on canvas, 61 × 43 (158 × 109)

Exh: probably Society of Artists 1767 (70); Buxton, Museum & Art Gallery, *Tales Retold: Boccaccio's Decameron 17th to 19th Century*, 1983 (20)

Coll: Sidney Sabin Esq.

Fig. 46 Aillamet after François Boucher, *Cymon and Iphigenia*. Engraving from *Le Decameron de Jean Boccace*, Vol. III (1757)

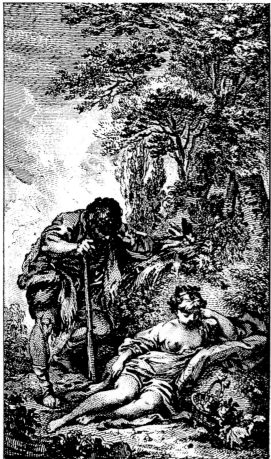

51.

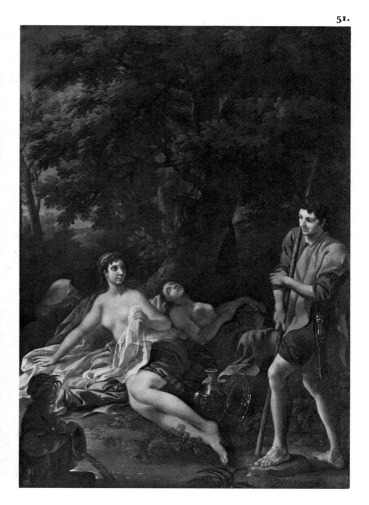

This is probably the picture that Hayman sent to the Society of Artists exhibition along with the lost *Abraham Offering Isaac* (CL. 107) in 1767. It probably deserved the comment 'very bad' that Horace Walpole jotted in the margin of his catalogue at the exhibition.[1]

The subject is taken from Boccaccio's *Decameron* (5:1) in which Cymon, a handsome but uneducated youth, the son of a Cypriot nobleman, falls in love with Iphigenia, whom he eventually marries. The effects of his union with Iphigenia changes him into an accomplished gentleman. Hayman has chosen to depict the moment when Cymon, clad in his peasant clothes, first sets eyes on Iphigenia, who lies in a wood beside a fountain, here symbolised by the putto with a large vessel in the lower left foreground.

Although Garrick's play *Cymon* had received its debut only months before Hayman exhibited this picture, it is unlikely that there is any connection between the two and it is altogether more likely that Hayman's picture was a response to Benjamin West's pictures of this subject exhibited in 1764 and 1766.[2]

Hayman's choice of an upright composition is rather awkward since Iphigenia is nearly always shown lying asleep or reclining but this is almost certainly explained because, as Catherine Gordon has convincingly demonstrated, the design is modified from a book illustration by François Boucher.[3] A lavish French edition of *The Decameron* in five octavo volumes was published in London in 1757 with over one hundred full-page engraved plates.[4] Most of these illustrations were designed by Gravelot, who had returned to Paris in 1745, but Hayman would doubtless have noticed his old friend's work when it appeared in London, even though the design he chose to adapt was by Boucher. Hayman's painting reverses the Boucher design (fig. 46) but the compositions are otherwise very similar.

1. Walpole's original Society of Artists exhibition catalogues are now in the Lewis Walpole Library, Farmington, Conn. (see Hugh Gatty, 'Notes by Horace Walpole on the Exhibitions of the Society of Artists and the Free Society 1760–1791', *Walpole Society*, XXVII (1938–39) p. 68).
2. See Helmut von Erffa and Allen Staley, *The Paintings of Benjamin West* (New Haven & London, 1986) pp. 264–66, cat. nos. 195–6.
3. [Catherine Gordon], *Tales Retold: Boccaccio's Decameron 17th to 19th Century*, Buxton Museum & Art Gallery (1983) pp. 19–20.
4. *Le Decameron de Jean Boccace*, 5 vols. (London, 1757). The Boucher *Cymon and Iphigenia*, engraved by Aillament appeared in vol. III.

52.

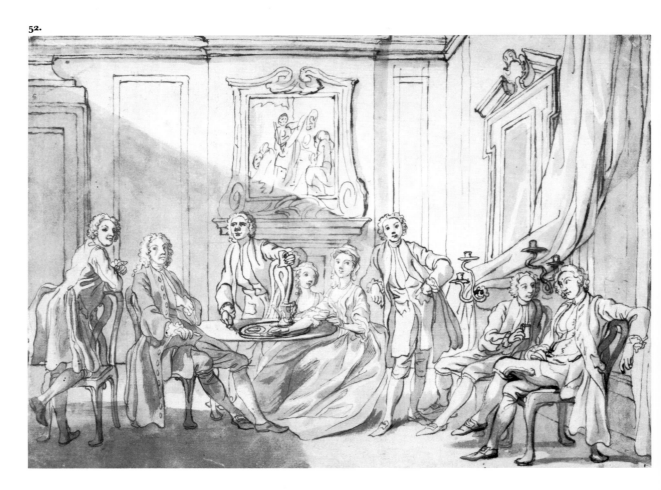

52. A STUDY FOR GROSVENOR BEDFORD WITH FAMILY AND FRIENDS *c.* 1741–2

Sepia, pen and ink and grey wash, 8 × 11⅛ (20.3 × 28.3)

Prov: Henry Reitlinger; sale, Sotheby's, 27 January 1954 (151)

Coll: Exeter, Royal Albert Memorial Museum

This unique early drawing is related to the Bedford conversation piece (cat. no. 4). In style it is very close to pen and ink drawings made for the Vauxhall supper box pictures (see cat. nos. 55–61) at the same date.

Very little is known about Hayman's use of drawings for portraits but it may well be that, early in his career, Hayman made bold pen and ink drawings like this one before working on canvas. This would make some sense for large groups of figures who were not likely to have sat together to the artist. Preliminary drawings like this not only enabled Hayman to work out the relationship of the sitters to one another and their surroundings but were also an aid to calculating the disposition of light and shade.

Confirmation that this drawing is preliminary to, rather than a copy made as a record of the finished painting, is suggested by changes Hayman made to the elaborate overmantel. In this drawing the square frame is in the style of James Gibbs but this gives way in the painting to an oval supported by putti (see also notes to cat. no. 4).

53. HENRY WOODWARD AS THE "FINE GENTLEMAN" IN GARRICK'S FARCE "LETHE" mid-1740s

Pencil, 13 × 8⅞ (33.2 × 22.5)

Prov: purchased by Fitzwilliam Museum in 1962

Exh: London, Victoria & Albert Museum, *British Antique Dealers' Association Golden Jubilee Exhibition,* 1968; London, British Library, *David Garrick 1717–1779,* 1979; Rococo, 1984 (O.15)

Engr: in mezzotint by James McArdell (Chaloner Smith II, no. 189)

Coll: Cambridge, Fitzwilliam Museum

This highly finished drawing must have been executed for James McArdell as the basis for his mezzotint. David Garrick's farce *Lethe: or Esop in the Shade* (1740) was his first effort as a playwright and pre-dates his acting debut. In this satirical burlesque, Garrick presents half a dozen types – a poet, a trailor, a female writer, a drunk, a 'Fine Lady' and the 'Fine Gentleman' – who come to the famous river of the underworld to take the waters, forget their troubles and start afresh.[1] Several of the songs therein, including two with lyrics by Garrick, became very popular. Henry Woodward (1714–1777) performed the rôle of the 'Fine Gentleman' in the first performance of *Lethe* at Drury Lane on Tuesday 15 April 1740 and repeated the part many times thereafter.[2]

Hayman's drawings of this type are scarce – only one other example is known (cat. no. 54) – which makes dating difficult; but on the basis of style *c.* 1745 is likely. The figure was reproduced *c.* 1750 as a piece of bow porcelain based on McArdell's mezzotint.[3]

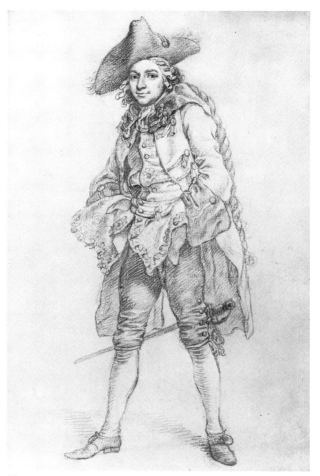

53.

1. See George Winchester Stone, 'David Garrick and the Eighteenth Century Stage: Notes towards a New Biography' in *In Search Restoration and Eighteenth-Century Theatrical Biography* (William Andrews Clark Memorial Library, U.C.L.A., 1976) p. 19.
2. See *The London Stage Part 3,* op. cit., p. 831.
3. See Arthur Lane, *English Porcelain Figures of the Eighteenth Century* (London, 1961) p. 86 and *Rococo,* 1984, p. 248 (O.16).

54. YOUNG MAN IN AN INTERIOR late 1740s

Black chalk heightened with white on buff paper, 17½ × 12½ (44.5 × 31.7)

Prov: Sir Gardner Engelhart; his sale, Sotheby's 16 March 1960 (62) as Hogarth, bt Ronald Lee (dealer); acquired by Fitzwilliam Museum

Exh: Kenwood, 1960 (37)

Coll: Cambridge, Fitzwilliam Museum

Although this rare portrait study cannot be related to any known painting it offers a possible insight into Hayman's working method. Perhaps Hayman regularly made drawings of this type for his small full-length portraits like, for instance, *George Dance* (cat. no. 20) which is about the same size as this drawing, but no others are known at present.

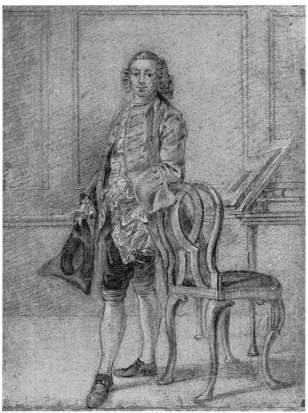

54·

of Gravelot's engravings from *Jeux d'Enfants*, which appeared in 1738.[3]

1. See C. Hart, *Kites – An Historical Survey* (London, 1967) p. 81.
2. See an impression in the Dept. of Prints & Drawing, British Museum (1865-10-14-319). Parr also engraved some of the Vauxhall pictures.
3. See Rococo 1984. (D. 6).

56. BATTLEDORE AND SHUTTLECOCK *c.* 1741–2

Pen, ink and grey wash, $6\frac{7}{8} \times 9\frac{1}{2}$ (17.4 × 24)

Prov: Henry Reitlinger; sale, Sotheby's, 27 January 1954 (152) bt. Johnson; Anon. sale, Sotheby's 19 June 1969 (160), bt. John Baskett for Paul Mellon

Exh: Kenwood, 1960 (32); New York, Pierpoint Morgan Library, *English Drawings and Watercolours 1550–1850 in the Collection of Mr and Mrs Paul Mellon*, 1972 (23); Yale, 1983 (49); *Rococo*, 1984 (F.30)

Coll: Yale Center for British Art, Paul Mellon Collection

The original large oil painting of his subject (CL. 184) disappeared from Vauxhall Gardens prior to the sale of 1841 and, with Parr's engraving, this drawing forms our only record of its appearance. Although the drawing is squared for transfer to canvas, Hayman apparently made modifications to the composition in the painting. Parr's engraving of 1743 differs in a number of details. In the engraving a chair is added to the left and the frames on the wall are filled with Van Dyck-style portraits. Much of the lively energy of Hayman's male youth has also been lost in the transition from drawing to canvas to the engraving, where this figure adopts a much more defensive stance.

The subject of Battledore and Shuttlecock can be found in French art of about the same date but Hayman may have derived the idea from one of the plates from Gravelot's *Jeux d'Enfants*.

On the verso of this sheet is a slight pencil sketch of the man holding the sword who appears in *The Jealous Husband* (cat. no. 61).

55. FLYING THE KITE *c.* 1741–2

Pen, brown ink and wash, $5\frac{1}{2} \times 9$ (14.2 × 22.9)

Inscribed: (in Hayman's hand) *the Figures 2 ft 5 In: or 6*

Prov: Henry Reitlinger; his sale, Sotheby's, 27 January 1954 (152) bt. Johnson

Exh: Kenwood, 1960 (31); Yale 1983 (50); Rococo, 1984 (F.29)

Coll: Yale Center for British Art, Paul Mellon Collection

This is the only record of the Vauxhall supper box picture of this title which had disappeared before the Vauxhall sale in 1841 (see CL. 181). The drawing is inscribed in Hayman's hand (see above) with instructions presumably for his studio assistants who helped produce the large canvases.

Although it never became the sport that it is in China or Japan, kite-flying increased in popularity among children during the eighteenth century. In France the sport created so much interest that in October 1736 the flying of kites in public places was forbidden by the authorities because rioting had broken out between participants.[1]

It is probably from France that the pictorial source for this drawing was derived. For instance, works like Lancret's *L'Air*, one of a series of *The Elements*, engraved originally by Tardieu in Paris in 1732 and later in London by Parr, shows kite-flying among its frivolous diversions.[2] Hayman's design seems to be adapted, as are some of the other Vauxhall pictures, from one

57. HUNT THE WHISTLE *c.* 1741–2

Pen, ink and brown and grey wash, $5\frac{1}{2} \times 9$ (14 × 22.9)

Inscribed: Hunt the Whistle the figures 3 Feet & 1 In.

Prov: Sir Robert Witt

Exh: Paris, Musée des Arts Decoratifs, 1938 (61); Bordeaux, 1938 (30); Exeter, 1951 (15); Kenwood, 1960 (33); *Rococo*, 1984 (F.27)

Coll: University of London, Courtauld Institute Galleries

The original supper box painting executed to this design was sold at the Vauxhall sale in 1841 and has not been traced since (CL. 185). This is one of several Vauxhall pictures whose subject matter relates to the passage of time throughout the year. Winter activities such as 'Sliding on the Ice' (see cat. no. 33) contrast with the likes of 'Blindman's Buff' (see cat. no. 66), set in a verdant summer glade.[1] Subjects like this one

55.

56.

57.

seem to be linked to seasonal holidays and are, like *The Cutting of Flour* (cat. no. 60), indoor activities for the winter months.

Hayman's composition owes much to the influence of the *fête galante* of Watteau and his followers. The young girl seated on the carpet in the left foreground is particularly Watteauesque. The interior setting with its sharp, angular perspective is very similar to the backgrounds in many of Hayman's conversation pieces and a comparison with the drawing for the Bedford family portrait (cat. no. 4) reveals how similar the artist's compositional method is for differing genres.

This drawing is squared for transfer, like *Battledore and Shuttlecock* (cat. no. 56), and is inscribed with specific instructions about the size of the figures, presumably for the studio assistants who did the bulk of the painting.

1. See Yale, 1983, p. 27.

58. THE ENRAGED VIXEN OF A WIFE (THE PLAY OF SKITTLES)
c. 1741–2

Pen, ink and bistre and grey wash, $5\frac{5}{8} \times 8\frac{7}{8}$ (19 × 27.5)

Inscribed in pencil lower centre: *The enraged Vixen of a Wife*

Prov: John H. Cattell, by whom presented in 1920 to Birmingham Museum

Exh: Kenwood, 1960 (36); Rococo, 1984 (F.28)

Coll: Birmingham, City Museum and Art Gallery

An early guidebook to Vauxhall Gardens described the supper box painting based on this drawing as 'The Play of Skittles, and the Husband upbraided by the Wife, who breaks his shin with one of the pins'.[1] This amusing subject may have been of personal interest to the artist since according to one anecdotalist 'Hayman, Scott and McArdle [sic.] were visitors of Moll King's and were all fond of skittle playing'.[2]

Skittle playing had a well-established pictorial tradition by Hayman's day, particularly in seventeenth-century Flemish art, and this type of subject was commonly engraved in the 18th century by French artists.[3] T. J. Edelstein, however, has noted that the depiction of the game of bowls was sometimes used in emblem books as a symbol of worldly vanity.[4]

1. Anon., *A Description of Vaux-Hall Gardens* (London, 1762) p. 34.
2. John Green [pseud. for G. H. Townsend], *Evans's Music or Supper Rooms, Odds and Ends about Covent Garden* (London, n.d. [*c.* 1860]) p. 14.
3. See, for example, Laurent's engraving after Teniers' *Le Jeu Quilles* (B.M. 50-7-13-92).
4. Yale, 1983, p. 28.

58.

59.

59. LADIES ANGLING *c.* 1741–2

Pen, ink and grey wash, $5\frac{3}{4} \times 9\frac{1}{8}$ (14.6 × 23.2)

Exh: Yale, 1983 (52)

Coll: Dudley Snelgrove Esq.

T. J. Edelstein has convincingly suggested that this drawing for the lost Vauxhall picture may have been inspired by poems such as John Gay's *Rural Sports*, published in 1713:

> Silks of all colours must their aid impart,
> And ev'ry fur promote the fisher's art.
> So the gay lady, with expensive care,
> Borrows the pride of land, of sea, and air;
> Furs, pearls, and plumes, the glittering things displays
> Dazles our eyes, and easy hearts betrays.[1]

Similarly, Hayman may have been familiar with Thomas Foxton's *Moral Songs Composed for the Use of Children*, published in 1728. In one of these songs, 'The Angler's Reflection', the author compares the innocence of the playful fishes lured by man to 'heedless Mortals' ensnared by pleasure, vanity and deceit.[2]

The young woman seated on the terrace with a fishing rod and her back to the spectator is as close as Hayman ever gets to the long-necked, langorous figures in Watteau's pastorals. Similar subject matter can be found in Parr's engravings after Lancret's pictures.[3] It is worth noting that one of the episodes from Richardson's *Pamela* illustrated by Hayman at this date showed Pamela, fishing rod in hand, throwing the carp into the stream (CL. 266(4)).

There was evidently a good deal of interest in fishing in the middle decades of the century, boosted by the publication of works like John Williamson's *The British Angler . . . &tc.* (1740) which had an engraved frontispiece by the younger Bickham.

1. John Gay, *Rural Sports* (London, 1713) lines 185–190 (see Yale, 1983, pp. 28–29).
2. Yale, 1983, pp. 28–29.
3. See especially Parr after Lancret, *Fishing* (B.M. 1877-8-11-1325).

60. THE CUTTING OF FLOUR *c.* 1741–2

Pen, ink and grey wash, $5\frac{5}{8} \times 8\frac{7}{8}$ (19 × 27.5)

Prov: Colnaghi; presented by Friends of the Whitworth Art Gallery

Exh: London, P & D Colnaghi, 1957 (33); Kenwood, 1960 (35)

Coll: University of Manchester, Whitworth Art Gallery

The Vauxhall canvas based on this drawing (CL. 213) is now lost but the author of one of the early guidebooks to the Gardens explained to his readers that this Christmas game is played 'by placing a little ball at the top of a cone of flower [sic.] into which all are to cut with a knife, and whoever causes the ball to roll from the summit must take it out with their teeth, which is represented in the painting'.[1]

60.

61.

Hayman depicts the moment when the unwigged man has just picked up the ball in his mouth and the sight of his flour-covered face amuses his friends. A young girl, meanwhile, is blowing the flour from the plate.

Like *Hunt the Whistle* (cat. no. 57), this design, squared up for transfer, has much in common with Hayman's early group portraits in which are frequently found chimneypieces, folding screens and wall mirrors like the ones seen here.

1. See Kenwood, 1960, p. 26.

61. THE JEALOUS HUSBAND *c.* 1741–2

Pen, ink and brown and grey wash, $5\frac{5}{8} \times 9$ (14.3 × 22.9)

Prov: Sir Robert Witt

Exh: Exeter, 1951 (14); Kenwood, 1960 (34)

Coll: University of London, Courtauld Institute Galleries

This lively composition, set in a lady's bedroom lit by candle-light, has an extremely theatrical appearance and it may be an illustration to a play. A man with a sword, aided by another standing on the table brandishing his slipper, attacks a third man who lies helpless on the floor. To the right the young woman tries to restrain her husband or lover (?) who is about to use his sword on the hapless victim.

It has, erroneously, in the past been thought to be an illustration to Frances Sheridan's play *The Discovery* but this was not published until 1763 and there are no known editions with illustrations by Hayman.[1]

Although this is almost certainly a design for one of the Vauxhall pictures, none of those in the early listings seems to correspond with it. However, it is probably a design for the picture entitled 'The Jealous Husband' which appeared in the Vauxhall sale in 1841 (see CL. 216). Although an anonymous play entitled *The Jealous Husband; or, Modern Gallantry* was performed on three occasions at Goodman's Fields Theatre in February 1732 – whilst Hayman was employed there as a scene painter – and later that year a different production, *The Jealous Husband Outwitted* was performed at the Haymarket Theatre, it seems unlikely that either of these little-known plays was the inspiration for the picture.[2]

1. See Hanns Hammelmann, *Book Illustrators in Eighteenth Century England* (New Haven & London, 1975) p. 55 and Gowing, 1953, p. 16.
2. See *The London Stage Part 3*, op. cit., I, pp. 192–93, 232–33.

62. VOLUME OF PRINTS TAKEN FROM PAINTINGS IN VAUXHALL GARDENS

Open at pl. 9, Charles Grignion after Francis Hayman, *May-Day*
Etching and engraving, $10\frac{1}{2} \times 13\frac{1}{4}$ (26.7 × 35)

Exh: Yale 1983 (48)

Coll: The Lewis Walpole Library, Farmington, Conn.

Within about a year of their appearance at Vauxhall Gardens, eighteen of the pictures were engraved for Thomas

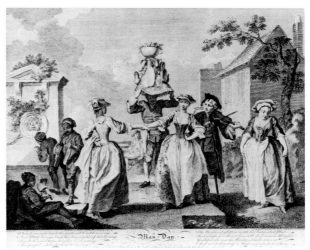

62.

and John Bowles and published in the spring and summer of 1743. This first edition of the prints had elaborate letter-press beneath the image but the plates were subsequently reworked for later printings and the letterpress verses, mostly composed by John Lockman, the author of an early guide-book to Vauxhall Gardens, were removed.

The engraving by Charles Grignion seen here was probably derived from Hayman's original painting (cat. no. 30) by way of the small *Modello* (cat. no. 31).

63. R. PARR AFTER HAYMAN, THE KING AND THE MILLER OF MANSFIELD

Etching and engraving, published 4 April 1743 $11 \times 13\frac{7}{8}$ (28 × 35.2)

Exh: Yale 1983 (80)

Coll: Yale Center for British Art, Paul Mellon Collection

Hayman's original canvas is lost but it was one of the first to be recorded at Vauxhall – it is mentioned in Colin's Song (see p. 107) *c.* 1742 – but it appears to have been removed from the Gardens by 1762, for it does not figure in the list of the pictures that appeared in *A Description of Vaux-Hall Gardens*.[1]

The subject matter is an episode from Robert Dodsley's popular 'Dramatick Tale' *The King and the Miller of Mansfield* which was first performed at Drury Lane on 29 January 1737.[2] Dodsley's play was based on the ancient story of a chance meeting between King Henry II and the Miller in Sherwood Forest. The King whilst out hunting has become separated from his friends and is sheltered by the Miller, John Cockle, whom he subsequently knights for his generosity. This is the moment represented here.

Dodsley's play, with its jibes at courtiers, was certainly anti-government in tone and met with popular approval from the political opposition centred on Frederick, Prince of Wales.[3] In the play the King, from his association with the simple

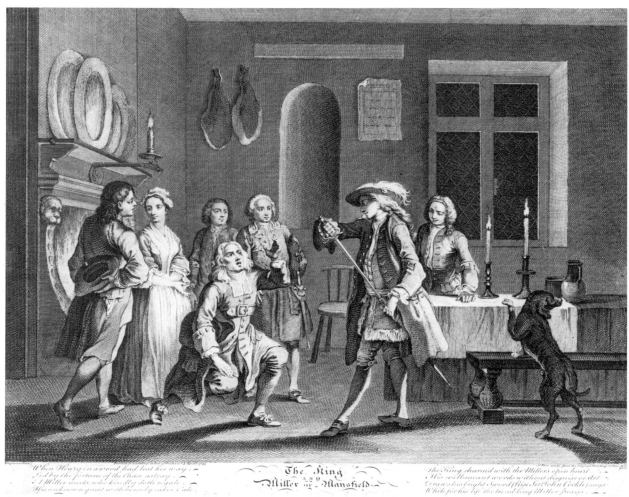

The King
AND
Miller of Mansfield.

63.

rustic Miller and his family, becomes aware of the corruption of his own court in London. John Loftis has argued that the city became the symbol of corruption in Walpole's government and that the country, by contrast, came to symbolise both an uncorrupted nation and the opposition.[4] Dodsley's play incorporated songs and the final one, sung by the King himself warned:

> But hence, to every Courtier be it known,
> Virtue Shall find Protection from the Throne.[5]

The notion of a 'Patriot King' became the embodiment of opposition politics and was made manifest in writings like Lord Bolingbroke's *The Idea of a Patriot King*, written in the late 1730s but not published until a decade later. The current notion of a Patriot King in the 1740s was of one who would restore the political balance through his own example.[6]

Hayman's painting was not the first image to illustrate the subject since a songsheet by George Bickham of 1737, one of the many that comprised the celebrated *Musical Entertainer*, had an engraved headpiece for a song entitled *The King and*

the *Miller*, set to music by Thomas Arne, the composer of *Rule Britannia*.[7]

The overt association of the play with opposition politics may account for its early removal from Vauxhall Gardens. It may have been removed by Jonathan Tyers, the Gardens' proprietor, on Prince Frederick's death in 1751.[8]

1. A painting which purported to come from Vauxhall Gardens was sold by Robinson & Fisher on 19 July 1928 (62) but, judging from a photograph, this appears to be a crude copy of Parr's engraving.
2. See *The London Stage Part 3*, op. cit., II, p. 634, also E. Rowlands, 'The Life and Work of Robert Dodsley (1703–1764)', unpublished M. A. thesis, University of London (1969) pp. 30–31.
3. See J. Lynch, *Box, Pit and Gallery – Stage and Society in Johnson's London* (Berkeley & Los Angeles, 1953) p. 250.
4. See John Loftis, *The Politics of Drama in Augustan England* (Oxford, 1963) pp. 116–17.
5. Robert Dodsley, *The King and the Miller of Mansfield* (London, 1737) p. 6.
6. See Isaac Kramnick, *Bolingbroke and His Circle* (Cambridge, Mass., 1968) p. 167.

7. See Bickham's *The Musical Entertainer*, Vol. 1, plate 40.
8. Lawrence Gowing has argued that the original canvas might well be the picture *Richard II and Wat Tyler* which appeared in the Tyers sale at Christie's, 28 April 1830 (26): see Gowing 1953, p. 16.

64. AFTER GRAVELOT'S DESIGN AND HAYMAN'S PAINTING, PLAY-
ING THE GAME AT QUADRILLE

Etching and engraving, originally published 1743
$6\frac{3}{8} \times 10\frac{1}{2}$ (16.2 × 26.8)

Exh: Yale 1983 (55)

Coll: Yale Center for British Art, Paul Mellon Collection

On this crude impression derived from Grignion's 1743 engraving of *Quadrille* the painter's name is not given but we know from the letterpress on the earliest state that Gravelot was credited with the design which was then executed by Hayman and his assistants onto the canvas which still survives today in the City Museum and Art Gallery, Birmingham.

The extent of Gravelot's involvement in the Vauxhall scheme cannot be precisely ascertained but he certainly also designed *Building Houses with Cards* (CL. 176) and possibly also *The Mock Doctor* (CL. 177), although the latter is not attributed to him on Truchy's engraving.[1] Hayman would have been glad to take advice from Gravelot, who had already employed subject matter similar to that seen in some of the Vauxhall pictures from his series of engravings *Jeux d'Enfants*, engraved in the late 1730s.

Even without Grignion's engraving of *Quadrille* which confirms Gravelot's involvement we might still have suspected that the design was his.[2] The composition is markedly French in feel and the figures have a poise and elegance rarely found in Hayman's more mannered productions. A comparison between this and, for example, Jean-François de Troy's *The Reading from Molière* of *c*. 1728 from the collection of the Dowager Lady Cholmondeley is instructive. The elaborate interior with its boiserie panelling was a product of Gravelot's fertile imagination and his Parisian background, for no such interior existed in England at the beginning of the 1740s. It has been suggested that the chairs with the interlaced back and shell-head motif were of Gravelot's own invention.[3] It was doubtless from Gravelot that Hayman learnt the fanciful treatment of interiors in his early book illustrations.

1. See my article 'Francis Hayman and the Supper Box Paintings for Vauxhall Gardens' in *The Rococo in England* (Victoria & Albert Museum, 1987).
2. As Lawrence Gowing put it before an impression of the print with Gravelot's name was discovered, 'If Quadrille were not designed by Gravelot it evidently followed his example closely' (Gowing, 1953, p. 11).
3. See Desmond FitzGerald, 'Gravelot and his influence on English Furniture', *Apollo*, XC (August 1969) p. 141.

64.

Playing the Game at QUADRILLE, *from an Original Painting in Vauxhall Gardens.*

65. AFTER HAYMAN, THE FORTUNE TELLER OR CASTING THE COFFEE GROUNDS

Etching and engraving, originally published 1743
$6\frac{1}{2} \times 10\frac{1}{2}$ (16.5 × 26.7)

Exh: Yale 1983 (53)

Coll: Yale Center for British Art, Paul Mellon Collection

This crude print is derived from the original engraving by Vivares published in 1743. Gypsy fortune tellers were much reviled by the respectable middle classes in mid-eighteenth-century England. A warning to innocent young girls appeared at the same time as this engraving after the lost Vauxhall supper box picture:

Telling of Fortunes has been one of the Pretences the Wretches above mentioned have found very successful for bringing about their wicked Designs; by no means, therefore, give way to any Insinuations of that sort; I know no Path that more readily leads to Destruction . . .[1]

Similarly, the last couplets of the verses beneath the image of the first state of this engraving warned:

Ah! Simple Maid, the faithless lore disdain,
Nor weep too late thy Parents cares were vain;
Let not an Hag's vile Cant thy Heart ensnare:
When Vertue guides thy Steps, thou canst not err.

The arrangement of the figures in a garden setting recalls the pastorals of Watteau, such as *Lecon Damour*, engraved by Mercier *c.* 1722–1723 and again by Dupuis in 1734.[2]

1. See *A Present for a Servant-Maid; or, the Sure Means of Gaining Love and Esteem* (London, 1743) 18, quoted by T. J. Edelstein, Yale 1983, p. 42.
2. Ingamells & Raines, loc. cit., p. 67, no. 293 and for the Dupuis engraving see Dacier and Vuaflart, op. cit., no. 263a.

66. R. PARR AFTER HAYMAN, BLINDMAN'S BUFF
Etching after engraving, originally published 1743
$9\frac{1}{4} \times 13\frac{7}{8}$ (23.5 × 35.2)

Exh: Yale 1983 (81)

Coll: Yale Center for British Art, Paul Mellon Collection

Hayman's rustic scene of *Blindman's Buff* is now only known

through this engraving since the original canvas was last seen at the Vauxhall Gardens sale in 1841 (see CL. 194). Hayman must have known Watteau's *Le Colin Maillard* for the blind-folded youth and his antagonist are taken from Brion's engraving after Watteau published in 1730 (fig. 47).[1] The subject can also be found in Dutch art of the 1730s and Troost's *Blindman's Buff*, for instance, would not have looked amiss at Vauxhall.[2]

The letterpress below the image on the first state of the engraving (not exhibited here) admonished its readers as follows in the final couplet:

Beware ye tender Maids, your Glowing Hearts,
For Love tho blind is not without its Darts

1. Dacier and Vuaflart, op. cit. no. 212.
2. The Troost is in the Boymans van Beuningen Museum, Rotterdam (see E. R. Mandle, *Dutch Masterpieces from the Eighteenth Century – Paintings and Drawings 1700–1800* (Minneapolis Institute of Fine Arts, 1971) p. 102, cat. 87, pl. 34.

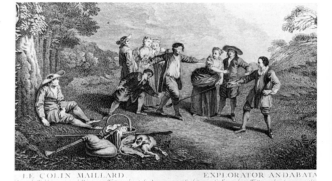

Fig. 47 Brion after Antoine Watteau, *Le Colin Maillard* (detail). Engraving. London, The British Museum

67. BENOIST AFTER HAYMAN, PLAYING AT CRICKET

Etching and engraving, originally published 1743
$9\frac{1}{4} \times 13\frac{7}{8}$ (23.5 × 35.2)

Exh: Yale 1983 (20)

Coll: Yale Center for British Art, Paul Mellon Collection

Benoist's engraving is our only record of the lost original painting. A crude nineteenth-century copy, which is often erroneously said to be the original, is in the Cricket Memorial Gallery at Lord's.[1]

The game of cricket shown here is the single wicket form commonly played before the formal printing of the rules of the game in 1744 deemed it improper. Unlike the highly accurate depiction of the game in Hayman's only authentic cricket picture (CL. 157),[2] this was probably never intended to be a serious illustration of the contemporary game. Alongside the other supper box pictures its rôle was essentially decorative but T. J. Edelstein has suggested that a rather puritanical spirit of nationalism, achieved through physical fitness, manifested itself in the verses beneath the image on the first state of the engraving:

66.

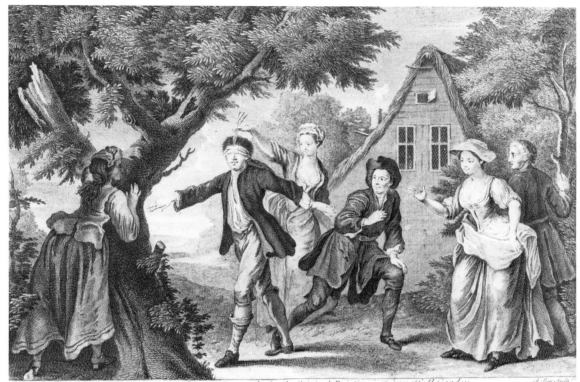

BLIND-MANS BUFF. *Engraved after the Original Painting in Vaux Hall Garden.*
Printed for John Bowles at the Black Horse in Cornhil, and Rob. Sayer ... London.

F. Hayman Pinxt. *R. Parr Sculpt.*

67.

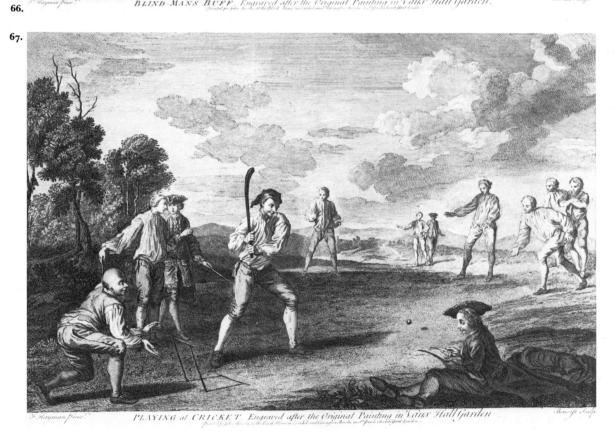

PLAYING at CRICKET. *Engraved after the Original Painting in Vaux Hall Garden*
Printed for John Bowles at the Black Horse in Cornhil, and Carington Bowles in St. Pauls Church Yard London.

F. Hayman Pinxt. *Benoist Sculp.*

Britons, whom Nature has for war designed
In the softcharms of ease no Joy can find:
Averse to waste in Rest the'inviting Day
Toil forms their Game, & Labour is their Play.[3]

It is worth noting that the original canvas was placed near to the Prince of Wales's Pavilion at Vauxhall and the Prince was one of the most enthusiastic supporters of the game.

1. See Robin Simon and Alastair Smart, *The Art of Cricket* (London, 1983) pp. 8–9, 87.
2. Ibid., colour plates II, III & IV.
3. See T. J. Edelstein, Yale 1983, p. 31.

68. CHARLES GRIGNION AFTER HAYMAN, SIR JOHN FALSTAFF IN THE BUCK BASKET

Etching and engraving, originally published 1743
$9\frac{1}{8} \times 13\frac{3}{4}$ (23.2 × 35.1)

Exh: Yale 1983 (102)

Coll: Yale Center for British Art, Paul Mellon Collection

As with the two paintings illustrating episodes from Richardson's *Pamela* (CL. 182, 186), Hayman simply adapted the as-yet-unpublished design drawn for the Hanmer edition of

Shakespeare from the horizontal format of the book plate to the rectangular shape of the Vauxhall canvases for this illustration to Shakespeare's *The Merry Wives of Windsor*.

The episode represented here is the comic moment in Act III, Scene IX (Hanmer edition) in which, aided by the two merry wives, Mistress Page and Mistress Ford, the amorous Falstaff climbs into the linen basket to escape from Mistress Ford's husband, who with 'half Windsor at his heels' is searching for him. It is one of two scenes from Shakespeare – neither of which survive – which Hayman adapted from supper box pictures (see also CL. 202).

Hayman's composition, now only known from this engraving, is a curious mixture of anachronisms. Although Falstaff is shown in a Tudor costume of sorts, Mistress Ford and Mistress Page wear eighteenth-century dress. The stage-like setting is a fashionable eighteenth-century interior with the sort of folding screen embellished with rococo ornament that appears in contemporary conversation pieces.

69. A SCENE FROM 'THE SUSPICIOUS HUSBAND' *c.* 1747

Pencil with red chalk highlights, $5\frac{1}{8} \times 6\frac{3}{4}$ (13 × 17.1)

Coll: Yale Center for British Art, Paul Mellon Collection

Although this lively drawing represents the same moment

68.

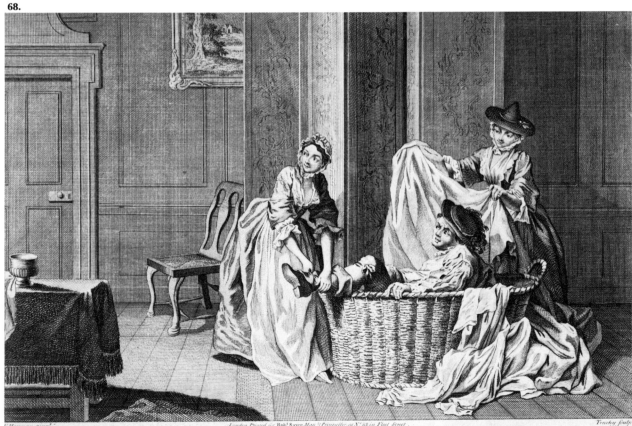

E. Hayman pinx *London Printed for Rob.t Sayer, Map & Printseller, at N.o 53 in Fleet Street*. *Truchy sculp.*
SIR JOHN FALSTAFF *in the* Buck Basket. *Scene* 9.th *Act* 3.d *in Shakespears.* ⟧ Le CHEVALIER FALSTAFF *dans le* Panier au linge Sale. *Act* 3. *Scene* 9. *de la Comédie de*
Merry Wives *of* Windsor. *From the Original Painting in Vaux hall Garden.* Shakespear, intitulée Les Commères de Windsor.

138

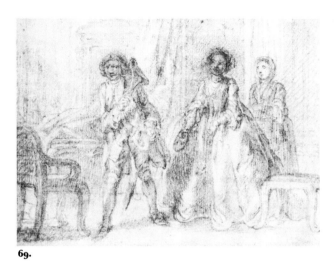

69.

This large life-class drawing – the only one of its kind by Hayman known at present – was possibly done at the St. Martin's Lane Academy *c.* 1751 and seems to be the model for the naked victim of the robber in *The Good Samaritan* (cat. no. 47). Hayman makes only minor modifications in transfering the figure to canvas, notably the bending of the left leg.

Despite its battered condition, it is a pleasing reassurance that, as we might expect from one of the leading instructors at the St. Martin's Lane Academy, Hayman could draw with the sort of anatomical correctness that is occasionally lacking in some of his portraits which appear to rely on the use of the lay-figure.

from Hoadly's play that Hayman painted (see cat. no. 39), there are some differences. The armchair seen in this drawing in the left foreground is replaced by a stool. Along with Clarinda's maid, the stool on the right is removed altogether in the painting and is replaced by a chair. Much of the spontaneity with which Clarinda unmasks in this drawing, which may have been done from the life, is lost in the painting.

70. AN ACADEMY STUDY (A STUDY FOR 'THE GOOD SAMARITAN')
c. 1751

Black chalk with white highlights on buff paper, $16\frac{1}{4} \times 21$ (41×54)

Prov: possibly presented by the artist to the R.A. (?)

Coll: London, Royal Academy of Arts

71. A STUDY FOR 'THE DEATH OF AN UNBELIEVER' *c.* 1745–50 (?)

Black chalk heightened with white, $10\frac{1}{2} \times 13\frac{1}{8}$ (27.1×33.7)

Prov: Benjamin West; William Esdaile; purchased in Paris *c.* 1911–13 by Dr Pál Majorsky by whom presented to Museum of Fine Arts, Budapest in 1935

Coll: Budapest, Museum of Fine Arts

Formerly attributed to Hogarth, this sheet appears to be related to *The Death of an Unbeliever*, one of two paintings executed by Hayman as decorations for an alcove in Jonathan Tyers's macabre garden at Denbies in Surrey (see cat. no. 72). These paintings are now only known through engravings which were published after the originals were destroyed and it is not known how exact a record they are. However, since this drawing is squared for transfer it may even be closer to the design of the Denbies painting than the engraving.

With the exception of the drawings for the Vauxhall pictures no other working drawings related to decorative schemes are known. On the verso of the sheet is another similar study that might even be a portrait of Tyers.

70.

71.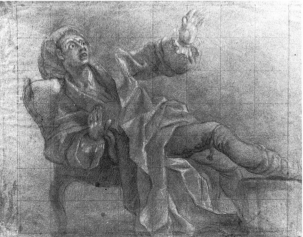

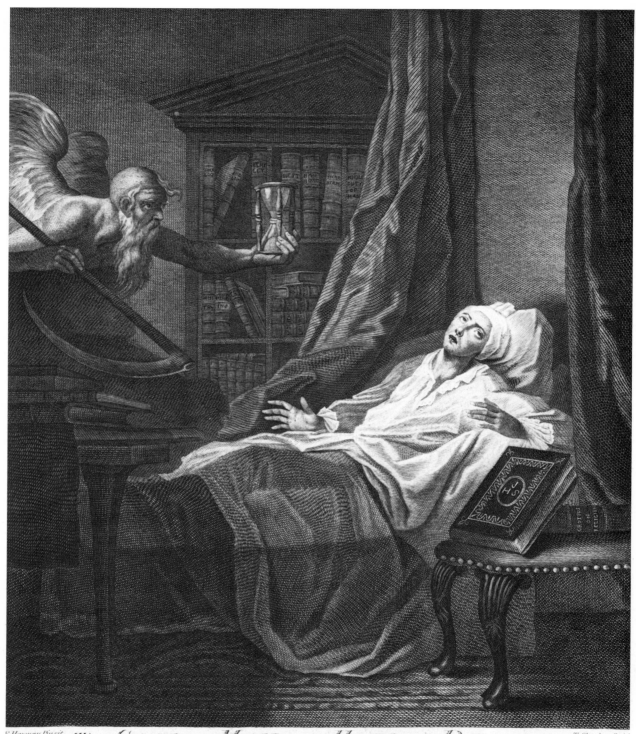

G. Hayman Pinxit. **The GOOD MAN at the HOUR of DEATH.** T. Chambars Sculp.t

When from this Life Heaven calls the JUST away, Of all Offence he finds his Conscience clear,
Serene he does the pleasing Call obey. — And all is Hope, and nothing is to fear. —

Published Mar. 1st 1783 by John Boydell Engraver in Cheapside London.

72a.

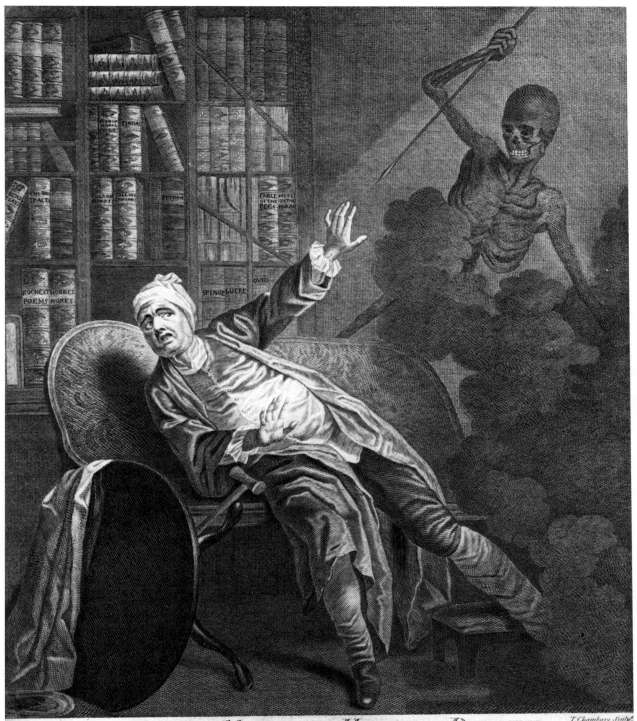

The BAD MAN at the HOUR of DEATH.

Lo, to what End a Life of Luxury brings! Mispent his Time, the Sinner dreads to die,
The Gout's acute and Death's acuter Stings! And fain he would the King of Terrours fly.

Published by W. Marshall, J. Holborn Bars London Novr 1 1836.

72b.

141

72. T. CHAMBERS AFTER HAYMAN
A. THE GOOD MAN AT THE HOUR OF DEATH
B. THE BAD MAN AT THE HOUR OF DEATH

Etching and engraving, 16 × 12½ (40.6 × 31.7)

Coll: London, The British Museum

These two large engravings, published by Boydell in 1783, are the only surviving record of a fascinating decorative scheme commissioned by Jonathan Tyers, probably in the late 1740s, for the garden of his weekend retreat, Denbies, near Dorking in Surrey.[1]

If Vauxhall Gardens was designed primarily for public enjoyment then, by contrast, Denbies was created for Jonathan Tyers' personal delectation and reflects his apparent preoccupation with the theme of death and *momento mori*. It was a sort of visual equivalent to the 'Graveyard' school of poets.

Tyers only retreated to his country estate on Sundays and the iconography of his garden was thus appropriately serious and contemplative. The principal feature was an eight-acre wood which he named *Il Penseroso*, in which stood a Temple of Death. The walls of his gloomy, Gothic structure were filled with verses reflecting on the vanity, transience and insufficiency of human pleasures. Chained to a desk in this temple were volumes of Young's *Night Thoughts . . . &tc.* and Robert Blair's *The Grave* bound in black leather. The focal point of the Temple of Death was a sculpted monument by Roubiliac to Robert, Eighth Baron Petre, who died in 1742. We know nothing of Tyers' relationship with Lord Petre but since he was one of the most remarkable botanist/gardeners of his day we might speculate that he had some involvement in the re-shaping of Vauxhall for Tyers or, more probably, of Denbies.

Deeper into Tyers' garden, beyond what he called the 'Valley of the Shadow of Death', lay a large alcove which formed an amphitheatre. Inside, on a pedestal, stood a large statue of a figure removing a vizor and treading on a mask inscribed 'TRUTH'. Although not documented, this statue was almost certainly also the work of Roubiliac and it directed the spectator's gaze towards two life-size pictures by Hayman – to which these engravings are related – set into compartments in the wall. These were described as 'The Death of a Christian' and 'The Death of an Unbeliever'.

Hayman had already experimented with such Greuze-like moralising genre paintings at Vauxhall where two of the supper box pictures, alas, now lost, were in contemporary guidebooks described as 'The good family; the husband is reading; the wife with an infant in her arms, and the other children are listening; the rest are spinning, and the maid is washing the dishes'. Its companion piece was described as 'The bad family; with the parson coming into make peace; the husband has the tongs ready lifted up to strike his wife, who is at his feet kneeling and supplicating mercy, and their three children are crying' (CL. 203, 204).[2]

These moral narratives were no doubt part of Tyers' attempt in the 1730s and 1740s to purge Vauxhall of its reputation as a sort of outdoor brothel. By the time John Lockman penned his guidebook in the early 1750s he could write of the 'Charm and Innocence of the *Entertainments*' where 'even Bishops have been seen . . . without injuring their Character . . .'.[3]

Hayman's paintings at Denbies were, along with all traces

of this macabre garden, destroyed soon after Tyers' death in 1767 but these engravings provide us with sufficient evidence to attempt to describe them.

The Good Man at the Hour of Death, as Chambers' engraving is described, was a suitably peaceful affair, the dying Christian meets the figure of Time clutching his scythe and an almost expired hour-glass with open-armed, pious serenity. Propped prominently on the stool beside him is the Bible resting on a volume entitled 'Grotius on Religion'. The contents of his bookcase, containing volumes by noted divines, including Tillotson and Clarke, are a testament to his piety.

The Bad Man's sharply contrasting lifestyle is also indicated by the contents of his library; in this case religious tracts are replaced with volumes by Hobbes, Tyndale, Toland, Morgan, Spinoza and that notorious libertine Lord Rochester who went through a celebrated death-bed repentance. The sharp diagonal pose of the terror-stricken sinner vainly attempting to repel Death's dart is highly reminiscent of Roubiliac's dramatic monumental figures seen in the Nightingale or Hargrave monuments in Westminster Abbey, and of Hogarth's *Garrick as Richard III* which is similarly indebted to the sculptor's technique. Even the overturned table partly shrouded in drapery – a device used by Hogarth in *The Election Entertainment* – has its origin in the type of medallion portrait seen in some of Roubiliac's more modest monuments.[4]

By about 1750 Hayman had developed a considerable reputation as an illustrator of poetic melancholy. His twelve plates for Dr Newton's edition of *Paradise Lost*, his frontispieces for Hervey's *Meditations and Contemplations* and Young's *Night Thoughts* are just a few examples of this extraordinary genre (see cat. nos. 85, 86).

A small version of this subject which was on the art market in London in the 1960s is probably a copy of the engraving or possibly an engraver's *modello*.[5]

1. I have discussed the Denbies garden at length in my article 'Jonathan Tyers's Other Garden', *Journal of Garden History*, I, 3 (July-September 1981) pp. 215–238.
2. See Gowing 1953, p. 15.
3. [John Lockman], *A Sketch of Spring Gardens . . . &tc.* (London, n.d. [1752] p. 27.
4. cf. Allen, loc. cit., fig. 17.
5. Repr. E. K. Waterhouse, *The Dictionary of British 18th Century Painters in Oils and Crayons* (Woodridge, 1981) p. 163.

73. THE FIVE SENSES 1753

Engravings in mezzotint by Richard Houston, published by Bowles 1 August 1753
Each *c.* 13¾ × 9¾ (35 × 24.9)

Coll: Yale Center for British Art, Paul Mellon Collection

a. *Seeing*
b. *Feeling*
c. *Hearing*
d. *Smelling*
e. *Tasting*

Hayman may well have been inspired to produce these domestic genre prints as a result of the success of Mercier's domestic genre paintings which enjoyed considerable popularity from the end of 1730s. By the end of the 1740s,

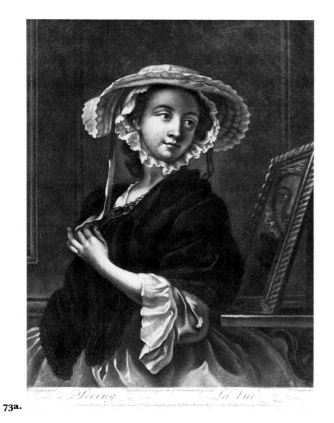

73a.

Seeing. *La Vue*

Published according to Act of Parliament Aug. 1 1753

London Printed for The Bowles in S.t Pauls Church Yard & John Bowles & Son at the Black Horse in Cornhill

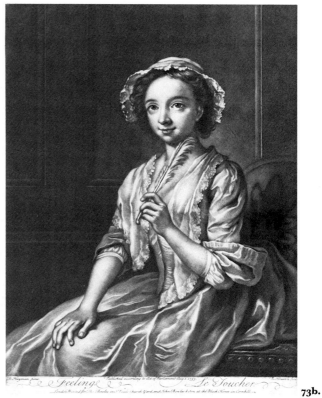

73b.

Feeling. *Le Toucher*

Published according to Act of Parliament Aug. 1 1753

London Printed for The Bowles in S.t Pauls Church Yard & John Bowles & Son at the Black Horse in Cornhill

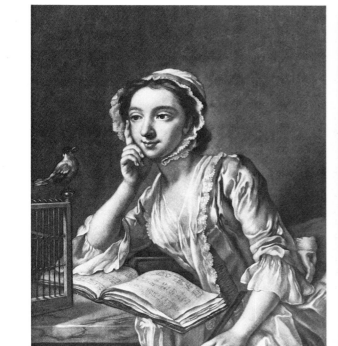

73c.

Hearing. *L'Ouie*

Published according to Act of Parliament Aug. 1 1753

London Printed for The Bowles in S.t Pauls Church Yard & John Bowles & Son at the Black Horse in Cornhill

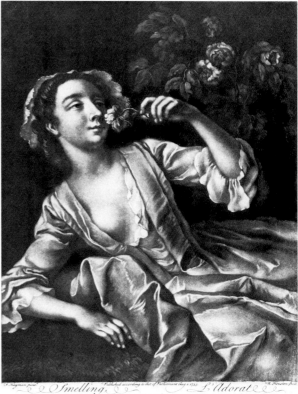

73d.

Smelling. *L'Odorat*

Published according to Act of Parliament Aug. 1 1753

London Printed for The Bowles in S.t Pauls Church Yard & John Bowles & Son at the Black Horse in Cornhill

143

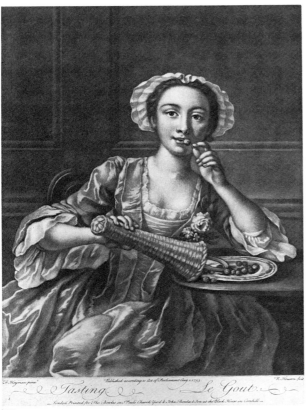

'Tasting'. *Le Goût.*

73e.

74.

Mercier had already produced two painted sets of the five senses. The larger set, now in the Yale Center for British Art,[1] are likely to be those which Vertue tells us were brought to London by Mercier in April 1747 which 'he disposed of here and sold for [£] 100'.[2] Those ambitious compositions contain four and five figures but perhaps closer to Hayman's more modest designs are the single-figure fancy pictures produced by Mercier and engraved in mezzotint by the younger Faber. For instance, the risqué *Girl at a Mirror*, engraved by Faber in 1739[3] makes an interesting comparison with Hayman's *Seeing* (a). This type of subject matter is more commonly found in French art and Chevillet's engraving after Jean Raoux's *La Jeune Coquette* is a good example of the sort of comparable French print to which Hayman would have had access.

Hayman painted small *modellos* for the engraver to work from, one of these, for *Seeing*, has survived (CL. 158). A slight pencil sketch by Hayman, also at Yale, is very closely related to the same design and seems to be Hayman's first idea for the composition (CL. 259).

These mezzotints were executed by the Irish engraver Richard Houston who arrived in London in 1746.[4] Houston followed Faber in engraving subject pictures as well as portraits and his success with some of Mercier's fancy pieces probably prompted this commission from Hayman and Bowles.

1. All are reproduced in Malcolm Cormack, *A Concise Catalogue of Paintings in the Yale Center for British Art* (New Haven, 1985) pp. 158–59.
2. Vertue Note Books III, op. cit., p. 135.
3. See Ingamells & Raines, loc. cit., 43, cat. 163.
4. See David Alexander, 'The Dublin Group: Irish Mezzotint Engravers in London 1750–1775', *Quarterly Bulletin of the Irish Georgian Society*, XVI (1973) p. 72–93.

74. SPRANGER BARRY AND MRS ELMY IN 'HAMLET' *c.* 1755–60

Pencil, grey wash, black ink, heightened with white, $7\frac{3}{8} \times 7\frac{1}{8}$ (17.8 × 17.3)

Coll: Washington, D.C., The Folger Shakespeare Library

This is a preliminary study for the large picture now in the Garrick Club (cat. no. 41).[1] It differs from the painting as executed in several respects, notably in the organisation of the background which here is dominated by a large wardrobe whilst in the painting and in the later engraving (CL. 311) a large frame-like piece of panelling is visible. Here Hamlet grapples vigorously with his mother the Queen but in the painting Hayman exercises much more restraint.

1. I am grateful to Dr Geoffrey Ashton, Librarian of the Garrick Club, for drawing my attention to this study.

75. FALSTAFF REVIEWING HIS RECRUITS early/mid-1760s (?)

Black chalk with white highlights on buff paper, $7\frac{3}{8} \cdot \times 9\frac{5}{8}$ (18.75 × 24.5)

Prov: Colnaghi; acquired by Paul Mellon in 1967

Exh: Yale Center for British Art, *Shakespeare and British Art* 1981 (67)

Coll: Yale Center for British Art, Paul Mellon Collection

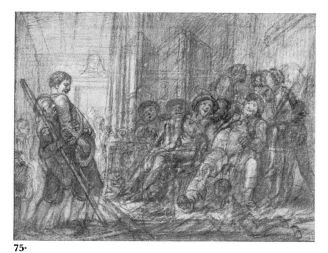

75.

This black chalk drawing is compositionally closest to the Folger Library painting (CL. 142, fig. 7). It is one of a number of variations on the subject which Hayman executed in the 1760s. Few drawings survive from Hayman's later years and it is instructive to compare the coarsely vigorous style exhibited here with the controlled precision in pen and ink of the early book illustrations or the Vauxhall drawings where the pervasive influence of Gravelot is apparent. By the end of the 1750s Hayman's mannerisms become more exaggerated and the spidery delicacy of his early works in pen and ink gives way to a bolder and more rounded drawing style.

76. GERARD VANDER GUCHT AFTER HAYMAN, THE PATRIOT STATESMAN

Broadside with engraved headpiece, published 1740
$6\frac{1}{2} \times 11\frac{1}{2}$ (16.5 × 29.3)

Coll: London, The British Museum (Satire no. 2459)

This headpiece, with three columns of letterpress beneath, is the only political print designed by Hayman and is one of his earliest datable works. It is also one of the few pro-Walpole prints ever to appear.[1] By the early 1740s Hayman was on good terms with Grosvenor Bedford (see cat. nos. 4, 16), one of Walpole's placemen, and it is possible, although there is no evidence whatsoever to support the theory, that there is some connection.

The Prime Minister, Sir Robert Walpole, is shown being conducted along the path of virtue by the Elizabethan statesman Lord Burleigh, towards the Temple of Fame in which a winged figure of Fame on an altar announces his glory with a trumpet. Above Walpole hovers Minerva who, brandishing a spear and reflecting light from her shield, drives off per-

76.

F. Hayman Inv. Burleigh. Walpole. G. Vander Gucht Sculp. 1740.

The PATRIOT-STATESMAN.

sonifications of Envy, War, Anarchy and the Vices. In shadow in the left foreground, Age and Youth are struck with admiration and awe at the scene before them whilst to the right, behind the allegorical figures is a view of the sea with merchantmen representing Trade and Empire.

Walpole, although an advocate of peace, was forced to declare war with Spain on 19 October 1739. This print, however, with the aid of its allegorical apparatus, pleads in favour of Walpole's policy of peace. Beneath the print is the character of 'The Patriot Statesman' (Walpole) eulogised in letterpress:

> SEE virtuous WALPOLE to FAME'S *Temple* goes,
> Where the known Entrance to mighty Burleigh shows.
> *Pallas*, to every *Hero's* Cause inclin'd,
> Keeps Envy's meagre *Offspring* far behind.

Walpole is described as: 'Like *Burleigh*, shining with Victorious Rays.'

A few years earlier Hogarth had apparently been pressed 'by the Patriots in Opposition to Sir Robert Walpole to design a series of prints, to be entitled *The Statesman's Progress*, but he, scorning to prostitute his art to the purposes of faction, rejected their offer'.[2] Hayman's pro-Walpole broadside, however, must have been extensively circulated since there are at least two editions of the letterpress beneath it as well as impressions of the print without letterpress which betray considerable wear.[3]

The horizontal type of composition is appropriate for a headpiece but it also reflects Hayman's interest in the panoramic format which he exploited for the Vauxhall supper box pictures begun about this time.[4] In view of the shortage of decorative history paintings by Hayman, this design at least provides some idea of his powers of composition for a very challenging subject.

The engraver Gerard Vander Gucht seems to have been actively involved in political print-making for many years from his shop at his London residence in Bloomsbury Square.[5]

1. See Herbert M. Atherton, *Political Prints in the Age of Hogarth: A Study of the Ideographic Representation of Politics* (Oxford, 1974) p. 47.

77.

2. See John Hawkins, *The Life of Samuel Johnson LL.D.* (London, 1787) 500n.
3. See F. G. Stephens and E. Hawkins, *Catalogue of Prints and Drawings in the British Museum, Division 1 Political and Personal Satires no. 2106 to no. 3116*, III, Part 1. March 1928, 1734 to *c.* 1750 (London, 1877) no. 2459 also Paul Langford, *Walpole and the Robinocracy* (Cambridge, 1986) p. 172.
4. Lawrence Gowing has even suggested that this design originated as one of the Vauxhall canvases, but this seems unlikely (Gowing, 1953, 19).
5. See Atherton, op. cit. p. 47.

77. A DESIGN FOR A SUBSCRIPTION TICKET FOR A SERIES OF PRINTS, 'ENGLISH HISTORY DELINEATED' *c.* 1749–50

Pencil and grey wash, $5\frac{1}{4} \times 6\frac{3}{4}$ (13.2 × 17.1)

Signed lower left: F. HAYMAN

Engr Grignion

Coll: London, Victoria & Albert Museum

This is the design for the subscription ticket for the series of prints issued in 1751–2 by Knapton & Dodsley (cat. no. 78). Hayman depicts Clio, the muse of History, introducing Painting to the History of England. The seated figure of Painting at the easel is compositionally close to the *Self-Portrait at the Easel* of 1750 (cat. no. 21).

78. ENGLISH HISTORY DELINEATED 1750–1752

a. *The Noble Behaviour of Caractacus, Before the Emperor Claudius* 1751 Fig. 37. p. 66
Engraving by Grignion after Hayman, $16\frac{1}{2} \times 15\frac{1}{2}$ (41.9 × 46.9)

b. *The Druids: or, the Conversion of the Britons to Christianity* 1752
Engraving by Ravenet after Hayman, $16\frac{3}{4} \times 19$ (42.6 × 48.3)

c. *The Norman Conquest, or the Battle of Hastings* 1752
Engraving by Grignion after Hayman, $16\frac{1}{2} \times 18\frac{1}{2}$ (41.9 × 46.9)

Coll: Yale Center for British Art, Paul Mellon Collection

These prints, published by John and Paul Knapton and Robert Dodsley were, to use Edward Edwards' words, 'the first attempt that was made in England to produce a regular suite of engravings from our national history'.[1] They form part of a proposed scheme of fifty prints, to be issued by subscription 'Representing the most memorable Actions and Events, from the landing of JULIUS CAESAR to the Revolution.' On 19 January 1749–50 the Knaptons and Dodsley placed an advertisement in the press to solicit subscriptions, and three weeks later they published a full list of the fifty intended subjects with a plea that 'Gentlemen of Taste and Knowledge might favour the publishers with their Objections and Remarks'[2] The subjects were chosen to please a varied audience: 'Care will be taken that they be First., Important, or Interesting: Secondly Striking, or such as will make a good Picture; Thirdly, So different from each other as to afford an agreable Variety'.[3]

F. Hayman Inv.º et Del. S. F. Ravenet Sculp.ᵗ

The Druids; or, the Conversion of the Britons to Christianity.

Publish'd for J. & P. Knapton & R. Dodsley, according to Act of Parliament. 1752.

78b.

The designs for the first suite of six prints were entrusted equally to Hayman and the little known Nicholas Blakey and these were engraved by Grignion, Ravenet and Scotin.[4] Hayman was also commissioned to design an elaborate subscription ticket for the series which was engraved by Grignion (see cat. no. 77).

Louise Lippincott has suggested that Arthur Pond, who had been in partnership with the Knaptons since 1737, had a part in conceiving and planning the series and may even have supervised the printing and maintenance of the plates, which were in his shop at the time of his death.[5] Pond had earlier been involved in illustrating Paul Rapin de Thoyras' popular *History of England*, first published in an English translation by James Knapton in 1725.[6]

The venture, however, was a failure since only the first six

of the proposed fifty prints appeared because soon after their publication John and Paul Knapton went bankrupt 'apparently as a result of financial mismanagement over a long period'.[7]

Of Hayman's three designs, which are exhibited here, *The Noble Behaviour of Caractacus Before the Emperor Claudius* (fig. 37, p. 66) is the most impressive composition. Grignion, the engraver, evidently thought it worthy of exhibition at the Society of Artists a decade after its publication. The elaborate architectural interior with its paired columns and pilasters and spacious rotunda recall the small oil sketch for *The Artists Presenting A Plan for An Academy to Frederick, Prince of Wales and Princess Augusta* (cat. no. 48, fig. 36). Ravenet's engraving of *The Druids or, the Conversion of the Britons to Christianity* makes full use of the landscape elements but the overall impression

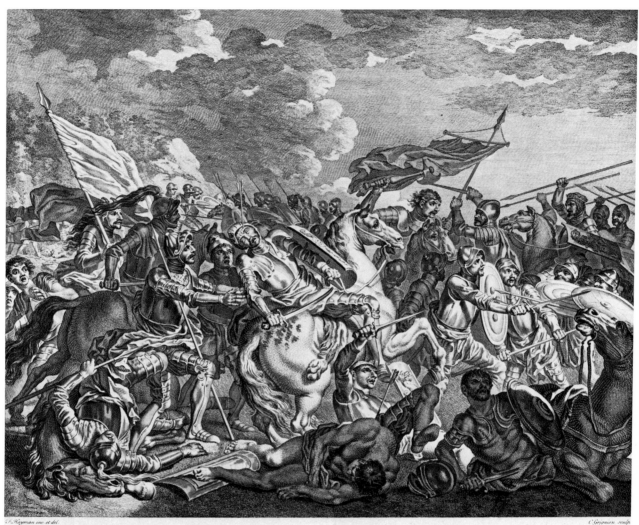

F. Hayman inv. et del. C. Grignion sculp.

The Norman Conquest, or the Battle of Hastings.

78c.

is one of picturesque confusion as too many groups of figures fail to successfully relate to each other. Perhaps the least successful of the three was *The Norman Conquest, or the Battle of Hastings.* This is a regrettably clumsy parody of *The Victory of Constantine at the Milvian Bridge,* designed by Raphael (but executed by Giulio Romano and his assistants) in the so-called Sala di Constantino in the Vatican, and which Hayman no doubt knew through engravings. Although Hayman's figures are recognisably medieval, they wear the stock costume of all his medieval figures, which approximates to about the time of Edward IV. It must have been figures like these which Joseph Strutt had in mind later in the century when he censured those painters who failed to achieve the correct degree of archaeological exactitude.[8]

The three Hayman designs were re-engraved in a much smaller format by Grignion, Ravenet and Anthony Walker

and appear in the first of the eleven-volume octavo edition of Smollett's *A Complete History of England . . . &tc.,* published in 1758 (CL. 302).

1. Edwards, op. cit., p. 4.
2. See *The General Advertiser,* no. 4656 (19 January 1749–50) and no. 4775 (9 February 1749–1750).
3. Ibid., no. 4656.
4. Little is known of Blakey except that he was born in Ireland and worked for some years in Paris where he died in 1758 (see Walter Strickland, *A Dictionary of Irish Artists,* 2 vols. (Dublin, 1913) I, p. 67. He collaborated with Hayman over several publishing projects including the illustrations for Warburton's edition of Pope's *Works* (see CL. 290).
5. Louise Lippincott, *Selling Art in Georgian London: The Rise of Arthur Pond* (New Haven & London, 1983) p. 157. The six plates were acquired by Robert Sayer and prints were reissued by him in 1778.

This edition is in the British Museum, Dept. of Prints and Drawings (B.M. 1855–6–9–1825.)

6. Lippincott, op. cit., pp. 149–150.
7. Ibid., p. 156.
8. See Joseph Strutt, *Regal and Ecclesiastical Antiquities of England* (1793) p. 8.

79. RAVENET AFTER HAYMAN, THE TRIUMPH OF BRITANNIA 1765
Fig. 35, p. 65

Etching and engraving, published by Boydell, 1765, 15 × 20⅜ (38 × 51.8)

Exh: An impression exhibited at the Society of Artists 1765 (227)

Coll: Yale Center for British Art, Paul Mellon Collection

Of the four large Vauxhall history paintings executed in the early 1760s, only *The Triumph of Britannia* was engraved. Despite surviving until the Vauxhall sale in 1841, the original canvas (CL. 98) is lost but in the opinion of one critic who viewed the sale it was 'really [a] national picture . . . proper to adorn the National Gallery at Greenwich'.[1]

Hayman's pupil John Taylor, now best remembered as an anecdotalist (see cat. no. 99), claims to have made the engraver's *modello* from which Ravenet produced this impressive large print.[2]

The large painting from which this is taken was on view to the public by mid-May 1762 and a printed account of it placed underneath its frame in the Rotunda annexe at Vauxhall Gardens provided the following account, which appeared in *The London Chronicle* of 18–20 May 1762[3]:

> The new emblematical picture, in the Great Room in Vauxhall-gardens, painted by Mr Hayman, exhibits Neptune, as represented by the poets; Britannia, holding in her hand a medallion of his present Majesty, and sitting by Neptune in his chariot drawn by sea-horses, who, by their attitudes, and the spirit they discover, seem to partake in the triumph, which is supposed to be occasioned by the defeat of the French fleet (represented on the back ground) by Sir Edward Hawke, Nov. 20, 1759. Neptune's car is surrounded by Nerieds, or Sea-nymphs, who attend the triumph, and are gently impell'd along by the agitation of the waves; they hold in their hands medallions, as big as the life, representing those British Admirals, and Sea-commanders, who, during the late and present wars against France and Spain, have, with a courage and conduct unstained by dishonour and inhumanity (and therefore peculiar to to their country) extended the conquests, and raised the naval glory of Great Britain to a higher pitch than ever was known in this or any other age or nation. – As a medallion, representing Adm. Boscawen, could with no propriety be omitted, it is held by a Nereid, who weeps over it.

The *Description of Vaux-Hall Gardens* published a few months later printed a similar account but added:

> When this painting was finished, admiral Anson was not dead [he died 6 June 1762]. The sea-fight represents the engagement between the Royal George commanded by admiral Hawke in person and the Soleil Royal commanded by admiral de Conflans.[4]

Another critic described this picture and *The Surrender of Montreal* (CL. 95) in 1763 as 'standing monuments of the glory of Great Britain'.[5]

Hawke's victory over the French fleet at Quiberon Bay on 20 November 1759 was one of the most decisive actions of the Seven Years War[6] and Hayman was by no means the only artist to glorify the event in paint.[7] Hawke's portrait, like the others in the form of a medallion born by a sea-nymph was, we are told, based on a sitting to Hayman and, although not documented, it is likely that the other Admirals (Pocock, Boscawen, Anson, Saunders and Keppel) sat, too.[8] Only the portrait of Admiral Howe, who is partially obscured by a triton, suggests that either he did not sit to Hayman or that he was being discreetly snubbed because of his relative lack of success.[9]

Hayman's composition, which owes something to Raphael and Annibale Carracci, seems to have inspired several later works by other artists, including James Barry's *Commerce, or the Triumph of the Thames*.[10]

1. Anon. cutting, dated 12 October 1841 (day of Vauxhall sale) in the Wroth collection of cuttings related to Vauxhall Gardens in the Library of the Museum of London (Vol. III, p. 181].
2. John Taylor claimed of his friendship with Jonathan Tyers, 'many a time I have dined with him in the gardens, when I was making the drawing for Boydell of Hayman's picture of the Admirals' (see J. T. Smith, *A Book for a Rainy Day* (London, 1845) p. 302.
3. No. 843, p. 279.
4. *A Description of Vaux-Hall Gardens*, op. cit., p. 27.
5. See *The Universal Director . . . of the Liberal Arts and Sciences* (London, 1763) p. 13.
6. See G. Marcus, *Quiberon Bay* (London, 1960).
7. Paintings of the subject exist by Richard Wright (Society of Artists, 1763 (135)), now in the National Maritime Museum, Greenwich and Richard Paton (Society of Artists, 1769 (121), engraved by P. C. Canot.
8. See *The Ambulator; or the Stranger's Companion in a Tour Round London*, 10th edition (1807) p. 291 ('for that of Lord Hawke, his Lordship sat to the painter').
9. Two of Howe's expeditions, capturing the Island of Aix in 1757 and a second expedition in 1758 against St. Malo had turned out to be fiascos (see Sir John Barrow, *The Life of Earl Howe* (London, 1838)).
10. See William Pressly, *The Life and Art of James Barry* (New Haven & London, 1981) 104, pl. 77. See also a curious composition by the young John Flaxman, engraved by Collyer and published in 1780, which is a copy in reverse of Hayman's design.

80. AN ILLUSTRATION TO RICHARDSON'S PAMELA c. 1741

a. *Sir Jacob Surveying Pamela*
 Pen and ink, with grey wash, indented for transfer, 5⅜ × 3⅛ (12.8 × 7.3)

Prov: E. V. Utterson (?); Lt. Col. A. T. Utterson, by whom it was presented to the British Museum in 1951.

This is the only drawing at present known for the twelve illustrations which Hayman produced for the four-volume, sixth edition of 1742. All twelve were engraved by Gravelot whose influence on Hayman in the early 1740s was at its strongest. (See cat. no. 81 for further details).

b. *Gravelot After Hayman, Sir Jacob Surveying Pamela*

Etching and engraving, 5 × 3 (12.5 × 7.5) to face p. 377 in Vol. III of 6th edition of *Pamela*, published in 1742

81. SAMUEL RICHARDSON, PAMELA; OR, VIRTUE REWARDED . . . IN FOUR VOLUMES . . . SIXTH EDITION CORRECTED AND EMBELLISHED WITH COPPER PLATES DESIGNED AND ENGRAVED BY MR HAYMAN AND MR GRAVELOT

PAMELA FLEEING FROM LADY DAVERS (Vol. III, f. 267) 5 × 3 (12.4 × 7.5)

Engr : Gravelot

Coll : London, The British Library

Soon after the publication of *Pamela* in November 1740, Samuel Richardson took the unusual step of deciding to embellish a subsequent edition with illustrations.[1] Initially, he approached Hogarth to produce illustrations, but these were never published. The only reference to the plan is to be found in a letter from Aaron Hill to Richardson, dated 29 December 1740, in which he remarks:

> The designs you have taken for the frontispieces, seem to have been very judiciously chosen; upon pre-supposition that Mr Hogarth is able (and if anybody is, it is he), to teach pictures to speak and to think.[2]

Richardson explained to his readers in his introduction to the second edition his reasons for a change of heart:

> We shall only add, That it was intended to prefix two neat frontispieces to this Edition (and to present them to the Purchasers of the first) and one was actually finished for that Purpose: but there not being Time for the other, from the demand for the new impression; and the Engraving Part of that which was done (tho' no Expence was spared) having fallen very short of the Spirit of the Passages they were intended to represent, the Proprietors were advised to lay them aside.[3]

8oa.

8ob.

More important, however, than the unpublished Hogarth designs (which are lost) are the illustrations which the author commissioned from Hayman and Gravelot in 1741. These were published on 10 May 1742, in this the sixth edition. As Richardson noted in a letter to Ralph Aller on 8 October 1741, there were to be engravings in this edition 'done by the best hands'.[4] Of the twenty-nine illustrations – an unusually large number for any English literary work of the period – Hayman designed twelve whilst the remainder, and all the engraving, was done by Gravelot.[5]

Richardson apparently lost money on the venture since this edition did not sell well, mainly because the price had been doubled, from 12 to 24 shillings, to pay for the plates. As late as 1772 there were enough sheets of this edition remaining for a re-issue, minus the plates and with a different title-page.[6] Never again did Richardson embellish his work with copperplates.

This was Hayman's first published work as a book illustrator and his designs are much influenced by the stylish elegance of the Gravelot's work. Ronald Lightbown and Michael Snodin have convincingly suggested that Hayman's treatment of interiors, with their elaborate rococo overdoors and panelling in these plates recalls the illustrations after Boucher in the *Oeuvres de Molière* (Paris, 1734), which was almost certainly known to him since Gravelot may have been involved in the project.[7]

Richardson's story – his first work of fiction – is told in a series of letters from the heroine, Pamela Andrews, a young maidservant whose mistress has just died. Her Lady's son, Mr B, thereafter pursues Pamela and, by her virtuous resistance to his attempted seduction wins his affection and eventually marries him. The episode represented here was one of the scenes which Hayman reworked into a supper box picture for Vauxhall Gardens (CL. 186) and the narrative is described by the author of *A Description of Vaux-Hall Gardens* (1762) as follows:

> Mr B and Pamela . . . had mutually appointed a day for their marriage, but Lady Davers, his sister, hearing of it, came down to prevent it, and one evening while Mr B was gone out with some of his friends, Lady Davers took the opportunity of using Pamela extremely ill, who not liking such treatment, jumped out of the parlour window, and is represented in the painting as flying to the coach which is waiting without the court-yard, while Lady Davers sends two of her footmen to stop her, but Mr B's gentleman luckily interferes, and threathens to drive them if they stir an inch further.[8]

1. See T. C. D. Eaves, 'Graphic Illustrations of the Novels of Samuel Richardson, 1740–1810', *Huntington Library Quarterly*, XIV, No. 3 (1950–51) pp. 349–369 and more recently Robert Halsband, 'The Rococo in England: Book illustrators, mainly Gravelot and Bentley', *Burlington Magazine*, CXXVII (December 1985) pp. 870–880.
2. Eaves, loc. cit., p. 350.
3. Ibid., p. 350–51.
4. See *Select Letters of Samuel Richardson*, ed. John Carroll (Oxford, 1964) p. 53.
5. For a list of Gravelot's subjects see Eaves, loc. cit., 354.
6. See W. M. Sale, *Samuel Richardson : A Biographical Record of his Literary Career* (New Haven, 1936) p. 22.
7. See *Rococo*, 1984, pp. 57–8, D.18.
8. *A Description of Vaux-Hall Gardens* (London, 1762) pp. 30–31.

F. Hayman H. Gravelot

81.

82. THE WORKS OF SHAKESPEARE. IN SIX VOLUMES CAREFULLY REVISED AND CORRECTED BY THE FORMER EDITIONS AND ADORNED WITH SCULPTURES DESIGNED AND EXECUTED BY THE BEST HANDS

4to 'Oxford, printed at the Theatre', published 1743–1744

a. *The Wrestling Scene from "As You Like It"* c. 1741
Pen, ink and grey wash, $8\frac{1}{2} \times 5\frac{3}{4}$ (21.6 × 14.6)

Prov: Sir Thomas Hanmer; Sir Henry Bunbury

Engr: by Gravelot

Coll: Washington, D.C., The Folger Shakespeare Library

b. *The Heath Scene from 'King Lear'* Vol. iii Fig. 4, p. 18
Engraving by Gravelot after Hayman, $8\frac{1}{2} \times 5\frac{3}{4}$ (21.6 × 14.6)

Coll: London, The British Library

The six-volume quarto edition of Shakespeare was not published by Sir Thomas Hanmer at Oxford until 1743/4 although copy had been delivered to the press at Oxford by

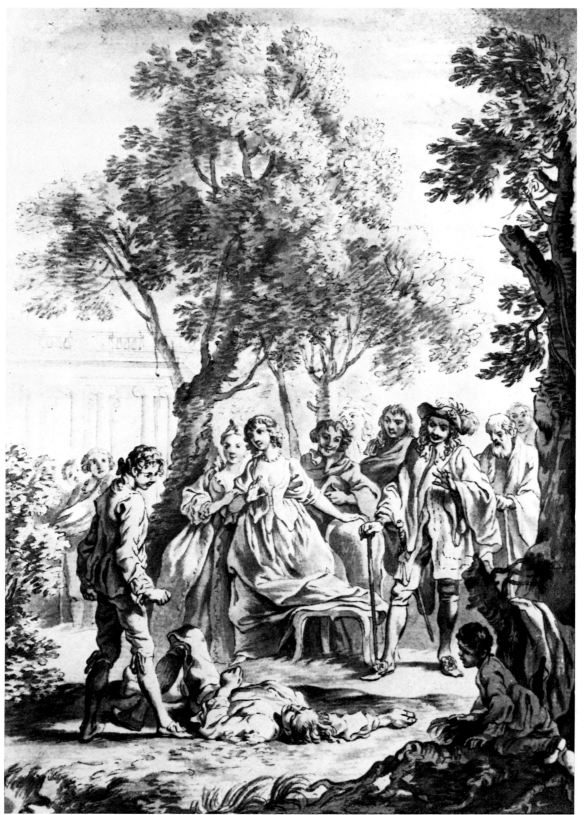

the end of 1742.[1] A few months earlier, Hanmer had complained in a letter to Dr Joseph Smith that the copperplates would not be ready before the end of the summer.[2] The six-volume set in the Folger Library (a above is volume II) contains the 31 original drawings by Hayman plus five by Gravelot who engraved all of them as well as a portrait of Shakespeare, a large title-vignette and three tail-pieces.

George Vertue reported after their publication that 'these prints are now the admiration of the public and curious' and went on to state that they cost Hanmer £450–£150 to Hayman for the drawings and £300 to Gravelot for the engraving.[3] Hanmer's bank account for the period with Hoare's bank reveals payments of £78-15-0 to Hayman, paid in instalments in April and June 1742 and £217-7-0 paid to Gravelot in five instalments between July 1741 and May 1743.[4]

This entire project offers a very rare example of a well-documented commission for book illustration in the eighteenth century, for not only do records of payments from publisher to artists survive, but so too does the text of the agreement between Hanmer and Hayman, which reads as follows:

The said Francis Hayman is to design and delineate a drawing to be prefix'd to each Play of Shakespeare taking the subject of such scenes as Sr Thomas Hanmer shall direct. and that he shall finish the same with Indian ink in such a manner as shall be fit for an Ingraver to work after them and approved by the said Sr Thomas Hanmer.

That the said Sr Thomas Hanmer shall pay the said Francis Hayman the sum of three Guineas for each drawing taking one with another as soon as the whole number shall be finished. upon this condition nevertheless and it is declared and mutually consented to that if the whole number shall not be completed in the manner before-mention'd by Lady-day which shall be in the year of our Lord 1741. The said Francis Hayman shall not be intitled to receive payment or consideration whatsoever for any part of the said work.

Tho: Hanmer
Fr: Hayman[5]

It is not clear if the latter part of the second clause was invoked, for the illustrations show that Hayman did not, in fact, complete the work; the illustrations in Volume IV were drawn and engraved by Gravelot who had previously designed thirty-six plates for the octavo second edition of Theobald's *The Works of Shakespeare*, published in 1740.

To add to our already considerable knowledge of the commission, in 1973 Dr Marcia Allentuck discovered in the Cottonian Library in Plymouth a holograph copy of Hanmer's directions to Hayman for twenty-seven of the plates, transcribed by Charles Rogers. This manuscript is in two parts. The first consists of a letter to Hayman from Hanmer written in August 1741 in which the publisher comments on drawings submitted by Hayman for *Julius Caesar*, *Titus Andronicus* and *Macbeth*. The second part is considerably longer and is entitled 'Sir Thomas Hanmer's Instructions to Mr Hayman for his Designs to Shakespeare's Plays. From the Autographs in the possession of Mr Lowth'.[6]

The drawing for *As You Like It* (I. vi), is seen here (a) and Hanmer offered the following advice to Hayman:

The Wrestling before the Duke, Lords, Attendants, Celia and Rosalind. Orlando a handsome young man well pro-portioned for strength throws Charles, the Duke's champion. The attendants give a shout of applause, but the two ladies show greater joy than all the rest. Their figures must must be set off to all possible advantage as young beautifull and of the highest rank.

And for *King Lear* (III, vi) (b above):

A naked barren heath, with a poor thatch'd weather-beaten hovel upon it. Edgar comes out of the hovel like a Tom o'Bedlam, all in rags, his hair ruffled and gnarl'd and mix'd with straws, and his gesture and action frantick. The King's fool having peep'd into the hovel runs back from the mad-man in a fright, the King bare-headed and in grey hairs stares with amazement at the fellow and fixes great attention upon him. Kent habited like a serving-man waits upon the King. A very stormy sky with light'ning and rain.[7]

Hayman followed Hanmer's instructions to the letter and, in the case of the wrestling scene was well-enough pleased with his design to work it up into the painting now in the Tate Gallery (cat. no. 37).

1. According to John Nichols, *Literary Anecdotes of the 18th Century*, 9 vols. (London, 1812–15) V, p. 589.
2. See *Biographica Britannica*, VI (1763) p. 3743.
3. Vertue Note Books VI, *Walpole Society*, XXX (1948–50) p. 199.
4. To Francis Hayman: 30 April 1742 £52.10; 30 June 1742 £26.5
To Hubert Gravelot: 17 July 1741 £29.80; 30 December 1741 £29.80; 5 July 1742 £58.16; 31 January 1742/3 £84; 27 May 1743 £15.15.
5. See W. Moelwyn Merchant, 'Francis Hayman's Illustrations of Shakespeare', *Shakespeare Quarterly*, IX, p. 2 (Spring 1958) pp. 141–47, also Edward Hodnett, *Image and Text Studies in the Illustration of English Literature* (London, 1982) pp. 51–69.
6. Marcia Allentuck, 'Sir Thomas Hanmer Instructs Francis Hayman: An Editor's Notes to his Illustrator', *Shakespeare Quarterly*, XXVII, 3 (Summer 1976) pp. 288–315.
7. Ibid., pp. 303, 307.

83. EDWARD MOORE & HENRY BROOKE, FABLES FOR THE FEMALE SEX 1744

Open at pl. 12, Grignion after Hayman *The Young Lion and The Ape* $6\frac{1}{4} \times 3\frac{7}{8}$ (15.9 × 9.9)

Coll: Yale Center for British Art

Moore's *Fables* was the first book that Hayman illustrated completely independently and, as with the Hanmer *Shakespeare* and Smollett's *Don Quixote*, all the original drawings survive (CL. no. 220). Edward Edwards described the drawings as 'equal to any of the productions of his contemporaries'.[1]

The dramatist Edward Moore (1712–1757) turned to literature, after failing as a linendraper.[2] As a protegé of Lord Chesterfield he became in 1753 editor of *The World*, a short-lived weekly periodical which specialised in satirising contemporary manners.[3] He was assisted in writing these *Fables* by the Irish playwright and novelist Henry Brooke (1703–1783).

Not surprisingly, Hayman's designs owe a good deal to previous illustrated editions of Aesop's *Fables*. Pictorial precedents for this type of illustration date back to antiquity and

83.

4. See Ruch, loc. cit., p. 393.

5. See Philip Hofer, 'Francis Barlow's Aesop', *Harvard Library Bulletin* (1948) pp. 279–295.

6. Ruch, loc. cit., p. 393. Barlow's design appeared as an engraving in J. Ogilby, *Aesopies* (1668).

84. THE PRECEPTOR; CONTAINING A GENERAL COURSE OF EDUCATION WHEREIN THE FIRST PRINCIPLES OF POLITE LEARNING ARE LAID DOWN . . . FOR . . . THE INSTRUCTION OF YOUTH 1748
Fig. 6, p. 19

Folding plate, engraved by Grignion in Vol. 1, depicting *The Passions*
$7 \times 13\frac{1}{2}$ (17.8×34.3)

Coll: London, The British Library

Robert Dodsley's well-known *The Preceptor* was first published in two volumes in 1748. Samuel Johnson wrote the Preface and also contributed a short allegorical story, 'The Vision of Theodore, the Hermit of Tenerife'. Boswell described *The Preceptor* as 'one of the most valuable books for the improvement of young minds' and it apparently had a wide sale for many years.[1] It contained twelve chapters of Instruction for the young on various aspects of the arts and sciences including a section 'On Drawing' (Chapter VI). This chapter was further subdivided into ten lessons and the folding plate seen here illustrates Lesson IX 'On the Passions'.[2] Hayman also designed the frontispieces for both volumes (see CL. 276).[3] It is even possible that Hayman wrote this section himself. He was, by the late 1740s, a leading instructor at the St. Martin's Lane Academy and Dodsley informs us that the various chapters had been 'executed by Persons qualified to do them in the best Manner'.[4]

The section of the chapter to which this plate corresponds was comprised largely of quotations from Charles Le Brun's *Treatise on the Passions* and Roger de Piles' *The Triumph of Painting*, editions of which had been published in English in 1734 and 1743 respectively. The student is introduced to this lesson by the following advice:

> The Passions, says M. *Le Brun*, are Motions of the Soul, either upon her pursuing what she judges to be for her Good, or shunning what she thinks hurtful to her; and commonly, whatever causes Emotion of Passion in the Soul, creates also some Action in the Body that express the several Passions of the Soul, and how to delineate them[5].

1. *Boswell's Life of Johnson*, ed. G. Birkbeck Hill, 6 vols (Oxford, 1887) I, p. 192.
2. This chapter also contains engravings after designs by L. P. Boitard.
3. Hayman's drawing for the frontispiece to Vol. 1 is in the Witt Collection at the Courtauld Institute Galleries (CL. 223).
4. See Ralph Straus, *Robert Dodsley Poet, Publisher and Playwright* (London, 1910) p. 94.
5. From Vol. 1, p. 408.

85. JOHN MILTON, PARADISE LOST. A POEM IN TWELVE BOOKS 1749

Frontispiece for Book II, *Satan at the Gates of Hell*

numerous examples survive from the Middle Ages. When printed books replaced manuscripts in the fifteenth century, the *Fables* was the first illustrated volume known to have been supplied with printed woodcut illustrations.[4] The edition best known to Hayman would possibly have been the 1666 edition with plates by Francis Barlow,[5] and it has been pointed out that *The Young Lion and The Ape* seen here is adapted from Barlow's *The Lion: King of Animals* by using a similar grouping of the animals dominated by a camel facing the lion.[6] By keeping the animals to a relatively small scale, Hayman is able to concentrate on the rugged imaginary landscape in a style similar to his French contemporary Jean Baptiste Oudry.

The seventeen plates, engraved by Grignion (10), Mosley (4) and Ravenet (3) were also used in the second edition of 1746 and again in the third edition of 1766.

1. See Edwards, op. cit., 52. For a more detailed analysis of Hayman's drawings see John Ruch, 'Francis Hayman's Drawings for Moore's Fables', *Master Drawings*, VIII, 4 (Fall 1970) pp. 392–395.
2. See John H. Caskey, *The Life and Works of Edward Moore* (New Haven, 1927).
3. See William B. Todd, 'The First Edition of the *World*', *Library*, II (1956): pp. 283–84.

Engraving by Grignion after Hayman, $8\frac{1}{2} \times 6\frac{3}{4}$ (21.6 × 17.1)

Coll: London, The British Library

Although not published in this edition until 1749, Hayman must have received his designs by the summer of 1745 for in October of that year, David Garrick wrote reassuringly to him saying:

> Your Drawings for Milton will do you great Service, I have promis'd the Doctor to read ye third book & give him my opinion for the Drawing, wch I'll send you.[1]

A few months later George Vertue noted:

> 1746 began to be publisht. A New Edition of Miltons Paradis Lost by Dr Newton the drawings to be done by Mr Hayman and Engravers. – each plate 4 guineas drawing and 8 guineas graving by Ravenet.[2]

As it transpired, S. F. Ravenet engraved only four of the twelve plates; the remainder were cut by Grignion. Hayman's original drawings have not been traced.

The Rev. Dr Thomas Newton (1704–1782), who edited this edition, began his editorial career by assisting the widow of the dramatist Nicholas Rowe in the preparation of a new edition of her husband's plays and poems, published by the Tonsons. It was presumably this connection with the publishers that led to this edition of Milton.[3] Newton tells us in his introductory words that his patron, William Pulteney, Earl of Bath, was not only the source of much encouragement in the venture but also bore the expense of the copper plates – the not inconsiderable sum of £144, if Vertue's figures are correct – in order to 'give some encouragement to the art of designing here in England'. Newton was alarmed at the discrepancy between English literature and English painting, a concern still shared a quarter of a century later when, as Dean of St. Paul's, he urged the acceptance of the scheme proposed by Reynolds and Barry for the completion of Thornhill's decorations in the cathedral.[4]

Newton's edition was the third illustrated *Paradise Lost* to have appeared.[5] The first was published by Bentley and Tonson in 1688 with a frontispiece for each of the twelve books, seven of which were designed by J. B. de Medina. The second, published for Jacob Tonson, appeared in 1720 with new plates by Thornhill and Chéron.[6]

Rather than depict the moment of dramatic conflict between Satan and Death mostly preferred by later artists,[7] Hayman chose for his frontispiece for Book II the moment of Satan's departure from the Gates of Hell for his flight through Chaos. He is represented, with spread wings, already suspended above the fiery soil of Hell. Hayman follows Milton's text very closely in both narrative and detail:

> At last his Sail-broad Vans
> He spreads for flight, and in the surging smoke
> Uplifted spurns the ground, . . .[8]

Satan's pointing finger indicates the realm of chaos through which he intends to travel. Hayman's figure of Death not only carries the deadly dart but wears the crown of the 'king of terrors'. He points towards his grinning mouth as a sign of his hunger soon to be assuaged. Sin is shown as the portress of Hell. In her left hand she holds the massive key to Hell's Gate, whilst with her right she lowers one of the iron bars which hold fast the doors. Hayman does not attempt to depict the thrice three-fold gates described by Milton, but instead shows just one massive pair of doors. In showing the opening of the Gates of Hell and Satan's departure through Chaos, Hayman illustrates precisely those actions which will lead to the Fall of Man.

Hayman's designs subsequently had a chequered history. In 1750 a second edition of this work appeared for Tonson and Draper with Hayman's designs engraved anew, but in a smaller format ($5\frac{3}{4} \times 3\frac{3}{4}$ ins.) by J. S. Müller. They are all in the same direction as the 1749 edition. In 1750–51 the same plates appeared again, slightly reduced ($4\frac{7}{8} \times 2\frac{7}{8}$ ins.). These plates were re-printed again, somewhat worn, for Tonson, Draper and Birt, and were still being used in 1757 in an edition published by C. Hitch, L. Hawes, etc.[9]

85.

1. See *The Letters of David Garrick*, op. cit., I, pp. 52–55, Letter 33.
2. Vertue Note Books VI, *Walpole Society*, XXX (1951–1952) p. 202.
3. See Mary Ravenhall, 'Illustrations of "Paradise Lost" in England, 1688–1802', unpublished PhD dissertation, University of Illinois at Urbana-Champaign (1980) pp. 306–310. This catalogue entry is much indebted to Dr Ravenhall's researches.
4. See William Pressly, *The Life and Art of James Barry* (New Haven & London, 1981) p. 43.
5. See C. H. Collins Baker, 'Some Illustrations of Milton's "Paradise Lost", *The Library*, III, 1 (June 1948) pp. 1–21.
6. Ibid., pp. 7–14.
7. For instance, compare with Hogarth's painting of the subject in the Tate Gallery (see David Bindman, 'Hogarth's "Satan, Sin and

Death" and its influence', *Burlington Magazine*, CXII (March 1970) p. 154).

8. *Paradise Lost*, Book II, lines 927–929.

9. See Collins Baker, loc. cit., pp. 15–16.

86. JAMES HERVEY, MEDITATIONS AND CONTEMPLATIONS 1750 EDITION

Frontispiece for Volume I inscribed 'F Hayman del. J. Wall M.D. Inv. C. Grignion Sculp.', $4\frac{7}{8} \times 3\frac{7}{8}$ (12.4 × 9.8)

Coll: London, The British Library

James Hervey's *Meditations and Contemplations* was first published in two octavo volumes in 1746. The third edition of 1748 was the first to carry a frontispiece designed by the amateur artist Dr John Wall (1708–1776) and engraved by Ravenet. Wall was not only a practising physician but also

86.

M.ʳ Hervey's Meditations &c. Vol. I. to face the Title.

F. Hayman del. J. Wall M.D. inv. C. Grignion Sculp.

He gave Himself a Ransom for All.
1. Tim. ii. 6.

Published Jan. 8 by J. & J. Rivington

a chemist prominent in the establishment of the Worcester Porcelain Company. The author explained in an advertisement in the book itself:

> IT is owing to the delicate Design, of the eloquent Pencil and the still more amicable condescension, of the very ingenious Dr Wall, an eminent Physician at Worcester, that I am enabled to present my Readers with two beautiful and instructive frontispieces . . .

Hervey was apparently not altogether happy with Ravenet's engraving since new plates were engraved for the 1750 edition, seen here. Hervey wrote in a letter of 10 May:

> Ravenet, the engraver, is reckoned to be the very best hand in London; but in this performance, though it has evident marks of a masterly genius, yet the sculpture does by no means come up to the delicacy, the expressiveness, the life, of my very ingenious friend Dr Wall's drawing.[1]

Hayman was evidently persuaded to re-draw Dr Wall's design and Charles Grignion re-engraved it. Hayman kept the narrative intact but rearranged the various components of the originals and strengthened the general effect.

The subject matter of the frontispiece is explained by the author on p. vii of Vol. I:

The FRONTISPIECE

Presents the inside View of a Church – the Floor, the Pillars, and the Walls, are intersperced with sepulchral Stones, and funeral Inscriptions – On one Side, is the Monument of an Infant, adorned with an Urn, with a weeping Statue, and inscribed with the following Epitaph – NASCENTES MORIMUR, *No Sooner born, than dead* – On a more elevated Tomb, and under an Assemblage of military Weapons, is pourtrayed a Warrior; supposed to be mortally wounded, expiring in the Attitude of Adoration, and with the Spirit of that noble line,

Oh! save my Country, Heav'n shall be thy last

A Youth, beholding the Representation of this gallant Patriot, seems to be struck with Admiration, and charmed with Delight. A Minister diverts his Attention to an Object of infinitely higher Dignity, and greater Wonder. If the Hero died – PRO PATRIA, *In Defence of his Country:* CHRIST died – PRO INIMICUS, *For the Salvation of his Enemies.* An instance this, of such disinterested diffusive, and divine Benevolence; as makes all that Heroes have achieved, and Patriots suffered, dwindle into Nothing, and scarce deserve our Notice.

Hayman may well have been called in by Hervey because in the late 1740s his ability to visualise poetic melancholy was already in demand. His designs for Dr Newton's edition of *Paradise Lost* had appeared in 1749 (cat. no. 85) and he was later to illustrate *Paradise Regain'd* and Young's *Night Thoughts . . . &tc.*[2]

1. See Geoffrey Wills, 'Dr John Wall, Artist', *Apollo*, LXI (May 1955) 149. No source is given for the letter. An historical picture by Wall is illustrated in *Country Life*, CLXXX (11 September 1986) p. 776.

2. See Allen, 1981, p. 233.

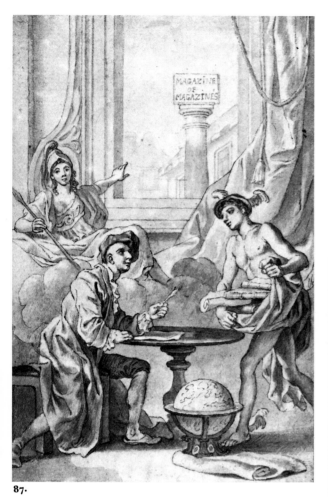

87.

87. FRONTISPIECE FOR 'THE MAGAZINE OF MAGAZINES' *c.* 1750

Pen and ink, with grey wash, indented for transfer, $6\frac{1}{8} \times 4$ (15.6 × 10.1)

Prov: W. H. Carpenter (?); from whom purchased by the B.M. in 1857

Exh: Kenwood, 1960 (41)

Engr: by Charles Mosley as frontispiece for Vol. I (1751)

Coll: London, The British Museum

Engraved as the frontispiece for the short-lived *Magazine of Magazines* which appeared in 1751, this allegorical design shows an author, in a nightcap and dressing gown, interrupted by the arrival of Mercury with a pile of books. In the background is Minerva seated on a cloud pointing through an open window to a column surmounted by a tablet inscribed *Magazine of Magazines.*

The composition is similar to one of Hayman's designs for Warburton's edition of Pope illustrating the *Epistle to Satires.*[1]

1. Vol. IV, pl. XVII (see CL. 290)

88. A DESIGN FOR A FRONTISPIECE FOR THE 1759 EDITION OF 'THE TATLER'. ISAAC BICKERSTAFF LUNGING WITH HIS SWORD AT FIGURES DRAWN ON THE WALL

Pen, ink, with grey wash; indented for transfer, $5\frac{1}{2} \times 3$ (13.8 × 7.6)

Prov: A. E. Evans & Sons, from who purchased by the B.M. in 1859

Exh: Kenwood 1960 (44)

Engr: By Charles Grignion in reverse as frontispiece for Vol. II

Coll: London, The British Museum

Hayman's drawing illustrates the following passage in *The Tatler,* no. 93, written by Sir Richard Steele and first published on 12 November 1709:

88.

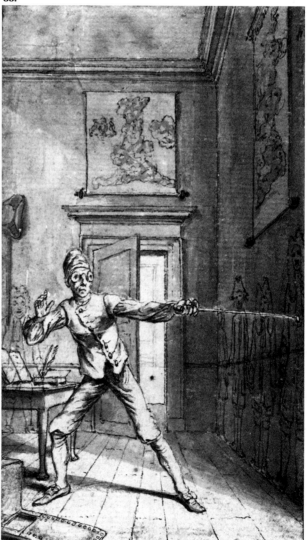

Chimney Side of the Banquetting Room

James Paine inv.^t et delin.

Edw^d Rooker sculp^t

89.

I have bought Pumps and Files, and am every Morning prac-
tising in my Chamber . . . I have upon my Chamber-Walls,
drawn at full Length, the Figures of all Sorts of Men, from
eight Foot to three Foot two Inches. Within this Height, I
take it, that all the fighting Men of *Great Britain* are compre-
hended. but as I push, I make Allowances for my being of
lank and spare Body, and have chalked out in every Figure
my own Dimensions; for I scorn to rob any Man of his Life
by taking advantage of his Breadth . . .

A drawing for another of *The Tatler* frontispieces is in the col-
lection of Denys Oppé (see CL. 233).

89. JAMES PAINE, PLANS, ELEVATIONS, SECTIONS AND OTHER
ORNAMENTS OF THE MANSION HOUSE BELONGING TO THE COR-
PORATION OF DONCASTER 1751

Open at pl. XX, *Chimney Side of the Banqueting Room*
Edward Rooker after James Paine, 10¼ × 14¾ (26 × 37.5)

Coll: London, The British Library

The Mansion House at Doncaster was built to the designs
of James Paine between 1745–1758 (see pp. 55–6). It is clear
from this extravagant folio volume, published in 1751, that
Paine had intended the elaborate stucco compartments,
executed by Thomas Perritt and Joseph Rose, to be filled with
decorative paintings but this was never done, probably

because Paine over-ran his estimates for the building by a con-
siderable margin.[1]

In the preface to his volume Paine was still trying to shame
the penurious Doncaster authorities into completing the
work:

Stucco-Work forming compartments for Painting, I was
ever of Opinion to be much more elegant, than Ceiling and
Sides finish'd entirely with either Painting, or Stucco. I
have therefore design'd, and with my own Hands drawn,
suitable Compartments of Ornament; and, that nothing
should be wanting to render the Work compleat, have been
at the Expence to have them fill'd with proper Subjects for
Paintings; all of which I humbly conceive is engraved with
at least as much Exactness, as any Thing heretofore of its
Kind. The Merits of the Performance I leave to the Publick.

There can be little doubt that Paine intended to use his
friend Hayman as his decorative painter. Not only was Hay-
man's portrait of Paine engraved by Grignion for the title-
vignette of this volume but Paine was to use Hayman
regularly on other schemes, mostly in the north of England
in the 1750s, including nearby Cusworth Hall (see
cat. no. 47).

The bulk of Paine's proposed decorations were to be on
the sides of the grand staircase and in the magnificent
Banqueting Room – a double cube of 60 by 30 feet. This splen-
did room with its coved ceiling and musicians' gallery over

the entrance was to be extensively decorated; the overmantels, overdoors as well as the remarkable assymetrical compartments in the coving, were to be filled with mythological and allegorical paintings by Hayman. Three large compartments on the ceiling which Paine also intended for painting (see fig. 30) were instead filled with stucco-work; the cove received neither its paintings nor its stucco frames and remains today an uncomfortable blank.

Had the scheme been completed it would have been Hayman's grandest decorative work.

1. On 26 February 1745/6 Paine's estimate of £4523–4–6 was recorded by the Doncaster authorities but it was later reported that the total cost, including the furniture, was almost £8000 (see Peter Leach, 'Doncaster Mansion House, Yorkshire', *Country Life* (6 July 1978 p. 20).

90. FIVE DRAWINGS FOR THE 1753 EDITION OF 'THE WORKS OF WILLIAM CONGREVE' *c.* 1752

Pen, ink and grey wash, each 5 × 3 (12.7 × 7.6)

Engr: all engraved by Grignion

Coll: London, Victoria & Albert Museum

a. *The Old Batchelor* III, x
Congreve's first comedy, *The Old Batchelor*, was produced in 1693. Hayman's illustration shows Heartwell, the 'Old Batchelor' and woman-hater, with Silvia, with whom he has fallen in love. He has here attempted to bribe her into his bed with a purse full of money which she has cast to the floor. The panelled interior recalls the background in many of Hayman's conversation pieces of the later 1740s and the pose of Heartwell is close to Garrick as Ranger in *The Suspicious Husband* (cat. no. 39).

90a.

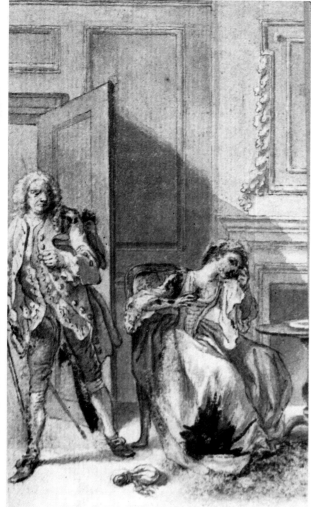

90b.

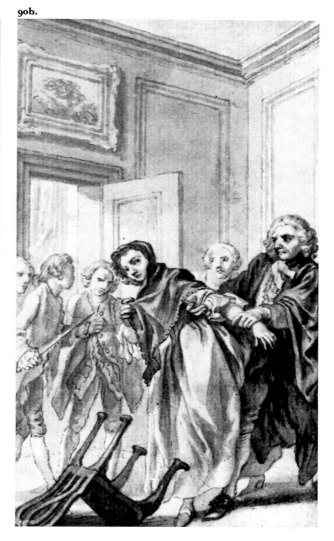

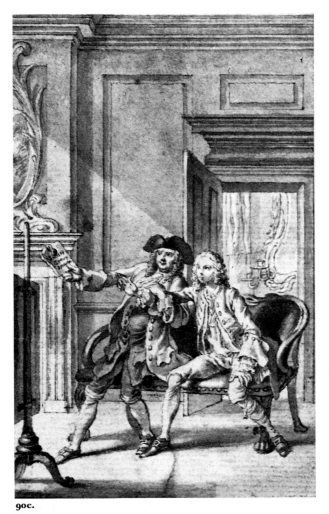

90c.

90d.

b. *The Double Dealer* V, xxiv

This is the last scene of the play, first produced by Congreve in 1694. Mellefont, 'disguised in a parson's habit' foils Mashwell's treachery in trying to carry off Cynthia.

c. *Love for Love* IV, viii

This play was first performed in 1695. Valentine, on the right, has incurred the displeasure of his father by his extravagance and debts. His father, Sir Sampson Legend, on the left, gives him £4000 – enough to pay his debts – on the condition that he sign a bond making over his inheritance to his younger brother, who is away at sea. Hayman here illustrates the moment when Sir Sampson reminds Valentine of his bond which he holds outstretched in his right hand.

d. *The Mourning Bride. A Tragedy* II, v

This was Congreve's only attempt at tragedy and was first performed in 1697. We see Almeria and her chief attendant Leonora startled by the appearance of Osymn, a noble prisoner ascending from the tomb. Hayman's composition recalls his illustrations for *Romeo and Juliet* for the Hanmer Shakespeare (CL. 219 (29)) in which Romeo, having slain Paris, enters a similar vault with the sort of sculpted term figures more commonly seen on chimneypieces.

e. *The Way of the World. A Comedy* IV, x (?)

Produced in 1700, this was Congreve's last work for the stage and it was not well received. This episode cannot be identified with certainty but it probably represents Sir Willfull Witwould drunk in the company of Lady Wishfort, Witwould, Millamont and Miss Fainall.

These designs, engraved by Grignion, were used again for the Baskerville edition of 1761, imposed on larger paper, and again for the 7th edition in two 12mo volumes of 1774.

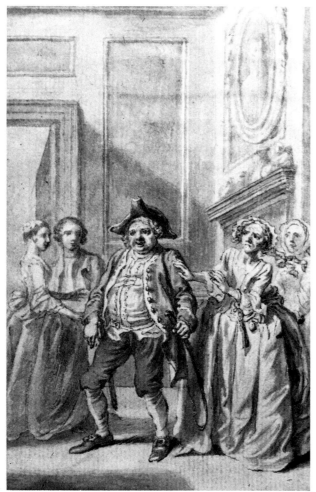

90e.

91. MARITORNES AND SANCHO PANZA FIGHTING IN BED *c.* 1754

Pen and ink, with washes of grey over red chalk; indented for transfer, $8\frac{7}{8} \times 7$ (22.6 × 17.9)

Prov: Andrew Miller (publisher); Jane Miller (subsequently Lady Grant); Henry Fulton (1814); Mr Boone, from whom purchased by the B.M. in 1859

Exh: Kenwood, 1960 (43.B)

Engr: by Müller for Vol. I, facing p. 92

Coll: London, The British Museum

Tobias Smollett's translation of Cervantes' celebrated *The History and Adventures of the Renowned Don Quixote* was published in two quarto volumes by Andrew Millar in March 1755. In style and format it was based on the 1742 version, translated by the portrait painter Charles Jervas and the well-known 'Carteret' edition in the original Spanish of 1738, with plates designed by Vanderbank.[1] In his brief introduction Smollett noted:

> The translator's aim, in this undertaking, was to maintain that ludicrous solemnity and self-importance by which the inimitable Cervantes has distinguished the character of Don Quixote, without raising him to the insipid rank of any philosopher, or debasing him to the melancholy circumstances and unentertaining caprices of an ordinary madman; and to preserve the native humour of Sancho Panza from degenerating into mere proverbial phlegm, or affected buffoonery.

This drawing has been removed for exhibition from an album containing pen, ink and wash drawings for twenty-eight plates, which were originally engraved by Grignion (12); Ravenet (8); Scotin (6) and J. S. Müller (2).

The episode illustrated here is the scene in which Sancho finds Maritornes, who is fleeing from Don Quixote's embraces, in his bed:

> The landlord now entered the apartment, and crying with a loud voice, "Where have you got, Strumpet?" . . . Sancho started, and feeling a prodigious weight upon him, thought he was labouring under a nightmare; and beginning to lay about him on all sides, chanced in the course of his efforts, to bestow divers cuffs on Maritornes, who feeling herself thus belaboured, forgot the care of her reputation, and returned the squire's compliments so heartily that sleep forsook him whether he would or not . . .[2]

Hayman is at his best with this sort of slapstick full of violent

91.

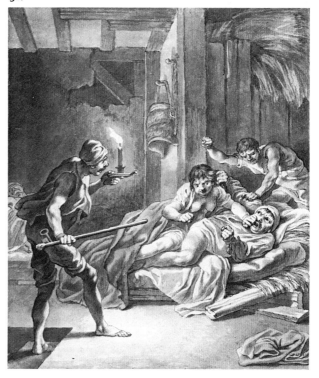

movement, exaggerated poses and facial expressions that fore-shadow the comic tradition of Rowlandson who, significantly, made a very accurate pen and ink copy of this drawing.[3] Here those mannerisms which were so frequently criticised in Hay-man's work ('bulbous noses and shambling legs' [Walpole]) work to positive comic effect.

We should note that Müller's engraving showed some changes from this the original design. Maritornes lunges at Sancho Panza from a standing position and the innkeeper's pose is modified as is the position of the sleeping man on the bed in the background.

In the later 1760s Hayman produced a series of oil paintings whose compositions are mostly related to these earlier illustrations (see cat. nos. 44, 45). Hayman's designs were extremely popular and were reduced by C. V. Neist for later editions. They appear for the last time as late as 1811.[4]

1. See Hanns Hammelmann, 'John Vanderbank's "Don Quixote" ', *Master Drawings*, 7 (1969) pp. 3–15 and Paulson, I, pp. 161–67. For the most recent study of Don Quixote and art, see Johannes Hartau, 'Don Quijote in der Kunst. Wandlungen einer Symbolfigur in Deutschland, England und Frankreich 17–19 Jahrhundert', unpublished PhD dissertation, University of Hamburg (1983).
2. See the new edition of Smollett's translation, published in London by André Deutsch (1986) p. 116.
3. See Ronald Paulson, 'The Tradition of Comic Illustration from Hogarth to Cruickshank' in *George Cruikshank: A Revaluation*, ed. R. Patten (Princeton, 1974) pp. 43–5., repr. fig. 10b.
4. See H. S. Ashbee, *An Iconography of Don Quixote 1605–1895* (London, 1895) pp. 26–7 and the same author's *Don Quixote and British Art* (London, 1900) p. 17.

92. TOBIAS SMOLLETT, A COMPLETE HISTORY OF ENGLAND . . . FROM . . . JULIUS CAESAR, TO THE TREATY OF AIX LA CHAPPELLE, 1748, 1757

Frontispiece for Vol. II *Edward III Introducing Britannia to Liberty*
Engraved by Grignion, $9\frac{1}{2} \times 6\frac{3}{8}$ (24.1 × 16.2)

Coll: London, The British Library

Smollett probably chose Hayman as the illustrator for this work because of their successful partnership with *Don Quixote* which had appeared in 1755 (see cat. no. 91). Hayman designed frontispieces for two of the four volumes of this the first edition of Smollett's *History*. This allegorical design appears to represent King Edward III introducing Britannia to Liberty. Edward III did much to revive the prestige of the British monarchy after his father's disastrous reign. Perhaps his fame as the king who led his country into the Hundred Years War with France in 1337 made him a particularly appropriate subject in 1757 whilst England was engaged in another war with France.

The King is depicted leading Liberty with the cap atop a staff towards the welcoming figure of Britannia. Behind these can be seen a ploughman tilling the land, and a man with a dagger and another with a thonged whip trampling the King's enemies underfoot. In the background Windsor Castle, to which Edward III made so many improvements, is clearly visible whilst to the forefront reclines a river god, symbolic of the Thames.

Smollett's *History* was apparently a great financial success

– the author for his share receiving some £2000 and his friend Archibald Hamilton the publisher, making a substantial fortune out of the venture.[1] The first edition, although a very considerable run, was soon sold out, and a second edition, with revisions, was brought out between 1758 and 1760 in weekly parts. This revised edition was afterwards sold in eleven octavo volumes (CL. 302) and contained four small plates by Hayman, three of which were adapted from the aborted 1751 series of large history prints (see cat. no. 78).

1. See Lewis Melville, *The Life and Letters of Tobias Smollett* (London, 1926) p. 166.

92.

93. [ROBERT SAYER], THE ARTIST'S VADE MECUM BEING THE WHOLE ART OF DRAWING 1762

Open at pl. 24, *The Head of An Old Man in Outline and Shade*

Unsigned engraving after Hayman, $4\frac{1}{8} \times 7$ (10.5 × 17.8)

Coll: Yale Center for British Art

Robert Sayer's *The Artist's Vade Mecum*, first published in 1762 was re-issued in at least three editions.[1] It contains two pages of text giving general advice about drawing which begins:

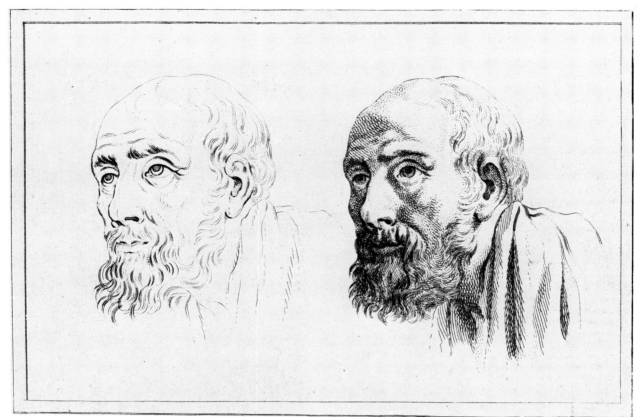

93.

Drawing is the Art of representing by lines and shades, the figure of anything seen in Nature, or whatever form we conceive in Idea; it is the noblest Operation of human Ingenuity, and may certainly be reckoned among the Qualifications, which are characteristic of a Gentleman.

Sayer later adds:

The Outline conquered, our advice, touching light and shadow, might also be spared; so shall only say, in the Examples before you, cover not the light too much at first, for that will throw a gloom over your Drawing, and cannot easily be effaced.[2]

The most important part of the book is the plates, which number more than one hundred. Plates 23 and 24, although unsigned, are clearly Hayman's work. They reappear, credited to him, re-engraved by Grignion in *The Triumph of Painting*, published in 1794. (CL. 316).

1. Joan Friedman, 'Every Lady Her Own Drawing Master', *Apollo*, CV (April 1977) p. 262.
2. p. 7.

94. WILLIAM SHAKESPEARE [ED. AND COLLATED BY CHARLES JENNENS], OTHELLO 1773

Frontispiece, engraved by Grignion, $5\frac{1}{4} \times 3\frac{1}{2}$ (13.5 × 9)

Coll: London, The British Library

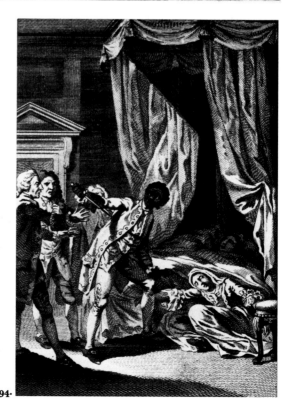

94.

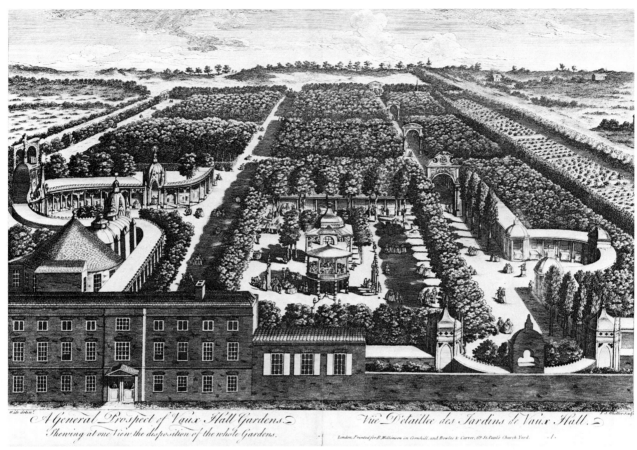

A General Prospect of Vaux Hall Gardens.
Shewing at one View the disposition of the whole Gardens.

Vue Détaillée des Jardins de Vaux Hall.

London, Printed for R. Wilkinson in Cornhill, and Bowles & Carver, 69 St Pauls Church Yard.

95.

In the last years of his life, Charles Jennens (1700–1773) edited some of Shakespeare's tragedies 'collated with the old and modern editions' as he put it. *King Lear* appeared in 1770 (see fig. 5), *Hamlet, Macbeth* and *Othello* in 1773 and *Julius Caesar* after his death in 1774. Evidently not much of a scholar, Jennens drew together from worthless copies numerous typographical errors, and his editions were severely criticised.[1] Jennens had, however, been one of Hayman's most prolific patrons in the 1750s and 1760s and he owned a number of theatrical and historical pictures by him (see p. 61–2).

In his earlier illustrations to Shakespeare for Hanmer, Hayman had drawn for *Othello* 'the terrible accusation of Desdemona' but soon after that was published he was taking advice from David Garrick about illustrating *Othello* for one of a proposed series of six Shakespeare prints. Although these never materialised, Hayman must have retained Garrick's advice, for this frontispiece to the Jennens *Othello* closely follows his thoughts written in a letter to Hayman in 1746. Garrick recommended Hayman to depict the moment in the last act, 'when Emilia discovers to Othello his Error about the Handkerchief'. Othello should be shown 'Thunderstruck into Horror, his Whole figure extended, wth his Eyes turn'd up to Heav'n'.[2]

1. See George Steevens in *The Critical Review*, XXXIV p. 475 and XXXV, p. 230.

2. See Little & Kahrl, op. cit., I, 81–84 and Kalman Burnim, 'The Significance of Garrick's letters to Hayman', *Shakespeare Quarterly*, IX, 2 (Spring 1958) pp. 151–52.

95. J. S. MÜLLER AFTER SAMUEL WALE, A GENERAL PROSPECT OF VAUXHALL GARDENS, published 1751

Etching and engraving, 10 × 15⅜ (25.5 × 39.1)

Exh: Yale, 1983 (73)

Coll: Yale Center for British Art, Paul Mellon Collection

This aerial view of Vauxhall Gardens illustrates the arrangement of the supper boxes around the quadrangular Grove. Many of these contained the large decorative paintings executed *c.* 1741–2. The Prince of Wales' Pavilion, for which Hayman painted four larger Shakespearean pictures *c.* 1745, is the structure at the bottom centre of this engraving, with the three shuttered windows. Inside the Gardens it faced eastwards towards the focal point in the Grove, the orchestra tent. To the left can be seen the conical roof of the Rotunda or 'Elegant Music Room' with its annexe that adjoined the exotic Chinese Pavilions. Inside the annexe (see cat. no. 96)

were placed Hayman's four large historical pictures painted between 1761 and 1764.[1]

1. For the architectural history of Vauxhall in the mid-eighteenth century see my article 'The Landscape' in Yale, 1983, pp. 17–24.

96. H. ROBERTS AFTER SAMUEL WALE, THE INSIDE OF THE ELEGANT MUSIC ROOM IN VAUX HALL GARDENS
published 1751 Fig. 33, p. 62

Line engraving, hand-coloured, $10\frac{3}{8} \times 16\frac{3}{4}$ (26.4 × 42.4)

Exh: Yale, 1983 (88)

Coll: Yale Center for British Art, Paul Mellon Collection

The Rotunda or 'Elegant Music Room' was built at the end of the 1740s as a somewhat more modest rival to Ranelagh Gardens' enormous covered amphitheatre, wherein concerts could be held in wet weather.[1] The Rotunda was extended eastwards in the form of a spacious annexe which connected with the Chinese Pavilions. This annexe, or Saloon, as it was usually called, was about 70 feet long by 34 feet wide and contained the four large frames (seen here empty in 1751) which were later filled with Hayman's giant historical pictures (see pp. 66–70).

1. See Yale, 1983, p. 22

97. A CLUB OF ARTIST'S 1754

Etching [by or after Thomas Burgess], $8\frac{1}{2} \times 7\frac{1}{8}$ (21.6 × 12.9)

Coll: London, The British Museum (Political satire no. 3278)

This crude etching, published in 1754,[1] was drawn by Thomas Burgess (?1730–1791), a little known portrait and history painter, as a rather crude response to Paul Sandby's satirical attacks on Hogarth which had appeared as etchings between December 1753 and April 1754.[2]

97.

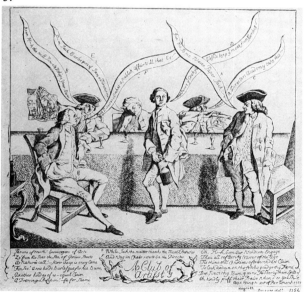

Hogarth's increasingly anti-academic stance had isolated him from most of his brother artists at the St. Martin's Lane Academy, including Hayman, who wanted to establish a more formal state-sponsored academy like those on the Continent of Europe. Hogarth, who viewed the St. Martin's Lane Academy with particular fondness, had no wish to see it changed to a more hierarchical body and distanced himself from the Committee of Artists formed under Hayman's Chairmanship in the autumn of 1753 to press the case for a public academy (see p. 4).

In this etching only Hogarth (on the extreme right) has been identified with certainty[3] but the figure immediately to his right is almost certainly Hayman, whose features are compatible with his portrait in Cruikshank's headpiece (cat. no. 99). Hayman, in his rôle as Chairman of the Artists' Committee, offers Hogarth an Academy study of a naked woman, and says 'hear a Directors Academy take this'. Hogarth says 'Give me Some waste Paper Jack' whilst one of the men seated at the table offers him an impression of Sandby's satire on Hogarth entitled *Burlesque sur le Burlesque*[4] and says 'hear, H – h this will serve to Whipe Your B–m'. Another of the seated figures, referring to Hayman and the Academy study, cries 'Such Directors O what a publick Affair will that be'. Another says 'D–m such Burlesques if I am a Director'.

1. Publication of the print is recorded in *The Gentleman's Magazine* (1754) p. 99.
2. See Paulson, II, pp. 144–152.
3. See F. G. Stephens, *Catalogue of Prints and Drawings . . . in the British Museum Division I – Personal and Political Satires Nos. 2016–3116*, III (London, 1877) pp. 924–5, no. 3278.
4. Paulson, II, pl. 326.

98. THE COMBAT *c*. 1762 Fig. 1, p. 6

Anon. etching, $10\frac{1}{2} \times 6\frac{5}{8}$ (26.6 × 16.9)

Coll: London, The British Museum (Political satire no. 3999)

In the spring of 1762 Hogarth, with his friend Bonnell Thornton, was involved in promoting a hoax exhibition of sign-paintings which caused a good deal of controversy as it was designed to ridicule the Society of Artists exhibition and those connoisseurs who promoted high art.[1]

This is one of the satiric prints that attacked the Sign-Painters exhibition[2] and, once more, we find Hogarth in the opposite camp to Hayman and his fellow members of the Society of Artists. Hogarth (marked A) is shown as a Don Quixote tilting at windmills, urged on by Bonnell Thornton and 'A Medley of Young Nothings', in opposition to a mob of artists, many of whom, including Hayman (marked E with the Chairman's gavel) are recognisable.[3]

In the inscription beneath the image, Hayman is described as 'The Chairman of a New Club [the Society of Artists], chosen into that office for his great knowledge of the Argumentum Baccalinum'. Samuel Johnson, who wrote the artists' manifestoes, on the right (marked I) is described as 'Toast Master General'.

1. See Paulson, II, pp. 334–38, 345–52.
2. Another relevant satire is 'A Sign for Ex(eye) b(eye) t(eye) on' (BM satire no. 3842)
3. For a lengthy description see Paulson, II, p. 350, pl. 294.

Published 20th February 1798, by LAURIE & WHITTLE, 53 Fleet Street, London.

FRANK HAYMAN;

A TALE;

Written by JOHN TAYLOR, *Esquire, Author of* MONSIEUR TONSON,

AND ORIGINALLY INTENDED FOR RECITATION AT THE HAYMARKET THEATRE,

DURING THE LENT SEASON.

FRANK HAYMAN, once a Brother of the Brush,
Had talents much distinguish'd in his day,
But for his art he hardly car'd a rush,
If some old mischief flumm'd in his way

This Wag was deem'd by all the Social Tribe
A jovial, easy, careless, pleasant fellow,
Fond of a frolic, ready at a gibe,
And sometimes in his cups a little mellow.

There is a famous Place, yclept VAUXHALL,
Where Cits, good folks, regale with merry hearts,
And oft to busy Waiters eager bawl,
For fresh supplies of Ham, and Beef, and Tarts.

There may you see of Boxes many a row,
For such as like to sup in state design'd,
With Pictures deck'd, that make a goodly show:
Now in these Pictures HAYMAN's skill we find.

There old JACK FALSTAFF, guilty of a lie,
Attempts his bragging cowardice to screen;
There, with the sage Magician, NELL we spy,
While surly JOBSON low'rs with jealous spleen.

And there too may Remembrance fondly trace,—
Ah! sweet reflections to the pensive mind,
The simple pleasures of a careless Race,
Ere yet they learn to prey upon their kind.

The Shuttle-cock that like AMBITION flies,
Driv'n by contending Factions to and fro;
The blinded boy, who wanders by surmise,
True emblem of our darkling state below.

And other pastimes of our early days
Recal, in various scenes, life's jocund May,
Where e'en the proud Philosopher might gaze,
And envy Ignorance is thoughtless play.

Oh! INFANCY, whate'er thy fortune, gay,
Whom no sad records of THE PAST annoy,
THE PRESENT rapt in frolics of the day,
And all thy FUTURE but to-morrow's joy.

But in a spacious Room, ROTUNDA hight,
Where all the crowd with gaping wonder roam,
There HAYMAN's genius wings a prouder flight,
And British triumphs decorate the Dome.

Here Asia's Tribes submit to English Bands,
While all the Blacks and Whites seem quite alive,
And here great Albion's Chief superior stands,
MEER JAFFIER, a mere nothing to LORD CLIVE.

Here AMHERST, too, a fav'rite Son of Fame,
Shews the true temper of a British breast,
Not more awake to Valour's active flame,
Than prompt with zeal to succour the Distrest.

And other Martial Heroes too are there;
GRANBY, who rears his head in naked grace—
A head that could not miss the wither'd hair,
Since Wreaths of deathless Laurels crown the place.

There heads of Naval Heroes, wond'rous sight,
Are floating on the billows, just like fishes,
A host of heads, with powder'd locks bedight,
Borne up by Nereids, or on buoyant dishes.

And not a face among them sinking dreads,
But on they glide together full of glee;
Nor need we wonder that they raise their heads,
Since BRITONS find their element at Sea.

At length, to dignify a train so dear,
And to complete the splendour of the scene,
A PATRIOT MONARCH, and a VIRTUOUS QUEEN.

But now, methinks, some Critic, with a smile,
Exclaims, " But where's the Story all this while?
" Why all this tedious stuff about VAUXHALL,
" When ev'ry body here has seen it all?
" What more of this FRANK HAYMAN shall we know,
" We knew he was a Painter long ago!"

Dull Snarler, Writers for the Stage,
When they the Passions would engage,
Announce, with previous art,
Some fav'rite Part,
Who when he comes he is better able,
To make a figure in the Fable.
Now if this hint should not explain
Our Proem to thy torpid brain,
Stop where you are—my friend adieu—
The Story was not made for you.
Yet, as some wiser folks may say,
The Prologue's longer than the Play,
'Tis time to check the rambling Muse,
Who thus her idle Tales pursues.

FRANK HAYMAN, tempted by a pleasant day,
After a long contention with the Gout,
A foe that oft besieg'd him, sallied out,
To breathe fresh air, and while an hour away.
It chanc'd as he was strolling, void of care,
A drunken Porter pass'd him with a Hare.

The Hare was o'er his shoulder flung,
Dangling behind, in piteous plight,
And as he crept in zig-zag style,
Making the most of every mile,
From side to side poor Puffy swung,
As if each moment taking flight.

A Dog, who saw the man's condition,
A lean and hungry Politician,
On the look-out was lurking close behind,
A sly and subtle chap,
Of most sagacious smell,
Like Politicians of a higher kind,
Ready to snap
At any thing that fell.

The Porter stagger'd on, the Dog kept near,
Watching the lucky minute for a bite,
Now made a spring, and then drew back with fear,
While HAYMAN, follow'd, titt'ring at the sight

Great was the contrast 'twixt the Man and dog,
The one a negligent and stupid lout,
That seem'd to know not what he was about,
The other keen, observant, all agog;
Nor need it wonderment excite I ween,
That HAYMAN clos'd the train to mark the scene.

Through many a street nor tipsey Porter reels,
Then stops— as if to solemn thought inclin'd—
The watchful dog was ready at his heels,
And HAYMAN hobbled on not far behind.

Then rolling on-again, the man survey'd
One of those happy mansions where
A cordial drop imparts its cheering aid
To all the thirsty Sons of Care.

The sight of this refreshing place,
The scent that hails him from the door,
Arrest at once his rambling pace—
As they had often done before.

Mine Host, with accents that were wond'rous kind,
Invites him in, a jolly crew to join,
The man the gen'rous courtesy declin'd,
Merely perhaps for want of thirst—or coin.

Strait on a bench without he stretch'd along,
Regardless of the passing throng,
And soon his weary eye-lids close,
While SOMNUS sooths him to repose.
The Hare now prostrate at his back
This was the time to get a snack.
The Dog unable longer to refrain,
Gaz'd at the Hare,
Who caus'd his care,
Jumpt and bit, jumpt and bit, jumpt and bit, and bit again.
At length, when he had clear'd away the rest,
The fated spoiler finish'd on the breast.

Then having made a hearty meal,
He careless turn'd upon his heel,
Nor thought of asking " What's to pay?"
But scamper'd at his case away;
Perhaps to find some four-foot fair,
And tell the story of the Hare.

And here some Sage, with moral spleen may say,
"This HAYMAN should have driv'n the Dog away,
" Th' effects of vice the blameless should not bear,
" And folks who are not drunkards lose their Hare."

All this, we grant, is very true—
But in this giddy world how few
To VIRTUE's height sublimely move,
Relinquishing the things they love.

Not so unfashionably good,
Our waggish Painter laughing stood,
In hopes more sport to find;
Dispos'd to keep in view his game,
And with th' ambitious Thane exclaim,
" The greatest is behind."

Besides, he knew, whate'er the plan
That tempts the fond pursuits of Man,
Though Pleasure may the course attend,
The Wise are heedful of the end.

Hence, though of mirth a lucky store,
So aptly tumbled in his way,
Yet still he linger'd after more,
And thus he said, or seem'd to say.

" How will the people fret and scold
" When they the busy wreck behold!
" And how the drunken rogue will stare
" When first he sees what was the Hare!
" The denouement must needs be droll—
" 'Twere folly not to see the whole."
Presuming thus on future pleasure,
HAYMAN kept post to wait the sleeper's leisure.

At length our Porter's slumber o'er,
He jogg'd on, tottering as before;
Unconscious anybody kind
Had eas'd him in his load behind.
Now on the houses turn'd his eye,
As if his journey's end were nigh,
Then read the paper in his hand,
And made a stand—
HAYMAN drew near, with eager mien,
To mark the closing of the scene,
Expecting strait a furious din,
His features ready for a grin.
And now we need but mention one thing more,
To shew how well he must have lik'd the whim,
Though drunk, our Porter hit at last the door,
And HAYMAN found the Hare was sent to HIM.

MORAL.
A wise old Proverb says, " To others do,
" E'er as you would those robots should to you—"
Now had our Painter mark'd this rule with care,
He, not the Dog, had din'd upon the Hare.

98.

Headpiece engraving after Isaac Cruikshank, published 20 February 1798

$18\frac{1}{4} \times 11\frac{1}{2}$ (46.3 × 29.2)

Coll: London, The British Museum (Satire no. 9333)

The engraved headpiece on this broadside illustrates an amusing anecdote about Hayman told in the verses below the image. The scene is set outside Hayman's house where a drunken porter delivers a mangled hare to a maid-servant who holds up her hands in horror. Thinking he would witness an amusing scene when the porter arrived at his destination, Hayman, the large well-dressed man on the right, has followed him with the hare, which has been partly eaten by a dog whilst its guardian dozed, only to find that he is the victim of his own sense of humour, for the hare is intended for the painter himself. As the verses below suggest, the moral of the story is:

> To others do,
> E'en as you would those others should to you –

Now had our Painter mark'd this rule with care,
He, not the Dog, had din'd upon the Hare.

The verses were written by Hayman's former pupil John Taylor (1739–1838)[1] who was the source of many of the anecdotes related by J. T. Smith and W. H. Pyne.[2] The broadsheet was published over twenty years after Hayman's death and was, according to the inscription above the verses, 'originally intended for recitation at the Haymarket Theatre'. Joseph Farington apparently had a preview for he records in his Diary on 20 April 1797 that 'Taylor and Chas. Kemble called on me. – Taylor read a Poem on a story of Hayman'.[3]

The original drawing for the headpiece by Isaac Cruikshank is now in the Huntington Library.[4]

1. For notes on John Taylor see my PhD thesis, loc. cit. 506–7.
2. J. T. Smith, *Nollekens and his Times . . . &tc.*, 2 vols. (London, 1829) and (W. H. Pyne], *Wine and Walnuts; or, After Dinner Chit-Chat*, 2 vols. (London, 1823).
3. *The Diary of Joseph Farington*, ed. Kenneth Garlick & Angus McIntyre, III, p. 825.
4. See Robert R. Wark, *Drawings for Drolls* (Huntington Library, San Marino, 1968) no. 72.

CHECKLIST NOTE

With the exception of the identified portraits which are arranged in alphabetical order by sitter's name, I have attempted within the various sub-divisions listed below to arrange Hayman's work in chronological order of execution.

I have included untraced works attributed to Hayman recorded in auction sales, catalogues and other sources from the eighteenth and early nineteenth centuries, since the probability of authenticity is thought to be reasonably high. However, the numerous optimistic sale-room attributions of the present century have been largely excluded unless other evidence, either photographic or documentary, confirms authenticity.

Although the Vauxhall Gardens supperbox pictures were not all *designed* by Hayman – we know for instance that several were designed by Gravelot – it is highly likely that Hayman and his assistants actually executed them (see pp. 107–9). Therefore, although some of these works are at least collaborative efforts, it seems prudent to list them all all here.

Much of Hayman's surviving work is in the form of engraved book illustrations and many of these were first listed by Hanns Hammelmann in his posthumously published *Book Illustrators in Eighteenth Century England* (New Haven & London, 1975). Without this pioneering work my listings would be much diminished. However, I have added a number of items to Hammelmann's list as well as correcting some errors. In addition I have attempted to identify the subject matter of each of the engraved plates.

The Checklist is arranged as follows:

PAINTINGS

Portraits

Identified sitters	1–63
Unidentified sitters (male)	64–71
Unidentified sitters (female)	72–3
Unidentified sitters (groups)	74–5
Copies after other artists	76–7
Historical subjects (including decorative work)	78–124
Theatrical and Literary subjects	125–55
Genre and Miscellaneous	156–70

169

CHECKLIST OF PAINTINGS, DRAWINGS, BOOK ILLUSTRATIONS AND PRINTS

PAINTINGS

PORTRAITS

IDENTIFIED SITTERS

1. *The Atkins Brothers* Fig. 10
 Mid 1740s
 Canvas, 29¼ × 24¼ (74.3 × 61.6)
 Prov: By family descent until 1948; Mrs P. J. Syms;
 Christie's, 21 November 1980(94)
 Coll: Private Collection

2. *William Barrowby M.D.*
 Mid-to-late 1740s
 Canvas, dimensions unknown
 Coll: Untraced
 Engr: In mezzotint by James Muller (Chaloner Smith III,
 941)

3. *Grosvenor Bedford with his Family and Friends*
 *c.*1741–2 Colour Plate I
 Canvas, 43 × 52 (109.2 × 132.1)
 Prov: see cat. no. 4
 Coll: Private Collection

4. *Elizabeth and Charles Bedford in a Landscape With a St. Bernard
 Dog*
 c. 1746–7
 Canvas, 30 × 25 (76.2 × 63.5)
 Prov: see cat. no. 12
 Coll: Private Collection

5. *Grosvenor Bedford with Francis Hayman*
 Late 1740s
 Canvas, 28¼ × 36 (71.8 × 91.5)
 Prov: see cat. no. 16
 Coll: London, National Portrait Gallery (217)

6. *Grosvenor Bedford with his Wife Jane and Son Charles*
 c. 1747–8
 Canvas, 25 × 30 (63.5 × 76.2)
 Prov: see cat. no. 15
 Coll: Exeter, Royal Albert Memorial Museum

7. *Mrs Jane Bedford with her two sons Charles and Richard Earle*
 c. 1755
 Canvas, 40 × 50 (101.6 × 127)
 Prov: as for cat. no. 4
 Coll: Private Collection

8. *The Fourth Earl and Countess of Berkeley and Their Son, Frederick
 Augustus (?)*

Mid 1760s (?)
Canvas, 35 × 44 (88.9 × 111.8)
Prov: see cat. no. 29
Coll. Private Collection, U.S.A.

9. *Queen Charlotte in Her Coronation Robes*
 Early 1760s
 Canvas, 'full-length'
 Prov: formerly in the annexe to the Rotunda at Vauxhall
 Gardens; recorded in an advertisement for the proposed
 sale by Hoggart of the contents of Vauxhall, 15–16 June
 1840. (The sale was postponed)
 Coll: Untraced

10. *Charles Chauncey M.D.*
 Signed and dated 1747
 Canvas, 25 × 17 (63.5 × 43.2)
 Prov: see cat. no. 13
 Coll: Yale Center for British Art, Paul Mellon Collection

11. *Mrs Mary Chauncey*
 Signed and dated 1748
 Canvas, 23¾ × 20 (60.3 × 50.8)
 Prov: see cat. no. 14
 Coll: Yale Center for British Art, Paul Mellon Collection

12. *Rev. Alured Clarke, Dean of Exeter*
 c. 1741–2
 Canvas, 50 × 40 (127 × 101.6)
 Prov: see cat. no. 5
 Coll: Exeter, The Deanery

13. *Portrait of a boy (called Henry Seymour Conway)*
 c. 1738–40 (?)
 Canvas, 60 × 40 (152.4 × 101.6)
 Coll: The Marquess of Hertford (Ragley Hall)

14. *John Conyers M.P.* Colour Plate III
 1747
 Canvas, 21¼ × 18¼ (54 × 46.4)
 Prov: see cat. no. 15
 Coll: English Heritage (Marble Hill House, Twickenham)

15. *George Dance The Elder* Colour Plate IV
 c. 1750
 Canvas, 21½ × 17 (53.3 × 43.1)
 Prov: see cat. no. 20
 Coll: Cambridge, Fitzwilliam Museum

16. *William Ellis and His Daughter Elizabeth*
 c. 1744–5

Canvas, 30 × 25 (76 × 63.5)
Prov: see cat. no. 8
Coll: Newcastle-upon-Tyne, The Laing Art Gallery

17. *David Garrick and William Windham*
c. 1745
Canvas, 33½ × 40 (85 × 102)
Prov: see cat. no. 10
Coll. Private Collection

18. *Mrs David Garrick (Eva Maria Viegel)*
c. 1750 (?)
Canvas, 30 × 25 (76 × 63.5) ?
Prov: With Leicester Galleries in 1929
Coll. Untraced

19. *The Gascoigne Family* Fig. 9
c. 1740
Canvas, 40 × 50 (101.6 × 127)
Prov: London art market 1925; Hon. Mrs R. O'Brien; bt.
 by Agnew's at her sale, Christie's, 25 October 1957
Coll: San Marino, California, Henry E. Huntington
 Library & Art Gallery

20. *King George III in His Coronation Robes*
Early 1760s
Canvas, 'full-length'
Prov: see CL. 9
Coll: Untraced (companion to CL. 9)

21. *The Grant Family*
c. 1740–42
Canvas, 40½ × 42 (103 × 108)
Prov: by family descent until 1896; Mr and Mrs Basil
 Ionides
Coll: Private Collection

22. *The Hallett Family*
c. 1756
Canvas, 64 × 48 (162.6 × 121.9)
Prov: see cat. no. 27
Coll: Private Collection

23. *Self-Portrait*
Early-to-mid 1730s (?)
Canvas, 15½ × 12½ (39.4 × 31.7)
Prov: see cat. no. 1
Coll: Exeter, Royal Albert Memorial Museum

24. *Self-Portrait at the Easel*
1750
Canvas, 23½ × 16 (59.7 × 41.9)
Prov: see cat. no. 21
Coll: Exeter, Royal Albert Memorial Museum

25. *Self-Portrait with Grosvenor Bedford and Friends (?)*
c. 1745–8
Canvas, 44 × 55½ (111.8 × 141)
Prov: see cat. no. 19
Coll. Yale Center for British Art, Paul Mellon Collection

26. *Joseph Henry* Fig. 17
c. 1745
Canvas, 23¼ × 19¼ (59 × 49)
Prov: see cat. no. 9
Coll: Margery, Lady Sebright

27. *Augustus Hervey Taking Leave of His Friends* Fig. 20
1750–51
Canvas, 39 × 49 (99.1 × 124.5)
Prov: by family descent
Coll: The National Trust, Ickworth House
Hayman painted only Augustus Hervey and his mother
(the two figures on the right see, pp. 37–8)

28. *Dr Benjamin Hoadly and His Wife Anne (?)*
Late 1740s (altered in the 1770s)
Canvas, 29½ × 25 (75 × 63.5)
Coll: London, The Wellcome Institute of the History of
 Medicine

29. *Dr John Hoadly and Dr Maurice Greene*
1747
Canvas, 27½ × 35 (69.8 × 90.2)
Prov: see cat. no. 17
Coll: London, National Portrait Gallery (2106)

30. *The Jacob Family*
c. 1743–4
Canvas, 38 × 42½ (96.5 × 108)
Prov: see cat. no. 7
Coll: Private Collection

31. *Charles Jennens*
Prov: Recorded in Sir George Pauncefoot's sale at
 Christie's in 1809, a sale not recorded by Lugt but listed
 in F. P. Seguier's *Dictionary of the Works of Painters*
 (London, 1870) p. 87
Coll: Untraced

32. *Sir Edward Littleton*
1750
Canvas, 23¼ × 16 (59 × 40.6)
Prov: see cat. no. 22
Coll. Private Collection

33. *William Mason*
Probably 1740s
Canvas, dimensions unknown
Prov: Formerly at Hartlebury Castle (see James Nankivell,
 *The Collection of Portraits in Oils of Bishop Richard Hurd at
 Hartlebury Castle* (Worcester, 1953) pp. xii, 20–21)
Coll: Untraced

34. *Moses Mendez*
Canvas, dimensions unknown
Coll: Untraced (see pp. 26)

35. *William Milward (d. 1742)*
Pre-1742
Canvas, dimensions unknown
Prov: mentioned by Samuel Ireland, *Graphic Illustrations of
 Hogarth . . . &tc.* (London, 1794) pp. 103–4
Coll: Untraced

36. *Thomas Nuthall and Hambleton Custance*
1748
Canvas, 28 × 36 (71 × 91.5)
Prov: see cat. no. 18
Coll: London, Tate Gallery

37. *James Paine*
Pre-1751

Canvas, dimensions unknown
Coll: Untraced
Engr: by Charles Grignion as title vignette to Paine's *Plans, Elevations, Sections and Other Ornaments of the Mansion-House, Belonging to the Corporation of Doncaster* (1751). See CL. 289

38. *John, Viscount Perceval, later Second Earl of Egmont* Fig. 15
c. 1742
Canvas, 50 × 40 (127 × 101.6)
Prov: see cat. no. 6
Coll: Dublin, National Gallery of Ireland
Engr: in mezzotint by John Faber, Jr. (Chaloner Smith I, pp. 409–410)

39. *Hannah Pritchard*
1750
Canvas, 27½ × 20¼ (69.9 × 51.4)
Prov: T. Harris; Charles Mathews; probably given to Garrick Club by Mrs Mathews in 1836
Coll: London, The Garrick Club
Engr: in mezzotint by James McArdell (Chaloner Smith II, 146). The print is inscribed *F. Hayman Pinxit. 1750*

40. *Hannah Pritchard*
Mid-1750s (?)
Canvas, 29½ × 25 (74.9 × 63.5)
Prov: T. Harris; Charles Mathews; purchased by the Garrick Club in 1835
Coll: London, The Garrick Club

41. *William Pritchard*
Canvas, dimensions unknown
Prov: recorded in his wife's (Hannah Pritchard's) will and bequeathed to his daughter Judith Spilsbury (see Anthony Vaughan, *Born to Please: Hannah Pritchard, Actress 1711–1768 A Critical Biography* (London, Society for Theatre Research, 1979) p. 104
Coll: Untraced

42. *Mr and Mrs James Ralph*
Pre-1762
Canvas, dimensions unknown
Prov: Ralph sale, Langford's, 21 April 1762, (20)
Coll: Untraced

43. *Samuel Richardson and his Family* Fig. 11
c. 1740–41
Canvas, 30 × 40 (76.2 × 101.6)
Prov: by family descent
Coll: Private Collection

44. *The St. John Family in Dogmersfield Park* Fig. 19
c. 1747
Canvas, 94½ × 106 (240 × 269.2) reduced
Prov: Probably commissioned by the Rev. Ellis St. John; by descent; Sotheby's, 26 June 1968 (lots 41 & 42, in two halves); purchased by present owner
Coll: Private Collection

45. *Sir Paulet St. John*
c. 1750
Canvas, 30 × 22 (76.2 × 55.9)
Prov: by descent; Sotheby's 26, June 1968 (43)
Coll: Private Collection

46. *A Gentleman of the St. John Family, possibly Goodyer St. John*
c. 1750
Canvas, 30 × 22 (76.2 × 55.9)
Prov: by descent; Sotheby's, 26 June 1968 (44)
Coll: Private Collection

47. *A Lady of the St. John Family*
c. 1750
Canvas, 11 × 9 (27.9 × 22.9)
Prov: by descent; Sotheby's, 26 June 1968 (46)
Coll: Private Collection

48. *Lady St. John (Lady Tynte)*
c. 1750
Canvas, 11 × 9 (27.9 × 22.9)
Prov: by descent; Sotheby's, 26 June 1968 (45)
Coll: Private Collection
CL. 47 & 48 may have been cut down from a group portrait; this would explain their unusual size and composition

49. *Sir Paulet St. John and His Family*
c. 1753–4
Canvas, 39 × 42½ (99.1 × 108)
Prov: see cat. no. 26
Coll: Private Collection

50. *Sir Henry Paulet St. John*
c. 1760
Canvas, 30½ × 41 (77.5 × 104.2)
Prov: by descent; Christie's, 26 April 1985 (91); Christie's, 11 July 1986 (66)
Coll: Private Collection

51. *The Sadler's Wells Group*
1754
Canvas, dimensions unknown
Prov: Painted for Thomas Rosoman, the manager of Sadler's Wells Theatre, who hung the picture in the Sir Hugh Myddleton's Head, an Inn which was almost opposite the present Sadler's Wells' main entrance. It was still there in 1795 when Mark Lonsdale, then proprietor of the theatre, listed the sitters as Rosoman in the centre with his hand on his pug-nose; a dancer nicknamed Bug Nose because of his warts; the scene-painter Holtham; the Sadler's Wells tailor Rawson; Davenport the ballet master; the scene painter Thomas Greenwood; Peter Hough (Rosoman's partner) who had previously been a tumbler at Goodman's Fields Theatre; Maddox the wire-dancer, in a blue and gold theatrical dress; Peter Garman, rope-dancer and tumbler; and the tumbler Billy Williams who collapsed and died on stage on 7 June 1754 (see D. Arundell, *The Story of Sadler's Wells 1683–1977* (London, 1979) pp. 18–19)
Coll: Untraced

52. *George Taylor (d. 1758)*
Pre-1758
Canvas, dimensions unknown
Prov: recorded in the mid-nineteenth century by John Green [pseud. G. H. Townsend, *Evans Music or Supper Rooms, Odds and Ends About Covent Garden* (London, n.d. [mid. 19th cent.]) p. 14
Coll. Untraced

53. *Philip Thicknesse* (?) Fig. 22
Mid-1750s
Canvas, 24½ × 29¼ (62.3 × 74.3)
Prov: purchased 1945 by present owner
Coll: St. Louis, Miss. U.S.A., St. Louis Art Museum

54. *Jonathan Tyers and His Family*
Signed and dated 1740
Canvas, 29½ × 40½ (74.3 × 102.8)
Prov: see cat. no. 3
Coll: London, National Portrait Gallery (5588)

55. *Jonathan Tyers*
Canvas, 48 × 39 (121.9 × 99.1)
Prov: formerly in the collection of Col. Boyd Hamilton at
 Brandon House, Norfolk. Sold (on premises) by Messrs.
 Lacy Scott & Sons, 5 September 1919 (621)
Coll: Untraced (for a lengthy description of the picture,
 see Prince Frederick Duleep Singh (ed. E. Farrer),
 Portraits in Norfolk Houses, 2 vols., n.d., I, no. 44)

56. *Elizabeth Tyers*
Canvas, 48 × 39 (121.9 × 99.1)
Prov: as for 55 (lot 622)
Coll: Untraced
Companion to CL. 55 (see Duleep Singh & Farrer, op. cit.)

57. *Jonathan Tyers with his Daughter Elizabeth and Her Husband
John Wood*
c. 1747–8
Canvas, 39 × 34 (99 × 86.3)
Prov: see cat. no. 23
Coll: Yale Center for British Art, Paul Mellon Collection

58. *Margaret Tyers with Her Husband George Rogers and His Sister
Margaret Rogers* Fig. 13
c. 1748–50 (?)
Canvas, 41 × 39 (104 × 99)
Prov: see cat. no. 24
Coll: Yale Center for British Art, Paul Mellon Collection

59. *Margaret Tyers and Her Husband George Rogers*
c. 1750–52 (?) Colour Plate V
Canvas, 35½ × 27½ (90.25 × 69.75)
Prov: see cat. no. 25
Coll: Yale Center for British Art, Paul Mellon Collection

60. *The Wagg Family of Windsor*
c. 1738–40 (?)
Canvas, 25½ × 30½ (64.8 × 77.5)
Prov: see cat. no. 2
Coll: Exeter, Royal Albert Memorial Museum

61. *John Weller and His Wife Margaret*
Late 1740s
Canvas, 31½ × 28 (80 × 71.2)
Prov: Mr and Mrs Basil Ionides; Sotheby's, 29 May 1963
 (106); Christie's 16 April 1982 (74)
Coll: Private Collection

62. *Master John Wightwick*
Early 1750s
Canvas, 23 × 18½ (58.4 × 47)
Prov: probably in the collection of Mrs S. H. Lloyd by
 descent from her aunt; Sotheby's, 29 July 1953
Coll. Plymouth, City Art Gallery

63. *Joseph Wilton with His Wife and Daughter Frances*
1760
Canvas, 30 × 40½ (76.2 × 102.9)
Prov: see cat. no. 28
Coll: London, Victoria & Albert Museum

UNIDENTIFIED SITTERS (MALE)

64. *An Officer in Hungarian Hussar Uniform*
Mid-to-late 1740s
Canvas, 16¼ × 12¾ (41.5 × 32.5)
Coll: Private Collection
This is possibly a portrait of William Windham II of Fel-
 brigg who was painted by Hayman in the double portrait
 with his friend Garrick (cat. no. 10).

65. *A Gentleman Seated At a Table*
Late 1740s
Canvas, 23¼ × 19¼ (59 × 49)
Prov: The Hon. Michael Astor; Christie's, 26 June 1959
 (65); Tooth Galleries; Viscountess Ward of Witley;
 Christie's 26 June 1981 (125); Richard Courtenay
 (dealer); Christie's, 26 April 1985 (89)
Coll: Private Collection
Companion to CL. 73

66. *A Gentleman Seated At a Table Holding a Letter*
c. 1750
Canvas, 23 × 20 (58.4 × 50.8)
Prov: Christie's, 26 July 1935 (171) as 'Dean Swift', bt.
 Butler 3 gns.
Coll. Untraced

67. *A Bailiff*
Early 1750s (?)
Canvas, 26 × 18 (66 × 45.7)
Prov: Mr Justice Charles McLean
Coll: San Marino, California, Henry E. Huntington
 Library & Art Gallery

68. *A Sportsman In a Landscape With His Dog*
Early 1750s
Canvas, 29 × 24 (73.7 × 61)
Prov: Major C. Disraeli; his sale, Christie's, 18 December
 1936 (14)
Coll: Untraced

69. *A Gentleman Leaning On a Tree Stump*
Early 1750s
Canvas, 24½ × 17½ (62.3 × 44.5)
Prov: Mrs Colin Davy; Anon. sale, Christie's, 18 June 1976
 (133)
Coll: Untraced

70. *A Gentleman With a Horse and Groom* Fig. 25
c. 1750–55
Canvas, 28 × 36 (71.1 × 91.4)
Prov: Miss Alice de Rothschild; James de Rothschild
 bequeathed it to the National Trust in 1957
Coll: Waddesdon Manor, The National Trust

71. *A Study of Two Boys*
Canvas, dimensions unknown

Prov: David Garrick; Mrs Garrick's sale, Christie's, 23
June 1823 (25) bt. with CL. 155 by Noseda for £12.12.0
Coll: Untraced

UNIDENTIFIED SITTERS (FEMALE)

72. *A Lady at a Spinning Wheel*
 c. 1745
 Canvas, 35½ × 29 (90.2 × 73.7)
 Prov: see cat. no. 11
 Coll: English Heritage, Twickenham, Marble Hill House

73. *A Lady Tatting Lace*
 Late 1740s
 Canvas, 23¼ × 19¼ (59 × 49)
 Prov: as for CL. 65
 Coll: Private Collection

UNIDENTIFIED SITTERS (GROUPS)

74. *A Family in a Landscape*
 Early 1750s
 Canvas, 27¼ × 35¼ (69.2 × 89.5)
 Prov: Arthur Tooth & Son (1951); M. Bernard; Leggatt
 Bros.; Sir James Dunn Foundation
 Coll: Fredericton, New Brunswick, Beaverbrook Art
 Gallery

75. *Two Gentlemen and a Dog in a Landscape* Fig. 24
 c. 1750–55
 Canvas, 30 × 25 (76.2 × 63.5)
 Prov: A. H. Skinner; with Tooth (1945), from whom pur-
 chased by Lord Bearsted
 Coll: Upton House, Bearsted Collection, National Trust

COPIES AFTER OTHER ARTISTS

76. *Peregrine Bertie, Lord Willoughby of Eresby*
 1739
 Inscribed: *THE RT. HON. PEREGRINE BERTIE Ld.*
 WILLOUGHBY OF ERESBY BORN IN THE CHURCH
 PORCH OF ST. WILLEBRODE AT WESEL IN GER-
 MANY OCTr. 12th 1555 TAKEN FROM THE ORIG-
 INAL IN THE COLLECTION OF HIS GRACE THE
 DUKE OF ANCASTER DECr 1739 BY FRANCIS HAY-
 MAN THE RT. HON. PEREGRINE LORD WIL-
 LOUGHBY OF ERESBY FATHER OF ROBERT EARL
 OF LINDSEY
 Canvas, 82 × 50 (208.2 × 127)
 Prov: by descent
 Coll. Scottish Private Collection

77. *Robert Bertie, Earl of Lindsey*
 c. 1739
 Canvas, 40½ × 66 (103 × 167.6)
 Prov: by descent
 Coll: Scottish Private Collection
 A copy of a seventeenth-century portrait by an unidentified
 artist

HISTORY PAINTINGS: DECORATIVE, HISTORICAL, BIBLICAL AND MYTHOLOGICAL

78. *London, Goodman's Fields Theatre*
 1732
 Miscellaneous decorative painting
 All destroyed
 i. *King George II Attended by Peace, Liberty and Justice Trampling
 Tyranny and Oppression Under His Feet*
 ii. *The Heads of Shakespeare, Dryden, Congreve and Betterton*
 iii. *Cato Points to The Dead Body of His Son Marcus (vide.
 Shakespeare's "Julius Caesar")*
 iv. *The Stabbing of Julius Caesar (vide. Shakespeare's "Julius
 Caesar")*
 v. *Mark Anthony and Octavia With Their Children (vide.
 Dryden's "All for Love")*
 vi. *Apollo and The Nine Muses*

79. *London, Goodman's Fields Theatre*
 1734
 Decorative Paintings
 Destroyed
 i. *Portraits of The Royal Family and His Highness The Prince
 of Orange*
 ii. *A New Ceiling Piece of Apollo and The Nine Muses* (see fig. 3)

80. *London, Drury Lane Theatre*
 1736
 Painted scenery for William Pritchard's *Fall of Phaeton*
 Destroyed

81. *London, Drury Lane Theatre*
 1736
 Painted and designed scenes for 'A New Entertainment
 after the Manner of Spring Garden Vaux-Hall, with a
 scene representing the place' (*The London Daily Post and
 General Advertiser*, 22 May 1736)

82. *London, Vauxhall Gardens*
 c. 1740 (?)
 Painted decorations on the 'grand Gothic obelisk' ('At the
 corners . . . are painted, by Hayman, a number of slaves
 enchained' (see John Nichols, *Bibliotheca Topographica
 Britannica*, 9 vols. (London, 1790) II, p. 103)

83. *Twickenham, Radnor House*
 1743
 Unspecified decorative work for John Robartes, Fourth
 Earl of Radnor
 Destroyed

84. *Norton, Suffolk, Little Haugh Hall* Fig. 27
 1743–4
 i. Painted ceiling of the staircase: *Apollo and the Nine Muses
 Crowning Archimedes*
 Oil on plaster, approx. 180 × 300 (457 × 762)
 ii. Painted ceiling of the summer house in the garden: *Apollo
 with Time Bringing Truth to Light Flanked by Justice,
 Fortitude, Temperance and Prudence*
 Probably oil on plaster, dimensions unknown
 Destroyed

85. *Doncaster, Mansion House*
 c. 1745
 Unexecuted designs for decorative work (see. cat. no. 89)
 i. Designs for paintings in compartments on side of staircase and coving
 ii. For the Banqueting Room:
 a) In the coving surrounding the room, designs within an elaborate rococo cartouche
 b) Chimneyside; overdoors and overmantels within ornamental plasterwork surrounds
 c) End of room; painted panel within entablature
 d) Ceiling; three compartments. The central compartment containing a design for an allegorical picture of *Doncaster receiving the homage of Apollo, Ceres & Flora* (fig. 30), the two other compartments containing figures of *Apollo* and *Flora*

86. *London, The Foundling Hospital*
 The Finding of Moses in The Bulrushes
 1746
 Inscribed: *Painted & given by F. Hayman, 1746* lower right
 Canvas, $68\frac{1}{4} \times 80\frac{1}{2}$ (173×204)
 Prov: see cat. no. 46
 Coll: London, The Thomas Coram Foundation (formerly the Foundling Hospital)

87. *The Finding of Moses in The Bulrushes*
 c. 1746
 Canvas, $20 \times 24\frac{1}{2}$ (50.8×62.2)
 Prov: James Ralph; his sale, Langford, 21 April 1762 (60) Garnham sale, Puttick & Simpson, 27 April 1927 (10), as by Hogarth
 Coll: Untraced
 A preparatory oil sketch for the Foundling Hospital picture (CL. 86)

88. *Dorking, Surrey, Denbies*
 Mid-1740s (?)
 In a large alcove forming an amphitheatre in the garden:
 i. *The Death of an Unbeliever*
 ii. *The Death of a Christian*
 Probably oil on plaster 'as large as life'
 Destroyed soon after 1767
 Engr: Both engraved by T. Chambers and published in 1783 (cat. no. 72)

89. *The Artists Presenting A Plan for An Academy to Frederick, Prince of Wales and Princess Augusta* Fig. 36
 c. 1750–51
 Canvas, 25×30 (63.5×76.2)
 Prov: see cat. no. 48
 Coll: Exeter, Royal Albert Memorial Museum

90. *The Good Samaritan*
 1751–2
 Oil on canvas, $78\frac{1}{4} \times 48$ (99.7×121.9)
 Prov: see cat. no. 47
 Coll: Yale Center for British Art, Paul Mellon Collection

91. *Hardwick Park, near Sedgefield, Co. Durham*
 c. 1760–61
 In the Banqueting House in the garden designed by James Paine:
 i. On the ceiling: *The Assembly and Banquet of the Gods*
 ii. Overdoor: *Cupid and Psyche*
 iii. Overdoor: *A Procession of Bacchanals*
 iv. On the ceiling of the ante-room: *Venus*
 v. Over the chimneypiece in the ante-room: *Diana and Endymion*
 Probably all oil on plaster
 Prov: Painted for John Burdon, owner of Hardwick Park
 Destroyed
 These decorative works and others by Samuel Wale are described in the anonymous *A Walk through Hardwicke Gardens, near Sedgefield, in the County of Durham* (Stockton-on-Tees, 1800)

92. *The Resurrection of Christ*
 Pre-1761
 Canvas, dimensions unknown
 Prov: In the collection of Charles Jennens by 1761 (see Dodsley's, *London and its Environs described . . . &tc.*, 6 vols. (London, 1761) VI, p. 80)
 Coll: Untraced

93. *The Cure of Saul*
 Pre-1761
 Canvas, dimensions unknown
 Exh: Society of Artists 1768 (63); Society of Artists Special Exhibition in honour of the King of Denmark 1768 (49); Royal Academy 1772 (111)
 Prov: as for CL. 92
 Coll. Untraced

94. *The Surrender of Pondicherry to Sir Eyre Coote*
 Early 1760s
 Canvas, 48×60 (121.9×152.4)
 Prov: see cat. no. 50
 Coll: RAMA Sandhurst, National Army Museum

95. *The Surrender of Montreal to General Amherst*
 1760–61
 Canvas, 144×180 (365.6×457.2)
 Prov: as for CL. 9
 Coll: Untraced (see CL. 96 below)
 One of the four pictures illustrating episodes from the Seven Years War in the annexe to the Rotunda at Vauxhall Gardens (see also CL. 98, 99, 102)

96. *The Surrender of Montreal to General Amherst* Fig. 39
 1760–61
 Canvas, $27\frac{3}{4} \times 36$ (69.4×91.4)
 Prov: C. V. H. Baker; Mr Campbell from whom purchased in 1955
 Coll: Fredericton, New Brunswick, Beaverbrook Art Gallery
 A study for CL. 95

97. *The Surrender of Montreal to General Amherst*
 1760–61
 Canvas, $27\frac{1}{4} \times 35\frac{1}{4}$ (69.2×89.5)
 Prov: Anon. sale, Sotheby's, 18 December 1963 (139)
 Coll: Sidney Sabin Esq.
 A rejected design for CL. 95

98. *The Triumph of Britannia*
 1762
 Canvas, 144×180 (365.6×457.2)

Prov: Last recorded at the Vauxhall Gardens sale by Ventom & Hughes, 12 October 1841 (206)
Coll: Untraced
Engr: by Ravenet, published in 1765 (see cat. no. 79)

99. *Lord Clive Receiving the Homage of the Nabob* Fig. 40
1762
Canvas, 144 × 180 (365.6 × 457.2)
Prov: as for CL. 9
Coll: Untraced

100 *Lord Clive Receiving the Homage of the Nabob*
1762
Canvas, 40 × 50 (101.6 × 127)
Prov: see cat. no. 49
Coll: London, National Portrait Gallery
A study for CL. 99

101. *Lord Clive Receiving the Homage of the Nabob*
1762
Canvas, dimensions unknown
Prov: Spink & Son Ltd.
Coll: Untraced
A small oil sketch related to CL. 99

102. *Britannia Distributing Laurels*
c. 1764
Canvas, 144 × 180 (365.6 × 457.2)
Prov: as for CL. 9
Coll: Untraced

103. *Peter Denying Christ* Fig. 22
1763
Canvas, approx. 96 × 120 (243.8 × 304.8)
Exh: Society of Artists 1763 (54)
Prov: William Hanmer; purchased at Iscoid sale, October 1778 by Penn Assheton Curzon who presented it to St. Oswald's Church
Coll: Malpas, Cheshire, St. Oswald's Church

104. *Sigismunda*
c. 1765
Canvas, dimensions unkown
Exh: Society of Artists 1765 (48)
Prov: probably Jonathan Tyers Jnr. sale, Christie's, 28 April 1830 (48)
Coll: Untraced

105. *Aeneas Carrying his Father Anchises*
c. 1765
Canvas, dimensions unknown
Exh: Society of Artists 1765 (50); Society of Artists Special Exhibition in honour of the King of Denmark 1768 (50)
Coll: Untraced

106. *The Burning of Troy*
Mid-1760s (?)
Canvas, dimensions unkown
Prov: Sale, Phillips, 29 January 1806 (11) as 'the property of a nobleman, removed from his Mansion in the North'
Coll: Untraced

107. *Abraham Offering Isaac*
c. 1767
Canvas, dimensions unknown

Exh: Society of Artists 1767 (71)
Prov: last recorded at sale by Phillips, 20 May 1807 (24) as 'property of a Gentleman removed from his mansion in Yorkshire'
Coll: Untraced

108. *Diana and Actaeon* Fig. 42
Late 1760s (?)
Canvas, 20 × 24 (50.8 × 61)
Prov: Anon. sale, Sotheby's, 27 July 1977 (54) as Prud'hon
Coll: Sidney Sabin Esq.

109. *The Raising of Lazarus*
c. 1770
Canvas, dimensions unknown
Exh: Royal Academy 1770 (100)
Coll: Untraced

110. *The Prodigal Son*
c. 1770 (?)
Canvas, dimensions unknown
Exh: Royal Academy 1770 (99)
Prov: probably Charles Jennens; sale, Langford's, 28 April 1774 (44)
Coll: Untraced

111. *Christ and the Two Disciples at Emmaus*
c. 1771 (?)
Canvas, dimensions unknown
Exh: Royal Academy 1771 (92)
Coll: Untraced

112. *Christ Raising the Dead*
Prov: last recorded in a sale by Phillips, 29 January 1806 (50) as 'the property of a Nobleman removed from his Mansion in the North'
Coll: Untraced

113. *Jacob's Vision*
Prov: as CL. 112 (lot 7)
Coll: Untraced

114. *Healing the Blind*
Prov: as CL. 112 (lot 51)
Coll. Untraced

115. *The Butler and The Baker (Joseph in Prison with Pharoah's Butler (?)*
Prov: as CL. 112 (lot 7)
Coll: Untraced

116. *Adam and Eve*
Prov: as CL 112 (30 January, lot 7)
Coll: Untraced (see CL. 263)

117. *Judas Betraying Christ*
Prov: Charles Jennens; sale, Langford's, 28 April 1774 (29); Anon. sale, Christie's 20 April 1776 (59)
Coll: Untraced

118. *A Repose in Egypt*
Prov: Anon. sale, Christie's, 3 June 1825 (27) bt. Yarmouth 9 gns.
Coll. Untraced

119. *Cupid*
Prov: referred to by author of 'Extracts from the Portfolio

of an Amateur', *New Monthly Magazine and Universal Register*, VI (September 1816) p. 316
Coll: Untraced

120. *Venus at Her Toilet*
Prov: Last recorded in the sale of the effects of Nathaniel Chauncey, who inherited his brother Charles' pictures, Christie's, 27 March 1790 (61)
Coll: Untraced

121. *Hercules Between Vice and Virtue*
Prov: as CL. 112 (30 January, lot 100)
Coll: Untraced

122. *Richard II and Wat Tyler*
Prov: Jonathan Tyers Jnr. sale, Christie's, 28 April 1830 (26)
Coll: Untraced

123. *London, Fenchurch Street 'a large house on the right hand side . . . going from Aldgate'*
Decorative paintings on the ceilings and staircase
Prov: mentioned in *The European Magazine and London Review*, LV (1809) p. 443
Destroyed

124. *Signboard for 'The Barley Mow' Tavern in Piccadilly*
Prov: mentioned in *The New Monthly Magazine and Universal Register*, VI (September 1816) p. 136
Coll: probably destroyed

THEATRICAL AND LITERARY SUBJECTS

125. *The Wrestling Scene from "As You Like It"*
 c. 1741–2 (?) Colour Plate VII
Canvas, 20¾ × 36¼ (52.7 × 92.1)
Prov: see cat. no. 37
Coll: London, Tate Gallery

126. *Timon and Alcibiades Mistresses*
 c. 1743–4
Prov: painted for Dr Cox Macro (see CL. 84) as an overdoor in the Little Parlour at Little Haugh Hall
Coll: Untraced

127. *The Storm Scene in "King Lear"*
 c. 1745
Canvas, dimensions unkown
Prov: painted for Jonathan Tyers and formerly in the Prince of Wales's Pavilion at Vauxhall Gardens. Either this or CL. 128 or 133 may have been the 'Scene from Shakespeare' in Jonathan Tyers Jnr. sale, Christie's, 28 April 1830 (73)
Coll: Untraced

128. *The Storm Scene in "King Lear"*
 mid-1740s (?)
Canvas, 15 × 24 (38.1 × 61)
Prov: Anon. sale, Bonhams 1966; David Barclay (dealer)
Coll: John A. Taylor, Oklahoma City

129. *Garrick as King Lear*
 c. 1743–4

Prov: as for CL. 126
Coll: Untraced

130. *The Play Scene from "Hamlet"*
 c. 1745
Prov: as for CL. 127 (lot 72 in Tyers sale was a 'scene from Hamlet', possibly either this or CL. 131 or 132 below)
Coll: Untraced

131. *The Play Scene from "Hamlet"*
 c. 1745
Canvas, 13 × 10½ (33 × 26.7)
Prov: see cat. no. 38
Coll: Washington, D.C., Folger Shakespeare Library
A *modello* for CL. 130

132. *The Play Scene from "Hamlet"*
 c. 1745
Canvas, 25 × 30 (63.5 × 76.2)
Prov: Anon. sale, Robinson, Fisher & Harding, 29 May 1924 (66)
Coll: Untraced
A reduced version, with differences, of CL. 130

133. *Henry V Before the Battle of Agincourt from Shakespeare's "King Henry V"*
 c. 1745
Canvas, dimensions unknown
Prov: as for CL. 127
Coll: Untraced

134. *A Scene From "The Tempest"*
 c. 1745
Canvas, dimensions unknown
Prov: as for CL. 127 but possibly this or CL. 135 was lot 28 in Tyers sale, bt. Gilmore (inc. CL. 125) for £2.17.0
Coll: Untraced

135. *A Scene From "The Tempest"*
 c. 1745
Prov: James Ralph, his sale, Langford's, 21 April 1762 (45) as 'Prospero and Miranda. A Sketch for the Picture at Vauxhall'. See also 134 above
Coll: Untraced

136. *A Scene From "The Suspicious Husband"*
 1747 Colour Plate VIII
Canvas, 28 × 36 (71.25 × 91.5)
Prov: see cat. no. 39
Coll: Yale Center for British Art, Paul Mellon Collection

137. *A Scene from "The Suspicious Husband"*
 c. 1752
Canvas, 25½ × 30½ (63.75 × 76.5)
Prov: painted for David Garrick who paid Hayman 20 gns. for it on 26 May 1752; acquired by present owners in 1955
Coll: London, Museum of London
A replica, with differences, of CL. 136

138. *Robert Lovelace Preparing to Abduct Clarissa Harlowe From Samuel Richardson's Novel "Clarissa"*
 c. 1753–4
Canvas, 24½ × 29½ (62.2 × 74.9)
Prov: see cat. no. 40
Coll: Southampton, City Art Gallery

139. *Spranger Barry and Mrs Mary Elmy in the Closet Scene from "Hamlet"*
c. 1755–60
Canvas, 50½ × 43 (128.3 × 109.2)
Prov: see cat. no. 41
Coll: London, Garrick Club

140. *David Garrick as Richard III*
Signed and dated 1760
Canvas, 36¼ × 28 (89.5 × 64.1)
Exh: Society of Artists 1760 (25)
Prov: see cat. no. 42
Coll: London, National Theatre (Somerset Maugham Collection)

141. *Falstaff Reviewing His Recruits*
Early-mid 1760s (?)
Canvas, 39¼ × 49¼ (99.7 × 125)
Prov: see cat. no. 43
Coll: Dublin, National Gallery of Ireland

142. *Falstaff Reviewing His Recruits*　　　　　Fig. 7
Early-mid 1760s (?)
Canvas, 39½ × 48½ (100.3 × 123.2)
Prov: Col. W. B. Molony; his sale, Puttick & Simpson 18 March 1927 (25) as Fuseli
Coll: Washington, D.C., Folger Shakespeare Library

143. *Falstaff Reviewing His Recruits*
Early-mid 1760s (?)
Canvas, 20½ × 23½ (52.1 × 59.7)
Prov: Anon. sale, Christie's, 28 October 1955 (96)
Coll: Birmingham, City Art Gallery

144. *Falstaff Reviewing His Recruits*
Early-mid 1760s (?)
Canvas, dimensions unknown
Coll: Untraced
Engr: W. W. Ryland, published 25 March 1776

145. *Cymon and Iphigenia*
c. 1767
Canvas, 61 × 43 (155 × 109.2)
Exh: Society of Artists 1767 (70)
Prov: see cat. no. 51
Coll: Sidney Sabin Esq.

146. *Don Quixote Knighted by the Innkeeper*
Late 1760s (?)
Canvas, 20½ × 24¾ (52.1 × 62.9)
Prov: see Cat. no. 44
Coll: Exeter, Royal Albert Memorial Museum

147. *Don Quixote Brought Home by the Peasant After the Tilt with the Toledo Merchant*
Late 1760s (?)
Canvas, 20½ × 24¼ (52.1 × 61.6)
Prov: see cat. no. 44
Coll: Exeter, Royal Albert Memorial Museum

148. *Don Quixote Attacking the Barber to Capture The Basin*
Late 1760s (?)
Canvas, 20½ × 24¾ (52.1 × 62.9)
Prov: see cat. no. 44
Coll: Exeter, Royal Albert Memorial Museum

149. *Don Quixote Disputing with Mad Cardenio*
Late 1760s (?)
Canvas, 20½ × 24¾ (52.1 × 62.9)
Exh: probably the picture exhibited at the Royal Academy in 1769 (51) as 'Meeting Cardenio in the Black Mountain'
Prov: see cat. no. 45
Coll: Exeter, Royal Albert Memorial Museum

150. *Don Quixote's Battle with The Wine Skins*
Late 1760s (?)
Canvas, 20½ × 24¾ (52.1 × 62.9)
Prov: see cat. no. 44
Coll: Exeter, Royal Albert Memorial Museum

151. *The Barber Reclaiming his Basin from Don Quixote*
Late 1760s (?)
Canvas, 20½ × 24¾ (52.1 × 62.9)
Exh: probably the picture exhibited at the Royal Academy in 1769 (50) as 'The Dispute with the Barber upon Mambrino's helmet'
Prov: see cat. no. 44
Coll: Exeter, Royal Albert Memorial Museum

152. *The Priest Enraged with Don Quixote at The Table of the Duke and Duchess*
Late 1760s (?)
Canvas, 17½ × 13 (44.5 × 33)
Prov: Anon. sale, Christie's, 16 June 1961 (140)
Coll: Private Collection, Rome

153. *Two Scenes from "Don Quixote"*
Canvas, dimensions unknown
Prov: as CL. 112 (lot 133)
Coll: Untraced

154. *Falstaff and Prince Hal*
Canvas, 14 × 12 (35.6 × 30.50
Prov: sold as property of American Shakespeare Festival Theatre, Stratford, Connecticut by Sotheby Parke Bernet (New York), 15 January 1976 (119)
Coll: Untraced

155. *James Quin in The Character of Falstaff and Prince Henry*
Prov: David Garrick; Mrs Garrick's sale, Christie's, 23 June 1823 (25, with CL. 71) bt. 12 gns. Noseda
Coll: Untraced

GENRE & MISCELLANEOUS

156. *A Portrait of a Mastiff*　　　　　Fig. 28
c. 1743–4
Canvas, 17¾ × 39½ (45 × 103)
Prov: see cat. no. 34
Coll: Norwich Castle Museum
Originally one of a set of four overdoors (the other three by Peter Tillemans) painted for Little Haugh Hall

157. *A Cricket Match at The Artillery Ground*
c. 1748
Canvas, 28½ × 36½ (72.4 × 92.7)
Prov: Thomas Lord (?); William Ward by 1825; J. H. Dark; purchased by M.C.C. in 1867

Coll: London, Marylebone Cricket Club, Cricket Memorial Gallery
Engr: by C. Grignion, published 16 July 1748

158. *Seeing – La Vue*
c. 1753
Panel, 12 × 9 (30.5 × 22.9)
Coll: Sidney Sabin Esq.
Engr: in mezzotint by Richard Houston and published in 1753 (Chaloner Smith II, 694, no. 129), see cat. no. 73a
One of a set of the Five Senses; the remaining four engravers' *modellos* have not been traced

159. *Hearing – L'Ouie*
Coll: Untraced

160. *Feeling – Le Toucher*
Coll: Untraced

161. *Smelling – L'Adorat*
Coll: Untraced

162. *Tasting – Le Gout*
Coll: Untraced

163. *Rustic Figures Dancing* Colour Plate VI
Early 1750s
Canvas, 25¼ × 20¼ (64.1 × 51.4)
Prov: See cat. no. 35
Coll: Private Collection

164. *A Lecherous Monk (possibly a portrait of Lord Le Despencer?)*
Early 1760s (?)
Canvas, 23 × 18½ (58.4 × 47)
Coll: Dijon, Musée Magnin
See 165 below

165. *A Lecherous Monk (possibly a portrait of Lord Le Despencer?)*
Early 1760s (?)
Canvas, 21 × 19 (53.3 × 48.2)
Prov: see cat. no. 36
Coll: Private Collection

166. *The Head of a Friar*
Prov: Jonathan Tyers Jnr. sale, Christie's, 28 April 1830 (29)
Coll: Untraced

167. *Playing at Top*
Prov: Anon. sale, Christie's, 10 May 1787 (1) as 'the property of a man of fashion'
Coll: Untraced

168. *A Boy Drawing*
Prov: as for CL. 167
Coll: Untraced

169. *A Toper with his Pot and Pipe*
Prov: according to F. P. Seguier sold at auction in 1824 (see *Dictionary of the Works of Painters . . . &tc* [London, 1870] p. 87)
Coll: Untraced

170. *A Timber Carriage Under an Archway*
Prov: Sir Mark Masterman Sykes sale, Christie's, 15 May 1824
Coll: Untraced

DECORATIVE PAINTINGS FOR VAUXHALL GARDENS

The following list consists of the supper box paintings designed by Hayman and others and executed by Hayman with his studio assistants c. 1741–2. The later paintings in the Prince of Wales's Pavilion and in the annexe to the Rotunda have been listed under HISTORY PAINTINGS

171. *Two Mahometans Gazing in Wonder and Astonishment at the Many Beauties of the Place*
Prov: last recorded in 1822 in *A Brief Historical and Descriptive Account of the Royal Gardens, Vauxhall*
Coll: probably destroyed

172. *A Shepherd Playing on his Pipe and Decoying a Shepherdess into the Wood*
Prov: as for CL. 171
Coll: probably destroyed

173. *New River, at Islington With a Family Going Awalking, a cow Milking, and The Horns Archly Fixed Over the Husband's Head*
Canvas, 54 × 50 (137.2 × 127) fragment
Prov: removed from Vauxhall Gardens in the early nineteenth century by George Barrett; Earl of Lonsdale; his sale at Lowther Castle, 29 April 1947 (1855)
Coll: Untraced
A copy of Hogarth's *Evening*, from his *Four-Times-of-the-Day*

174. *The Game of Quadrille*
Canvas, 54 × 80 (137.2 × 203.2)
Prov: Vauxhall sale by Ventom & Hughes, 12 October 1841 (197); Anon. sale, Sotheby's, 23 February 1955 (163)
Coll: Birmingham, City Art Gallery
Engr: by Charles Grignion, published 1743
Designed by Gravelot but painted by Hayman and his studio.

175. *Music and Singing*
Prov: as for CL. 171
Coll: Untraced

176. *Children building Houses with Cards*
Canvas, 55 × 80 (139.7 × 203.2)
Coll: Private Collection
Engr: by Truchy, published 1743
Designed by Gravelot but painted by Hayman and his studio

177. *A Scene in "The Mock Doctor"*
Canvas, 52 × 62 (132.1 × 157.4) reduced
Prov: Vauxhall sale by Ventom & Hughes, 12 October 1841 (200); Earl of Lonsdale; his sale at Lowther Castle, 29 April 1947 (1851)
Coll: Sizergh Castle, the late H. Hornyold Strickland
Engr: by Truchy, published 1743
Probably designed by Gravelot but painted by Hayman and his studio

178. *An Archer and a Landscape*
Prov: as for CL. 171
Coll: Untraced

179. *Country Dancers Round a Maypole*
Canvas, $53\frac{1}{2} \times 84\frac{1}{2}$ (136 × 214.7)
Prov: probably Vauxhall sale by Ventom & Hughes, 12 October 1841 (195) bt. F. G. Gye; W. H. Forman; Major A. S. C. Browne; sale, Christie's, 21 November 1986 (67)
Coll: London, Victoria & Albert Museum

180. *Thread My Needle*
Prov: as for CL. 171
Coll: Untraced

181. *Flying the Kite*
Prov: as for CL. 171
Coll: Untraced
The design is known from Hayman's drawing (cat. no. 55)

182. *A Story in Pamela, Who Reveals to the Housekeeper Her Wishes of Returning Home*
Prov: as for CL. 171
Coll: Untraced
Adapted from Hayman's book illustration, (see CL. 266 (2))

183. *A scene from "The Devil to Pay"*
Canvas, 54 × 80 (137.2 × 203.2)
Prov: Vauxhall sale by Ventom & Hughes, 12 October 1841 (182); Earl of Lonsdale; his sale at Lowther Castle, 29 April 1947 (1857)
Coll: Private Collection
Engr: by R. Parr, published 1743

184. *Battledore and Shuttlecock*
Prov: as for CL. 171
Coll: Untraced
The design is known from Hayman's drawing (cat. no. 56)

185. *Hunting the Whistle*
Prov: possibly 'a Children's party with numerous figures by Hayman' in Vauxhall sale, Ventom & Hughes, 12 October 1841 (198)
Coll: Untraced
The design is known from Hayman's drawing cat. no. 57

186. *Pamela . . . Flying to the Coach . . . While Lady Davers Sends Two of Her Footmen to Stop Her*
Canvas, 52 × 72 (132.1 × 182.8)
Prov: Earl of Lonsdale; his sale at Lowther Castle, 29 April 1947 (1844)
Coll: Sizergh Castle, the late H. Hornyold Strickland
Adapted from Hayman's book illustration (CL. 266 (7))

187. *Sir John Falstaff in the Buck-Basket*
Prov: probably the 'Scene from the Merry Wives of Windsor by Hayman' in the Vauxhall sale, Ventom & Hughes, 12 October 1841 (192)
Coll: Untraced
Engr: by Charles Grignion, published 1743

188. *The Entrance to Vauxhall With a Gentleman and a Lady Coming to It*
Prov: still at Vauxhall in 1807 (see *The Ambulator: or, The Stranger's Companion in a Tour Round London*, 10th edition [London, 1807] p. 293)
Coll: Untraced

189. *Friendship on the Grass Drinking*
Prov: as for CL. 188
Coll: Untraced

190. *Difficult to Please*
Prov: as for CL. 171
Coll: Untraced

191. *Sliding on the Ice*
Canvas, 55 × 96 (139.7 × 243.8)
Prov: see cat. no. 33
Coll: London, Victoria & Albert Museum
Engr: by R. Parr, published 1743

192. *Players on Bagpipes and Hautboys*
Prov: possibly Vauxhall sale, Ventom & Hughes, 12 October 1841 (187) as 'Minstrels'
Coll: Untraced

193. *A Bonfire at Charing Cross, and Other Rejoicings, The Salisbury Stage overturned, &tc.*
Prov: as for CL. 173
Coll: Untraced
A copy of Hogarth's *Night* from his *Four-Times-of-the-Day* series

194. *The Play of Blindman's Buff*
Prov: Vauxhall sale, Ventom & Hughes, 12 October 1841 (191)
Coll: Untraced
Engr: by N. Parr, published 1743

195. *The Play of Leap Frog*
Prov: possibly Vauxhall sale, Ventom & Hughes, 12 October 1841 (184 or 185), 'Boys and Children at Play'; Joseph Parkes; Charles Mathews; Lord Queenborough
Coll: Private Collection
Engr: By Truchy, published 1743

196. *The Wapping Landlady, and the Tars Who Are Just Come Ashore*
Canvas, 39 × $40\frac{3}{4}$ (99.1 × 103.5) fragment
Prov: Anon. sale, Robinson & Fisher, 10 February 1949 (219) bt. by Dr S. A. Henry who later presented it to the V & A
Coll: London, Victoria & Albert Museum
Engr: by Benoist, published 1743

197. *The Play of Skittles, and The Husband Upbraided by The Wife, Who Breaks His Shin with One of the Pins*
Prov: as for CL. 171
Coll. Untraced
The design is known from Hayman's drawing (cat. no. 58)

198. *Mademoiselle Catherina, the Famous Dwarf*
Prov: as for CL. 171
Coll: Untraced
Engr: by Charles Grignion, published 1743

199. *Ladies Angling*
Prov: as for CL. 171
Coll: Untraced
The design is known from Hayman's drawing (cat. no. 59)

200. *Bird Nesting*
 Canvas, $56\frac{1}{2} \times 91\frac{1}{2}$ (143.5 × 232.4)
 Prov: as for CL. 179; sale, Christie's, 21 November 1986
 (66)
 Coll: London, Victoria & Albert Museum

201. *The Play at Bob-Cherry*
 Prov: Vauxhall sale, Ventom & Hughes, 12 October 1841
 (201)
 Coll: Untraced

202. *Falstaff's Cowardice Detected*
 Prov: as for CL. 171
 Coll: Untraced
 Engr: by Charles Grignion, published 1743

203. *The Bad Family*
 Prov: probably Vauxhall sale, Ventom & Hughes, 12
 October 1841 (189) as 'The Enraged Husband'
 Coll: Untraced

204. *The Good Family*
 Prov: probably Vauxhall sale, Ventom & Hughes, 12
 October 1841 (183)
 Coll: Untraced

205. *Bird Catching by a Decoy with a Whistle and Net*
 Canvas, $55\frac{1}{4} \times 92$ (140.3 × 233.6)
 Prov: F. Gye; W. H. Forman; by descent to Major A. S. C.
 Browne; sale, Christie's, 21 November 1986 (65)
 Coll: London, Victoria & Albert Museum

206. *The Play of See-Saw*
 Canvas, 54×95 (137.2 × 241)
 Prov: see cat. no. 32
 Coll: London, Tate Gallery
 Engr: Truchy, published 1743

207. *Fairies Dancing on the Green by Moonlight*
 Two Canvasses in one frame, $50\frac{1}{4} \times 59\frac{1}{2}$ (128 × 152) and
 $56\frac{3}{4} \times 36\frac{1}{4}$ (144 × 92)
 Prov: Vauxhall sale, Ventom & Hughes, 12 October 1841
 (194); F. Gye; J. Parkes; W. H. Forman; by descent to
 Major A. S. C. Browne; sale, Christie's, 21 November
 1986 (64)
 Coll: Callally Castle, Major A. S. C. Browne

208. *May Day, or, The Milkmaid's Garland*
 Canvas, $54\frac{1}{2} \times 94\frac{1}{2}$ (138.5 × 240)
 Prov: see cat. no. 31
 Coll: London, Victoria & Albert Museum

Engr: by Charles Grignion, published 1743

209. *Stealing a Kiss*
 Prov: as for CL. 171
 Coll: Untraced
 Engr: by R. Parr, published 1743

210. *A Northern Chief, with his Princess and Her Favourite Swan
Placed in a Sledge, and Drawn on Ice by a Horse*
 Prov: as for CL. 171
 Coll: Untraced

211. *The Play of Hot-Cockles*
 Prov: as for CL. 171
 Coll: Untraced

212. *An Old Gipsy telling Fortunes by the Coffee Cups*
 Prov: as for CL. 171
 Coll: Untraced
 Engr: by Vivares, published 1743

213. *The Cutting of Flour*
 Prov: as for CL. 171
 Coll: Untraced
 The design is known from Hayman's drawing (cat. no. 60)

214. *The Play of Cricket*
 Prov: as for CL. 171
 Coll: untraced
 Engr: by Benoist, published 1743

215. *The King and the Miller of Mansfield*
 Prov: Carr sale, Robinson & Fisher, 19 July 1928 (62)
 Coll: Untraced
 Engr: by R. Parr, published 1743

216. *The Jealous Husband*
 Prov: Vauxhall sale, Ventom & Hughes, 12 October 1841
 (196)
 Coll: Untraced
 The design is known from Hayman's drawing (cat. no. 61)

217. *The Man and his Two Wives*
 Prov: Vauxhall sale, Ventom & Hughes, 12 October 1841
 (181) as 'Figures with a looking glass A Female Pulling
 out the Grey Hairs of an Aged Man'
 Coll: Untraced
 Engr: Anonymously as one of a series entitled 'ROYAL
 AMUSEMENT or a Curious Representation of one of
 ye Celebrated Paintings at Vauxhall done by ye
 Ingenious Mr HYMEN'

DRAWINGS

DESIGNS FOR BOOK ILLUSTRATIONS

218. *Sir Jacob Swynford Surveying Pamela* (for Samuel Richardson's *Pamela*, 6th edition 1742)

c. 1740

Pen, ink and grey wash indented for transfer) $5\frac{3}{8} \times 3\frac{1}{8}$ (12.8×7.3)

Prov: see cat. no. 80a

Coll: London, British Museum 1951–12–19–3

Engr: see CL. 266 (12)

219. *31 Drawings for Sir Thomas Hanmer's edition of "The Works of William Shakespeare"*

c. 1740–1 (not published until 1743/4)

All pen, ink and grey wash, average size c. $8\frac{1}{2} \times 5\frac{3}{4}$ (21.6×14.6)

Prov: see cat. no. 82a

Coll: Washington, D.C., Folger Shakespeare Library

1. *Miranda Discovers Ferdinand* "The Tempest" I, iv
2. *Bottom With an Ass's Head, Quince, Snug &tc.* "A Midsummer Night's Dream", III, ii
3. *Valentine Rescues Sylvia* "Two Gentlemen of Verona" V, ix
4. *Falstaff in the Buck Basket* "The Merry Wives of Windsor" III, ix
5. *Lucio Discovers the Duke* "Measure for Measure" V, iv
6. *The Binding of Antipholus* "The Comedy of Errors" IV, ix
7. *Hero Swoons* "Much Ado About Nothing" IV, i
8. *Portia and Morochius* "The Merchant of Venice" II, viii
9. *Boyet and the Princess* "Love's Labour Lost" V, iv
10. *Orlando Throws Charles* "As You Like It" I, vi
11. *Petruchio and Kate Arrive Home* "The Taming of the Shrew" IV, ii
12. *Helena Before The King* "All's Well That Ends Well" II, iii
13. *Oliva and Viola* "Twelfth Night or What You Will" I, ix
14. *Perdita, Florizel, Polixenes &tc.* "The Winter's Tale" IV, v
15. *The Heath Scene* "King Lear" III, vi
16. *King John Close to Death* "King John" V, ix
17. *The Lists at Coventry* "King Richard II" I, iv
18. *Falstaff and Prince Henry* "King Henry IV, Part I" II, xi
19. *Falstaff Reviewing Recruits* "King Henry IV, Part II" III, v
20. *King Henry and Mountjoy* "King Henry V" IV, viii
21. *Timon and Alcibiades* "Timon of Athens" IV, iv
22. *Coriolanus, Virgilia and Volumnia* "Coriolanus" V, iii
23. *Brutus Cassius Disputing in a Tent* "Julius Caesar" IV, iii
24. *Cleopatra and The Clown* "Anthony and Cleopatra" V, vi
25. *Demetrius, Aaron and the Nurse* "Titus Andronicus" IV, iii
26. *Lady Macbeth Sleepwalking* "Macbeth" V, i
27. *Troilus Delivers Cressida to Demetrius* "Troilus and Cressida" IV, vii
28. *Imogen at the Cave's Mouth* "Cymbeline" III, vii
29. *The Death of Paris* "Romeo and Juliet" V, iv
30. *The Play Scene* "Hamlet" III, vii
31. *Othello Repulses Desdemona* "Othello" IV, vi

Five additional drawings were added by Gravelot

Engr: All by Gravelot, published 1743/4

220. *17 Drawings for Edward Moore's "Fables for the Female Sex"*

c. 1743

Pen and grey wash (except no. 4 below which is in pencil) all c. $6\frac{1}{4} \times 3\frac{7}{8}$ (15.9×9.9)

Prov: Charles Chauncey M.D. (see cat. no. 13); Nathaniel Chauncey; his sale, Sotheby's, 15 April 1790 (3065); Thomas Allen; George Baker; William Beckford; Beckford Library sale, 30 June–13 July 1882 (2602) bt. Quaritch, sold to Rothschild

Coll: Waddesdon Manor, James A. de Rothschild Collection

1. *Frontispiece*
 Engr: S. F. Ravenet
2. *The Eagle and The Assembly of Birds*
 Engr: C. Mosely
3. *The Panther, The Horse and Other Beasts*
 Engr: C. Grignion
4. *The Nightingale and The Glow-Worm*
 Engr: C. Grignion
5. *Hymen and Death*
 Engr: C. Grignion
6. *The Poet and His Patron*
 Engr: C. Grignion
7. *The Wolf, The Sheep and The Lamb*
 Engr: C. Mosley
8. *The Goose and The Swans*
 Engr: C. Mosley
9. *The Lawyer and Justice*
 Engr: C. Grignion
10. *The Farmer, The Spaniel and The Cat*
 Engr: C. Grignion
11. *The Spider and The Bee*
 Engr: C. Grignion
12. *The Young Lion and The Ape*
 Engr: C. Grignion
13. *The Colt and The Farmer*
 Engr: C. Grignion
14. *The Owl and The Nightingale*
 Engr: C. Mosley
15. *The Sparrow and The Dove*
 Engr: C. Grignion
16. *The Female Seducers*
 Engr: S. F. Ravenet
17. *Love and Vanity*
 Engr: S. F. Ravenet

See also CL. 268

221. *12 Drawings for Dr Newton's edition of Milton's "Paradise Lost"*
 c. 1745 (not published until 1749, see CL. 281)
 Coll: Untraced
 Engr: by Ravenet and Grignion
 The only reference to these drawings is in Garrick's letter to Hayman written in the autumn of 1745: 'Your Drawings for Milton will do you great Service, I have promis'd the Doctor to read ye third Book & give him my opinion for the Drawing, wch I'll send you' (see p. 155)

222. *A Design For the Title-page of William Mason's "MUSAEUS: A Monody to the Memory of Mr Pope in Imitation of Milton's 'Lycidas'"*
 Signed: below the image, *Hayman delin. 1747.*
 Pen and wash, $3\frac{3}{8} \times 4\frac{5}{8}$ (8.6 × 11.7)
 Prov: given by William Mason to Richard Hurd, Bishop of Worcester
 Coll: Hartlebury Castle, The Bishop of Worcester
 Engr: in reverse by C. Grignion, published 1747 (CL. 273)

223. *A Design for The Frontispiece to Vol. I of Dodsley's "The Preceptor"*
 Youth Led By Wisdom
 c. 1748
 Pen and brown ink, $7\frac{1}{8} \times 4\frac{7}{8}$ (18.1 × 12.4)
 Coll: University of London, Courtauld Institute Galleries (Witt Collection)
 Engr: C. Grignion (see CL. 276 i)

224. *A Design for The Frontispiece to Vol. I of "The Magazine of Magazines" pub.* 1751
 c. 1750
 Pen, ink with grey wash, indented for transfer, $6\frac{1}{8} \times 4$ (15.6 × 10.1)
 Prov: see cat. no. 87
 Coll: London, British Museum 1857–12–12–2
 Engr: C. Mosley (see CL. 288)

225. *An Illustration to Pope's "The Dunciad", Book I*
 c. 1750
 Pen, ink and grey wash, $5\frac{3}{4} \times 3\frac{5}{8}$ (14.6 × 9.2)
 Coll: University of London, Courtauld Institute Galleries (Witt Collection)
 Engr: by C. Grignion (see CL. 290, 5)

226. *5 Drawings for the 1753 edition of "The Works of William Congreve"*
 c. 1752
 Pen, ink and grey wash, each 5 × 3 (12.7 × 7.6)
 Prov: see cat. no. 90
 Coll: London, Victoria & Albert Museum E. 656–660–1949
 1. *The Old Batchelor. A Comedy* III, ix
 2. *The Double Dealer. A Comedy* V, xxiv
 3. *Love for Love. A Comedy* IV, viii
 4. *The Way of the World. A Comedy* IV, x
 5. *The Mourning Bride. A Tragedy* II, v
 Engr: all by C. Grignion (see CL. 293)

227. *An Illustration For Jonas Hanway's "An Historical Account of British Trade Over The Caspian Sea"* (1753)
 The State of Great Britain with Regard to Her Debt
 c. 1753
 Pen and grey wash; scored, verso blackened for transfer, $8\frac{1}{4} \times 6\frac{3}{4}$ (21 × 17.1)
 Prov: Sir Bruce Ingram
 Coll: San Marino, California, Henry E. Huntington Library & Art Gallery
 Engr: by Grignion (see CL. 294 (2))

228. *An Illustration for Jonas Hanway's "An Historical Account of British Trade Over The Caspian Sea"* (1753)
 After a Duel
 c. 1753
 Pen, ink and grey wash, $7\frac{5}{8} \times 6\frac{1}{4}$ (19.4 × 15.9)
 Coll: University of London, Courtauld Institute Galleries (Witt Collection)
 Engr: C. Grignion (see CL. 294 (1))

229. *A Design for The Frontispiece to Charles Denis' "Select Fables"* (pub. 1754)
 c. 1754
 Pencil, pen and ink wash, $6 \times 3\frac{3}{4}$ (15.2 × 9.5)
 Coll: London, Victoria & Albert Museum E. 661. 1949
 Engr: C. Grignion (see CL. 295)

230. *28 Drawings for Tobias Smollett's Edition of Cervantes "Don Quixote"* (pub. 1755)
 c. 1754
 Prov: see cat. no. 91
 Coll: London, British Museum 1859–6–11–331–358 inc.
 1. *The Decay of Chivalry* (frontispiece)
 Pen and brown ink, brown and grey wash over black lead $8\frac{3}{8} \times 6\frac{7}{8}$ (21.8 × 17.4)
 2. *Don Quixote Knighted by the Innkeeper*
 Pen and ink, brown and grey wash, heightened with white, indented for transfer, $9\frac{1}{2} \times 7$ (24.3 × 17.8)
 Engr: by Grignion for Vol. I, f.p. 17
 3. *Don Quixote Brought Home by a Countryman on His Ass*
 Pen and ink, with grey wash; indented for transfer, 9×7 (23.2 × 17.9)
 Engr: by Grignion for Vol. I, f.p. 26
 4. *The Burial of Chrysostom*
 Pen and ink, with grey wash; indented for transfer, $9\frac{1}{8} \times 7\frac{1}{8}$ (23.2 × 18.1)
 Engr: by Scotin for Vol. I, f.p. 75
 5. *Maritornes and Sancho Panza Fighting in Bed*
 Pen and ink, with washes of grey over red chalk; indented for transfer, $8\frac{7}{8} \times 7$ (22.6 × 17.9)
 Engr: by Müller for Vol. I, f.p. 92
 6. *Sancho Panza Examining Don Quixote's Mouth*
 Pen and ink, with grey wash, over black lead; indented for transfer, $9\frac{1}{8} \times 7$ (23.3 × 17.9)
 Engr: by Grignion for Vol. I, f.p. 106
 7. *Don Quixote Threatening to Kill The Unhorsed Bachelor With His Lance*
 Pen and ink, with grey wash; indented for transfer, $9\frac{3}{8} \times 7$ (23.8 × 17.8)
 Engr: by Ravenet for Vol. I, f.p. 111
 8. *Don Quixote Taking The Barber's Basin for Mambrino's Helmet*
 Pen and ink with grey wash; indented for transfer, $9\frac{1}{8} \times 6\frac{7}{8}$ (23.2 × 17.5)
 Engr: by Ravenet for Vol. I, f.p. 126

9. *Don Quixote and Sancho Felled by Cardenio*
Pen and ink, with grey wash, $9\frac{1}{8} \times 7$ (23.2 × 17.7)
Engr: by Ravenet for Vol. I, f.p. 159

10. *Dorothea Bathing her Feet in the Stream*
Pen and ink with grey wash, over black lead $9 \times 6\frac{3}{4}$
(23.1 × 17.2)
Engr: by Grignion for Vol. I, f.p. 196

11. *Dorothea Received by Don Quixote as The Princess Miromicona*
Pen and ink with grey wash, over red chalk, 9×7
(22.8 × 17.8)
Engr: by Scotin for Vol. I, f.p. 211

12. *Don Quixote Attacking The Wine Bags in His Sleep*
Pen and ink with grey wash, 9×7 (22.8 × 17.8)
Engr: by Grignion (with differences)

13. *Dorothea Pleading with Don Fernando as He Draws His Sword Against Cardenio*
Pen and ink with grey wash, over red chalk, $9\frac{3}{8} \times 7\frac{1}{8}''$
(23.6 × 18.2)
Engr: by Ravenet (with modifications) for Vol. I,
f.p. 281

14. *The Barber Confounded by The Assurances of Don Quixote, Don Fernando and The Rest That His Basin is a Helmet*
Pen and ink with grey wash, over black lead; indented for transfer, $9\frac{1}{8} \times 7$ (23.4 × 17.9)
Engr: by Grignion for Vol. I, f.p. 352

15. *Sancho Panza Presenting The Country Wench As Dulcinea to Don Quixote*
Pen and ink with grey wash; indented for transfer, $9\frac{1}{8} \times 6\frac{7}{8}$ (23.3 17.7)
Engr: by Scotin for Vol. II, f.p. 54

16. *Don Quixote Prevented by The Squire of the Nose From Killing The Knight of the Mirrors*
Pen and ink with grey wash; indented for transfer, $9\frac{1}{8} \times 7$ (23.3 × 17.8)
Engr: by Scotin for Vol. II, f.p. 80

17. *Quiteria Wedded to Basilio While He Feigns to Be Dying of A Wound*
Pen and ink with washes of brown and grey, touched with white; indented for transfer, $9\frac{1}{4} \times 6\frac{7}{8}$
(23.5 × 17.6)
Engr: by Müller for Vol. II, f.p. 127

18. *Don Quixote Attacking The Puppet Show*
Pen and ink with grey wash, $9\frac{1}{4} \times 6\frac{7}{8}$ (23.6 × 17.5)
Engr: by Ravenet for Vol. II, f.p. 163

19. *Don Quixote Paying His Respects to The Duchess*
Pen and ink with grey wash; indented for transfer, $9\frac{1}{4} \times 6\frac{7}{8}$ (23.6 × 17.6)
Engr: by Ravenet for Vol. II, f.p. 186

20. *Sancho Panza's Quarrel With The Duenna Rodriguez*
Pen and ink with grey wash, touched with white; indented for transfer, $9 \times 6\frac{7}{8}$ (22.9 × 17.6)
Engr: by Scotin for Vol. II, f.p. 189

21. *The Priest Enraged with Don Quixote at The Table of The Duke and Duchess*
Pen and ink with grey wash; indented for transfer, $9\frac{1}{8} \times 6\frac{7}{8}$ (23.2 × 17.4)
Engr: by Grignion for Vol. II, f.p. 194

22. *Sancho Panza at Dinner*
Pen and ink with grey wash; indented for transfer, $9\frac{1}{8} \times 6\frac{3}{8}$ (23.4 × 17.6)

Engr: by Grignion for Vol. II, f.p. 284

23. *The Duenna Rodriguez Entering Don Quixote's Bedchamber*
Pen and ink with grey wash, touched with white; indented for transfer, $9\frac{1}{4} \times 6\frac{7}{8}$ (23.4 × 17.6)
Engr: By Grignion for Vol. II, f.p. 296

24. *The Maiden, Disguised as a Youth, Brought Before Sancho*
Pen and ink with grey wash, touched with white; indented for transfer, $9\frac{3}{8} \times 6\frac{7}{8}$ (23.7 × 17.6)
Engr: by Grignion for Vol. II, f.p. 305

25. *The Page Presenting Sancho's Letter to His Wife and Daughter*
Pen and ink with brown wash, touched with white, $8\frac{1}{2} \times 6\frac{3}{4}$ (21.6 × 17.3)
Engr: by Ravenet for Vol. II, f.p. 311

26. *Sancho Displeased by The Answers Given Him by The Enchanted Head*
Pen and ink with grey wash; indented for transfer, $9\frac{1}{4} \times 6\frac{7}{8}$ (23.6 × 17.6)
Engr: by Grignion for Vol. II, f.p. 400

27. *Don Quixote Restraining Sancho in His Zeal to Scourge Himself*
Pen and ink with grey wash; indented for transfer, $9\frac{3}{8} \times 7$ (23.5 × 17.9)
Engr: by Scotin for Vol. II, f.p. 449

28. *Sancho's Return to His Wife and Daughter*
Pen and ink with grey wash; indented for transfer, $9\frac{1}{8} \times 6\frac{7}{8}$ (23.3 × 17.6)
Engr: by Ravenet for Vol. II, f.p. 458

231. *A Design for An Illustration to Smollett's Edition of Cervantes' "Don Quixote"* (pub. 1755)
The Barber Confounded by The Assurances of Don Quixote Don Fernando and The Rest That His Basin Is A Helmet
c. 1754
Pen and ink with chalk and brown wash, $8\frac{1}{8} \times 6\frac{7}{8}$
(20.6 × 17.6)
Prov: Iolo Williams who presented it to the B.M. in 1962
Coll: London, British Museum 1962–7–14–44
A variant on CL. 230 (14)

232. *An Illustration for Smollett's "A Complete History of England . . . &tc."* (pub. 1758–60)
Caractacus before the Emperor Claudius at Rome
c. 1757
Pen, ink and grey wash; squared for transfer, $7\frac{1}{8} \times 5\frac{1}{8}$
(18.1 × 13)
Coll: Mrs Hanns Hammelmann
Engr: Grignion (see CL. 302)

233. *A Design For a Frontispiece to "The Tatler"* (pub. 1759)
A Writer by a Window, a Girl Seated by a Pile of Books
Late 1750s
Pen and grey wash; indented for transfer, $5\frac{1}{4} \times 3\frac{1}{2}$
(13.2 × 8.8)
Inscribed: *F. HAYMAN* lower left
Coll: Denys Oppé Esq.
Engr: Grignion (see CL. 305)

234. *A Design for a Frontispiece to "The Tatler"* (pub. 1759)
Isaac Bickerstaff Lunging with his sword at figures drawn on the wall
late 1750s
Pen, ink and grey wash; indented for transfer, $5\frac{1}{2} \times 3$
(13.8 × 7.6)

Prov: see cat no. 88
Coll: London, British Museum 1859-7-9-59
Engr: Grignion (see CL. 305)

235. *A Design for an unidentified book illustration*
Britannia (?) with Time escorting a Youth
mid-late 1740s (?)
Pen, ink and grey wash; indented for transfer, $4\frac{3}{4} \times 2\frac{7}{8}$
(12.1 × 7.2)
Coll: London, British Museum 1972.U.513

236. *A Design for An Unidentified Book Illustration*
A Jewish Marriage
late 1740s (?)
Pencil and grey wash, $6\frac{5}{8} \times 4$ (16.8 × 10.2)
Inscribed: *F. HAYMAN* lower right and collectors' mark
(Mu) or (M)
Coll: London, Victoria & Albert Museum D.1206.1887

237. *A Design For an Unidentified Book Illustration*
A Wounded Duellist Comforted By A Woman
early-mid 1750s (?)
Pen, ink and brown wash, $7\frac{1}{4} \times 7\frac{5}{8}$ (18.4 × 19.4)
Prov: Henry Reitlinger; his sale, Sotheby's, 27 January
1954 (150) bt. Matthews
Coll: Untraced
Possibly related to CL. 294 (i)

PRELIMINARY DRAWINGS FOR THE VAUXHALL DECORATIONS

238. *Flying The Kite*
Pen, brown ink and wash, $5\frac{1}{2} \times 9$ (14 × 22.9)
Prov: see cat. no. 55
Coll: Yale Center for British Art, Paul Mellon Collection-
See CL. 181

239. *Battledore and Shuttlecock* (recto)
Pen, ink and grey wash, $6\frac{7}{8} \times 9\frac{1}{2}$ (17.4 × 24)
Prov: see cat. no. 56
Coll: Yale Center for British Art, Paul Mellon Collection
See CL. 184
On the verso is a slight pencil study for the man holding
the sword in CL. 245

240. *Hunting The Whistle*
Pen, ink and brown and grey wash; squared for transfer,
$5\frac{1}{2} \times 9$ (14 × 22.9)
Prov: see cat. no. 57
Coll: University of London, Courtauld Institute Galleries
(Witt Collection)
See CL. 185

241. *Sliding on The Ice*
Prov: formerly in the coll. of Henry Reitlinger
Coll: Untraced
See CL. 191

242. *The Enraged Vixen of a Wife (The Play of Skittles . . . &tc.)*
Pen, ink and bistre with grey wash, $5\frac{5}{8} \times 8\frac{7}{8}$ (19 × 27.5)
Prov: see cat. no. 58

Coll: Birmingham, City Museum and Art Gallery
See CL. 197

243. *Ladies Angling*
Pen, ink with grey and brown wash, $5\frac{3}{4} \times 9\frac{1}{8}$ (14.6 × 23.2)
Coll: Dudley Snelgrove Esq.
See CL. 199 and cat. no. 59

244. *The Cutting of Flour*
Pen, ink and grey wash; squared for enlargement, $5\frac{5}{8} \times 8\frac{7}{8}$
(19 × 22.5)
Prov: see cat. no. 60
Coll: University of Manchester, Whitworth Art Gallery
See CL. 213

245. *The Jealous Husband*
Pen, ink with brown and grey wash, $5\frac{5}{8} \times 9$ (14.3 × 22.9)
Prov: see cat. no. 61
Coll: University of London, Courtauld Institute Galleries
(Witt Collection)
See CL. 216

MISCELLANEOUS DRAWINGS

246. *A Card Party*
late 1720s/early 1730s (?)
Pen and wash, dimensions unknown
Signed: *Fr. Hayman* lower right
Prov: Colnaghi's
Coll: Untraced

247. *Landscape with Cattle and Trees*
early 1740s (?)
Watercolour, $9\frac{1}{4} \times 12\frac{1}{4}$ (24 × 33)
Inscribed: *Fr. Hayman* lower left on stile
Coll: Exeter, Royal Albert Memorial Museum

248. *Grosvenor Bedford with Family and Friends*
c. 1741-2
Sepia, pen and ink and grey wash, $8 \times 11\frac{1}{8}$ (20.3 × 28.3)
Prov: Henry Reitlnger; sale, Sotheby's, 27 January 1954
(151); purchased by Gooden and Fox for Exeter
Coll: Exeter, Royal Albert Memorial Museum
A drawing related to cat. no. 4

249. *The Finding of Moses*
probably *c.* 1745-6
'Crayons', dimensions unknown
Prov: David Garrick (?); Mrs Garrick's sale (on premises
at Hampton) by Burrell, 21 July 1823 (14)
Presumably a study for the Foundling Hospital picture
(cat. no. 46)

250. *Two studies related to "The Death of an Unbeliever"*
c. 1745-50 (?)
Black chalk, heightened with white, $10\frac{1}{2} \times 13\frac{1}{8}$ (27.1 × 33.7)
recto and verso squared for enlargement
Prov: see see cat. no. 71
Coll: Budapest, Museum of Fine Arts

251. *Henry Woodward as The Fine Gentleman in Garrick's Farce*
"Lethe"
mid-1740s

Pencil, $13 \times 8\frac{7}{8}$ (33.2×22.5)
Prov: see cat. no. 53
Coll: Cambridge, Fitzwilliam Museum
Engr: in mezzotint by McArdell (Chaloner Smith II, p. 904, no. 189)

252. *Young Man in an Interior*
late 1740s
Black chalk, heightened with white on buff paper, $17\frac{1}{2} \times 12\frac{1}{2}$ (44.5×31.7)
Prov: see cat. no. 54
Coll: Cambridge, Fitzwilliam Museum

253. *A Scene from "The Suspicious Husband"*
c. 1747
Pencil with red chalk highlights, $5\frac{1}{8} \times 6\frac{3}{4}$ (13×17.1)
Coll: Yale Center for British Art, Paul Mellon Collection
A study for cat. no. 39
On the verso is a slight pencil sketch, probably related to *The Good Samaritan*

254. *Figures in Boats*
Mid-1740s (?)
Pen and grey and brown wash, $5\frac{1}{2} \times 10\frac{3}{4}$ (14.1×27.3)
Prov: Anon. sale, Sotheby's, 26–27 April 1966 (360) bt. by Leonard Duke (D.4395); Cyril Fry
Coll: Mr & Mrs Paul Mellon

255. *A Design for a subscription ticket for a series of prints "English History Delineated"*
c. 1750
Pencil and grey wash, $5\frac{1}{4} \times 6\frac{3}{4}$ (13.2×17.1)
Coll: London, Victoria & Albert Museum D.114–1887
See CL. 321

256. *An Academy Study (A Study for The Good Samaritan)*
early 1750s
Black chalk heightened with white on buff paper, $16\frac{1}{4} \times 21$ (41×54)
Prov: see cat. no. 70
Coll: London, Royal Academy of Arts

257. *A Girl Holding a Cat*
c. 1750
Charcoal, stump, heightened with white, $9\frac{1}{8} \times 7\frac{7}{8}$ (23.2×20)
Prov: Paul Sandby (collectors' mark lower left corner); by descent to William Sandby who presented it to the B.M.
Coll: London, British Museum 1904–8–19–193
Previously attributed to Paul Sandby

258. *A Girl Seated*
c. 1750
Charcoal, stump, heightened with white on blue paper, $9\frac{1}{4} \times 8\frac{1}{2}$ (23.5×21.6)
Prov: as for CL. 257
Coll: London, British Museum 1904–8–19–208
Previously attributed to Paul Sandby

259. *A Study for "Seeing – La Vue" (One of the Five Senses)*
c. 1752
Pencil, $3\frac{7}{8} \times 5\frac{3}{4}$ (9.8×14.6)
Coll: Yale Center for British Art, Paul Mellon Collection
See CL. 158

260. *Spranger Barry and Mrs Mary Elmy in the Closet Scene from "Hamlet"*
1755–60
Pencil, grey wash, heightened with red and white chalks, $7\frac{3}{8} \times 7\frac{1}{8}$ (17.8×17.3)
Prov: see cat. no. 41
Coll: Washington D.C., Folger Shakespeare Library A study for cat. no. 41

261. *Falstaff Reviewing His Recruits*
early-mid 1760s (?)
Black chalk heightened with white on buff paper, $7\frac{3}{8} \times 9\frac{5}{8}$ (18.75×24.5)
Prov: see cat. no. 75
Coll: Yale Center for British Art, Paul Mellon Collection

262. *Studies for an Unidentified Historical/Mythological Composition*
1760s (?)
Pencil, recto and verso, 8×6 (20.3×15.2)
Coll: Private Collection

263. *Adam and Eve in The Garden of Eden*
1760s (?)
Pen and brown ink, brown wash heightened with white, $4 \times 6\frac{5}{8}$ (10.2×16.8)
Prov: Edward Basil Jupp; Thomas Waller; Elizabeth Moore; by descent to Elizabeth Richardson Simmons; Christie's, 12 November 1968 (86)
Coll: Private Collection
Possibly related to CL. 116

264. *The Swing*
mid-1760s (?)
Pencil, white and red chalk with grey wash, $9\frac{1}{4} \times 12$ (23.3×31)
Prov: Francis Douce who presented it to the Ashmolean
Coll: University of Oxford, Ashmolean Museum

265. *A Study of a Man Clutching a Purse*
1760s (?)
Black chalk, heightened with white, $14\frac{3}{4} \times 18\frac{3}{4}$ (37.4×47.6)
Prov: formerly in the Reitlinger collection; Sotheby's, 27 January 1945 (154)
Coll: Private Collection
On the verso is a drawing in pencil, heightened with white of a young man with his left hand on his hip

BOOK ILLUSTRATIONS

266. 1742 Samuel Richardson, *Pamela: or, Virtue Rewarded . . . in four volumes . . . Sixth edition corrected and embellished with copper plates designed and engraved by Mr Hayman and Mr Gravelot*
4 vols. 8vo 'For S. Rivington'
12 full page plates, each *c.* 5×3 (12.5×7.5)
 1. *Mr B Reading Pamela's Letter* (Vol. 1, p. 4)
 2. *Pamela Revealing to Mrs Jervis Her Wishes to Return Home* (Vol. 1, p. 123)
 3. *Goodman Andrews Pleading with Mr B for the return of his daughter* (Vol. 1, p. 151)
 4. *Pamela throwing the carp into the stream* (Vol. 1, p. 214)
 5. *Pamela taking refuge in the woodhouse after her attempted escape* (Vol. 1, p. 290)
 6. *Pamela Begging Mr B Not To Ruin Her* (Vol. 1, p. 358)

7. *Pamela Fleeing From Lady Davers* (Vol. 2, p. 267)

8. *Goodman Andrews Conversing with Mr Longman* (Vol. 3, p. 11)

9. *Sir Simon Throwing a Book at His Daughter* (Vol. 3, p. 94)

10. *Mr B Rebuking Pamela for her Behaviour Toward Sir Simon* (Vol. 3, p. 161)

11. *Mr B., Lord and Lady Davers, the Countess, and Pamela* (Vol. 3, p. 228)

12. *Sir Jacob Surveying Pamela* (Vol. 3, p. 377)

Engr: all engraved by Hubert Gravelot who also designed the other 17 plates

267. 1743–4 *The Works of Shakespeare. In Six Volumes carefully revised and corrected by the former editions and adorned with sculptures designed and executed by the best hands* (edited by Sir Thomas Hanmer)
6 vols., 4to 'Oxford, printed at the Theatre'
Hayman's 31 designs are listed CL. 219

268. 1744 Edward Moore & H. Brooke, *Fables for the Female Sex*
8vo 'For R. Franklin'
Frontispiece and 16 full page plates listed CL. 220

269. 1744 [Mark Akenside], *An Epistle to Curio*
4to 'For R. Dodsley'
Title vignette
Clio, The Muse of History and Time Escorting The Reluctant William Pulteney towards the Devil at the Cave of Despair
$2\frac{5}{8} \times 3\frac{1}{2}$ (6.7 × 9)
Engr: Grignion

270. 1745 [Mark Akenside], *Odes on Several Subjects*
4to 'For R. Dodsley'
Unsigned title vignette, illustrating the first eleven lines of Ode X 'On Lyric Poetry' (p. 48)
$4\frac{1}{2} \times 3\frac{5}{8}$ (11.4 × 9.4)

271. 1746–1747 *The Museum; or the Literary and Historical Register*
3 vols. 8vo 'For R. Dodsley'
Title vignette (identical for all three vols.)
Apollo Seated on a Rock Holding His Lyre And Looking Over His Shoulder at Clio, The Muse of History with Mercury Descending from The Heavens
$2\frac{7}{8} \times 3\frac{1}{2}$ (7.4 × 9)
Engr: Ravenet

272. 1747 *The Spectator*
8 vols 12mo 'For J. & R. Tonson and S. Draper'
8 frontispieces, each *c.* $4\frac{3}{4} \times 3$ (12.1 × 7.6)
1. Vol. 1 *Spectator no. 12*
Engr: Grignion
2. Vol. 2 *Spectator no. 91*
Engr: Grignion
3. Vol. 3 *Spectator no. 216*
Engr: Gringnion
4. Vol. 4 *Spectator no. 301*
Engr: Mosley
5. Vol. 5 *Spectator no. 379*
Engr: Mosley
6. Vol. 6. *Spectator no. 462*
Engr: Mosley

7. Vol. 7 *Spectator no. 499*
Engr: Müller
8. Vol. 8 *Spectator no. 623*
Engr: Müller
These designs were re-engraved for the 1749 edition in 12mo by Grignion (2); Müller (3) and Mosley (3). They appeared again in the 1750 (12mo) edition all re-engraved by Grignion. With slight differences these plates re-appear in later reprints. They were all re-engraved as title vignettes by Grignion and appeared in the 1789 8vo edition.

273. 1747 [William Mason], *Museus: a monody to the Memory of Mr Pope, in imitation of Milton's "Lycidas"*
4to 'for R. Dodsley'
Title vignette
Chaucer, Spenser and Milton attending the last moments of Pope who is comforted by a goddess of virtue
$2\frac{7}{8} \times 4\frac{1}{8}$ (7.25 × 10.6)
Engr: Grignion
Hayman's drawing for this (CL. 222) is still at Hartlebury Castle (CL. 222)

274. 1747 *The Guardian*
2 vols. 8vo 'For J. & R. Tonson'
1. Title vignette, illustrating *Guardian no. 17*
$2\frac{5}{8} \times 3\frac{1}{2}$ (6.6 × 8.8)
2. Title vignette, illustrating *Guardian no. 167*
$2\frac{5}{8} \times 3\frac{1}{2}$ (6.6 × 8.8)
Engr: both by Grignion

275. 1748 Charles Coffey, *The Devil to Pay: or, The Wives Metamorphos'd. An Opera*
8vo 'For J. Watts'
Frontispiece, *Jobson and Nell*
$6\frac{1}{4} \times 3\frac{3}{4}$ (15.8 × 9.6)
Engr: Van der Gucht
Adapted from Hayman's Vauxhall painting (CL. 183)

276. 1748 *The Preceptor: Containing a general course of Education Wherein the first principles of Polite learning are laid down . . . for . . . the instruction of Youth*
2 vols. 8vo 'For R. Dodsley'
1. Frontispiece for Vol. 1
Youth Led By Wisdom
Inscribed:
The Youth, who, led by Wisdom's guiding Hand
Seeks VIRTUE's Temple, and her law reveres:
He, he alone, in Honour's Dome shall stand,
Crown'd with Rewards, & rais'd above his Peers:
Recording Annals, shall preserve his Name.
And give his Virtues to immortal FAME
$4\frac{7}{8} \times 3\frac{7}{8}$ (12.4 × 9.8)
Engr: Grignion
See also CL. 223
2. Folding plate in Vol. 1
12 Heads (The Passions) Fig. 6
$7 \times 13\frac{1}{2}$ (17.8 × 34.3)
Engr: Grignion
3. Frontispiece for Vol. 2
Youth Led By Pleasure
Inscribed:
Ah fly, incautious Youth, the flattering Snare,

Which PLEASURE spreads to lure thee to her Gate;
In her Soft Courts conceal'd pale WANT and CARE,
And dire DISEASE, and keen REMORSE await:
These Friends shall drive thee from her sizzling shrine
And swift to INFAMY's dread Cave consign
5 × 3¾ (12.7 × 9.7)
Engr: Grignion

277. 1748 Tobias Smollett, *The Adventures of Roderick Random*
2 vols., 2nd edition 12mo 'For J. Osborn'
1. Frontispiece for Vol. 1
Roderick Keeps Weazel at Bay With a Spit From The Chimney
7¾ × 4¾ (19.7 × 12.1)
Engr: Grignion
2. Frontispiece for Vol. 2
A Scene in a Tavern (?)
7¼ × 4½ (18.4 × 11.4)
Engr: Grignion

278. 1749 Benjamin Hoadly, *The Suspicious Husband*
12mo 'For Tonson & Draper'
Frontispiece
Ranger and Clarinda
4¾ × 3 (12 × 7.5)
Engr: Grignion

279. 1749 Horace *Horatii Flacci Opera*
2 vols. 8vo 'Apud. Gul. Sandby in vico dicto Fleetstreet'
Dedication plate for Vol. 1
George, Prince of Wales Surrounded by Trophies of the Arts
The inscription 'Wilson pinxit Hayman delin' indicates that Hayman's portrait of the Prince was drawn from one of Richard Wilson's early portraits of the young Prince.

280. 1749 Horace *A Poetical Translation of the Works of Horace . . . &tc.* by Philip Francis]
2 vols.. 4to 'For A. Millar'
1. Frontispiece for Vol. 1
Medallion Portrait of Horace Within Ornamental Cartouche
8¼ × 6½ (20.8 × 16.6)
Engr: Grignion
2. Frontispiece for Vol. 2
Medallion Portrait of Maecenas Within Ornamental Cartouche
8⅛ × 6½ (20.6 × 16.8)
Engr: Ravenet

281. 1749 John Milton *Paradise Lost. A Poem in Twelve Books*
[ed. Dr Thomas Newton]
2 vols. 4to 'For Tonson & Draper'
12 frontispieces (one for each book of the poem), each
8½ × 6¾ (21.6 × 17.1)
1. *Satan Calling his Legions* (Book 1)
Engr: Ravenet
2. *Satan at the Gates of Hell* (Book 2)
Engr: Grignion
3. *Satan Ascending to the Sun* (Book 3)
Engr: Ravenet
4. *Satan Watching Adam and Eve* (Book 4)
Engr: Grignion
5. *Adam Watching The Unawakened Eve* (Book 5)
Engr: Grignion
6. *The Battle of the Angels* (Book 6)
Engr: Grignion
7. *Raphael Discoursing* (Book 7)
Engr: Ravenet
8. *The Departure of Raphael* (Book 8)
Engr: Grignion
9. *The Temptation of Adam* (Book 9)
Engr: Grignion
10. *Christ in Judgement* (Book 10)
Engr: Grignion
11. *Michael foretells the future* (Book 11)
Engr: Grignion
12. *The Expulsion* (Book 12)
Engr: Ravenet

282. 1749 A. Selden *Love and Folly. A Poem in Four Cantos*
8vo 'For W. Johnston'
Title vignette, illustrating lines from Canto IV (p. 239)
Cupid awakes to discover that he has been struck blind by the Gods
2¾ × 3⅛ (7 × 8)
Engr: Grignion

283. 1750 *Poetic Essays, on Nature, Men and Morals Essay 1 to Dr Askew of Newcastle*
4to 'For R. Akenhead, jun. in Newcastle upon Tyne'
Title vignette
The author [possibly Dr Askew's son, the founder of the Bibliotheca Askeviana] indicating to Dr Adam Askew 'the genuine light of uncorrupted and unperverted nature'
3¼ × 5½ (8.3 × 14)
Engr: Grignion

284. 1750 James Hervey *Meditations and Contemplations*
2 vols. 8vo 'For Rivington & Leake'
1. Frontispiece for Vol. 1
The Interior of a Church with a Clergyman Instructing a Youth on The Subject of Christ's Sacrifice
5¼ × 3½ (13.3 × 8.9)
Engr: Grignion
2. Frontispiece for Vol. 2
A Scientist Discoursing to His Students on The Celestial Heavens
5¼ × 3½ (13.3 × 8.9)
Engr: T. Cook

285. 1750 Jeremiah Seed *The Posthumous Works of Jeremiah Seed M.A.*
2 vols. 8vo 'For M. Seed'
Frontispiece for Vol. 1
Portrait of Jeremiah Seed (1700–1747) Within an Oval Frame
5⅝ × 3⅞ (14.4 × 9.7)
Engr: Ravenet

286. 1750 Jeremiah Seed *Discourse on Several Important Subjects*
2 vols. 8vo 'For R. Manley & H. S. Cox'
Frontispiece for Vol. 1
Identical with CL. 285

287. 1750–51 *The Student, or, The Oxford and Cambridge Monthly Miscellany* [ed. Christopher Smart]
2 vols. 8vo 'For Newbury, Barrett & Merrill'
2 frontispieces (identical for each volume)
The Union of The Cam and The Isis
6 × 3¾ (15.1 × 9.6)
Engr: Grignion

288. 1751 *The Magazine of Magazines*
2 vols. 8vo
Frontispiece, $6\frac{1}{8} \times 4$ (15.6×10.2)
See Hayman's drawing (CL. 224)

289. 1751 James Paine *Plans, Elevations, Sections and Other Orna-ments of the Mansion-House, belonging to the Corporation of Doncaster* folio 'For the author'
Title vignette
Medallion portrait of James Paine
$5\frac{3}{4} \times 7\frac{1}{8}$ (14.6×18)
Engr: Grignion
See CL. 85 and cat. no. 89

290. 1751 *The Works of Alexander Pope. In nine volumes complete with the notes . . . of Mr Warburton*
9 vols. 8vo 'For Knapton, Lintot, Tonson & Draper'
A frontispiece (for Vol. V) and 8 full page plates.
Each $5\frac{1}{2} \times 3\frac{1}{2}$ (14.1×8.8)
1. Illustration to the *Epistle to Arbuthnot*
 Vol. IV, pl. XVI f. p. 9
2. Illustration to the *Epistle to Satires, Part 2*
 Vol. IV, pl. XVII f. p. 53
3. Illustration to the *Epistle to Satires, Part 2*
 Vol. IV, pl. XVIII f. p. 299
4. Illustration to the *Dunciad* Book II
 Vol. V, pl. XIX frontispiece
5. Illustration to the *Dunciad* Book I
 Vol. V, pl. XX f. p. 65
6. Illustration to the *Dunciad* Book II
 Vol. V, pl. XXI f. p. 121
7. Illustration to the *Dunciad* Book III
 Vol. V, pl. XXII f. p. 178
8. Illustration to the *Dunciad* Book IV
 Vol. V, pl. XXIII f. p. 225
9. Illustration to the *Essay on Criticism*
 Vol. VI, pl. XXIV f. p. 1
Engr: all engraved by Grignion
The remaining 29 plates were supplied by N. Blakey (23); S. Wale (4) and Anthony Walker (2). These designs appear again, crudely and anonymously reduced, in the 10 vol. 12mo edition of 1757. They were also re-engraved by French engravers for the 1754 Amsterdam edition of the *Oeuvres* in French.
One of Hayman's drawings survives: see CL. 225

291. 1752 John Milton *Paradise Regain'd . . . to which is added Samson Agonistes; and Poems Upon Several Occasions . . . A new edition . . . by Thomas Newton*
4to 'For J. & R. Tonson & B. Draper'
5 plates, each $8\frac{3}{8} \times 6\frac{5}{8}$ (21.3×16.8)
1. Frontispiece for *Paradise Regain'd*
 Christ tempted to change the stone to bread
 Engr: Müller
2. *Delilah Visits Samson* (*Samson Agonistes* f. p. 185)
 Engr: Grignion
3. *Euphrosyne Leads The Poet* (*L'Allegro* f. p. 356)
 Engr: Grignion
4. *The Poet by The Pool* (*Il Penseroso* f. p. 368)
 Engr: Grignion
5. *The Brothers Attack Comus* (*Comus* f. p. 391)
 Engr: Ravenet

These designs were re-engraved in a smaller format by Grignion for the 2 volume 8vo edition of 1753. They were re-issued again in 1773

292. 1752 Christopher Smart *Poems on Several Occasions*
4to 'For the author by W. Strahan'
Full page plate to illustrate *The Hop Garden Peasants Merrymaking in a Hop-field* (f. p. 130)
$9 \times 7\frac{1}{4}$ (22.8×18.4)
Engr: Grignion

293. 1753 [William Congreve] *The Works of William Congreve*
3 vols. 12mo 'For Tonson & Draper'
5 plates, each 5×3 (12.7×7.6)
Engr: all by Grignion
For details see CL. 226

294. 1753 Jonas Hanway *An Historical Account of British Trade over the Caspian Sea . . . &tc.*
4 vols. 4to 'Dodsley, Nourse et. al.'
1. Full page plate in Vol. II (f. p. 255, to illustrate Chap. XL)
 A Duel fought between two of the King's HANOVERIAN subjects, Reflections on duelling
 $7\frac{5}{8} \times 6\frac{1}{4}$ (19.4×16)
 Engr: Grignion
 See CL. 228
2. Full page plate in Vol. II (f. p. 308, to accompany Chap. XLVII)
 Comparison of the debt of the UNITED PROVINCES with that of GREAT BRITAIN. The situation of BRITISH subjects in regard to their debt. The reduction of national interest. Moral reflections on the motive to oeconomy
 $7\frac{5}{8} \times 6\frac{1}{4}$ (19.4×16)
 Engr: Grignion
 See also CL. 227
3. Frontispiece (full page) for Vol. III (Vol. III is entitled *The Revolution of Persia: Containing The Reign of Shah Sultan Hussein, with The Invasion of The Afghans, Huseein, King of Perdia, Delivering His Diadem to Mir Maghnud the Afghan Usurped in 1722*
 $7\frac{1}{2} \times 6\frac{1}{4}$ (19×15.6)
 Engr: Grignion

295. 1754 Charles Denis *Select Fables*
8vo 'For Tonson & Draper'
Frontispiece
The Muses paying Homage to George, Prince of Wales
$6 \times 3\frac{3}{4}$ (15.2×9.6)
Engr: Grignion
See CL. 229

296. 1754 John Gay *The Beggar's Opera. Written by Mr Gay*
8vo 'For John Watts'
Frontispiece
Lucy Lockett and Polly Peachum entreat their Fathers, the Gaoler and the Informer, to save the life of Macheath the Highwayman, who each takes to be her husband (Act III Scene IX)
$5\frac{3}{4} \times 3\frac{1}{2}$ [14.5×9]
Engr: Grignion
Same frontispiece used for the 1765 edition for J. & R. Tonson

297. 1755 M. Cervantes *The History and Adventures of the Renowned Don Quixote. Translated by T. Smollett*
2 vols. 4to 'For A. Millar'
Frontispiece and 27 full page plates
For a list of the individual plates see CL. 230
Engr: Grignion (12); Müller (2); Ravenet (8) and Scotin (6)
Hayman's design subsequently had a chequered history. They reappeared in a reduced format ($5\frac{1}{8} \times 3$) re-engraved by G. V. Neist for the 2nd 12mo edition of 1761; the third edition of 1765; the fourth edition of 1770 (all in four volumes). In 1771 Motteaux's 4 volume edition (pub. in Glasgow) contained four unsigned frontispieces taken from Hayman's designs. An edition of 1778, printed for F. Newbery, contained a frontispiece and five unsigned engravings (*c.* 5×3 ins.) derived from Hayman's designs. In 1793 another four volume edition was published with a frontispiece and fifteen plates (*c.* 5×3 ins.) based on Hayman's designs. Hayman's designs were still in use as late as 1811 in the two volume edition published in that year for J. Stratford, engraved by A. Warren (2); M. N. Bate (2); F. Deeves (3); Audinet (4) with four unsigned.

298. 1756 Edward Young *The Complaint: or, Night Thoughts on Life, Death and Immortality &tc.*
8vo 'For A. Millar & R. J. Dodsley'
Frontispiece
A Man in Bed is Startled and Awoken from his Sleep by a Skeletal Figure of Death
$4\frac{7}{8} \times 2\frac{7}{8}$ (12.5 × 7.4)
Engr: Grignion
The same plate appears as the frontispiece to the four volume edition of 1757 pub. for D. Browne

299. 1757 Tobias Smollett *A Complete History of England . . . from . . . Julius Caesar to the Treaty of Aix la Chappelle 1748*
4 vols. 4to 'For J. Rivington & J. Fletcher'
1. Frontispiece for Vol. 1
Boadicea in her Chariot
$9\frac{1}{2} \times 6\frac{3}{8}$ (24.1 × 16.2)
Engr: Grignion
2. Frontispiece for Vol. 2
Edward III introducing Liberty to Britannia
$9\frac{1}{2} \times 6\frac{3}{8}$ (24.1 × 16.2)
Engr: Grignion

300. *c.* 1757 Jonas Hanway *To the Marine Society, in Praise of the great and Good work they have done by Clothing & Fitting out for the Sea-Service 2682 Men, and 1668 Boys, in the Space of Fifteen Months, to the 6th October last, Recommending Constancy and Perseverance in the Cause they have espoused*
4to
Frontispiece
The Poor Led to Britannia for Welfare. In The Background a Battle at Sea
$7\frac{1}{2} \times 6$ (19.2 × 15.2)
Engr: Inscribed F. Hayman delint et donavit, Ant. Walker Sculpt et donavit

301. 1758 Jonas Hanway *Three Letters on The Subject of The Marine Society*
4to 'For Dodsley, Vaillant & Waugh'
Frontispiece, identical with CL.300

302. 1758–1760 Tobias Smollett *A Complete History of England . . . from . . . Julius Caesar to the Treaty of Aix la Chappelle, 1748*
11 vols. 8vo 'For J. Rivington & J. Fletcher'
4 folding plates in Vol. 1, each *c.* $7\frac{1}{2} \times 5\frac{1}{4}$ (19.1 × 13.3)
1. *The Noble Behaviour of the British King Caractacus before the Emperor Claudius at Rome*
Engr: Grignion
See CL. 232
2. *The Druids or the Conversion of ye Britons to Christianity*
Engr: A. Walker
3. *Vortigern, King of Britain, espouses Rowena, a Saxon Lady, Which Occasioned The Settlement of The Saxons in Britain*
Engr: Ravenet
4. *The Battle of Hastings with The Death of Harold, King of Britain; Which Decided The Conquest of England by William, Duke of Normandy*
Engr: Grignion
1, 2 & 4 were adapted from Hayman's earlier designs for a set of prints published by the Knaptons and Dodsley (see CL. 321)

303. 1759 Robert Dodsley *Cleone, A Tragedy*
8vo 3rd edition 'for Dodsley'
Frontispiece
Cleone having discovered her murdered child swoons and dies. Her father and brother look on whilst her husband Sifroy proclaims:
'She's gone! – for ever gone! Those lovely eyes
Are clos'd in death – no more to look upon me!'
$5\frac{3}{8} \times 3\frac{1}{2}$ (13.7 × 8.7)
Engr: W. Ryland

304. 1759 *The Tragedies of Sophocles from the Greek, by Thomas Francklin*
2 vols. 4to 'For R. Francklin'
1. Title vignette (unsigned)
Medallion Portrait of Sophocles
$2\frac{1}{2} \times 4$ (6.4 × 10.2)
2. Frontispiece (identical for each volume)
Sophocles and The Muses
Engr: Grignion

305. 1759 *The Tatler; or, The Lucubrations of Isaac Bickerstaff Esq.*
4 vols. 4to 'For J. & R. Tonson'
1. Title vignette (unsigned)
Portrait of Sir Richard Steele
Height, $2\frac{7}{8}$ (7.3)
Engr: I. Miller
2. Frontispiece for Vol. 1
A writer seated by a window and a girl with a pile of books
$6\frac{3}{8} \times 4\frac{1}{8}$ (17 × 10.3)
Engr: Grignion
See CL. 233
3. Frontispiece for Vol. II (*Tatler* no. 93)
Isaac Bickerstaff lunging with his sword at figures drawn on the wall
$6\frac{3}{8} \times 4\frac{1}{8}$ (17 × 10.3)
Engr: Grignion
See CL. 234
4. Frontispiece for Vol. III (*Tatler* no. 116)

The Petticoat Court
6 × 4⅛ (15.3 × 10.3)
Engr: Grignion
5. Frontispiece for Vol. IV (*Tatler* no. 266)
Betty Frisk and Tom Feeble
6½ × 4⅛ (17.3 × 10.3)
Engr: Grignion

306. 1760 *An Essay on Immorality, In Three Parts*
4to 'For the Author and sold by John Hunt'
Frontispiece
Fallen Virtue Appealing to Terpsichore to Raise Her Spirits
6 × 4 (15 × 9.8)
Engr: Grignion

307. 1760 [Anne Steele] *Poems on Subjects Chiefly Devotional*
2 vols. 8vo 'For J. Buckland & J. Ward'
1. Frontispiece for Vol. 1
 Two women in a landscape. One holds a Bible and points heavenward, the other, seated on a bench, gazes downward
 Engr: Grignion
2. Frontispiece for Vol. 2
 Inscribed:
 We look not at the things which are seen
 For the things which are not seen are Eternal *2 Cor: 4, 18*
 5¼ × 3⅜ (13.3 × 8.6)
 Engr: Grignion

308. 1761 Joseph Addison *The Works*
4 vols. 4to 'For J. & R. Tonson'
1. *Rosamund: An Opera* (Vol. 1, f. p. 79)
 9 × 6¾ (22.9 × 17.3)
 Engr: Grignion
2. *Cato Meeting The Corpse* (Vol. 1, f. p. 247)
 9¼ × 6⅞ (23.5 × 17.5)
 Exh: Society of Artists 1762 (183)
 Engr: Grignion
3. *A Scene From "The Drummer"* (Vol. 1, f. p. 377)
 9 × 7 (23 × 17.6)
 Engr: Grignion

309. 1762 *The Artists Vade Mecum Being The Whole Art of Drawing*—4to 'For R. Sayer'
2 full page plates (unsigned)
1. *The Head of a Young Man in Outline and Shade*
 6 × 7 (15.2 × 17.8)
2. *The Head of an Old Man in Outline and Shade*
 4⅛ × 7 (10.5 × 17.8)
See cat. no. 93

310. 1767–1768 William Guthrie *A General History of Scotland*
10 vols. 8vo 'printed for the author by A. Hamilton'
Frontispiece for Vol. 1
An allegory of the Act of Union – Britannia flanked by the King of England and Scotland. The King of England Transfers a volume inscribed 'REGIAM MAIESTATEM' to the King of Scotland
Engr: J. Taylor
There are numerous portraits of ancient Scottish Kings and Noblemen in Vols. 1 & 2, some of which may be after Hayman, but none are acknowledged as his designs.

311. 1773 William Shakespeare *Hamlet, Prince of Denmark; a Tragedy. Collated with Old and Modern Editions* [by Charles Jennens]
8vo
Frontispiece
The Closet Scene III, xi
5½ × 3⅞ (13.8 × 9.8)
Engr: Grignion
See CL. 139

312. 1773 William Shakespeare *Macbeth – A Tragedy . . . Collated With The Old and Modern Editions* [by Charles Jennens]
8vo
Frontispiece
The Ghost of Banquo Appears to Macbeth
5½ × 3⅜ (13.9 × 9.2)
Engr: W. Ryland

313. 1773 William Shakespeare *Othello . . . A Tragedy . . . Collated With The Old and Modern Editions* [by Charles Jennens]
8vo
Frontispiece
Emilia Tells Othello of his Error About The Handkerchief
5¼ × 3½ (135 × 9)
Engr. Grignion

314. 1774 William Shakespeare *Julius Caesar, A Tragedy . . . Collated With The Old and Modern Editions* [by Charles Jennens]
8vo
Frontispiece
Brutus seated a table reading by candlelight starts at the sight of the Ghost of Caesar. Lucius lies sleeping on the floor IV, x
5¼ × 3½ (13.5 × 9)
Engr: W. Ryland

315. 1774 William Shakespeare *King Lear. A Tragedy . . . Collated With The Old and Modern Editions* [by Charles Jennens]
8vo
Frontispiece
The Heath Scene III, vii Fig. 5
5¼ × 3½ (13.5 × 9)
Engr: Ravenet

316. 1794 *The Triumph of Painting, A New Drawing Book in Forty Folio Copper-Plates; consisting of Features and Parts of the Human Body &tc. by Hayman, Worlidge, Le Brun &tc. . . . engraved by Mr Ravenet*
4to 'For Laurie & Whittle'
6 full page plates each *c.* 11¾ × 7¾ (30 × 19.8)
1. pl. 6 *Hands and Feet in Shade*
 Inscribed: *Engrav'd from the Originals of Peter da Cortona, Van Loo & Mr Hayman by S. F. Ravenet*
 Engr: Ravenet
2. pl. 7 *Hands, Breast and Feet in Shade*
 Engr: Grignion
3. pl. 16 *Head and shoulders of putto in two positions outline and shade*
 Engr: Ravenet
4. pl. 17 *Head and shoulders of an Old Man in outline and shade. Head and shoulders of a youth (after the Antique) in outline and shade*
 Engr: Grignion
5. pl. 18 *Head of a Young Woman Wearing a Veil, Outline and Shade*

Head of Young Woman Wearing a Mob-cap Outline and Shade
Engr: Ravenet

6. pl. 19 *Head of an Old Man, outline and shade, Head of Youth, outline and shade*
Engr: Grignion

317. Undated *An illustration to an Unidentified Edition of Dryden's "Amphitryon" (Act II Scene v)*
Alcimena and Phaedra Welcoming Home Amphitryon and Sosia With The Spoils of War (?)
5 × 3 (12·7 × 7.6)
Engr: C. Mosley
Coll: Plymouth City Art Gallery, Cottonian Collection (loose plate)

318. Undated *Unidentified Title Vignette*
A Scholar Seated at his desk with Busts of Ancient Worthies in the Background
Engr: Ravenet
Coll: A proof impression before lettering is bound into J. H. Anderdon's Society of Artists Catalogues for 1763/4 in the Dept. Prints and Drawings, British Museum

MISCELLANEOUS ENGRAVINGS

319. 1740 *The Patriot Statesman*
Broadside with engraved headpiece
Sir Robert Walpole led by Burleigh to the Temple of Fame
6½ × 11½ (16.5 × 29.3)
Engr: G. Vander Gucht, pub. 1740 (see cat. no. 76)

320. *Design for a Trotting Carriage*
Early-mid 1740s (?)
12¼ × 15¾ (31 × 40)
Engr: J. S. Müller

321. 1751–1752 *A Set of Historical Prints*
1. *The Noble Behaviour of Caractacus Before The Emperor Claudius*
14½ × 18 (36.8 × 45.7)
Engr: Grignion

2. *The Druids, or, The Conversion of The Britons to Christianity*
14½ × 18 (36.8 × 45.7)
Engr: Ravenet

3. *The Norman Conquest, or The Battle of Hastings*
14½ × 18 (36.8 × 45.7)
Engr: Grignion
For full details see cat. no. 78
See also CL. 302

322. 1755 *Quin as Falstaff*
Etching by Francis Hayman
No impression is known to survive
According to J. T. Smith (*Nollekens and His Times . . . &tc.* II, 353–4) 'In 1755 Hayman etched a small quarto plate of Quin, the actor in the character of Falstaff, seated on a drum, in a swaggering attitude, with his right elbow resting upon the hilt of his sword, by the side of the body of Hotspur. This is a truly spirited production, and is so rare, that the only impression known to collectors is the one the artist gave to his friend, the late President of the Royal Academy in 1770, and which was by the liberality of Mrs Benjamin West, presented to me.'

323. N.D. *Headpiece to a Sun-Fire Office Policy*
3¾ × 5½ (9.5 × 14)
Engr: by Morrison, Moorfields
Coll: There is an impression in an extra-illustrated copy of Edward Edwards, *Anecdotes of Painters . . . &tc.* in the Dept. Prints & Drawings, British Museum p. 51

324. N.D. *Headpiece for Fire Policy*
Inscribed: in ink, No. 14974
5½ × 8¼ (14 × 21.3)
Coll: 'Collectanae Biographica', Vol. 47, Dept. Prints & Drawings, British Museum

LENDERS

Birmingham Museum and Art Gallery 58
Budapest, Museum of Fine Arts 71
Cambridge, Fitzwilliam Museum 20, 53, 54
Dublin, National Gallery of Ireland 6, 43
English Heritage, Kenwood 11, 15, 31
Exeter, The Cathedral Church of St. Peter 5
Exeter, Royal Albert Memorial Museum 1, 2, 21, 44, 45, 48, 52
London, The British Library 81, 82b, 84, 85, 86, 89, 92, 94
London, The British Museum 72a, b; 76, 80a, b; 87, 88, 91, 97, 98, 99
London, The Thomas Coram Foundation for Children 46
London, The Garrick Club 41
London, National Portrait Gallery 3, 16, 17, 49
London, The National Theatre 42
London, Tate Gallery 18, 32, 37
London, The Royal Academy of Arts 70
London, Victoria & Albert Museum 28, 30, 33, 77, 90
University of London, Courtauld Institute Galleries 57, 61
University of Manchester, Whitworth Art Gallery 60
Newcastle-upon-Tyne, Laing Art Gallery 8
Norwich Castle Museum 34
Private Collections 4, 7, 9, 10, 12, 22, 26, 27, 29, 35, 36, 50
Sidney Sabin Esq. 51
Dudley Snelgrove Esq. 59
Southampton Art Gallery 40
Washington, D.C., Folger Shakespeare Library 38, 74, 82a
Yale Center for British Art 13, 14, 19, 23, 24, 25, 39, 47, 55, 56, 63–69 inc., 73,
 75, 78, 79, 83, 93, 95, 96
Yale University, Lewis Walpole Library, Farmington, Conn. 62

INDEX

This index refers only to the Introductory Chapters